Emotions and Architecture

Emotions and Architecture: Forging Mediterranean Cities Between the Middle Ages and Early Modern Time explores architecture as a medium to arouse or conceal emotions, to build consensus through shared values, or to reconnect the urban community to its alleged ancestry.

The chapters in this edited collection outline how architectonic symbols, images, and structures were codified – and sometimes recast – to match or to arouse emotions awakened by wars, political dominance, pandemic challenges, and religion. As signs of spiritual and political power, these elements were embraced and modulated locally, providing an endorsement to authorities and rituals for the community. This volume provides an overview of the phenomenon across the Italian region, stressing the transnationality of selected symbols and their various declinations in local contexts. It deepens the issue of refitting symbols, artworks, and structures to arouse emotions by carefully analysing specific cases, such as the Septizodium in Rome, the Holy House of Loreto in Venice, and the reconstruction of L'Aquila. The collection, through its variegated contributions, offers a comprehensive view of the phenomenon: exploring the issue from political, social, religious, and public health perspectives, and seeking to propose a new definition of architecture as a visual emotional language. Together, the chapters show how the representation of virtues and emotions through architecture was part of a symbolic practice shared by many across the Italian context.

This book will be of interest to researchers and students studying architectural history, the history of emotions, and the history of art.

Francesca Lembo Fazio is a Research Fellow in the Department of History, Representation and Restoration of Architecture in Sapienza University of Rome. Her research activity focuses on the perception of ruins and *spolia*, traditional building techniques, and issues of built heritage and climate change. Her main works and publications are on the protection and reuse practices on ancient ruins in Early Modern Rome and on the restoration of modern architecture, from fascism to post-war reconstruction.

Valentina Tomassetti is currently a PhD student in the History Department at the University of Warwick. Valentina's research explores the gendered dimensions of female shame, from Renaissance to modern time. Valentina has extensive experience in teaching and has served as Senior Graduate Teaching Assistant between 2018 and 2021. As a proud first-generation graduate, Valentina is passionate about inclusivity and diversity in education. As well as completing her research and collaborating with different charities, Valentina is currently employed as Education and Engagement Officer at UK Parliament.

Routledge Research in Architectural History
Series Editor: Nicholas Temple

The books in this series look in detail at aspects of architectural history from an academic viewpoint. Written by international experts, the volumes cover a range of topics from the origins of building types, the relationship of architectural designs to their sites, explorations of the works of specific architects, to the development of tools and design processes, and beyond. Written for the researcher and scholar, we are looking for innovative research to join our publications in architectural history.

Architecture for Spain's Recovered Democracy
Public Patronage, Regional Identity, and Civic Significance in 1980s Valencia
Manuel López Segura

Arieh Sharon and Modern Architecture in Israel
Building Social Pragmatism
Eran Neuman

Developing Iran
Company Towns, Architecture, and the Global Powers
Hamidreza Mahboubi Soufiani

The Life and Work of Jerzy Sołtan
the "last modernist architect"
Szymon Ruszczewski

Architecture of Extraction in the Atlantic World
Luis Gordo Peláez and Paul Niell

Emotions and Architecture
Forging Mediterranean Cities Between the Middle Ages and Early Modern Time
Edited by Francesca Lembo Fazio and Valentina Tomassetti

For more information about this series, please visit: https://www.routledge.com/architecture/series/RRAHIST

Emotions and Architecture
Forging Mediterranean Cities Between the Middle Ages and Early Modern Time

**Edited by
Francesca Lembo Fazio and
Valentina Tomassetti**

LONDON AND NEW YORK

Cover image: Giovanni Paolo Panini (1691–1765), View of the Colosseum and the Arch of Constantine.

First published 2024
by Routledge
4 Park Square, Milton Park, Abingdon, Oxon OX14 4RN

and by Routledge
605 Third Avenue, New York, NY 10158

Routledge is an imprint of the Taylor & Francis Group, an informa business

© 2024 selection and editorial matter, Francesca Lembo Fazio and Valentina Tomassetti; individual chapters, the contributors.

The right of Francesca Lembo Fazio and Valentina Tomassetti to be identified as the authors of the editorial material, and of the authors for their individual chapters, has been asserted in accordance with sections 77 and 78 of the Copyright, Designs and Patents Act 1988.

All rights reserved. No part of this book may be reprinted or reproduced or utilised in any form or by any electronic, mechanical, or other means, now known or hereafter invented, including photocopying and recording, or in any information storage or retrieval system, without permission in writing from the publishers.

Trademark notice: Product or corporate names may be trademarks or registered trademarks, and are used only for identification and explanation without intent to infringe.

British Library Cataloguing-in-Publication Data
A catalogue record for this book is available from the British Library

Library of Congress Cataloging-in-Publication Data
Names: Lembo Fazio, Francesca, editor. | Tomassetti, Valentina, editor.
Title: Emotions and architecture : forging Mediterranean cities between the Middle Ages and early modern time / edited by Francesca Lembo Fazio and Valentina Tomassetti.
Description: Abingdon, Oxon : Routledge, 2024. |
Series: Routledge research in architectural history | Includes bibliographical references and index. |
Identifiers: LCCN 2023035863 (print) | LCCN 2023035864 (ebook) | ISBN 9781032412467 (hardback) | ISBN 9781032415635 (paperback) | ISBN 9781003358695 (ebook)
Subjects: LCSH: Architecture—Italy—Psychological aspects. | Architecture and society—Italy—History.
Classification: LCC NA2540 .E36 2024 (print) | LCC NA2540 (ebook) | DDC 720.945—dc23/eng/20230828
LC record available at https://lccn.loc.gov/2023035863
LC ebook record available at https://lccn.loc.gov/2023035864

ISBN: 9781032412467 (hbk)
ISBN: 9781032415635 (pbk)
ISBN: 9781003358695 (ebk)

DOI: 10.4324/9781003358695

Typeset in Times New Roman
by codeMantra

To our families and friends
– our shared emotions

Contents

List of figures *ix*
List of contributors *xiii*
Preface *xv*

1 **Fragments, *spolia* and remains. Emotional antiquities in Rome between the Early Modern and Renaissance era** 1
FRANCESCA LEMBO FAZIO

2 **Spaces of virtue. Transcultural affection and its representation in Ottoman-Venetian relations** 25
LUC WODZICKI

3 **The geopolitics of simulacra and the seventeenth-century Venetian Holy House of Loreto** 53
LIV DEBORAH WALBERG

4 **Mythmaking, fidelity, and urbanism in early modern Messina and Palermo** 77
TAMARA MORGENSTERN

5 **Architecture and emotions in early modern quarantine centres** 104
MARINA INÌ

6 **The rebuilding of L'Aquila after the 1703 quake: Death and rebirth** 127
ROSSANA MANCINI

7 **Identity perception in monuments, ruins and remains: Roman and Romano-British heritage in British travel accounts c. 1770–1820** 151
BARBARA TETTI

Index 175

Figures

1.1 Rodolfo Lanciani, *Reconstruction of the Pilgrimage Routes*, 1891 (in Frutaz, *Le Piante di Roma*, tav. 137) 5

1.2 The Septizodium in the city maps through centuries. On the left, up to bottom: Francesco Paciotti, *Rome*, 1557; Giorgio Braun, Simone Novellanus and Francesco Hogenberg, *Rome*, 1575; Mario Cartaro, *Rome*, 1576. On the right, up to bottom: Giambattista Nolli, *Rome*, 1748; Giuseppe Lugli and Italo Gismondi, *Reconstruction of the Ancient Rome*, 1949 (in Frutaz, *Le piante di Roma*, tavv. 13-14, 122, 228, 235, 238) 13

2.1 Gentile Bellini, *La Processione in Piazza San Marco*, 1496, Venezia, Gallerie dell'Accademia, with details 26

2.2 Siblizade Ahmed (attr.), *Mehmed II Smelling a Rose*, 1480–1481, Istanbul: Topkapi Palace Museum Library 39

2.3 Gentile Bellini, *The Sultan Mehmet II*, 1480, The National Gallery, London 41

3.1 Façade of the church of San Clemente in Isola, architecture by the Lombardo family, 1483–1488; Niches, inscriptions, bas reliefs, and sculptures by Andrea Cominelli, 1651–1652. Francesco Morosini's monument at left; Tommaso Morosini's monument at right. Photograph by the author 63

3.2 Funeral monument of Gerolamo Gradenigo, Patriarch of Aquileia, c. 1658–1660. Photograph by the author 65

3.3 View of the Holy House and altar of the *Annunciata* from the nave of San Clemente, with Giorgio Morosini's monument at left and Pietro and Lorenzo Morosini's monument at right. Photograph by the author 67

3.4 Left: Funeral monument of Pietro and Lorenzo Morosini. Right: Funeral monument of Giorgio Morosini. Both monuments by Giusto LeCourt, 1677–1685. Photographs by the author 68

x *Figures*

4.1 Top: Sixteenth-century view of Messina with waterfront fortifications. Braun & Hogenberg, *Civitates Orbis Terrarum*, 1588–1597, Historic Cities Center of the Department of Geography, the Hebrew University of Jerusalem and the Jewish National and University Library. Bottom: View of the port of Messina with the Palazzata, Abraham Casembrot, c. 1623–1658, Museo Regionale di Messina 84

4.2 Left: Plan of Messina with Habsburg projects. 'Plan de la Ville de Messine', in *Description de l'isle de Sicile, e de ses côtes maritimes, avec les Plans de toutes ses Forteresses,* Pierre del Callejo y Angulo and Baron Agatin Apary, Amsterdam, 1734, Austrian National Library. 1. Porta Reale; 2. Strada Marina; 3. Neptune Fountain; 4. Orion Fountain; 5. Porta Imperiale; 6. Statue of Don John of Austria; 7. Palazzo Reale; 8. Via Cardines; 9. Strada Austria; 10. Palazzata; 11. Forte del Santissimo Salvatore. Right: Plan of Palermo with Habsburg projects. 'Plan de la Ville de Palermo', in *Description de l'isle de Sicile, e de ses côtes maritimes, avec les Plans de toutes ses Forteresses,* Pierre del Callejo y Angulo and Baron Agatin Apary, Amsterdam, 1734, Image from the collections of the National Library of Spain. 1. Cala; 2. Foro Italico; 3. Porta Felice; 4. Quattro Canti; 5. Fontana Pretoria; 6. Cassaro; 7. Maqueda; 8. Piazza Bologni; 9. Cathedral; 10. Palazzo dei Normanni; 11. Porta Nuova 90

4.3 Clockwise from top: Palermo, Braun & Hogenberg, *Civitatus Orbis Terrarum*, 1588–1597; Porta Nuova, exterior elevation, Henry Pauw van Wieldrecht, c. 1893–1903, Rijksmuseum; Quattro Canti, Giuseppe Barberis, 1890, in Gustavo Strafforello, *La patria, geografia dell'Italia, Parte 5. Italia insulare*, 1893; Porta Felice, anonymous, 1890, in Gustavo Strafforello, *La patria, geografia dell'Italia, Parte 5. Italia insulare*, 1893 96

5.1 Plan, section and view of the Lazzaretto della Foce in Genoa, from John Howard, *An Account of the Principal Lazarettos in Europe* (London: 1789), Plate 3, Plate 2; Getty Research Institute, Los Angeles (85-B11700) 109

5.2 Sketch for a Lazzareto, from John Howard, *An Account of the Principal Lazarettos in Europe* (London: 1789), Plate 14; Getty Research Institute, Los Angeles (85-B11700) 111

5.3 From the top left: Chapel of San Rocco in the lazzaretto of Ancona, photograph by the author; Chapel of San Leopoldo in the homonymous lazzaretto in Livorno, by kind permission of Belforte Editore Libraio; ruins of the chapel of the lazzaretto of San Pancrazio, Verona, photograph by the author 116

6.1 Foglio di Orazione Contro il Terremoto (1703). https://ingvterremoti.com/2022/08/11/la-sequenza-sismica-che-colpi-il-centro-italia-nel-1703 136

6.2	Map of Piazza del Mercato (1713), showing the Church and its distance from the Cathedral, Archivio di Stato dell'Aquila, F. Del Baccaro, Allegationes facti et iustis, 1713, E. 83	140
7.1	(Left) W. Gell with J. P. Gandy, *Pompeiana. The Topography, Edifices, and Ornaments of Pompeii*, 1817. (Right) W. Gell, A. Nibby, *La Carta de' Dintorni di Roma*, 1837	158
7.2	(Left) Giacomo Rocrué, *Antico Foro Romano / Tempio dei Castori già Giove Statore / Tempio e recinto di Vesta l'antico Foro Romano*, Robert Cockerell, 1818. (Right) Thomas Babington Macaulay, *Lays of Ancient Rome*, 1847	160
7.3	(Left) James Hakewill, *A Picturesque Tour of Italy*, 1820. (Right) Elizabeth Batty, *The Temple of Antonino e Faustina in the Campo Vaccino*, in Italian Scenery, 1820	163

Contributors

Francesca Lembo Fazio (Research Fellow, Department of History, Representation and Restoration of Architecture, Sapienza University of Rome) is an architect with a background in conservation and restoration. Her research activity focuses on protection and reuse practices on ancient ruins in Early Modern Rome and on the restoration of modern architecture, from fascism to post-war reconstruction.

Marina Inì (Assistant Professor in Early Modern European History; Fellow at Churchill College, University of Cambridge) is an early modern cultural historian interested in material culture, history of medicine, and spatial and urban history of the early modern Mediterranean. Her research interests focus on diversity, cross-cultural encounters in urban contexts, and funerary practices in Mediterranean port cities of the late seventeenth and eighteenth centuries.

Rossana Mancini (Associate Professor, Department of History, Representation and Restoration of Architecture, Sapienza University of Rome) is an architect and specialist in restoration of monuments. Her research activity focuses mainly on theoretical aspects of restoration and the history of building techniques. She is the author of contributions in the field of restoration, in particular on the topics of fortified architecture and on the history of traditional building materials and techniques.

Tamara Morgenstern is an independent scholar who received her doctorate in architectural history from University of California Los Angeles and her B.A. from Brown University. She has written on Louis Kahn's proposal for the Hurva Synagogue in Jerusalem, early modern architecture and planning in Naples and Sicily, Gilded Age architecture in Florida and Palm Beach, and early twentieth-century architecture in Los Angeles.

Barbara Tetti (Research Fellow, Department of History, Representation and Restoration of Architecture, Sapienza University of Rome) is an architect, a specialist in Restoration of Monuments, and a PhD student in History and Restoration of Architecture. Among her research topics, she focuses on the perception of ruins between the eighteenth and nineteenth centuries from the perspective of women travellers.

xiv *Contributors*

Valentina Tomassetti (PhD student, History Department, University of Warwick) explores the gendered dimensions of female shame, from Renaissance to modern time. She served as Senior Graduate Teaching Assistant between 2018 and 2021 and is passionate about inclusivity and diversity in education. She is currently employed as Education and Engagement Officer at UK Parliament.

Liv Deborah Walberg (Associate Professor, Bloomsburgh University of Pennsylvania) is a scholar of Italian Renaissance and Baroque visual culture, with secondary interests in the seventeenth-century Ottoman Empire and the history of textiles and fashion. Her studies include publications on the interaction between art, religion, and politics in early modern Venice.

Luc Wodzicki (Postdoctoral Researcher, Division for Early Modern History at Freie Universität Berlin's Friedrich-Meinecke-Institut) is an historian of the Early Modern. His research focuses on Mediterranean History, Intellectual History, Transculturality, and more recently the History of Knowledge. He has a background in Islamic Studies and Global History.

Preface

Francesca Lembo Fazio
Valentina Tomassetti

This collection sees the contribution of scholars from different scientific backgrounds, ranging from Architecture to History and History of Art. The overarching theme of the volume is the relationship between architecture and emotions, analysed over a chronological arch that extends from the Late Middle Ages into the early nineteenth century. The volume analyses a diverse range of emotions and values, from collective memory and identity connected to ideals of power and authority, to more intimate feelings such as boredom, wonder, and grief.

In *Emotions and Architecture*, architecture is explored as a medium to arouse or conceal emotions, to build consensus through shared values, or to reconnect the urban community to its alleged ancestry. In particular, the chapters outline how architectonic symbols, images, and structures were codified – and sometimes recast – to match or to arouse emotions awaken by wars, political dominance, pandemic challenges, and religion. As signs of spiritual and political power, these elements were embraced and modulated locally, providing an endorsement to authorities and rituals for the community. This volume aims to provide an overview of the phenomenon across the Italian region, opening the dialogue regarding the transnationality of selected symbols and their various declinations in local contexts.

The volume deepens the issue of refitting symbols, artworks, and structures to arouse emotions by carefully analysing specific cases. Through its variegated contributions, the collection offers a comprehensive view of the phenomenon, as it explores the issue from political, social, religious, and public health perspectives. The chapters, together, show how the representation of virtues and emotions through architecture was part of a symbolic practice shared by many societies across the Mediterranean context. Architecture emerges, from this volume, as a common emotional language that often crossed the boundaries of local use. Although the topics covered refer to different territorial contexts and to different eras, it will be possible to appreciate a strong continuity in how communities expressed public and common emotions, with striking similarities to our recent history.

In Chapter 1, Francesca Lembo Fazio explores the emotional responses of people that came in contact with ancient ruins in the city of Rome. The emotionality of these encounters, explains Lembo Fazio, is modified by different perceptions

of time, as clearly shown by the example of the roman Septizodium. The peculiar history of this building and the different narrations of it across centuries highlight the conflicted emotional approaches to ruins across time. Lembo Fazio reconstructs how, in the span of a few decades, the Septizodium went from being a respected ancient site, which generated awe, fascination, and reverence among its visitors, to a place of abandonment, towards which people projected their disgust and melancholy for the lost glory of the past. These feelings gave way to the possibility, for local authorities, to dismantle the building and to reuse its precious materials in other construction sites. This act of breaking down a physical memory, and disseminating it in other parts of the town, is compared, by the author, to the act of dismembering the holy bodies of Saints. Fragments of architecture, similarly to relics, can travel, be transported and transposed, change form, and acquire new meanings for local communities. What remains unaltered, explains Lembo Fazio, is the power of fragmented pieces to bring a community together as a whole: when feelings of identity and devotion arise, ruins as well can be imagined again as a whole, in an emotional suggestion triggered by the senses.

Travelling symbols is the narrative thread that connects Lembo Fazio's article to the second contribution of the volume. In Luc Wodzicki's chapter, we are presented with a convincing explanation of how shared virtues and emotions were adapted to different cultural and territorial contexts, thanks to spatiality and architecture. Starting from a simple handkerchief, Wodzicki shares a new, interesting, light on the relationship between Venice and the Ottomans, proving the possibility of transposing emotions beyond the Italian territory and across the Mediterranean. Thanks to architecture, Wodzicki explains, the same emotions and values can be declined in different contexts: this is manifested clearly in the Sultan's Garden in Istanbul, where architecture and carefully planned space offered visitors a physical display of that virtue that the Sultan wanted as pillars of his empire. The handkerchief, then, becomes a symbol of friendship and shared values: an invisible but tangible connection between Venice and Istanbul, two of the most powerful nations of the Mediterranean, built on the same white marbles of virtue, as Petrarch would say. What emerges is a panorama of common and, at the same time, original feelings, transposed and interpreted through movement and space. In Wodzicki's chapter, we can see how two cultures, sharing and competing for the same territory, also shared similar values and emotions, aroused by the same architectural and spatial forms. Once again, architecture is understood as a mean of nurturing feelings of identity and belonging, as in the case of the Fondaco dei Turchi in Venice, in which architectural models, spatiality, and forms of extraterritorial management are transposed.

The relationship, this time conflictual, between Venice and the Ottomans is the background of the third contribution of this collection, a chapter signed by Liv Deborah Walberg exploring how nationalistic sentiments in the people of Venice melded in the architecture and commemorative monuments of San Clemente in Isola, the first simulacrum of the Holy House of Loreto constructed in Venice. Walberg narrates how military efforts against the Ottomans received the support of the

local population, thanks to the creation of places and structures that communicated shared emotions and strengthened the city's identity against a common enemy. The Sanctuary of the Madonna of Loreto reproduced the Holy House in all its parts, recreating the spatial experience of pilgrimage, and – through the transposition of the symbols connected to it – strengthened the devotion of the Venetian community, who saw in the building the physical manifestation of divine favour. Walberg's reconstruction of the history of San Clemente's Sanctuary is detailed and clearly encapsulates the evocative power of architecture, especially in a city like Venice, so well used to utilise sacred and common spaces for propagandistic purposes. Walberg's analysis enriches our knowledge of how Venetians used art and architecture to evoke memories and emotions, and the Holy House represents a successful example of how architecture became the physical symbol of a common identity that transcended time and geographic boundaries.

With Tamara Morgenstern's contribution, we move further down the Italian Peninsula to explore how symbols and political identities were forged by Baroque architecture in the Kingdom of Sicily. Morgenstern brings the reader into a fascinating journey through the urban structures of Messina and Palermo during the Spanish Habsburg dominion (the 1530s–1630s). Morgenstern captures the desire to strengthen the city's institutions through architectures and shared emotions. In this case, it is interesting to note how references to ancient architecture and models remained at the basis of the new Baroque creations, with a clear attempt to connect Sicily to the city of Rome and its classical values. Captivating is the reference to the river Tiber which, mirrored in one of Palermo's Baroque fountains, provided an endorsement to the newly established rulers, inspiring respect and obedience in the population. The new urban developments, described as stages of an imaginary journey through the cities, show the originality of the new elaborations and the full enjoyment of spaces – until then militarised – by the community, which fully adheres to the new programme and the emotional transport in putting it into action.

The almost opposite narration, instead, emerges from Marina Inì's analysis of quarantining stations in sixteenth- and seventeenth-century Venice. In this case, people struggled to occupy those spaces of containment and reclusion. For people stationing and working in the lazzaretti, architecture became a visual reminder of physical reclusion and spatial constriction. The lazzaretti, designed as spaces of containment, were often perceived as negative places, linked to imprisonment, and triggered emotional responses associated with boredom, rejection, and repugnance, which were reported by both travellers and officers. The skilful use of different primary sources allows Inì to diversify the analysis of emotions in quarantine. Inì, in fact, explains how, despite the standardised nature of lazzaretti's architecture, different categories of people perceived these spaces in different ways. For some categories of passengers, argues Inì, the lazzaretti became spaces of mobility, restful waypoints during long journeys, or spaces of religious contemplation. This description of the lazzaretto as an open space, so distant from the common idea of a sealed fortress, shows how people modelled the architecture around them in a multitude of manners. In a relatively small space, we can witness the different

emotional responses that people displayed, in response to the same standardised space that surrounded, and sometimes enclosed, them.

Architecture can reinforce the identity of a city not only through the recovery of ancient models but also during the development of new stages of urban expansion. This is addressed, in the sixth contribution of the collection, by Rossana Mancini, who studied the reconstruction of the Italian city of L'Aquila after the devastating earthquake of 1703. The tragic event triggered feelings of loss, desperation, and grief, which brought the community together and fuelled the desire to rebuild the city, together with its new destiny. Mancini explains how these new architectural models, brought by the Baroque, reflected the new identities and values of the Aquilan society, profoundly changed by the 1703 earthquake. Mancini projects the events of L'Aquila in a larger European panorama, comparing the emotional responses triggered by the rebuilding process to similar events that happened in Europe during the seventeenth century, like the Great Fire of London. Mancini's chapter deviates from the majority of the case studies presented in the collection as, in the case of L'Aquila, the main response was to abandon the previous Medieval and Renaissance models, to seize the opportunity for a total renewal in Baroque forms. In this context, Mancini proposes an interesting analysis of the role of the rubble in the rebuilding process. Used as building material, plastered and never exposed, rubble only re-emerged less than 15 years ago, during post-seismic inspections following the 2009 earthquake. Inspectors found that Santa Maria di Collemaggio had been partly rebuilt using fragments originated from previous collapses. This would suggest an emotional approach to fragments very different from the ones discussed in other contributions, but Mancini suggests how, in this case, the use of rubble could indicate a more articulated way to elaborate collective grief. In Mancini's analysis, rubble becomes the pillar of the city's rebirth, and architecture, with the collective emotions it arises, becomes the healing part of the community's grieving process.

In the final contribution, Barbara Tetti reflects once more on the role of architecture as a mean through which identity and memory are transmitted. Tetti focuses on how British travellers responded to encounters with ancient ruins while journeying through Italy. Emotions, in this case, are similar to the ones displayed centuries before and described by Lembo Fazio in the opening chapter of this collection. In a perfectly circular way, we can see the strong continuity in emotional responses across time, as classical ruins were studied and appreciated in their magnificence in the fourteenth, as well as in the nineteenth, century. Most travellers, explains Tetti, responded with surprise, curiosity, and wonder to the glorious magnificence of the past displayed in the classical ruins. In particular, the travellers' testimonies highlight the perception of an ideal continuity between the ancient Roman Empire and the new British Empire. Architecture, in this case, translated imperial aspirations and enriched the colonial propaganda. Ideal reconstructions, proposed by scholars and enthusiastic travellers, transformed architecture into a vessel through which classical values were transposed into the modern British society. Notable, in Tetti's analysis, is the focus on female travellers and their emotions. The encounter

with classical ruins offered women the opportunity to navigate gendered societal rules. Women elaborated these encounters through knowledge and senses, exploring architecture from the dual extremes of emotions and rationality. The majestic architecture of the past inspired women to feel brave and empowered. Tetti explains how those ruins that women had only been able to study, draw, or imagine suddenly were available to explore with all the senses. By touching, seeing, and experiencing the materiality of the past, women were liberated from the emotional constrictions of the early modern society and finally projected into the future.

1 Fragments, *spolia* and remains. Emotional antiquities in Rome between the Early Modern and Renaissance era

Francesca Lembo Fazio

In modern times, especially from the nineteenth century on, ruins and fragments have gained increasing importance, which culminated in the full development of the so-called 'aesthetics of the fragment' in twentieth-century artistic movements.[1] Yet, excitement and awe aroused by ancient remains were already evident in earlier centuries, starting in the Middle Ages and especially in Rome. The feeling of amusement experienced when coming in contact with ancient fragments was different from the empowering excitement that re-appropriation and reuse of ancient architectural elements – the so-called *spolia* – procured to people. In Renaissance Rome, encountering ruins and fragments evoked emotions, mainly but not exclusively connected to the idea of common identity and re-connection with the ancient power of the Empire.

This chapter will describe the emotional responses of pilgrims, visitors and citizens that came into contact with fragmented ruins in Rome. The first section of the chapter will look at how these responses were influenced by changes in time perception, which resulted in feelings of temporal distance, awe and respect towards the antiquities. However, in this process, negative feelings and disruptive building practices will also be observed to contrast the sheer appreciation of ruins and fragments expressed in literature. For this reason, after framing the creative and imaginative thinking in approaching scattered pieces in the Medieval and Early Modern philosophy, as well as humanist and philological methods in the Renaissance, some examples of emotions aroused by fragments in the living city will be displayed. In the last section, the example of the Septizodium and its dismembering in the sixteenth century will reveal all the complex stages of emotional approaches towards fragments between the Middle Ages and the Renaissance.

Ruins, *spolia* and relics: emotions and identities through time-perception

In conservation studies, a ruin 'is anything that bears witness to human history but has changed so much from its former appearance as to be almost unrecognisable', at the same time embodying 'an implicit expectation of the conservation and transmission of its historical message'.[2] However, in common language, this word is used to identify the process or state of being spoiled or shattered,

a sense of lost opportunities, sparse broken parts – destroyed or badly damaged. The consciousness of time passing by – and the perception of its traces as memories – is the main issue that frames the two definitions, resulting in antithetical aspects.

Conceptions of time play a key role in the reception of ruins. In a linear time perspective, ruins embody loss: the emotions aroused are mainly pain and sadness, whilst in cyclical conceptions the leading feeling is the acceptance of death, and the consequent wait for rebirth. Thus, a disposition towards the fascination with ruins can be developed, as ruins can be perceived as physical remains of time consciousness.[3]

Narrations of ruins, as elements that universally and symbolically identify the precarious human condition, only find their full development in Latin culture, from the Late Antique period onwards. In the classical period, the description of ruins is mainly linked to specific historical events with few exceptions. It is possible to find descriptions of destroyed cities and buildings in war reports that remark the feeling of satisfaction in annihilating the enemies (or, in reverse, in showing the despair of the wretches, as described in the Trojan Women by Euripides). At the same time, ruins evoked both melancholy and solace like in the letter from Servius Sulpicius Rufus to Cicero after the death of his daughter Tullia. In analysing the emotions expressed in the letter, Silvia Azzarà highlights how for the first time the ruins of ancient cities served as warning on the frailty of human life: humans must accept the short lifespan of beloved ones, since even the most powerful cities are destined to come to an end. Above all, the ancient splendour of destroyed monuments is depicted as impossible to be recognised through worn-out remains, like when Thucydides in his *History of the Peloponnesian War* talks about the ruins of Mycenae, saying that it would be possible to recognise the ancient greatness of the city – narrated by the Homeric poems – looking at its ruins.[4]

In the Late Antique period, the physical presence of ancient remains has an active role in the experiences and conceptions of time, as means through which people expressed time consciousness. In several accounts, fragments are described with fascination, sometimes enriched with a touch of a morbid remark towards the decadence of mundane things, in contrast with divine greatness and nature. More often, it is possible to sense a selfish satisfaction in being alive and in the present time, thus being able to win over something already passed by, as splendid as it may have been.[5] The attitude towards fragments seems to evolve during the Middle Ages and the Renaissance, reconnecting the shattered pieces into a whole picture.

Antiquity's value is, therefore, strictly linked to time consciousness – especially the linear one. The historical distance from original events strengthens the fascination and powerful meanings of the remains. Partly as an expression of cyclical time consciousness, the materials from the past are the evidence of golden eras that can be recovered through their reuse and imitation. Moreover, fragments are often used as relics, expressing and forming the identity of the communities. It would be misleading to trace back all the attitudes towards ancient pieces as steps in the evolution of a heritage definition – that implies the acknowledgement of both the historical and the aesthetic value of the remains. Single elements were generally reused in different contexts and with opposing attitudes. In some cases,

ancient structures were spoliated and reused in new buildings with symbolic aims, being means to express value and virtues. In other contexts, fragments and ancient structures were practically transformed into building elements, without bearing any specific meaning. The interpretation of fragmented architecture was applied on different levels, depending on the patrons, local communities and contexts, and specific needs in building sites. The symbols and emotions evoked could vary even inside the same city due to shared symbols and practices in the population. Ruins and ancient structures were surely seen as evidence of human actions, but only in specific cases had the function to connect to the act of memory, linking to values and emotions. Being fractured, the ancient pieces bore an expressive and communicative potential that was fully disclosed – and grasped – only with the integration of the missing part.[6]

One of the meanings of *spolia* – seen as a shifting of the materials' semantic and functional declination – is probably connected to the perception of fragments and ruins as lacking parts of a wider context, emphasising the message of identity and reconnection to the past through the selection and the reuse of single elements.[7] Fragments and ruins were often perceived as memories from the past, thus like relics. The process of consciousness is similar to that of a saint's body, which acquires importance and dignity precisely in its *disiecta membra*, that is, in being dismembered and dispersed.[8] The feeling of devotion and respect for holy elements and the admiration for ancient remains have in common the honour paid towards physically broken elements. In this specific case, as shared symbols and sources of emotions, the materials miss a necessarily practical function and are valued in their fragmentary character.

Even if linear time organisation came directly from the Christian interpretation of history, in the Roman framework feelings towards relics developed, thanks to the blend of religious devotion and theories from the pagan world, on the topics of memory and physical remains.[9] Thus, a re-elaboration of the notion of death occurred, moving from the idea of a rigorous disconnection between the worlds of the living and the dead to the belief in resurrection, that is, in the survival in an afterlife and in immortality.[10] The decay and decomposition of bodies, as well as the physical decay of architectures, seems therefore unacceptable, and there is a sheer contrast between ordinary decaying corpses, which lead to a sense of repugnance, and the incorrupt and resplendent body of the saints, which generates joy.[11] The preservation of – the presumed – bodily integrity of saints was perceived as a sign of alienation from the ordinary fate of corpses' putrefaction, predicting the blissful epilogue in the afterlife and the 'ontological fullness of perfection'.[12] The difference between the body of a saint and a common corpse was such that the traditional prohibitions on the desecration of bodies were overruled, and the practice of dismemberment for the purpose of creating relics was allowed.[13]

Through the intercession of the relic, the true believer had the possibility of coming into direct contact with the *testimony* of the saint, a dimension that, from a memory, becomes real and tangible.[14] Even if dismembered in many different parts, the grace emanating from the relic remained whole, and its power was 'equal to that which the martyr would have if he had never been divided'.[15] Similarly,

a parallel can be drawn between the fragment of ancient material and the relic: even if dismembered and no longer recognisable, both *bodies* bear witness to a dimension that, from abstract and otherworldly, becomes real and tangible for communities sharing the same values and emotions.

Between the thirteenth and fourteenth centuries, Scholasticism amplified this feeling of reverence for the fragment, while at the same time finding new interpretations of feeling and perceiving physical reality.[16] According to Thomas Aquinas, since the earthly things are subdued to time and changing, when the intellect comes into contact with an object, a kind of adaptation takes place and the object is recognised, thanks to comparisons. Truth, then, is a kind of equality between intellect and things. For this reason, human knowledge is born and develops over time, constantly acquiring new impulses that force humans to constantly rethink their opinions. This assumption, made on Aristotelian basis, presupposes a knowledge that is always limited and a truth that is likely to adjust according to external changes.[17]

Thus, imagination is the mean by which humans are able to form an opinion about material reality. Fantasy is, moreover, associated with the vision – and, therefore, the first and most immediate perception – the root of the word coming from the Greek word *faos* [φάος], which is light.[18] In the late Middle Ages, Albertus Magnus and Thomas Aquinas used the term *imaginatio* (imagination) to indicate the properly 'reproductive' faculty in relation to sensible reality.[19] Fantasy, therefore, in the mediaeval world is the connection between senses and reason in which the spiritual joins the rational, not without producing a new – and, in some ways, plausible – interpretation of the real world.[20] Fantasy is not a mimetic mind reproduction of what exists but an authentic hypothesis, while taking into consideration reality.[21] A similar idea was introduced in the twentieth-century conservation practice by Roberto Longhi, who talked about the 'mental restoration' in which 'the eye […] could easily restore, but only mentally, what is missing, ideally connecting the surviving parts', and by Luigi Pareyson, according to which 'the seer eye can look at fragments and ruins, […] as if living in their wholeness'.[22] In the Early Modern, imagination or fantasy was more consciously implemented, especially in the artistic field: the artist, by going beyond matter, could intentionally create images that would help the intellect to feel multiple sensations, connecting both the sensory and the emotional activity.[23]

Therefore, the way of feeling the works of art as a oneness, even when in fragments, was possible through a process of *imaginative restoration*, which is a way of looking at buildings and views in a whole way through the aid of imagination and of fantastic interpretation. It is possible to trace this process, thanks to a specific type of literature: the city itineraries dedicated to Rome.[24] These itineraries were especially conceived to guide pilgrims in their visits to the holy places of worship. In these cases, the remains worked as milestones in the wanderings of pilgrims, even if, in some notes, fragments of ancient buildings were means to express antithetical emotions of admiration and repulsion towards the pagan world.[25]

The famous Einsiedeln Itinerary – probably composed in the ninth century, when pilgrimages in Rome became a stable practice – described several ways to cross the city from one gate to the other and referred to specific views and remains along the routes.

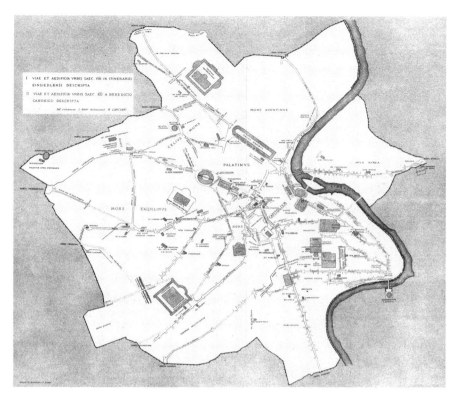

Figure 1.1 Rodolfo Lanciani, *Reconstruction of the Pilgrimage Routes*, 1891 (in Frutaz, *Le Piante di Roma*, tav. 137).

In the remarkable description of the Aurelian Walls, none of the towers, the loopholes or the gates are described as ruins or with missing parts, even though the Walls already presented evident signs of decay. This imaginative reconstruction also applies to the other sites and ancient places that pilgrims could find on different routes. Most of the time, these sites had already been stripped from their most precious materials, but in the itinerary are described as intact, as for the area for the Circus Maximus that had been already occupied by medieval structures. There is only one mention of a ruined structure on the itinerary starting from Porta Appia: in this case, this landmark is described as a 'ruined niche', and it is mentioned twice – in both travelling directions, going in and out of the city.[26] In the Einsiedeln text, the itineraries are described in a very plain tone: only the names of the landmarks are listed without characterizations or extensive descriptions. However, the equestrian group of Castor and Pollux (on the Quirinal Hill) is defined as '[statues of] beautiful horses' – an exceptional aesthetic appreciation of the sylloge. When referring to the 'marble horses', the author shows deep awe and appreciation for the sculpture group and its material, even if with vast missing parts.[27]

From the twelfth century, the habit of composing devotional routes is enriched with new themes. The so-called *Mirabilia* – manuscripts collecting all the admirable

itineraries and experiences to be undertaken once in Rome during a pilgrimage – are a mixture of sacred and secular stories.[28] Ancient places became the set for amazing – almost magical – past events depicted by the chronicles.[29] Fragments of antiquities, however, are often described as intact in a fantastic reconstruction of their former glory. In *Mirabilia Romae*, there is a list of gates, towers and main buildings enriched by the narration of fantastic legends of ancient events. The structures, still in place and recognised by the writer, are depicted as perfect and coated with precious materials, not even resembling ruins. The last paragraph explains that all the descriptions come from ancient accounts, as well as from direct observation ('as seen by our eyes'), trying to put into words 'how beautiful [the structures] were – made of gold, bronze, ivory and precious stones.'[30]

The so-called *Malmesbury Itinerary* is introduced by the abbot Hildebert of Lavardin's poem, written at the beginning of the twelfth century.[31] These verses describe Rome in the greatness of its ruins, declaring that it was so marvellous that it would be impossible to create again a similar work of art, or even restore its ruins. Everything is depicted as admirable, created with exceptional skills, precious materials and wide dimensions – suggesting these as the main features that attracted the visitors and aroused emotion and deep deference. The following list of remarkable places by William of Malmesbury doesn't indulge in descriptions and reports only a few hints of the stories of the Saints. However, it begins with a mention of the 'ancient dignity of remarkable things'.[32]

In the Prologue of the *Narratio de Mirabilibus Urbis Romae* by Magister Gregorius, written between the twelfth and thirteenth centuries, the topic are the *wonderful things* that existed in Rome, the vestiges of which are still in place as 'present memories'.[33] The writer describes the remarkable things that are 'the most deserving of admiration' built 'through magic or men's effort'.[34] The whole image of the city is amazing. The main feeling is awe, and the ruins are perceived as the most beautiful work of art: 'admiring for a long time the immense splendour of the city, I thanked God, who, great on all the earth, here made human works marvellous, with a priceless nobility'.[35] Magister Gregorius recalls the poem by Hildebert of Lavardin, declaring that 'nothing can be similar to you, Rome, even if you are almost a whole ruin. Now that you are crumbled, you show how great you were when intact'.[36] In this case, ruins are symbols of perishable human things, but their physical condition doesn't retrain the visitors from witnessing the decorum and the greatness of the city. Some fantasy stories are added to the list of remarkable places, even if the author becomes more emotional in describing the ruins. The bronze statues are described as astonishing and magnificent, sometimes 'horrific' in their great dimensions and lifelike aspect.[37] Talking about some huge fragments of a male statue, he explains that the pieces should have been a source of pride for the artist, since:

> A human head or a hand don't have any missing beauty, in any part: in this perfect way the artistic technique reproduced soft hair with stiff bronze. If someone stares at his eyes, he will seem on the verge of moving and talking.[38]

Fragments, spolia *and remains* 7

Gregorius can find the beauty even in a fragment, understanding it as part of a whole composition.

In some cases, the ruins are a symbol of the end of the pagan era. However, most of the descriptions recall great admiration in which there is no place for decay. In an imaginative description, the author recalls enjoying the warm thermal water in the still-in-use Apollo Bianeo's bath and admiring perfect and 'pulsating blood' statues.[39] Above all, the marble and the statue are remarkable for their exquisite beauty, even if the author acknowledges that some of the works had been damaged under pope Gregory the Great. The statue of Venus is described as 'perfect' and 'beautiful', almost as a living creature.[40] Again, in the Temple of Minerva, there was a statue of the goddess that 'lost her head, still offers a magnificent torso to the visitors'.[41] All the main palaces are partially in ruin, but the writer is sure that – thanks to their dimensions and their precious materials – it is not possible to tear them down.

On the Septizodium, Gregorium falls silent, astonished by the incredible art and highness of the site, as he quotes Ovidius's words: 'the palace was high with wonderful columns, with gold, its splendour reminiscent of flames'.[42] The particularly valuable materials, the grandeur of the buildings and, above all, the extreme realism of the statues and the skill of the craftsmen stand out. The ruins are described, but the descriptions do not include detailed information about the quantity of surviving materials. What one reads is admiration and awe, almost facing magic or mystery. The architecture is always intact and perfectly recognisable, whether it is in a simple list of landmarks or used to retrace the history of places through fantastic tales.[43]

We can find further descriptions of Rome and fragments in Early Modern writings. With Petrarch, antiquity and history are finally framed in the real context of the city from what emerges from the epistles collected in the *Familiarium Rerum Libri*. Although places and examples dear to Christian religiosity – such as places of martyrdom and anecdotes of miraculous events – are always mentioned in a catalogue form, at the heart of the narrative there is the physical approach to classical ruins, their observation and their acknowledgement as proof and memory of the past. The result is a chronicle of pieced-together events, always in balance between historical objectivity and Christian faith.[44]

Among the many accounts and descriptions of the city, Giovanni Dondi dall'Orologio's report of his Roman journey stands out (c. 1300–1388/1389). His inspection of the Roman ruins is particularly innovative: places are no longer taken into consideration for their allegedly magic atmosphere, nor for being the location for Christian key events, as in the *Mirabilia*. A careful analysis of the physical reality of the ancient remains is predominant. Thanks to his surveys, whose scientific originality stands out, it is possible not only to empirically calculate the dimensions of the buildings but also to verify impressions and assumptions regarding the structure under analysis.

His description of the Pantheon is carried out with an early philological approach, starting from the interpretation of the single parts to picture the whole composition. Dondi accurately describes the characteristics of the *rotunda*, by noting the number

of columns and pilasters, both inside and in the pronaos and outlining the position and size of each element. In describing the exterior of the Pantheon, he provides an image of the building isolated from its context and freed from the many buildings in close proximity – and, in some cases, even within the *pronaos* itself.[45] In the late sixteenth century, in the description by Pompeo Ugonio (c. 1550–1614), the Pantheon's *pronaos* have only 14 out of 16 granite columns – the two of them, possibly already lost at the date of Dondi's survey, even if there is no certain information on when the columns went lost or were spoliated.[46]

Dondi's narration of the Pantheon is, actually, a reconstruction of the ideal form of the monument, and it is possible that what he presents is an imaginary reconstruction, fabricated from what he could deduce by studying the materials and the remains. Dondi's look at the ancient architectures outlines a methodology based on scientific rigour and on the material traces, scrutinised as *imagines agentes*, images and views that can actively communicate once approached in a critical and imaginative way – a main topic of the fourteenth century.[47] This technical approach was surely Dondi's peculiarity – and is probably also a consequence of his linear conception of time, since he is well known for being among the first to study and implement the mechanical and standardised clock. His scientific detachment and deference towards antiquity are consequences of the knowledge of the cultural and temporal distance from the remains of the past. The reference is no longer to ancient monuments as *mirabilia* – awe-inspiring pieces – but rather to their character of *notabilia* – important elements to be known.[48] However, both shattered pieces and missing parts were not only objects of contemplation and reverie, but rather worked in an active way on human imagination and mind. In Petrarch's letters, the relics are:

> Fragments of ruins (*ruinarum fragmenta*) that fall under the wandering gaze of the spectator and are immediately transformed into true "working images" (*imagines agentes*), triggering an intellectual wandering that reflects time in physical and mental space.[49]

In *De Varietate Fortuna* by Poggio Bracciolini (1380–1459), instead, single and dismembered elements seem almost an obstacle in the perception of ancient beauty.[50] While Giovanni Dondi creates a *virtual reconstruction* through the use of feelings and imagination, for Poggio Bracciolini it seems impossible to perceive the ancient remains as part of a whole – he cannot feel the 'potential oneness of the work of art', to quote the words of Cesare Brandi.[51] The 'vestiges' of the past (*vestigia*) seem to be 'interrupted' and 'gnawed' (*interrupta* and *semesa*), since he seems not to be able to reconnect their meaning.[52] Hence, the temporal distance becomes a gap that cannot be bridged, even using the imagination. The living city still interacts in an active and contradictory way with the relics, re-functionalising and changing their appearance – both in using their substance in new building components (as in *spolia* and liming), and in becoming the foundations of new constructions. The perception of antiquity gradually changes from an imaginative interpretation to a rather conjectural one, taking the rediscovered works by Cicero

as the main reference. This way, Poggio suggests a true cognitive method that can be applied to antiquarian investigation.

The perception of antiquity is divided into two different steps of the knowledge process: the reproductive phase and the imaginative – hence productive – one.[53] Therefore, under the humanistic stimulus, there is a transition from the medieval approach, based on the subjective elaboration and imaginative interpretation of the fragments, to an attempt in finding a scientific truth through the remains. The real change lies in the description of the splintered elements as *traces* through which provide an approximation of the original shape, in a sort of 'hunting' of the model, using a metaphor that will be further reinforced during the sixteenth century.[54]

However, even if studied with a philological method, antiquities were still admired and associated with metaphysical aspects and virtues, as in the book *The Hypnerotomachia Poliphili*, attributed to Francesco Colonna and composed at the end of the fifteenth century.[55]

The volume tells the allegoric 'strife of love in a dream' of Poliphilo – that can be translated as *lover of Polia* or *lover of many things*, who wanders among buildings, ruins and gardens to reach his lost love. The quest, written in a mixed language of Latin and early Italian and illustrated with magnificent woodcuts, is often interpreted as an initiatory journey to reach the knowledge, in which architectures and ruins have a key role in revealing the deepest emotions of the main character. Poliphilo's adventure is actually 'a dream or a vision', and the itinerary is among the ruins of an abandoned city: the pieces are references to truly existing remains – probably from Rome, Tivoli and Palestrina – overlapping or ideally revived. The antiquity has an exemplary value; it triggers and supports poetic invention, stimulates the intellect, engages emotional registers, unleashes the erudite game of cross-references and fuels the ongoing journey of the character, seen as an inquisitive investigator seeking knowledge.[56] For this reason, all the journey's stopovers are parts of a treasure hunt, in which Poliphilo can reach the final stage only by virtue, as in the episode of Poliphilo's choice among the Three Doors: to reach Polia, Poliphilo must reach the Three Doors and chose the right passage, aided by the messages detected on ancient fragments on the way: 'happy is the one, who follows the middle path' and 'while sitting down, limit the speed; while standing up, limit the slowness'.

The architectures in Poliphilo's visionary dream are the *disiecta membra* of antiquity, which are the sparse, multiple fragments left from the past.[57] The urban space is not defined by them, and the ruins are not milestones to reconnect the landscape anymore – even if they guide through the inner journey of the main character, helping him to recognise the virtues through symbols and emotions. The wreckage is seen as a negative effect of the time passing by, and the structures are often described as smashed by events. On the Polyandrion structure, Poliphilo says that 'all the built things were broken down by the time, the antiquity, and by the wind, the rain and the sun'. In another passage, he describes a structure 'smashed by the time'.[58]

The fragments of ancient architecture are admired in their shattered nature, as a reference to both physical and spiritual values. However, most of the time the

sparse elements must be recognised and reinterpreted to have a meaning – in some cases, a new act of creation is necessary. When speaking of the temple near the sea, the writer says that it is not possible to understand its original function, and that for this reason, it lost its 'dignity'.[59] On the contrary, the decay and the vegetation mixed with the fragments intensify the aesthetic appreciation of the ruins.

In describing the fragments, the terms used are 'noble' and 'spectacular'.[60] The magnificence and splendour of specific remarkable parts of the monuments are emphasised.[61] The inscriptions are 'elegant' and 'well outlined' – not just for how they look but also for what they mean.[62] The power of the remains, even if in fragmentary form, dwells in their noble and solid character.[63]

Even when the structures are in ruin, Poliphilo goes through a mental process of reconstruction to understand them in all their parts. This process is matched by the drawings in the book, showing some of the main buildings, and by what Leon Battista Alberti (1404–1472) depicts in his architectural treatise *De Re Aedificatoria*, written between 1443 and 1452. In Alberti's book, based on Vitruvius and dedicated to the theoretical principles of architecture, the process of creation is described as purely imaginary. In this oneiric creative process, new systems can be invented and ancient structures recomposed.[64] Imagination thus returns, as the ability to go beyond fragmented physical reality and to enjoy individual pieces through their perception as part of a whole, imperishable but no longer timeless. Poliphilo seeks and studies the fragments as if involved in a treasure hunt, developing his own identity at the same time.[65]

A change in the perception of fragments seems to become more evident during the sixteenth and the seventeenth century. In his masterpiece *Scienza Nuova* (The New Science), Giambattista Vico (1668–1744) proposed a new philological approach based on ancient models of reasoning. Vico saw literary fragments from the antiquity as useless for the scientific process because of their fragmented and dislocated nature and aimed, through his work, to make them 'terse, composed and lodged'.[66] This process of reassembling ancient pieces bears similarities with the virtual reconstruction of fragmented architectures made by Early Modern scholars. The separated elements, classified as fragments, are no longer symbols of virtue and beauty, and there is no possibility to revive them, not even in a symbolic way or to express virtues as previously seen in late Medieval practices or in Poliphilo's dream. Fragments are no longer timeless. On the contrary, they are placed in the past on a linear timeline, fulfilling the only purpose to understand and learn from them. Ruins still convey curiosity and wonder, as they are described as 'marvellous' in the Aristotelian sense of the term: defining objects that urge the observer to focus on the surroundings. The ancient findings, resurfacing after a long time, are something that arouses wonder in those who encounter them.[67]

The meaning of fragments, though, doesn't emanate from their physical nature or the quality of their material. According to Vico, it is the historian who, collecting the single pieces, can truly interpret them in a philological way and find the definition of the whole. Thus, there is a shift of focus in the search towards the truth and certain interpretations. From simply being a relic, fragments become scientific evidence, sources to be selected and contextualised in order to express the right meaning of history.

Fragments and the living city: pieces of antiquity in describing the Roman activities

Medieval and Early Modern documents, describing everyday activities in Rome and in the lands right outside the walls, hold interesting information on the existence and position of specific fragments. The most common terms highlight the location of scattered ancient pieces, through which to delimit and recognise specific areas and properties. The erratic materials, displayed in specific locations, could also be a way to identify places in which crucial legal functions – such as the proclamation of truces – could be performed. They are usually described by adding specific qualities and terms, indicating the will to directly identify and recognise the ancient pieces.

It is interesting to note the recurrence of terms that denote a sense of awe, in documents prior to the twelfth century. One of them is the will 'for the salvation of her soul' (*pro anima*) made by Silvia, mother of the future pope Gregory the Great, to the monastery of St. Andrew and Gregory *ad Clivum Scauri*. This source is particularly useful in understanding the emotions aroused by ancient fragments and how their location in the Roman landscape was involved in shaping the reverence for antiquity. The will *pro anima* by Silvia, here analysed, was composed in 604, even if it is now proven to be a false document, written between the seventh and the beginning of the twelfth century to resolve a property controversy that involved the monastery on some adjacent lands. Due to the importance of the characters involved and the described places, this record can be valued as one of the most representative compendia of fragments' descriptions in the Roman countryside from the tenth century. The land left to the monastery is identified through a virtual tour of the Roman countryside and signposted by the ancient remains, which amplify the value of the bequest and mark the virtues of the noblewoman ('magna domina'), as well as the importance of the land. The single fragments seem to show deference towards the religious institution and emphasise the prestige of the heritage. All the fragments are placed as boundaries and are defined by synonyms of this word (*affines*, *arciones*, *terminus*). However, their importance and their connection to antiquity are expressed by the material quality – marble, travertine (*marmoreus, tiburtinus*) – and especially through the recurring term 'ancient' (*antiquus*), which appears in numerous similar documents in the collection. This last term shows the exceptional respect and admiration for works that are, in their present condition, no more than fragments: the Latin term used (*antiquus*) positively designates the remains, which are not 'old' – for which the Latin term *vetus* would have been used, thus with a negative meaning of decaying matter.[68]

The remains seem not to be described as gnawed pieces and remains of their physical composition – instead they seem to embellish the described landscape. In the description, it is possible to find mentions of small fragments, as well as more complete architectural elements, described with the terms 'column', 'bridge' and, above all, 'monument' (*monumentum*).[69] However, their importance and their beauty seem to lie precisely in their fragmentary nature. The places described, dotted with scattered fragments, gain in relevance and pulchritude, arousing emotions akin to ruin lust.

However, it bears witness to the approach towards fragments and the feelings connected to antiquities. This document, like many others from the tenth century and belonging to the monastery of St. Andrew and Gregory's archive, locates lands and properties through the description of ancient landmarks, making lists of pieces by analogy to the early pilgrimage itineraries. The term 'ancient' (*antiquus*) occurs in many descriptions of the fragments, indicating a feeling of respect and appreciation for ancient remains.

After the twelfth century, documents often mention building activities on ancient areas or remains inside the city, even if the Roman Statute of 1363 formally forbade the stripping of ancient monuments inside the walls 'since the ancient building represent the decorum of the city', whilst outside the Aurelian Walls was more common the use of contractual formulas, to rule potential fortuitous discoveries of slabs and fragments to be reused.[70]

These formulas prescribed the equal division of 'gold, silver, or other precious stones' between the tenants and the landlords, but without a specific mention to marble and travertine slabs.[71] Only in one case, in a contract made on the 22nd of June 1383 between the Monastery of Saint Praxedes and Andrea di Meolo, the Chapter adds a special prescription: 'not to touch or move any marble and travertine slabs eventually found, without the special permission of the Abbott or the Chapter'.[72] This particular case provides an insight on how precious were considered these materials; however, these formulas can generally show the widespread practice of trading and exchanging fragments as *minutiae*, with little information on the consistency of the findings.[73] Even after the twelfth century, the adjective *antiquus* is still used to describe fragments in some descriptions, as in the one recording the estate sale in *rione Pigna*, within the walls of Rome, where the boundaries of the property are defined by the fragment of an ancient building (*forma antiqua*).[74]

Similarly, other sale or lease contracts of properties in Rome use the same system, indicating marble or travertine slabs as cornerstones in describing places.[75] Compared to the Roman countryside, inside the walls there must have been several areas with architectures in ruin, and the life of the city was surely characterised by them. However, at the beginning of the Renaissance, the practice of defining property boundaries through ancient fragments seems to become increasingly occasional. Some specific fragments were chosen to seal pacts and truces between Roman families, showing how citizens were moved by the antiquity's honour and dignity and how they felt those pieces as part of their civic identity. In a document dated 25 June 1370, a truce was offered 'sitting on a marble slab'.[76] Other similar resolutions are proclaimed by the notary 'sitting on stone stairs'.[77]

Fragments with the meaning of *spolia* were similarly important, once included in civil and religious porticoes. Ancient elements went through an effective reintegration, displaying the virtue and the power of the owner, and reconnecting the new construction to the magnificence of the past one. Their importance was mainly linked to the desire to revive ancient meanings of political authority by transposing them. Once re-employed in new spaces, they were often used as well as notorious elements near which to close deals.[78] Porticoes and loggias in civil buildings were visual landmarks for residents, characterising the main focal points of the *contrade* – smaller areas inside the districts, the so-called *Rioni* – and the families' leaderships.

However, from the fifteenth century, ruins were often pictured in documents as negative elements showing the neglect of some areas. Some contracts on the area between the Circus Maximus and the slopes of the Palatine Hill describe some structures 'in ruin', 'sunken' and 'useless', clearly arousing negative feelings.[79] Slowly, there is a shift from respect and lust for fragments – the *antiquitas* – to displeasure towards the old, collapsed remains.

Sensing and transforming the Septizodium's fragments

Right next to the Circus Maximus, the transformation of the Septizodium's remains represents a practical example of the different approaches towards the fragmented ancient matter and how the very same ruin could evoke both positive and negative emotions between the Middle Ages and the Renaissance.[80]

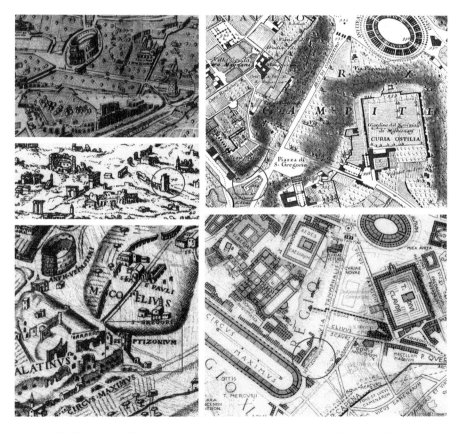

Figure 1.2 The Septizodium in the city maps through centuries. On the left, up to bottom: Francesco Paciotti, *Rome*, 1557; Giorgio Braun, Simone Novellanus and Francesco Hogenberg, *Rome*, 1575; Mario Cartaro, *Rome*, 1576. On the right, up to bottom: Giambattista Nolli, *Rome*, 1748; Giuseppe Lugli and Italo Gismondi, *Reconstruction of the Ancient Rome*, 1949 (in Frutaz, *Le piante di Roma*, tavv. 13-14, 122, 228, 235, 238).

The Septizodium, also referred to as Septizonium and Septem Solia, was a three-storey portico composed of as many vast exedras. It was built at the foot of the Imperial Palace by order of Septimius Severus in the early years of the third century, probably as a decoration of the Palatine Hill's side facing the Porta Capena. The exedras were adorned with ornamental fountains, and in the middle one, the *Forma Urbis* – the Severan Marble Plan of Rome – shows a base, possibly of a colossal statue of the emperor.

Included in all the itineraries and descriptions of the city in the Middle and Early Modern Ages, the fragments of this ancient structure drew the attention of the visitors and were described as impressive – both for their dimension and for their position since they were located along one of the main routes to enter the most densely populated area of the city. The structure of the Septizodium is mentioned, as an important landmark, in two different itineraries in the Einsiedeln text.[81] The descriptions of the *Mirabilia* emphasised the essential and emotional features of the antiquities, such as polychromy, grandeur and the use of precious materials. The Septizodium possessed all these characteristics, with a display of columns and marble slabs of different quality and colouring, as recorded in the sixteenth-century descriptions and from recent findings in archaeological excavations.

On the epistyle of the first floor was engraved the dedication, which was broken into two sections in the Middle Ages and, therefore, only partially reported in the epigraphic collection of the Einsiedeln itinerary. In the sixteenth century, the Septizodium's last section – with the epigraph's last part and the year of dedication – still existed, even if with a vast missing part in between the two chunks of ruins.[82] However, the descriptions in the Medieval itineraries lack information on the parts of the structure that were still in place – and in use. Some more specific data on this monument's remains can be found in the archive of the monastery of St. Andrew and Gregory *ad Clivum Scauri*.[83] The larger part – mentioned in documents as *Septem Solia maior* – was located towards the Circus Maximus, while there was also a smaller portion towards the Colosseum – the *Septem Solia minor*.

On the 22nd of July 975, Stefanus – 'noble man' (*vir illustris*), consul and duke of Rome – in his will left the 'temple' (*templum*) called '*Septem Solia minor*' to the abbot John I.[84] In the document, he also gives consent to the excavation and destruction of the smaller part of the Septizodium. In this way, the monastery of St. Andrew and Gregory *ad Clivum Scauri* would have had the opportunity to fortify the wider area called *Septem Solia maior*. The fragments were donated '*pro anima*' – in a will – by one of the city's notables, and this suggests the importance of the fragments, even in their crumbled shape. The possession of ancient pieces was a way to show a form of control over the city, and passing them on was a form of handing the authority over. The document indicates how the two sections of the Septizodium were clearly perceived in different ways. Probably, the focus is on the possibility to reuse some building materials. Precious materials such as marbles, travertine and peperino stones – all found in both sections of the building – were usually not used in the construction of plain defensive systems, but the ruins of the minor part of the Septizodium were probably recognised as less important, and, therefore, they could have been sacrificed for the construction and fortification

of the *maior* part owned by the monastery. The larger and better preserved part, destined to be completed and fortified, seems to arouse more emotions than the minor part, which presumably was in a state of ruin since the Middle Ages. It is not possible to determine the causes behind this different perception, but it is common to find other examples of selected structures – to be demolished, reused or, on the contrary, preserved – with few hints on the motivations.

In 1067 news circulated about a monetary donation to the St. Andrew and Gregory *ad Clivum Scauri* monastery for Septizodium-related matters, probably to redeem the structure – from some invader or, more likely, from some exchange or lease made previously – and to build further on it.[85] Later, on the 18th of March 1145, the Septizodium appears again in a document from the monastery, which leases in perpetuity to Cencio Frangipane – a member of one of the most important Roman families – the tower called '*de Arco*' (today identified as the Moletta tower) and a '*trullum*' (i.e., a probably fortified, circular construction) called *Septem Solia*.[86] In this case, the fragment – or better, the *spolia* – represents a way of corroborating the position of the Frangipane family, which in this period exponentially extended its rule over the city. In addition to its usefulness, the monastery's concession seems to indicate the Septizodium's pieces as relics, the possession of which could reinforce and protect who ruled over the city.

According to some sources, precisely because of its use as a military outpost, the Septizodium was abandoned and destroyed following various city clashes and at the behest of Brancalone degli Andalò in 1257 – a hypothesis rejected by Stevenson and that it is, indeed, not supported by reports.[87] If not as a fortress, the Septizodium continued to appear in descriptions of Rome and drawings until the beginning of the sixteenth century, including the two engravings made by Lefrery and Dupérac just before the final dismantling of the ancient ruin.

Further evidence of the importance and emotions aroused by the ancient fragments of this complex can be found in the description of the triumphal entry of Charles V into Rome on 5 April 1536. In a pamphlet addressed to the duke Alessandro de' Medici of Florence, written by the leading figure of the papal court Zanobio Ceffino (1499–?), there is a description of the sovereign's itinerary along a 'very wide road', where he would reach 'that very reputable simulacrum of Septizodium, where there was a beautiful fountain that bathed all who passed along the said road with rose water'.[88] Here too, like in the medieval Roman itineraries, the remains of the Septizodium are described as *worthy*, therefore deserving of respect, appropriate to the occasion, as if it were a structure still intact. Mention is also made of a 'beautiful fountain' that bathed passers-by with 'rose water', that is, rose-scented water, which must have increased the pleasure of passing through and ideally reconnected with the customs of ancient emperors.[89]

The dismantling of the structure, carried out by the architect Domenico Fontana between 1588 and 1589 at the behest of Pope Sixtus V, can be deduced from the building site documents, which describe the quantity of materials removed and their size. It is known that all the materials on the façade were spoliated, and that the stripping was continued by digging into the ground down to the foundations. The task was not recalled in the commemorative frescoes commissioned by the

pope, and there is no representation of the dismemberment of the ruin as a notable work carried out during his pontificate. This is because, according to Stevenson, 'the destruction of such a monument, deplored by contemporaries and scarcely tolerated by them because it was believed to be necessary, was not an event of which it was natural to leave a glorious memory'.[90] Fragments of the ancient structure, now meaningless and incoherent, are dismembered and used in the main papal building sites of the time.[91]

There may have been more practical causes for the demolition, linked to the increasing instability of the ruin, some of whose columns had collapsed shortly before 1588, perhaps already during the pontificate of Sixtus V and right before the official dismantling of the structure was carried out.[92] It seems that the fragments, especially ancient ones and of particularly valuable material, are now no longer perceived as a source of emotion and deep respect – through a virtual integration of architecture and an ideological connection to the classical past. It is not possible to find a proper explanation to this controversial way of behaving. However, an explanation can partially found if we look back to the theoretical frame and to Vico perception of fragments and linear history. In the Medieval and Early Modern periods, the structure of the Septizodium was perceived and valued in its fragmented and dismembered consistency, even if there were some cases of stripped materials. On the contrary, in the sixteenth century, the fragments are valuable only if it is possible to reconnect them, while finding a ratio behind the *dingy, truncated and dislodged* pieces through making them *terse, composed and lodged*. However, this approach seems strained by the Pope: the political and economic plans made by Sixtus V required adequate quantities of cheap building materials to reshape the city and to compete with the classical imperial era.[93] In this way, the fragment regains its own dignified dimension only in its physical inclusion in a new complex and its transformation into a new architecture.

Some final remarks

The described case of the Septizodium is not unique in the Roman landscape, and indeed numerous destructions and appropriations have always characterised the life of the city since the end of the Roman Empire.[94] It is assumed that Pope Paschal II (1099–1118) filled parts of the Medieval city, which were still almost at the ancient level, as evidenced by the remains enumerated in the Einsiedeln itinerary. The motivation, in this case, was probably to allow easier movement between the fragments and ruins of ancient Rome, which often impeded passage. This theory was supported by numerous finds of column shafts in the archaeological excavations in the nineteenth century, and perhaps some of the main monuments had already been buried at this time.[95]

Again, among the numerous accounts of such pleadings, mention must be made of the letter Petrarch sent to Cola di Rienzo in 1347, in which he complains about the sale of ancient material to other cities and describes the gradual disappearance

of the ruins that characterised the Roman landscape. He explicitly mentions marble columns, temple thresholds and statues from ancient sepulchres, which leads to question what was actually considered a *ruin* by the writer.[96]

As it was possible to consider during this analysis, emotions awaken by ruins and the fragment perception evolved through the Middle Ages and the Renaissance. Surely the main feeling for the visitors was awe and deep admiration. However, for the citizens, ruins and fragments were also perceived as physical means to express power and civic identity and, in some cases, were reused – or even destroyed – for practical purposes.

It is interesting to note an evolution in the interpretation of fragments – in literature and philosophy, as well as in the approach to physical and architectural reality – and how much this process involved emotions. However, through both the texts and the constructive examples, it is not possible to really understand the deep motivations that moved people. What it is possible to highlight, however, is the development of a linear time consciousness that, coupled with the imaginative power of the Middle Ages and the Renaissance, perhaps helped in the process towards the protection and conservation of fragmented antiquities, imagined as valuable and complete even when in pieces.

Notes

1 See: Pinelli, "Frammento e reliquia tra Otto e Novecento", pp. 167–174; Pinelli, "Cultura del frammento e orientamenti nel restauro del XIX secolo", pp. 11–20.
2 Brandi, *Theory of Restoration*, ed. by Giuseppe Basile, trans. by Cynthia Rockwell, pp. 65–66.
3 See, among the other analyses, the anthropologic studies on memory and recollecting process in: Assmann, "Communicative and Cultural Memory", pp. 109–118; Assmann, *Cultural Memory and Early Civilization: Writing, Remembrance, and Political Imagination*; Connerton, *How Societies Remember*; Halbwachs, *La mémoire collective*. On the creation of 'memory spaces', see: Nora, "Between Memory and History: Les Lieux de Mémoire", pp. 7–24.
4 Azzarà, "Osservazioni sul senso delle rovine nella cultura antica", pp. 1–12.
5 Macauley, *Pleasure of Ruins*, pp. xv–xvi.
6 Di Blasi and Robbiati, "Rovine, testimoni del tempo", p. 22.
7 See: Brilliant and Kinney (eds.), *Reuse Value. Spolia and Appropriation in Art and Architecture from Constantine to Sherrie Levine*; Esch, "Reimpiego"; Settis, "Continuità dell'Antico"; Centanni and Sperti, "Introduzione", p. 9.
8 Reference is made here to the bodily relic, that is, from a bodily remnant, rather than to the type of contact relic, typical of objects, and especially to the elaboration of the concept of relic in the Christian context. See in particular Canetti, *Frammenti di eternità. Corpi e reliquie tra Antichità e Medioevo*, p. 14. For the different approach to the practice of relic veneration in the pre-Christian period, see: Turchi, "Reliquie"; Eliade, *Il mito dell'eterno ritorno*.
9 Canetti, *Frammenti di eternità*, pp. 15–16.
10 Baudrillard, *Lo scambio simbolico e la morte*, pp. 144–147.
11 Canetti, *Frammenti di eternità*, p. 52 n. 4.
12 *Ivi*, p. 47, 85.
13 For the cultural implications underlying the practice of dismembering bodies in order to create relics, see *Ivi*, cap. I.

14 On the relic through memory and evidence, see *Ivi*, p. 83.
15 Teodoreto di Cirro, *Graecorum affectionum curatio*, in Canetti, *Frammenti di eternità*, p. 71 n. 148; Pomian, "Collezione", p. 338.
16 On the deep link between perception and time framework, see Thomae Aquinatis in Fiorentino (ed. and trans.), *Sulla verità*.
17 'It is not only right [...] to be grateful to those whose opinions we share, but also to those who have expressed rather superficial opinions; for they too have made a certain contribution to the truth, in that they have helped to form our speculative dress' (Aristoteles in Reale (ed. and trans.), *Metafisica*, p. 217). See also: Thomae Aquinatis, in Fiorentino (ed. and trans.), *Sulla verità*, p. 86.
18 '[...] and since sight is the sense par excellence, fantasy [φαντασία - fantasía] even the name has taken from light [φάος-faos], since it is not possible to see without light'. Aristoteles in Laurenti (ed. and trans.), *De Anima*, 429a 2-4.
19 Spinosa, "*Phantasia* e *imaginatio* nell'Aristotele latino", p. 132.
20 Bautier, "De l'image à l'imaginaire dans les textes du haut Moyen Age", p. 104.
21 Philostratus, *Vita di Apollonio*, VI 19, in Camassa, "*Phantasia* da Platone ai Neoplatonici", p. 50.
22 See Ercolino, "Roberto Longhi: idee sul restauro", p. 168.
23 The two terms 'fantasy' and 'imagination' slightly differ. However, in this chapter, they are used as synonyms. To have an overview on different meanings, see in Bianchi and Fattori (eds.), *Phantasia-Imaginatio*. On the creative act in the Middle Ages, see Eco, "Riflessioni sulle tecniche di citazione nel medioevo", pp. 53–76.
24 Krautheimer, *Rome, profile of a city: 312-1308*, pp. 250–251; Maire Vigueur, *L'altra Roma. Una storia dei romani all'epoca dei comuni (secoli XII-XIV)*, pp. 386–391.
25 See Cecchelli, "Mirabilia Romae".
26 Porta Appia was one of the main gates of the city on the south. The ruin is described on the stretch of road between the *Giovio* aqueduct and the *arco della Rimembranza* (probably, the Arch of Drusus). See: Miglio (ed. and trans.), *Pellegrinaggi a Roma: il Codice di Einsiedeln, l'Itinerario di Sigerico, l'Itinerario Malmesburiense, le meraviglie di Roma, Racconto delle meraviglie della città di Roma*, pp. 35, 42.
27 Miglio (ed. and trans.), *Pellegrinaggi a Roma: il Codice di Einsiedeln, l'Itinerario di Sigerico, l'Itinerario Malmesburiense, le meraviglie di Roma, Racconto delle meraviglie della città di Roma*, p. 35.
28 See: Nardella, "La Roma dei visitatori colti: dalla mentalità umanistica di Maestro Gregorio (XII-XIII secolo) a quella medievale di John Capgrave (XV secolo)", pp. 49–64; Miglio, "Petrarca una fonte della Roma instaurata di Biondo Flavio", pp. 615–625.
29 On the so-called *Mirabilia*, see: Frugoni, "Antichità: dai Mirabilia alla propaganda politica", pp. 5–72; Guerrini, "Il viaggio a Roma. Letterature, testimoni e Mirabilia", pp. 21–31; Miglio, *Pellegrinaggi a Roma*.
30 The latin text is in *Mirabilia Romae* in Valentini and Zucchetti, *Codice topografico della città di Roma: volume secondo*, pp. 17–65. The translated passage is in Miglio, *Pellegrinaggi a Roma*, p. 92.
31 Valentini and Zucchetti, *Codice topografico della città di Roma: volume secondo*, pp. 138–153; Miglio, *Pellegrinaggi a Roma*, pp. 61–69.
32 Miglio, *Pellegrinaggi a Roma*, p. 63.
33 *Ibidem*.
34 The Latin text is in Valentini and Zucchetti, *Codice topografico della città di Roma: volume secondo*, pp. 143–167. For the italian translation, see: Miglio, *Pellegrinaggi a Roma*, p. 95.
35 'Cuius incomprehensibilem decorem diu admirans deo apud me gratias egi, qui magnus in universa terra ibi opera hominum inaestimabili decore mirificavit'. Translated from Miglio, *Pellegrinaggi a Roma*, p. 96.
36 'Par tibi, Roma, nihil, cum sis prope tota ruina:/ Fracta docere potes, integra quanta fores'. Translated from *Ibidem*.
37 *Ivi*, p. 103.

Fragments, spolia *and remains* 19

38 'Nihil quippe habet perfecte pulcritudinis humanum caput vel manus, quod his ulla parte desit: miro enim modo ars fusilis in aere rigido molles mentitur capillos. Quod si quis defixis luminibus attentius inspexerit, moturo et locuturo simillimum videtur', translated in Italian in *Ivi*, p. 101.
39 *Ivi*, pp. 103–104.
40 'Quarum unam propter eximiae pulcritudinis speciem primum referam. [...] Haec autem imago ex Pario marmore tam miro et inexplicabili perfecta est artificio, ut magis viva creatura videatur quam statua', translated in Italian in *Ivi*, p. 104.
41 *Ivi*, p. 105.
42 *Ivi*, p. 107.
43 Lembo Fazio, *Antiche macerie, ma pur sempre nuove per spiriti moderni. Metamorfosi e valorizzazione dell'antico nel panorama architettonico della Roma comunale (XIII-XIV secolo)*, pp. 31–34.
44 See how Petrarca states that he will follow the pilgrimage itinerary before visiting the ancient ruins, in Miglio, *Scritture, scrittori e storia. Città e corte a Roma nel Quattrocento*, pp. 177–206.
45 'Intra eclesiam s. Mariae Rotundae [...] In porticu eius ante portam sunt 16 magnae columnae marmoreae rotundae quarum ambitus grossitiei est pedes circa 19, longitudo vero bona extimatione est pedes 40 praeter capitellos'. (Ioannis Dondis, *Iter romanum anno fere MCCCLXXV*, 4, in De Rossi, *Inscriptiones christianae urbis Romae septimo saeculo antiquiores*, II, I, p. 332).
46 'sopra 16 grossissime et altissime colonne, ne restavano in piedi 14' (Ugonio, *Historia delle stationi di Roma che si celebrano la Quadragesima*, f. 312).
47 On the interpretation and rediscovery of ancient fragments during humanism, which stretches up to the seventeenth century, see Bacchi, "*Vestigia, reliquia e fragmenta*: l'Umanesimo a caccia dell'Antico", pp. 11–23.
48 Ioannis Dondis, *Iter romanum anno fere MCCCLXXV*, 7, in De Rossi, *Inscriptiones christianae urbis Romae septimo saeculo antiquiores*, II, I, p. 333: 'Notabilia paganorum quae adhuc sunt Romae in parte et indicant quam magna fuerunt [...].'
49 Bacchi, *Vestigia, reliquia e fragmenta*, p. 11.
50 *Ivi*, pp. 12–14.
51 Brandi, *Theory of Restoration*, pp. 55–60.
52 Bacchi, *Vestigia, reliquia e fragmenta*, p. 12.
53 *Ivi*, p. 14.
54 See the considerations on Cusanus and Filippo Beroaldo, with the use of the metaphor of hunting to indicate the activity of amending ancient texts in *Ivi*, pp. 15–17.
55 It is possible to consult the text on https://archive.org/details/hypnerotomachiap00colo/page/n21/mode/2up [accessed 28 December 2022].
56 See Borsi, *Francesco Colonna e l'architettura antica. Il mito d'origine d'un ricercato metodo archeologico*, pp. 57–59.
57 Borsi, "L'architettura del Polifilo tra classico e anticlassico".
58 'tuto il residuo, fue dal instaurato, et vorace tempo absunto, et dalle antiquitate, et da venti, et piogie et ardente Sole distructo'; 'da annositate quassata', in Borsi, *Francesco Colonna e l'architettura antica. Il mito d'origine d'un ricercato metodo archeologico*, p. 15.
59 'abolita e ignorata la sua dignitate'.
60 'Queſto nobile & fpectatiſſimo fragmento'.
61 'For the magnificence of this obelisk' [Per la magnificentia dilquale obeliſco].
62 'a small part of its fastigium, i.e. frontispiece was considered to be well outlined' [una portiúcula dil ſuo faſtigio ,ouero frontifpicio ſe retinea egregiaméte liniato]; 'I saw inscribed an elegant capital lettering' [infcripto uididi elegáte fcriptura di maiufcule].
63 'This noble and most spectacular fragment still solid' [Queſto nobile & fpectatiſſimo fragmento in uno folido fruſto ancora].
64 On dream and architecture in the Hypnerotomachia Ploiphili and Leon Battista Alberti, see Borsi, *Polifilo architetto: cultura architettonica e teoria artistica nell'Hypnerotomachia Poliphili di Francesco Colonna (1499)*, pp. 23–24.

20 *Francesca Lembo Fazio*

65 Borsi, *Francesco Colonna e l'architettura antica. Il mito d'origine d'un ricercato metodo archeologico*, pp. 62–63.
66 *Ivi*, p. 30.
67 *Ibidem*.
68 See Cadei, "Antico".
69 See Esch, "Monumenti antichi nelle descrizioni medievali dei confini nei dintorni di Roma", pp. 9–14.
70 Lembo Fazio, *Antiche macerie, ma pur sempre nuove per spiriti moderni. Metamorfosi e valorizzazione dell'antico nel panorama architettonico della Roma comunale (XIII-XIV secolo)*, pp. 95–97.
71 *Ibidem*.
72 *Ivi*, p. 108.
73 *Ivi*, pp. 106–113.
74 *Lellus Pauli de Serromanis*, ed. by Mosti, n.d., p. 487, doc. 15.
75 See, as example, *Marinus Petri Milçonis*, ed. by Mosti, n.d., pp. 14–15, doc. 37.
76 '[…] Anthonius sedens in quodam lapide marmoreo in oppositione domus dicti Iacobi mandavit treguam et securitatem inter partes predictas durante compromisso […]' in Mosti, *I protocolli di Iohannes Nicolai Pauli: un notaio romano del '300 (1348-1379)*, p. 233, doc. 534.
77 Mosti, *Un notaio romano del Trecento. Il protocollo di Francesco di Stefano de Caputgallis (1374-1386)*, pp. 46–47, doc. 65.
78 Lembo Fazio, *Antiche macerie, ma pur sempre nuove per spiriti moderni. Metamorfosi e valorizzazione dell'antico nel panorama architettonico della Roma comunale (XIII-XIV secolo)*, pp. 103–106.
79 Bartola, *Il regesto del monastero dei SS. Andrea e Gregorio* ad Clivum Scauri, doc. 174, pp. 640-646; doc. 168, pp. 624–625; p. 618, doc. 166.
80 On the Septizodium, see the collection of evidences in Lanciani, *Storia degli scavi di Roma e notizie intorno le collezioni romane di antichità*, vol. 1, pp. 56–57, 146–149, 200–201; vol. 2, pp. 28, 58–59, vol. 3, pp. 137–139.
81 On descriptions of the Septizodium in Late Antique and Renaissance sources, see Ferretti, "All'origine di una nuova espressività dell'acqua nel contesto urbano: il Settizonio nel Trionfo di Carlo V a Roma (1536)", pp. 190–192.
82 Stevenson, "Il Settizonio severiano e la distruzione dei suoi avanzi sotto Sisto V", p. 271. See also the reports on the latest excavations in Mortera and Trivelloni, "Analisi e contestualizzazione di alcuni frammenti marmorei provenienti dall'area del Circo Massimo", pp. 241–258.
83 Bartola, *Il regesto del monastero dei SS. Andrea e Gregorio* ad Clivum Scauri.
84 *Ivi*, doc. 151, pp. 582–583.
85 Stevenson, "Il Settizonio severiano e la distruzione dei suoi avanzi sotto Sisto V", p. 294.
86 Bartola, *Il regesto del monastero dei SS. Andrea e Gregorio* ad Clivum Scauri, doc. 152, pp. 586–587.
87 *Ivi*, p. 296.
88 'a quel tanto degno simulacro di Settemsolio [Settizonio], dove era una bellissima fontana che de acqua rosa ne bagnava tutti che per detta strada passavano' in Ferretti, "All'origine di una nuova espressività dell'acqua nel contesto urbano: il Settizonio nel Trionfo di Carlo V a Roma (1536)", pp. 188–189.
89 *Ivi*, pp. 193-194. Note also the connection between the ancient function of the Septizodium, the etymology of one of the versions of the name – which contains the Latin word *solium*, referring to the fountain and water – and the renewed function on the occasion of the Triumph of Charles V.
90 Stevenson, "Il Settizonio severiano e la distruzione dei suoi avanzi sotto Sisto V", p. 291.
91 Details of papal building sites where fragments from Septizodium were used are in Stevenson, "Il Settizonio severiano e la distruzione dei suoi avanzi sotto Sisto V",

p. 298; Fancelli, "Demolizioni e 'restauri'nel Cinquecento romano, in Roma e l'antico nell'arte e nella cultura del Cinquecento", pp. 397–398.
92 *Ivi*, p. 284.
93 Ausilio, "Il Settizonio Severiano. Tracce del suo reimpiego dall'epoca di Sisto V (1585–1590) ad oggi", p. 696.
94 As well as attempts to restore and protect the ruins. See: Pergoli Campanelli, *Cassiodoro alle origini dell'idea di restauro*.
95 See Guidobaldi, "Un estesissimo intervento urbanistico nella Roma dell'inizio del XII secolo e la parziale perdita della «memoria topografica» della città antica".
96 'Delle vostre marmoree colonne, delle soglie dei vostri templi […], delle statue dei sepolcri […] l'accidiosa Napoli si adorna. Così a poco a poco scompaiono perfino le rovine, testimonianze magnifiche dell'antica grandezza' in Frugoni, "Antichità: dai Mirabilia alla propaganda politica", p. 31.

Bibliography

Assmann, Jan, "Communicative and Cultural Memory", in Erll Astrid (ed.), *Cultural Memory Studies. An International and Interdisciplinary Handbook* (Berlin and New York: Ansgar Nünning, De Gruyter, 2008), pp. 109–118.

———, *Cultural Memory and Early Civilization: Writing, Remembrance, and Political Imagination* (Cambridge: Cambridge University Press, 2011).

Ausilio, Alfonso, "Il Settizonio Severiano. Tracce del suo reimpiego dall'epoca di Sisto V (1585-1590) ad oggi", in Pascariello Maria Ines and Veropalumbo Alessandra (eds.), *La città Palinsesto. Tracce, sguardi e narrazioni sulla complessità dei contesti urbani e storici* (Napoli: FedOA – Federico II University Press, 2020), pp. 689–696.

Azzarà, Silvia, "Osservazioni sul senso delle rovine nella cultura antica", in Cupperi Walter (ed.), *Senso delle rovine e riuso dell'antico* (= *Annali della Scuola normale superiore di Pisa. Classe di lettere e filosofia. Quaderni*, 14, 2 (2002)), (Pisa: Scuola Normale Superiore, 2002), pp. 1–12.

Bacchi, Elisa, "*Vestigia, reliquia e fragmenta*: l'Umanesimo a caccia dell'Antico", in Marcheschi Matteo (ed.), *Rottami, rovine, minuzzerie: pensare per frammenti* (Pisa: Edizioni ETS, 2018), pp. 11–23.

Bartola, Alberto, *Il regesto del monastero dei SS. Andrea e Gregorio* ad Clivum Scauri (Roma: Società Romana di Storia Patria (Codice diplomatico di Roma e della regione romana, 7), 2003).

Baudrillard, Jean, *Lo scambio simbolico e la morte* (Milano: Feltrinelli, 1976).

Bautier, Anne-Marie, "De l'image à l'imaginaire dans les textes du haut Moyen Age", in Bianchi Massimo Luigi and Fattori Marta (eds.), *Phantasia-Imaginatio*, Atti del V colloquio internazionale (Roma: Edizioni dell'Ateneo, 1988), pp. 81–104.

Bianchi, Massimo Luigi, and Fattori, Marta (eds.), *Phantasia-Imaginatio*, Atti del V colloquio internazionale (Roma: Edizioni dell'Ateneo, 1988).

Borsi, Stefano, *Polifilo architetto: cultura architettonica e teoria artistica nell'Hypnerotomachia Poliphili di Francesco Colonna (1499)* (Roma: Officina Edizioni, 1995).

———, "L'architettura del Polifilo tra classico e anticlassico", *Bollettino Telematico dell'Arte*, 844 (24 luglio 2017) https://www.bta.it/txt/a0/08/BTA-Bollettino_Telematico_dell%27Arte-Testi-bta00844.pdf [accessed 28 December 2022].

———, *Francesco Colonna e l'architettura antica. Il mito d'origine d'un ricercato metodo archeologico* (Melfi: Libria, 2018).

Brandi, Cesare, *Theory of Restoration*, edited by Giuseppe Basile, translated by Cynthia Rockwell (Firenze: Nardini Editore, 2005).

Brilliant, Richard, and Kinney, Dale (eds.), *Reuse Value. Spolia and Appropriation in Art and Architecture from Constantine to Sherrie Levine* (London: Routledge 2016).
Cadei, Antonio, "Antico", in *Enciclopedia dell'Arte Medievale* (Roma: Istituto della Enciclopedia Italiana, 1991), https://www.treccani.it/enciclopedia/antico_%28Enciclopedia-dell%27-Arte-Medievale%29/#:~:text=Cadei%20Il%20termine%20deriva%20 dal,Meillet%2C%201932%2C%20s.v.
Camassa, Giorgio, "*Phantasia* da Platone ai Neoplatonici", in Bianchi Massimo Luigi and Fattori Marta (eds.), *Phantasia-Imaginatio*, Atti del V colloquio internazionale (Roma: Edizioni dell'Ateneo, 1988), pp. 23–55.
Canetti, Luigi, *Frammenti di eternità. Corpi e reliquie tra Antichità e Medioevo* (Roma: Viella, 2002).
Cecchelli, Carlo, "Mirabilia Romae", in *Enciclopedia Italiana* (Roma: Istituto della Enciclopedia Italiana, 1934), https://www.treccani.it/enciclopedia/mirabilia-romae_%28 Enciclopedia-Italiana%29/.
Centanni, Monica, and Sperti, Luigi, "Introduzione", in Centanni Monica and Sperti Luigi (eds.), *Pietre di Venezia. Spolia in se spolia in re* (Rome: L'Erma di Bretschneider, 2015), pp. 7–11.
Connerton, Paul, *How Societies Remember* (Cambridge: Cambridge University Press, 1989).
De Rossi, Giovanni Battista, *Inscriptiones christianae urbis Romae septimo saeculo antiquiores* (Roma: ex Officina libraria pontificia, 1988), II, I.
Di Blasi, Viviana, and Robbiati, Cinzia, "Rovine, testimoni del tempo", *Anagke*, 15 (1996), pp. 22–29.
Eco, Umberto, "Riflessioni sulle tecniche di citazione nel medioevo", in Umberto Eco (ed.), *Dal Latratus canis alle tecniche di citazione nel Medioevo* (Spoleto: Fondazione Centro italiano di studi sull'Alto Medioevo, 2016), pp. 53–76.
Eliade, Mircea, *Il mito dell'eterno ritorno* (Gallimard, Paris 1949; repr. Roma: Borla, 1999).
Ercolino, Maria Grazia, "Roberto Longhi: idee sul restauro", *Quaderni dell'Istituto di Storia dell'Architettura*, 55/56 (2010/2011), pp. 165–172.
Esch, Arnold, "Reimpiego", in *Enciclopedia dell'Arte Medievale* (Roma: Istituto della Enciclopedia Italiana, 1998), https://www.treccani.it/enciclopedia/reimpiego_%28 Enciclopedia-dell%27-Arte-Medievale%29/.
Fancelli, Paolo, "Demolizioni e 'restauri'nel Cinquecento romano", in Fagiolo Marcello (ed.), *Roma e l'antico nell'arte e nella cultura del Cinquecento* (Roma: Istituto della Enciclopedia italiana, 1985), pp. 357–403.
Ferretti, Emanuela, "All'origine di una nuova espressività dell'acqua nel contesto urbano: il Settizonio nel Trionfo di Carlo V a Roma (1536)", *Annali della Scuola Normale Superiore di Pisa. Classe di Lettere e Filosofia*, 5, 11/1 (2019), pp. 190–192.
———, "Monumenti antichi nelle descrizioni medievali dei confini nei dintorni di Roma", *Arte medievale*, 2 (2003), pp. 9–14.
Fiorentino, Fernando (ed. and trans.), *Sulla verità* (Milano: Bompiani, 2005).
Frugoni, Chiara, "Antichità: dai Mirabilia alla propaganda politica", in Settis Salvatore (ed.), *Memoria dell'antico nell'arte italiana. 1: L'uso dei classici* (Torino: Einaudi, 1984), pp. 5–72.
Guerrini, Paola, "Il viaggio a Roma. Letterature, testimoni e Mirabilia", in Guerrini Paola and Concetta Ranieri (eds.), *Qui c'era Roma. Da Petrarca a Bembo* (Bologna: Pàtron, 2000), pp. 21–31.
Guidobaldi, Federico, "Un estesissimo intervento urbanistico nella Roma dell'inizio del XII secolo e la parziale perdita della «memoria topografica» della città antica", *Mélanges de*

l'École française de Rome - Moyen Âge [Online], 126-2 | 2014 http://journals.openedition.org/mefrm/2223.

Halbwachs, Maurice, *La mémoire collective* (Paris: Presses universitaires de France, 1950).

Krautheimer, Richard, *Rome, profile of a city: 312-1308* (Princeton: Princeton University Press, 1980).

Lanciani, Rodolfo, *Storia degli scavi di Roma e notizie intorno le collezioni romane di antichità* (Bologna: Arnaldo Forni Editore, 1975).

Laurenti, Renato (ed. and trans.), *De Anima* (Napoli-Firenze: Il tripode, 1970).

Lellus Pauli de Serromanis, edited by Renzo Mosti, n.d., https://www.srsp.it/documents/Paulus%20de%20Serromanis%20(1359-1387).pdf [accessed 28 December 2022].

Lembo Fazio, Francesca, *Antiche macerie, ma pur sempre nuove per spiriti moderni. Metamorfosi e valorizzazione dell'antico nel panorama architettonico della Roma comunale (XIII-XIV secolo)* (Roma: Edizioni Quasar, 2022).

Macauley, Rose, *Pleasure of Ruins* (London: Weidenfeld and Nicolson, 1953).

Maire Vigueur, Jean-Claude, *L'altra Roma. Una storia dei romani all'epoca dei comuni (secoli XII-XIV)* (Torino: Einaudi, 2011).

Marinus Petri Milçonis, edited by Renzo Mosti, n.d., https://www.srsp.it/documents/Marinus%20Petri%20Mil%C3%A7onis%20(1357).pdf [accessed 28 December 2022].

Miglio, Massimo, *Scritture, scrittori e storia. Città e corte a Roma nel Quattrocento* (Manziana: Vecchiarelli, 1991).

———, "Petrarca una fonte della Roma instaurata di Biondo Flavio", in Hameses Jacqueline (ed.), *Roma magistra mundi. Itineraria culturae medievalis* (Louvain-La-Neuve: Federation Internationale des Instituts d'Etudes Medievales, 1998), pp. 615–625.

——— (ed.), *Pellegrinaggi a Roma: il Codice di Einsiedeln, l'Itinerario di Sigerico, l'Itinerario Malmesburiense, le meraviglie di Roma, Racconto delle meraviglie della città di Roma* (Roma: Città Nuova, 1999).

Mortera, Alessandro, and Trivelloni, Ilaria, "Analisi e contestualizzazione di alcuni frammenti marmorei provenienti dall'area del Circo Massimo", *Bullettino della Commissione Archeologica Comunale di Roma*, 119 (2018), pp. 241–258.

Mosti, Renzo, *I protocolli di Iohannes Nicolai Pauli: un notaio romano del '300 (1348-1379)* (Roma: Ècole française de Rome (Collection de l'École française de Rome, 63), 1982).

———, *Un notaio romano del Trecento. Il protocollo di Francesco di Stefano de Caputgallis (1374-1386)* (Roma: Viella, 1994).

Nardella, Cristina, "La Roma dei visitatori colti: dalla mentalità umanistica di Maestro Gregorio (XII-XIII secolo) a quella medievale di John Capgrave (XV secolo)", *Archivio della Società Romana di Storia Patria*, 119 (1996), pp. 49–64.

Nora, Pierre, "Between Memory and History: Les Lieux de Mémoire", *Representations*, 26 (1989), pp. 7–24.

Parducci, Tommaso, "«Squallidi, tronchi e slogati»: i frantumi vichiani tra metodo e metafora", in Marcheschi Matteo (ed.), *Rottami, rovine, minuzzerie: pensare per frammenti* (Pisa: Edizioni ETS, 2018), pp. 25–37.

Pergoli Campanelli, Alessandro, *Cassiodoro alle origini dell'idea di restauro* (Milano: Jaca book, 2013).

Pinelli, Orietta Rossi, "Frammento e reliquia tra Otto e Novecento", in Catalano Maria Ida and Mania Patrizia (eds.), *Arte e memoria dell'arte* (Pistoia: Gli Ori, 2011), pp. 167–174.

———, "Cultura del frammento e orientamenti nel restauro del XIX secolo", in Secco Suardo Giovanni (ed.), *La cultura del restauro tra tutela e conservazione dell'opera*

d'arte (= *Bollettino d'Arte*, supplemento (1998)), (Roma: Istituto Poligrafico e Zecca dello Stato-Archivi di Stato), pp. 11–20.

Pomian, Krizysztof, "Collezione", in *Enciclopedia Einaudi* (Torino: Einaudi, 1978), III, pp. 330–364.

Reale, Giovanni (ed. and trans.), *Metafisica* (Milano: Vita e pensiero, 1993).

Settis, Salvatore, "Continuità dell'Antico", in *Enciclopedia dell'Arte Antica* (Roma: Istituto della Enciclopedia Italiana, 1994), https://www.treccani.it/enciclopedia/continuita-dell-antico_%28Enciclopedia-dell%27-Arte-Antica%29/.

Spinosa, Giacinta, "*Phantasia* e *imaginatio* nell'Aristotele latino", in Bianchi Massimo Luigi and Fattori Marta (eds.), *Phantasia-Imaginatio*, Atti del V colloquio internazionale (Roma: Edizioni dell'Ateneo, 1988), pp. 117–133.

Stevenson, Enrico, "Il Settizonio severiano e la distruzione dei suoi avanzi sotto Sisto V", *Bullettino della Commissione Archeologica Comunale*, 8(1888), 269–298.

Turchi, Nicola, "Reliquie", in *Enciclopedia Italiana* (Roma: Istituto della Enciclopedia Italiana, 1936), https://www.treccani.it/enciclopedia/reliquie_%28Enciclopedia-Italiana%29/.

Ugonio, Pompeo, *Historia delle stationi di Roma che si celebrano la Quadragesima* (Roma: appresso Bartholomeo Bonfadino, 1588).

Valentini, Roberto, and Zucchetti, Giuseppe (eds. and trans.), *Codice topografico della città di Roma: volume secondo* (Roma: Tipografia del Senato, 1942).

2 Spaces of virtue. Transcultural affection and its representation in Ottoman-Venetian relations

Luc Wodzicki

In Gentile Bellini's *Processione in piazza San Marco* (Figure 2.1), a handkerchief forms a curious connection between two men. The first, Ducal Secretary Giovanni Dario, stands among the members of the *Scuola Grande di San Giovanni* who carry their relic, a splinter of the Holy Cross, over Venice's piazza San Marco.

The second is one in a group of three Ottoman men in the background, among them Sultan Mehmet II, who watches the procession from afar. Both Dario and the Ottoman hold a white handkerchief – a *fazzuol sotil* [thin handkerchief] as the Italian sources call it or a *destimal-i şerif* [royal handkerchief] in Ottoman.[1] The men knew each other well. Not only had the Secretary negotiated the peace treaty that would put an end to the Ottoman-Venetian War (1464–1479), which earned him the Ottoman's respect. The same year, he also supported Gentile Bellini's famous journey to Mehmet II's court. But, I argue, the handkerchief, used by Bellini to make this special connection visible, also refers to the philosophical and moral ideas on which the two men's transcultural affection was based. The Sultan, as Italian observers noted, took 'delight in *virtù*' when he wandered the garden of his palace, the *Topkapı Sarayı*. Virtue, which can be translated to Ottoman as either *fazilet* or *adalet* [Justice], was a concept that Italians and Ottomans alike inherited from Greek philosophy, and they used it to speak about character, morality, and emotions not only within but also between people.[2] Virtue, they believed, attracted virtue, and because of that, it allowed actors from different cultures to express a bond based on character rather than status and affection rather than formality. As this chapter will argue, the handkerchiefs in Bellini's painting are manifestations of such a virtuous connection. They symbolize early modern conceptualizations of moral and emotional attachment versus spatial distance, allowing for a deeper understanding of a shared intellectual culture. By speaking about the relationship between spatial distance versus affectionate bond, this chapter follows Venetian and Ottoman actors in their conceptualization of the Mediterranean as a shared space.

Approaching Bellini's *Processione in piazza San Marco* from a Mediterranean perspective reveals a particular way of thinking about the relationship between space and emotions which aimed to transcend cultural boundaries without neglecting them. The *Topkapı Sarayı* garden and Bellini's piazza San Marco are architectural spaces but also metaphorical ones. As a spatially limited area, they represent

DOI: 10.4324/9781003358695-2

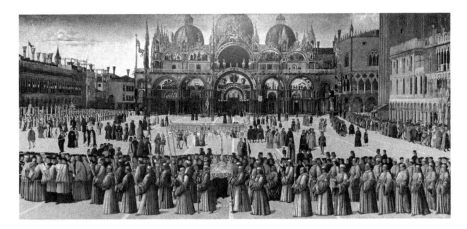

Figure 2.1 Gentile Bellini, *La Processione in Piazza San Marco*, 1496, Venezia, Gallerie dell'Accademia, with details.

a political state and its boundaries. As a canvas, however, these spaces invite and reflect the world this political state is embedded in and interacts with. This is the case with three kiosks in the *Topkapı* garden, each representing an element of the Sultan's empire in their design (Persian, Greek, Turkish); it is also the case with the Ottoman figures on the piazza San Marco inhabiting the scene of St. Marks day, the feast of the *Serenissima*'s patron saint. From this perspective, actors' movement through and interaction within architectural space becomes a mediation of proximity and distance. This mediation happens in not only a spatial but also an emotional sense: The presence of the seemingly foreign is a sign of affection. This affectionate making present of someone or something distant is reminiscent of a bond grounded in a shared intellectual culture. Virtue ethics, and the ideas of character, morality, and affection that come with it, provide this transcultural link. An important part of virtue is its social dimension. Virtuousness requires a stable character – a soul that is in emotional balance and control. This moral endeavour unites the virtuous, and it sustains their connection. On these principles of virtue ethics, Ottomans and Venetians agreed.[3] In a diverse array of constellations and settings, encounters, and exchanges, they developed it together, while the political meaning of virtue ethics remained closely tied to specific contexts. Virtue thus overcame cultural boundaries and, as I will explain in more detail later, it preserved them just as well. The presence of virtue allowed for a space to embody home and abroad, and to express affection and distinction.

It is no coincidence that Bellini was able to capture this trans-Mediterranean connection on canvas. For Venetians of the fifteenth and sixteenth centuries, as Deborah Howard put it, Constantinople 'did not represent a cultural "other" but rather an extension of the familiar'.[4] There was constant Venetian-Ottoman trade competition and frequent territorial conflicts, but there was also great consistency.[5] The ability to never let trade and the exchange of goods, ideas and people come to a standstill,

and to see oneself as part of a larger system, as well as to always find new ways to communicate in and about this system, characterizes the careful processualism of Mediterranean transculturality. Researchers have long pointed to the emblematic nature of Bellini's journey to the court of Mehmet II, expressed most clearly in his famous Italian-style portrait of the ageing Ottoman Sultan (Figure 2.2).[6]

But the iconisation of this portrait obscures a deeper, more enduring bond. Decades of gradual rapprochement between the Venetians and the Ottomans paralleled the Ottoman advance from Anatolia to the Mediterranean and its replacement of the Byzantine Empire as Venice's trading partner. Rather than an exception in a great East-West divide, Bellini was one of many actors who negotiated the perpetuation of Ottoman Mediterranean presence. To be sure, this happened accompanied by war (Constantinople 1453 followed by the Ottoman-Venetian War 1463–1479); yet, the *Serenissima* carefully chose diplomats, scholars, and artists who would open another level of negotiations with the Ottomans.[7] This chapter follows several Greek-born actors that stand out from this group. Connected to Venice but raised in the disparate Eastern Mediterranean, these had the ability to move smoothly through cultures. They possessed a privileged understanding of the legacy of the Byzantine Empire that the Ottomans claimed, as well as privileged access to the sources of antiquity that Ottomans and Venetians admired. It lay in their capacity to shape the political language of Ottoman-Venetian encounters, and they taught this language to Bellini and others.

Although this chapter is not primarily about diplomatic gifts, objects, such as the handkerchief, can serve us as an entry point to understand the connection between space and emotion within that language. In the context of Ottoman diplomatic gift exchange practices, the emotions associated with a gift, as well as the emotional response it was meant to evoke, play an important role.[8] Royal gifts expressed approval of a person's place in society. Thereby, the Ottomans did not practice material reciprocity; gestures, favours, and advancing the personal bond were in the foreground.[9] In his attempt to formulate an Ottoman *emotional ecology*, Walter G. Andrews assumed that the concept *muhabbet* (affection) was at the centre of a political thinking that was emotionally coded.[10] This finding is supported by Bilkent Tekgül's observations that expressions of affection and compassion served the Sultanate as tools to formulate political relations of domination and subordination.[11] Within this framework, the Ottoman emotional vocabulary consisted not only of words but of 'other cultural artifacts such as decoration, landscaping, architecture, ceremonies, rituals and the like'.[12] Therefore, though royal gifts were seldom associated with concrete or complex emotions, they expressed a particular form of affection, which resembled the affection between the Sultan or the state and the subject. This affection, often symbolizing royal protection, was supposed to mend the spatial and cultural distance between the ruler and vast parts of his empire and population.[13]

This is in line with the intellectual dimension of Mehmet II's Mediterranean expansionism.[14] Too often, the Sultan is framed as a patron of the arts, when, in fact, art was but one expression of his synthetic imperial vision. Ottomans were not only Turks: they were a steadily growing, heterogeneous group in which Muslims,

Christians, and Jews lived, and in which Ottoman Turkish, Greek, Hebrew, Italian, Arabic, and countless other languages were spoken. The Ottoman realm was one built on cultural diversity.[15] With the conquest of Constantinople, Mehmet II needed to embrace this diversity ideologically. His grandfathers had promoted political literature that highlighted that the character of man – and especially the character of the Sultan – was more important than religious affiliation (though Islam must be considered the basic pillar of the state's ideology).[16] Mehmet II centralized this idea. By adaptions and translations from Arabic, Persian, and Greek ethical and political philosophers, the Sultan became a divinely inspired mediator whose task was to assign the different groups inside and around the growing Ottoman *devlet* their appropriate place in the world.[17] In her groundbreaking work, Gülru Necipoğlu argued that as a patron '[Mehmet II] deliberately negotiated the expanding Western and Eastern cultural horizons of his empire through visual cosmopolitanism and creative translation'.[18] There can be little doubt that much like the Sultan in a forming Ottoman state ideology, Mehmet II was central to the construction of a multifaceted imperial identity. Yet, the 'indigenous aesthetics of fusion' that would evolve to express this identity go beyond the representation of one ruler's personal taste. They illustrate the emergence of a trans-Mediterranean sense of self, in which cultural difference was negotiated along the lines of a shared sense of space.

My chapter follows this idea in three parts. First, I show how, after the conquest of Constantinople, virtue ethics came to be recognized as a common heritage for Ottomans and Italians. Then, using the example of the *Topkapı* garden, I explain the role virtue played in breaking down the spatial separation in the connection between the ruler and the subject, and that Venetians were able to understand this. Finally, we return to Bellini's *Processione* in which the handkerchief as a sign of virtuous connection now creates a common space for Venetians and Ottomans.

Virtuous acquaintances

Soon after the Ottomans had conquered the former Byzantine capital Constantinople, Venice sent an embassy. In addition to the many practical political and economic issues that needed to be resolved, the members of this embassy had to investigate how to communicate with the Ottomans in the future.[19] This concerned not only ceremonial, payments, and gifts, which researchers have so far ostensibly studied.[20] Although it would be anachronistic to speak of shared values, the *Serenissima* was also interested in what political language the Ottomans spoke. What was the supposedly ethical dimension of their actions based on, and were there starting points that connected the two? It is striking that, oftentimes, Venice would send along subjects from its Greek-speaking territories, who were able to mediate interculturally not only through their knowledge of the language but also through their intellectual upbringing and their networks. Soon, it became apparent that the philosophies of Aristotle and Plato were already a genuine part of the Ottoman political philosophy. The Greek envoys of Venice were therefore amongst the first to uncover that striving for virtue – the moral perfection of the character – was

Spaces of virtue 29

a political necessity to Ottomans and Italians alike. Unravelling this intersection plays an important role in understanding the Venetian-Ottoman relationship. It allowed actors to conceptualize themselves as part of a common realm, the accessibility of which was conditioned not only by political or religious but also by ethical affiliation.

In 1453, awaiting access to the Ottoman court, the Venetian ambassador Bartolomeo Marcello received a letter from the Venetian Senate. It instructed him to make the acquaintance of a local Greek man named Nikolaos Sagundino, who was 'a trusted and learned person when it came to matters of the Turkish court'.[21] Despite the mission also including Lorenzo Moro, who had served as a Venetian ambassador to Mehmet II in 1451, translation and proper conduct seem to have been left to Sagundino.[22] The Greek was well equipped for this task. During the Ottoman capture of Euboea (1430), he spent 13 months in Turkish service. Later, he worked as an interpreter for the Venetians, who finally granted him the *fidele*-status (lower citizenship).[23] But, like many of his compatriots, Sagundino should not be seen as a Venetian freed from the yoke of the Turks. He was an agent in his own right who sold his talents to the highest bidder. Greeks who served as cultural mediators were not necessarily official servants; often they acted independently and aware of their special position. Venice and its expanded *Stato da Mar* formed an important point of passing for people from diverse backgrounds, since the administration of cultural and linguistic diversity required expertise.[24] Intellectuals from the Greek-speaking territories of the Eastern Mediterranean, such as Sagundino, were an important resource, since they had often encountered the Ottomans first-hand and spoke a language officially employed at their chancellery.[25]

Among the talents the Serenissima sought for this special mission were intellectual education and erudition. Venetian humanism developed differently than that in Florence or most other Italian states. It did not welcome a personal union of humanist endeavour and political office. While the *Scuola di San Marco* (founded in 1446) offered employment, around 1453, most humanists active in the city served as private tutors to the patrician class.[26] That is to say, that neither Marcello nor Moro would have been as qualified to inquire Ottoman intellectual culture as Sagundino. Sagundino's talent in translation, however, was directly linked to his philosophical education. His service as an interpreter at the Council of Florence (1439) had brought him great admiration, and it helped him to establish networks with other notable Greek scholars such as Georgios-Gennadios Scholarios, the Constantinopolitan patriarch under Mehmet II, George of Trebizond, and Gemisthos Plethon.[27] The Council was a formative experience that boosted Sagundino's interest in both Platonism and virtue ethics. His treatise *De originie et sectis philosophorum* begins with an explanation of how being learned meant training virtue. Studying philosophy, Sagundino explains, in fact serves 'to instruct and mould our lives to the standards of virtue'.[28] And there was another side effect: it enabled a more affectionate relationship between people. Writing about the relationship with his student Francesco Coppo, governor to Negroponte, Sagundino recalls how the intellectual connection between the two men created a realm of its own. Virtue, unlike worldly pleasures such as luxury or hunting, Sagundino explained, could provide for an 'honest' relationship between people.[29]

Sagundino was just one part of a Mediterranean movement, which proposed virtue as the central concept for the organization of social and political life. All over Italy, as James Hankins recently argued, humanists began to focus on the virtue of the ruling class – and on their position as its most profound teachers. Virtue became indispensable to political representation. Where there was virtue, the humanists argued, the government was just, the people were happy, and there was, overall, a sense of order and unity.[30] These aspects, of course, were no discovery of Italian humanism. They were a part of the classical heritage of Greek philosophy. For Plato, virtue meant to perfect one's character by attaining to the soul. Since people had different dispositions for that, the distribution of virtue in people should dictate the shape of the state. Aristotle, on the other hand, emphasised the social aspect of virtue. Virtue, he explained, was a human potential to be activated and trained by interacting with others; it was therefore at the base of society. The increasing importance of virtue in Venice can be seen by the Republic commissioning George of Trebizond to write a history of the Venetian constitution. No lesser than Plato, argued he, provided the original model for that.[31] Plato wanted his ideal state to be structured by the virtue of its inhabitants, and therefore, the Venetians, Trebizond explains, 'have certainly taken from Plato […] everything that makes the life of a republic long and happy […] one-man rule, aristocracy, and democracy'.[32] Virtue allowed the *Serenissima* to promote the image of a state build on individual virtue, a place of unique idealism and identity, when, in reality, it often kept the ranks of the governing elites firmly closed.[33] It allowed for a political language that was both representative and manipulative.

Because the core aspects of virtue ethics were part of a heritage from Greek antiquity, they were also present at the Ottoman court.[34] Though arguably, the Ottoman history of reception differed significantly. It drew on medieval Islamicate, Persian, and Arabic philosophers and political treatises. These had preserved Platonic and Aristotelian ideas, as well as elaborated them in religious and political terms. Thereby, they had given virtue a central position in practical politics. For example, in his *Siyasatname*, the Persian Seljuk Vizier Nizam al-Mulk (d. 1091) explained that the ruler ordered the state and prevented chaos by radiating virtue into society. Through his 'divine light [*nur-ı zade*] the people will come out of their cave and move towards the light'.[35] Prominent scholars of the so-called Islamic Golden Age and authors of both the *adab* and *akhlaq* genre, such as al-Fārābī (d. 950), al-Ghazali (d. 1111), Ibn Miskawayh (d. 1030), Ibn Sina (d. 1037), and Nasir al-Din Tusi (d. 1274), referred to Greek virtue ethics to speak about the complex relationship between God, the ruler, and the people of a state. For all of them, virtue was a desirable ordering principle of society.

Mehmet II promoted virtue ethics deliberately, since it offered an expansive ideology that legitimized not only the encounter with and integration of various peoples but also the ways in which these changed the imperial centre. In the early fifteenth century, the Ottomans had built their power on tribal warriors (Gazis) to whom they presented themselves as 'primus inter pares'. Accordingly, early Ottoman political thought such as Ahmedi's *Iskendername* or Ahmed Amasi's *Mirror for Princes* mixed elements from classical Islamicate philosophy to emphasize that

the Sultan was a better judge than religious authorities.[36] Speaking with Tusi's *Akhlâq-e Nâsirî*, they proposed that a state might include people that 'differed in community and doctrine', and therefore, the Sultan was to watch over the common acceptance of Justice so that 'every soul is drawn into a thread of order'.[37] With Mehmet II's imperial ambitions, the respective audiences for Ottoman political languages changed significantly. Intellectually, this meant a differentiation. The Sultan and his Viziers promoted copies and translations of prominent Persian and Arabic treatises, such as al-Fārābī's virtuous city, *al-madīna al-fadilah*, that discussed the role of virtue in bringing different peoples together.[38] Nevertheless, they were interested in seeing what the core ideas of Aristotle or Plato had been and what there was to learn about them from contemporary Greek scholars. Therefore, next to Arabic- and Persian-speaking savants, the imperial court comprised of a group of Greeks who engaged in administrative tasks as well as in philosophical exchange, translation, and amalgamation.[39] Kritovoulos of Imbros wrote a *History of Mehmet the Conqueror* in the style of Arrian's *Anabasis* (History of Alexander), bestowing Mehmet II classical ἀρετή [gr. virtue].[40] Parallel to that, the Greek philosopher Georg Amiroutzes and the Sultan engaged in regular conversations on Aristotelianism, Platonism, the nature of God, and virtue.[41] To the Ottomans, virtue had become a central quality and Greek scholars held a pivotal part in that.

Sagundino, therefore, arrived into an environment that put virtue at the basis of political competency; accordingly, virtue played an important role both in Sagundino's encounter with Mehmet II and in how the Greek described the Sultan to the Serenissima – a man full of creativity, eager to learn, to conquer, and to emulate the rulers of antiquity known for their virtue. During the successful negotiations, Sagundino's intellectual abilities played an important role. A 1454 letter from the Venetian Senate to Bartholomeo Marcello (now *bailó*) specifies that the Greek had translated formidably and that his knowledge of the Turkish customs was very useful; Sagundino, they write, assured the *Serenissima* about the Turk's 'friendship [*amicitia*]'.[42] It seemsthat he created a special intellectual bond with the Sultan. The letter connects this to Sagundino's '*prudentia*' that, he himself explained, meant 'to put the virtue of *Sapientia* [Wisdom] into practice', which happens in common 'activity, affection, and conversation'.[43] The common interests also figure prominently in Sagundino's report about the Sultan. Neither the protocol of the negotiations nor Sagundino's testimony before the Senate has been preserved. Yet, Alfonso of Aragon commissioned the Greek to pen down his knowledge about the Ottomans. Even though this *Oratio* is clearly aimed at a Christian audience, it still angered the pope so much that he demanded a new, anti-Ottoman version. In his original text, Sagundino had described the Sultan as a man of character, 'well-informed' and equipped with a 'sharp spirit'. Mehmet II, he furthermore explained, learned many languages and developed a great interest in the classics, employing two scholars in Latin and Greek to read them to him. In contrast to his people, Mehmet II trained his character and did 'exhibit self-control'.[44] For contemporaries, this not only contradicted common prejudices against the Turks but also painted the picture of a ruler who practised virtue just as the humanists wished.

Over the following years, Sagundino's observations became the most influential information on Mehmet II in Italy, and he built his career mainly on this connection. We can assume that what Sagundino initially reported to the Serenissima and what he later penned down in his *Oratio* differed significantly. While the *Oratio* leaves little doubt about the danger the Sultan posed to Italy, his cruelty, and his will to conquer, Sagundino certainly provided the Serenissima with more detailed information about a suitable political language to engage with the Ottomans. In fact, Sagundino himself became promoted to the rank of a *Segretario*, and, in 1461, he travelled to Mehmet II, successfully negotiating an agreement and apparently bonding again with the Sultan, who wished to be informed personally about the return of the Greek.[45] Following Sagundino's prominence and the apparent Ottoman interest in Greek scholars, new Mediterranean networks formed, which provided Italians with information and which co-created the myth of a virtuous Sultan. For example, the Greek Angelo Vadio, secretary to the Venetian *bailó* in Constantinople from 1460 to 1462, was an informant of Sigismondo Malatesta's secretary Roberto Valturio.[46] In 1461, the latter addressed Mehmet II on behalf of Sigismondo Malatesta, emphasizing that both rulers shared an interest in attaining to virtue.[47] Sagundino himself was present when Pius II worked on his *Epistola ad Mahometem*, a letter that claimed Mehmet II possessed the virtue necessary to unite the East and the West, if only he accepted Christendom (though supposedly this *Epistola* attempted to shock the Italian princes rather than convert the Sultan). The tone to approach the Sultan was set, and the tone was virtue.

The world is a garden

From 1463 to 1479, the Ottoman-Venetian War limited cultural exchange. The Venetians had considered sending Sagundino to prevent the outbreak, but in the last minute they decided to no longer endure Ottoman provocations.[48] On an intellectual level, however, curiosity persisted. Sagundino's report had inspired new ways of thinking about the Ottomans and trans-Mediterranean networks had been spun. In Ottoman lands, the development of virtue ethics continued and Greek humanists noticed that. During the 1460s and 1470s, in a vastly expanding realm, the court around Mehmet II developed a more centralized and more cohesive ideology of the order of the world [*nizam-ı alem*] in which virtue came to mend the spatial distance between the ruler and the ruled. Virtue now acquired a spatial dimension. On the one hand, this referred to the relationship with the subjects, who, despite his increasing physical absence, were to be influenced by the Sultan. On the other hand, however, it also referred to the emergence of a meta-space that could hypothetically be called the space of the virtuous. Belonging to this space was not primarily political but character based. Here, instead of political intention, both ethical and emotional affection bridged the spatial and cultural distance between individuals. This also solidified the political potential of virtue ethics as a transcultural mediator.

The special relationship between space and virtue did not escape the eyes of Italian observers. Although he had initially come to the Ottoman court as a prisoner of

war, the Italian Giovanni Maria Angiolello soon received a position in the Ottoman financial administration. He documented the late 1470s, including Gentile Bellini's visit, in his memoirs.[49] Angiolello was an attentive man, educated, and keen to document curiosities in the Sultan's conduct. Therefore, among his notes, there is a description of Mehmet II wandering through the Gardens of the *Topkapı* Palace. The garden he describes as decorated by three '*palazzi*', each representing a different, individual style to the Italian. With that, he referred to three pavilions that once decorated the palace gardens. One was in Persian mode, '*alla Persiana*'; one was in Turkish mode, '*alla turchesca*'; and finally, one was in the Byzantine style, '*alla greca*'.[50] Gülrü Necipoğlu has interpreted these pavilions as architectural manifestations of the different parts of Mehmet II's realm; metaphors for the universal empire the Sultan sought to create.[51] This theory complements another of Angiolello's observations. For the Italian, Mehmet II's walks between the pavilions were due to the delight he took in virtue. It was complemented by teachers reading to the Sultan in Latin and Greek and by looking at the fine art of painting.[52]

Angiollelo's observation is more than the speculation of a foreigner; it goes to the core of what the *Topkapı* garden represented. 'The world is a garden, its walls are the state', says the Circle of Justice, a poem first introduced to Ottoman political thought by Ahmed Amasi in 1406. At the beginning and at the end of that poem stands royal authority.[53] Many classic Islamicate garden spaces were a reference to paradise, a tradition that goes back to a number of *suwar* in the Qur'an.[54] Nevertheless, Persian, Arab, or Turkish gardens follow their own modes and styles.[55] Recently, Deniz Çalış Kural meticulously argued that, as a Mediterranean cross-cultural parallel to some Italian specimen, early Ottoman gardens 'symbolized the integrity of the cosmos following the Neoplatonic idea that a unique source exits concerning the creation of the whole universe ... all gardens house reflections of the original source of this unity – reflections of the paradise garden'.[56] Though I interpret Neoplatonism as an element, rather than a core, Ottoman gardens, which had yet to establish themselves as a distinct type, were certainly metaphorical and poetic spaces. Combining traditional and local elements, they produced a coherent narrative. In accordance with the emerging political thought, they brought the potentially conflicting pairs of old and new, heartland and conquered territory, and core population and new subjects into one harmonious unit.[57]

There are two ways, outside and inside, in which the garden of *Topkapı* Palace represented the political and ethical harmony virtue brought about. Both lay grounded in the fact that this garden was a metaphorical, spatialized realization of the ethics that underpinned Mehmet II's fledgling empire. The first, the outside, pertains to the location of the garden in the grander scheme of the palace setting. Mehmet II chose the location of *Topkapı* Palace in the heart of the ancient metropolis of Constantinople, where the Hippodrome stood and the emperors had resided in their palace. Much of the construction work was carried out in the first half of the 1460s, at a time when Ottoman Sultanic ideas were in upheaval. The Sultan was no longer one among equals. He was an almost remote ruler to whom only a few illustrious people would have access. Mehmet II's book of laws *kanunname* (c. 1477–1480) reflects the Sultan's position towards his subjects by calling him

'the cause for the world order [*nizam-ı alem*]'. The *nizam-ı alem* is no static concept. It is, suggested Gottfried Hagen, a permanent discourse about the nature of legitimacy in the Ottoman realm. The various intellectual traditions at the Ottoman court contributed to it in equal measure. As I explain in more detail below, the central underlying assumption of this system was that the virtue of the Sultan enabled him to govern the empire. To do this, however, as sources such as the Perso-Turkish scholar Şeyhoğlu makes clear, he needed the help of well-chosen men such as his vicegerents. These were to be distinguished by the fact that their virtue and the Sultan's virtue inspired each other.[58] Through a role of successive courts, the *Topkapı* Palace symbolized this new thinking. Each gate was allowed to be passed through by fewer people. And only a handful, finally, were allowed to follow the Sultan into his garden. Built in the heart of the new empire, locked behind impenetrable gates and courtyards, the very location of the garden symbolized that it was a place of pure virtue and virtuousness. Whoever counselled the Sultan here possessed the quality to guide the empire's destiny.

Second, in its inside design, *Topkapı* garden represented the virtuous nature of the connection between the ruler and the ruled. As I mentioned earlier, Mehmet II symbolically walked between the different parts of his empire, each represented by a pavilion. This resembles a permanent process of integration, which the Sultan's virtuousness was supposed to inspire. According to Ottoman ideology, the radiation of Sultanic virtue did not end with the legal borders of the Ottoman realm. The *Kanunname* introduces the Sultan not only as the 'orderer of the world' but also as the valid ruler 'over all the tent-dwellers and city-dwellers'.[59] The denominations city-dwellers and tent-dwellers stand for the dichotomy between the religiously civilized world of the *madina* (city) and the people yet to be integrated, the *badawī* (tent-dwellers). Virtue did not only connect the various parts of the empire, but it also built the connection to the people (still) outside it. This was in line with the Islamicate philosophy actualized at Mehmet II's court, such as al-Fārābī. One central concern of his *al-madīna al-fadilah* is the question if non-Muslims can be virtuous. Somewhat simplified, al-Fārābī argues that virtue depends on cultural specificities. While all people have a potential to virtue, a full realization of virtue can only happen by integration into the house of Islam. This integration was to be made possible by reason and an instructing prophet.[60] The Ottomans did not consider their Sultan a prophet, but, as Mehmet II's Vizier Sinan Pasha wrote in his *Ma'ârifnâme*, 'every place has an order that comes with it, and so every province needs a law that befits it'.[61] The order of the world [*cihanın nizamı ve alem intizamı*] is best secured when mutual protection and respect are instigated among people that naturally differ.[62] The Sultan's walk between the pavilions, his care for the garden, is an expression of that.

Both al-Fārābī and Sinan Pasha address the complicated question of how a place or space conditions the qualities of those living in it or moving through it. Neither of them is thinking primarily of smaller, enclosed spaces or, for example, urban spaces. Thus, there is no Ottoman literature that, like Leon Battista Alberti, for example, recognizes in concrete buildings or ensembles an expression of classical virtue.[63] Nevertheless, the Ottoman court showed great interest in exploring the connection between virtue and place in more detail. Although final proof is still

pending, the Italian architect Filarete (a name that translates as 'Lover of Virtue') probably travelled to Constantinople and to the court of Mehmet II.[64] Also, in the library of the Sultan, there was a copy of Filarete's *Trattato di Architettura* [1460–1464].[65] Here, in his search for the ideal city, Filarete establishes a clear link not only between the beauty of architecture and the virtue of man; he also opens contemporary ideas oriented to classical antiquity to influences from the territories of the Eastern and Islamicate Mediterranean. The architect believed that the various architectural forms of the East preserved a past as glorious as it was instructive. If architecture was to preserve and convey virtue, it had to be open to diverse influences.[66] These considerations bring Filarete into indirect dialogue with the Ottoman court's intellectual culture. Believing that the seed of virtue is sawn in many cultures, he not only saw a potential transculturality of virtue but also believed that the latter would become visible in respective architectural styles. Just as the pavilions in the garden would be capable of doing.

When speaking about the connection between virtue and place, Constantinople must not be ignored, since every conversation about place and rulership was also a conversation about the Platonic ideal city *Kallipolis*. In his dialogue on the Republic, Plato discusses the conditions under which Justice can excel; therefore, he imagines an ideal state with his interlocutors. The state, they find, is like a soul. Next to desire and temperance, embodied by craftsmen and warriors, reason is the highest among the soul's three parts. It is embodied by the philosophers since their virtue is wisdom, and so they should lead the state. Plato's search for the hypothetical perfect state contained two valuable lessons: first, justice exists when wisdom rules and the three classes are in harmony, and, second, virtue decides about the appropriate place of each individual in society. Not for nothing had the Venetians required Trebizond to proclaim that their city was based on Plato's ideals and, as Petrarch put it on their behalf: '[was] rich in gold but richer in fame, mighty in her resources but mightier in virtue!'[67] To many Greeks, however, the decline of the Byzantine Empire and its capital were a sign that the Byzantines had lost their wisdom, their virtue, and their talent to balance society. Referring to an ancient prophecy, the Greek historian Doukas complained that the Byzantines met the turn of Fortune [τύχη] against them unprepared.[68] Others saw a stronger connection between virtue and place, and argued that virtue was inherent even in the decaying Byzantine Constantinople. Doukas's contemporary Laonikos Chalcocondyles daringly stated that Mehmet II gained rule over the city legitimately; his possession of the virtue that the Byzantines lacked allowed him to (temporarily) take their place.[69] For the Sultan's historian the Greek Kritovoulos of Imbros, it was the sight of past virtue that tempted Mehmet II to take pity on the city and rebuild it – 'more complete than before', since now it would encompass the Roman, the Greek, and the novel Ottoman culture.[70] What is truly fascinating is the statement of the chronicler Ibn Kemal, albeit made several decades later, who said that Mehmet II turned the city into a 'deocrated rose garden' after its destruction. He thus made a direct connection between the harmony of the city and the metaphorical harmony of the garden.[71] For Greek and Ottoman actors alike, it seems, Constantinople was a reflection on the fact not only that virtue shaped the city but also that the (once) glorious city needed and could inspire virtue.

Notorious for his attempts to win the Sultan's favour, the Venetian Greek scholar George of Trebizond offers a remarkable example for the perception of the Ottoman Empire as an ideal city of virtue. George arrived in Venice at a young age and worked as a private tutor, a teacher of Latin and Greek, and a copist of manuscripts. However, he never attained stable employment. Together with some eschatologically inspired contemporaries, he suggested that the fall of Constantinople was a pre-apocalyptic event and that the Sultan was a prophet with the power to unite the different religions.[72] Although he had written a commendatory book for the Venetians on the Platonic Venetian constitution, Trebizond's opinion was anti-Platonic. One of his main criticisms was the Platonic ideal city. Its authoritarian, static caste structure offered no opportunity for the individual to develop their potential. Plato's ideal state was closed, especially to foreigners like himself. But a flourishing state should be meritocratic, cosmopolitan, and open to impulses from outside. Trebizond's words resonate bitterness about his lowly position as an immigrant in Venice. Supposedly inspired by messages from Constantinople, the Greek saw Mehmet II and the Ottoman Empire as the realization of his vision.[73] 'The Ottomans', he explains, 'are not like that [the Platonic state], they say that all alike are humans, and make no difference between man and man, except for differences of virtue'.[74] George was so fond of the Sultan; in 1465 he travelled to Constantinople and dedicated to him multiple treatises and letters, urging the 'ultimate ruler' to convert to Christianity. This strategy was communicated to the Vatican by the Greek, even though this would not spare him from being arrested in Italy. Here, George of Trebizond serves as an example for the radiance of the Ottoman court and the resonant understanding of the idea that spatial transition, despite a complete change in culture, could bring one closer to virtue.

The realm, the city, and the garden – Venetians knew that for the Ottomans each of these spaces expressed a particular relationship between the ruler and virtue. The realm, as Trebizond noticed, was tied together not by legal borders but by the Sultan's mediation of virtue, which was evident in his active role in ordering the world [*nizam-ı alem*]. Boundaries were thus dynamic, and character was valued over culture for belonging. Ethical and emotional affection bridged the spatial and cultural distance between individuals. Speaking about the novel situation in Constantinople illustrated that the Sultan's virtue could reach a new place and connect with the particular circumstances there. Although the city and its empire had fallen from a lack of virtue, it was an important reminder of a glorious past to which the Sultan, although not a Byzantine, could link. Inside the palace, finally, the garden symbolized all this. Its architectural structure solidified the political potential of virtue ethics both as a political competency and as a transcultural mediator. The enclosed space with its pavilions served as a metaphor for the Sultanic realm, filled with those cultures it did and those which it could encompass.

Giovanni Dario's handkerchief

The relations between Mehmet II and Italy are notorious precisely because of their material dimension. Interpretations often attempt an art-historical and rarely an intellectual contextualization of those objects that inspired the Sultan. This

art-historical focus, Antonia Gatward Cevizli reminds us, risks to make artwork and artist conceal the complex configurations, individual interests, and also broader social and intellectual schemes that were one part of the exchanges.[75] Integrating Bellini and his artwork into the narrative hitherto introduced allows a novel perspective on the artist's mission and the intellectual depth that vanguards it. Bellini's journey was not the starting point but rather the outcome of good relations; the artist himself was not an initiator of cultural diplomacy but a profiteer of a more complex exchange that had already happened. In 1478, a critical year in the Ottoman-Venetian War, the *Serenissima* had dispatched the Greek notary Giovanni Dario as an ambassador to the Ottoman court. Quickly, Dario and the Sultan developed a deep mutual affection. The Greek progressed to the Sultan's innermost circles and virtue played a decisive role in that. It was this connection that made Bellini's journey possible in the first place. His painting of the *Processione in piazza San Marco* is a testament to a personal affection that transcends space and that puts the virtue ethics shared between the Ottomans and the Italians into a transcultural practice.

Giovanni Dario attained his position by the qualities that he could bring to the Ottoman court. After the death of Sagundino in 1464, the Serenissima had trouble finding an ambassador that Mehmet II would respect. War was a time of sensitivities and the 1467 mission of the Italian Leonardo Boldu ended in disaster. Mehmet II appreciated his expensive gifts but was unwilling to negotiate political matters while additionally complaining about the 'bad translation' [*male interpretations*].[76] Marc Aurel, successive choice and distant relative of Sagundino, died before leaving for Constantinople.[77] Giovanni Dario, who had been a colleague of Marc Aurel, at the time of his appointment was well over 60, but therefore rich in experience. In previous missions, he had been to Constantinople to translate for the Venetians, though no visit to Mehmet II is documented. In 1477 Dario accomplished his first solo mission as an ambassador to the Cairo court of the Mamulk Qait Bay.[78] The Cretan stemmed from a family that was active in Levante trade and added to his native tongue Greek bits of Turkish and Arabic.[79] Presumably, in his youth he even encountered Mehmet II's father Murad II.[80] Dario's activities, education, and status did not qualify him as scholar in the ways of Sagundino or Trebizond, but he was culturally educated. He said about himself that he always tried to find time to study literature, and friends said about him that he was equally familiar 'with the muses as with business'.[81] Ultimately, Dario also had a great interest in the remnants of antiquity, which was also evident in his friendship with Cyriacus of Ancona.[82] With these passions, Dario possessed great potential to please the Sultan.

What exactly happened at the Ottoman court is uncertain, but Dario achieved a tremendous success. The mission to Mehmet II began in December 1478. He left equipped with an unusually wide scope for action which the *Serenissima* granted him due to the urgent situation. This seems to have accelerated the negotiations, because, already in January, Dario was able to report that he travelled towards the Serenissima with the Ottoman ambassador Lutfi Beğ. Here, the latter would sign a peace treaty on the Day of St. Mark, 16 April 1479.[83] While not revealing the course of the negotiations itself, indications about Dario's perception and conduct at the Ottoman court exist on two levels. The first concerns how Dario

is described in the existing sources. The fifteenth-century *Liber Graecus* in the *Archivio di Stato di Venezia* holds Latin and Greek versions of the 1479 treaty. The Latin version describes Dario with the virtues of *prudentia* [prudence] and *sapientia* [wisdom]; furthermore, he is referred to as *Ser* and and *Ingengio* 'Zan Dario'. The Greek version applies the attribut *sofon* [σοφων] for wise but refers to Dario as 'high/grand master [*archon kyrios*/ἄρχων κυρ(ιον)] Giovanni Dario, Secretary [σαὶκρετάρη(ον)]', instead of *Ser* and *Ingengio*, therefore underlining the Ottomans's high esteem for Dario. The second indication concerns a gift Dario received. The Sultan equipped him with three golden *Kaftans*. This was an act of high symbolic charge. Selected diplomats received the robe of honour, or *khil'a qaba*, as a sign of transition. By wearing the *khil'a qaba*, they were no longer mere guests of the ruler but a part of the familiar, intimate realm of the Sultan. Usually, therefore, the Kaftan was to be returned (in exchange for money) after the negotiations ended. Dario, however, got to keep not one but three robes of honour, emphasizing that for the Sultan, he would remain an outward post of his symbolic realm.[84]

The sympathy Dario experienced reinforces Andrews's and Bilkent's observations that *muhabbet* (affection) was central to the Ottomans's emotionally encoded political thinking – especially when one considers that this can also apply to the consolidation of political relations of domination and subordination.[85] In fact, in about 1481, the Ottoman historian Tursun Beğ explained the relationship between virtue, rule, and emotion. According to Beğ, the Sultan needs to attain training the cardinal virtues continuously, for he is the cause for the duration of the order of the world.[86] Without the Sultan, 'people cannot live together, and they would destroy each other and the *nizam-ı alem*'.[87] In his conception of the virtues, Tursun was inspired by Aristotle. For the latter virtues formed the middle between emotional extremes ('excess' and 'defiancy'). Each person, the Ottoman explained, had three different driving forces of the self [*kuvvet*] and virtue meant keeping them under control.[88] Here, the Sultan had a role model function; his self-control, his virtue, surpassed that of the rest of the world, whose people would fall into chaos without him. Consequently, receiving Sultanic affection was a form of right guidance. This affection expressed the ruler's unwavering emotional balance, which had recognized a potential in a subject and wanted to nurture it.

The interpretation described here becomes clearer if we return to the handkerchief mentioned at the beginning of this chapter. It first appears with the Ottoman legation arriving in Venice in 1480. Here, the Doge was handed what Malipiero describes as 'a thin scarf' [*fazzuol sotil*]. No lesser than Mehmet II had worn it in Constantinople, and now, the Doge was to wear it as a sign of the Sultan's 'strong and lasting friendship'.[89] The item received by the Doge, I suggest, is a so-called *destimal-i şerif* [royal handkerchief]. As such it plays with the aforementioned notions of distance versus intimacy, political versus private, and strategic relation versus sincere emotional affection. In the context of Ottoman diplomacy, the destimal connects these aspects with the Sultan's position at the centre of the *nizam-ı alem*.[90] An Ottoman visual example can illustrate this. On a painting attributed either to Sinan Bey or to Şibilizade Ahmed, the Sultan is seated, smelling a rose in his right hand, while his left hand is holding a white handkerchief.[91]

The rose, the Ottomans believed, acquired its fragrance from sweat on the face of Mohammed.[92] It was a symbol of divine inspiration and deep pious affection – a meditation on what blossoms in the garden protected by a Sultan. The handkerchief complements the rose in symbolizing the sincere affection between people. The illuminated *Dilsuzname* by Bedreddin Minucihr al-Tebrizī (1455–1456), a work composed for Mehmet II, emphasizes this. Its miniatures illustrate love and affection. One shows a couple, a nobleman and his beloved woman, sitting in front of a rose garden. The couple is connected by a handkerchief as a symbol of their shared love, with each holding one end of it in hand. In another illustration, a nightingale holds a handkerchief over the rose with which it has fallen in love.[93] The image of Mehmet II combining rose and handkerchief in his hands expresses the connection between affection and rulership.

A connection can be drawn between the robes Dario received and the handkerchief offered as a gift to the Doge. At the Ottoman court, the robes symbolized a transition into the imperial realm. The temporary wearing of the noble garment changed the social status of the wearer into a special form of appropriateness. For a brief moment, metaphorically, the strong bond between the ruler and the high-ranking subject was evoked. The handkerchief perpetuated this connection. It expressed a special form of affection that was no longer only directed into the here

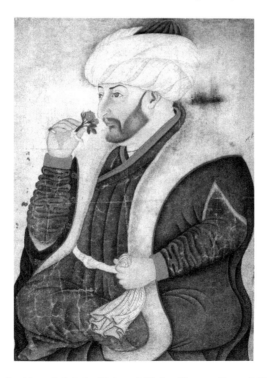

Figure 2.2 Şiblizade Ahmed (attr.), *Mehmed II Smelling a Rose*, 1480–1481, Istanbul: Topkapi Palace Museum Library.

and now, but into the future. The temporary transition that a robe allowed became a constant bond. Of course, this bond was neither neutral nor equal. From an Ottoman perspective, the handkerchief allowed for a particular but still inferior social position.[94] It was exclusive and limited to those allowed into the most secluded confines of the Sultan's realm – usually it was given to high-ranking officials such as the Viziers – but it entailed no further privileges. It was the sign of a relationship of mutual effort and under the leadership of the Sultan. And while there certainly was a contractual dimension, most importantly, the handkerchief expressed that now the Serenissima and the Ottoman court were in a state of amity in which the presence of the fabric was supposed to mend the spatial and cultural distance between the ruler and vast parts of his empire and population.[95]

From here, finally, a new perspective on the handkerchiefs in Bellini's *Processione* can be obtained. When they manifest a virtuous connection formed by moral and emotional attachment, how do they play into Venetian and Ottoman conceptualizations of the Mediterranean as a shared space? To begin with, Bellini's mission to the Ottoman court was planned only after the peace treaty was signed and the handkerchief handed over. The same Ottoman ambassador who brought the *fazzuol sotil* to Venice also transmitted the Sultan's request for 'un bon depentor che sapia retrazer' – 'a good painter who knows the art of the portrait'.[96] The choice quickly fell on Bellini, who was busy painting representative Doge portraits and may have caught Lutfi Beğ's eye. The Senate discussed the request in their meeting on 13 August 1479. Here, Giovanni Dario spoke out in favour of the Sultan's honest intentions.[97] Trusting Dario, the Senate accepted the Sultan's request with 109 to 0 votes and Bellini's journey began in September 1479. The artist spent a productive time in Constantinople, sketching the Sultan's courtiers, decorating the walls of his rooms, and painting the famous portrait of Mehmet II. Thereby, the transgression between realms that had hitherto been intellectual now became artistic. This not only relates to matters of style – Bellini had a visible imprint on Ottoman portraits of Mehmet II and himself returned to Venice with an expanded range of motifs and a differentiated picturing of the Eastern Mediterranean world.

This experience allowed Bellini to use a particularly sophisticated formal language in his paintings. For example, his famous portrait of Mehmet II plays with the motif of power, transcendence, and spatial transition. Painted around 1480–1481, historians and art historians assume that the portrait was aimed at an Ottoman audience or the Sultan's privy collection. There is no effort to hide the Sultan's poor health, but even this condition leaves no doubt about his authority. The Sultan sits behind a richly decorated arch. Above this arch, six crowns hover, probably indicating the different parts of the empire. This staging is already reminiscent of the secluded sultan in rapt connection with his empire. It takes on another dimension when one considers that the arch behind which Mehmet II is seated belongs to the Venetian church of San Zaccharia.[98] At Easter, the sisters of this Venetian nunnery presented the Doge with his noble headgear, the *Corno Ducale*.[99] The gate of San Zaccharia thereby symbolized the merging of religious and political legitimacy in the person of the Doge.[100] In Bellini's portrait, it opened the view to another ruler who claimed to bring religious and political authority together. The arch created a

Spaces of virtue 41

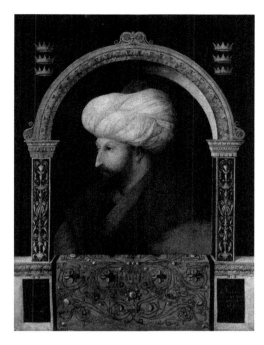

Figure 2.3 Gentile Bellini, *The Sultan Mehmet II*, 1480, The National Gallery, London.

Venetian window to the East and an Ottoman adaption of Venetian legitimacy. The gate as a symbol of connection and seclusion was just as important in the *Topkapı* Palace complex. The complex, Gülrü Necipoğlu reminds us, was designed to echo the new imperial identity of Mehmet II's realm. Thereby, only the front courtyards were open to visitors. Behind the gate of felicity [*bâb-üs saadet*] began the private realm of the Sultan. Here lay the privy chambers, holy relics, and, perhaps most importantly, the Sultanic garden. The gate was thus the point of transmission between the outside world and a place from which the world order was maintained. It is thus no coincidence that from the *bâb-üs saadet* justice was spoken. Bellini certainly spent a large part of his stay in Istanbul behind that gate. While we know about the rich gifts, such as a golden necklace with which Bellini was rewarded, also a Latin copy of Mehmet II's letter of recommendation for Bellini survives. It praises Bellini for having shown his faithful and loyal character, but most importantly his great virtue, which gained him the Sultan's benevolence.[101]

In his portrait of Mehmet II, Bellini had found a visual and architectural expression for the shared language of legitimacy and authority that virtue provided. That his painting can invite the viewer to transition between realms is due to the ease with which intermediaries such as Giovanni Dario transitioned between politically different realms. Thereby, affection over distance and the redefinition of space played a pivotal role. For the last part of this chapter, I will return to its point of departure, Bellini's *Processione in piazza San Marco*. Looking at the painting,

42 *Luc Wodzicki*

I will explain how it defines an affective relation over inter-imperial space from a Venetian perspective through St. Mark's Square and why Bellini was motivated to depict this.

The story of the painting *Processione in piazza San Marco* is closely connected with the interests of Giovanni Dario. It was commissioned as part of a cycle of paintings – the miracles of the true cross – for the *albergo* of the *Scuola Grande di San Giovanni Evangelista*. In the early 1490s, this major devotional confraternity (with up to 600 members) had decided to celebrate in painting the relic they were guarding: a splinter of the holy cross. The cycle was to be executed by various artists, among them Carpaccio. Bellini received the commission for one of the main pieces presumably through his connection with Giovanni Dario.[102] From 1492 to 1493, Dario served as the *Guardian Grande* of *San Giovanni Evangelista* (while the artist was a member of the *Scuola Grande di San Marco*) giving him an influential position in awarding the contract. A further connection can be found in Dario's testament, which names the Scuola as one heir.[103] In March 1493 [=1494], after Dario's death, the *Scuola* notes that from Giovanni Dario comes 50 Lira for the restauration of the *albergo*.[104] This sum corresponds to the amount Bellini had offered the Scuola Grande di San Marco shortly before for the production of a similar large-format painting. Therefore, in all likelihood, Bellini had several reasons to be grateful to Dario, and the *Scuola Grande di San Giovanni Evangelista* had every reason to memorialize Giovanni Dario through the painting.

Patricia Fortini-Brown has provided an in-depth analysis of the *Processione* as part of her work on Venetian narrative painting. The painting, one might think, hides its real motif: the healing of a young boy by the power of the splinter of the Holy Cross. This decisive moment is lost in the large crowd of people taking part in the procession and given the wide surface area of St. Mark's Square. But Fortini-Brown's interpretation happens through the 'period eye'. She describes the Venetian narrative painting style as an 'eyewitness style' that gives great attention to details since it imitates the density of a written *storia*. The paintings are not to preserve one moment but to testify for the reality of the miracle which, in turn, testifies for the reality of the relic. To be clear, neither Dario nor the turbaned figure in the background is the subject of the painting. They are one narrative element that is included into a sea of stories, claims, and representation the painting transmits. In the case of Dario, the painting might testify for something else. The procession we see in the picture is nothing less than the procession on St. Mark's Day, the very day Dario was able to negotiate as the day of the Venetian-Ottoman treaty signing.[105]

For a final view of the painting, it is important to bear in mind its sheer size, measuring 347 cm × 770 cm. The great spatial distance between Mehmet II and Giovanni Dario thus appears very real. Just as real as the dimensions of the *Piazza San Marco* where the action takes place. Two observations will allow us to bring together the different aspects this chapter raised. The first is how Bellini constructed the architectural space. As was common, the procession proceeded from the *piazzetta* in front of the Ducal Palace. This route is no coincidence. The *piazzetta* was a politically charged place that carried the power of the Doge's Palace and thus of the Republic, similar to the *Bâb-üs saadet*, into the public

sphere. On closer inspection, it is noticeable that the procession seems to come out of the Doge's Palace through the gate behind the *pietra del bando*. The *pietra* marked the place where the official made announcements such as proclamations of laws. It was positioned at the very spot at which religious authority in the form of St. Mark's Basilica and worldly authority in the form of the Ducal Palace and the *colonne di San Marco e San Todaro* met. From the *piazzetta*, symbolizing the rule of the Serenissima, the procession moves to the wide *piazza*, which embodied the Venetian public. As Daniel Leis argued, the ensemble stood for the permanence of the Republic and its organs.[106] With a focus on the procession rather than the individuals, the *Processione* proves to be a harmonious event that expresses the symbiotic nature of the Scuola Grande di San Giovanni's relationship with St. Mark's Republic and its legal foundations.

This architectural space transforms into a different story once we highlight Giovanni Dario and the three Ottoman men. The positioning of the Ottomans in the painting's arrangement corresponds to the position through which the 1480 delegation entered St. Mark's Square – from the seaside.[107] Here, still close to the *pietra*, they have entered an inherently public but deeply Republican space. They seem mere bystanders, yet, as witnesses, they contribute to the validation both of the painting's motif – the wonder of the holy cross – and the events surrounding the peace agreement of which they were actually a part. In contrast to the great distance the viewer has to the Ottomans, Dario stands in the foreground of the picture and, as almost the only person, looks directly at the viewer. His red robe not only makes him stand out, but it is also folded back on the right sleeve, presumably to show a noble fabric underneath. His right hand, in any case, points to the handkerchief his left hand is holding. The connection to the Ottoman standing in the background with his handkerchief is thus inevitably emphasized.

Referring to what has been said before, Bellini uses the handkerchiefs to perform a rich play about virtuous, emotional attachment against spatial distance. St. Mark's Square is transformed into a stage with two sets. One is a closed space, Venice, the virtuous republic in harmony with its citizens. The presence of the Ottomans, however, opens up this space. Their position in the picture not only pushes them into the background; above all, it reminds one of the conclusions of the peace treaty and therefore the successful connection with the Venetians and their legal institutions, St. Mark's Basilica and the Doge's Palace. Through the presence of the handkerchiefs, this space, this narrative, is now relativized and transcended once again. Dario's folded sleeve possibly refers to his stay at the Ottoman court – a stay in which the mutual understanding of virtue ethics allowed him an unusual negotiating success. In any case, however, the handkerchief in his hand refers to the perpetuation of this bond. It permeates the various narrative levels of the painting and underscores the affectionate relationship with the Ottoman Sultan. At this moment, what appears to be a vast, divisive space becomes a shared space, a space of the virtuous. This space, it seems, manifested itself not only in the thoughts and ethical discourses of Italians, Greeks, and Ottomans; where forms and things became shared and expressed connectedness over distance, and an openness of enclosed space, it also manifested itself architecturally.

Conclusion

Virtue provided the Ottoman-Venetian relations with a specific language that put the quality of character over religious or political affiliations and that integrated Venice into the Ottoman imperial world view, as well as the other way around. The basis of this language was a shared heritage of Greek antiquity which both integrated into their political vocabulary, if in accordance with their specific traditions. Thereby, virtue was an affectionate language. At least during the reign of Mehmet II, it helped actors to express an emotional bond that went beyond legal commitments. That this bond could overcome spatial and cultural distance is a central element of virtue ethics that becomes apparent when the construction of (symbolic) architectural spaces is included in the analysis. In this way, the *Topkapı* garden with its pavilions reveals itself as a de facto closed but metaphorically open place in which the Sultan symbolically shares his virtue with the (future) inhabitants of his empire; in this way, the Piazza San Marco becomes not only the centre of the Republic but also a reminder of the virtuous connections across the borders of this Republic. Or, put differently, the handkerchiefs that Giovanni Dario and the Sultan hold signify them as contenders of the same shared Mediterranean space – a space of the virtuous.

Archival sources

Archivio di Stato di Venezia (ASVe), Notarile, Testamenti, not. Giacomo Grasolario.
Archivio di Stato di Venezia (ASVe), Liber Graecus.
Archivio di Stato di Venezia (ASVe), Senato, Secreti.
Archivio di Stato di Venezia (ASVe), Senato, Terra.
Tiroler Landesarchiv Innsbruck, Kunstsachen.
Topkapı Palace Museum.

Notes

1 "[…] un fazzuol sotil, dignado che 'l so Signor, s'ha cinto con esso, e che anche lui fazza l'medemo in segno de stretta e ferma amicizia […]" quot. in Malipiero, "Annali veneti dell'anno 1457 al 1500", p. 122.
2 da Lecce, *Historia Turchesca*, pp. 119–120.
3 This topic will be developed further in a forthcoming publication..
4 Howard, "Cultural Transfer Between Venice and the Ottomans in the Fifteenth and Sixteenth Centuries", p. 138.
5 Dursteler, "On Renaissance Bazaars and Battlefields: Recent Scholarship on Mediterranean Cultural Contacts", pp. 413–434.
6 Chong, "Gentile Bellini in Istanbul: Myths and Misunderstandings"; Rodini, *Gentile Bellini's Portrait of Sultan Mehmed II*.
7 Rothman, *Brokering Empire. Trans-Imperial Subjects between Venice and Istanbul*.
8 D'Amora, "Emotion, Diplomacy and Gift Exchanging Practices in the Ottoman Context".
9 Reindl-Kiel, "Ottoman Messages in Kind: Emotions and Diplomatic Gifts".
10 Andrews, "Ottoman Love: Preface to a Theory of Emotional Ecology", p. 23.
11 Tekgül, "Early Modern Ottoman Politics of Emotion: What Has Love Got to Do With it?", pp. 132–154.

12 Andrews, "Ottoman Love".
13 Tekgül, *Emotions in the Ottoman Empire*.
14 For an overview, see: Sariyannis, *A History of Ottoman Political Thought up to the Nineteenth Century*.
15 Asutay-Effenberger and Rehm (eds.), *Sultan Mehmet II. Eroberer Konstantinopels – Patron der Künste*; Barkey, *Empire of Difference. The Ottomans in Comparative Perspective*.
16 Küçükhüseyin, "The Ottoman Historical Section of Ahmedî's İskendernâme: An Alternative Reading in the Light of the Author's Personal Circumstances", pp. 285–311.
17 Hagen, "Legitimacy and World Order"; Ferguson, *The Proper Order of Things. Language, Power, and Law in Ottoman Administrative Discourses*.
18 Necipoğlu, "Visual Cosmopolitanism and Creative Translation: Artistic Conversations with Renaissance Italy in Mehmed II's Constantinople", pp. 1–2.
19 O'Connell, "Legitimating Venetian Expansion: Patricians and Secretaries in the Fifteenth Century"; Norton, "Blurring the Boundaries".
20 Pedani, "Il Silenzio del Sultano".
21 '[...] qui est persona fida et docta et in curia Teucri pratica.', quot. in Pertusi, *La Caduta di Constantinopoli (Vol. 2): L'eco nel mondo*, p. 28.
22 Archivio di Stato di Venezia (ASVe), Senato, Secreti, 20, 9r; for the 1451 mission, see: Fleet, "Tax-Farming in the Early Ottoman State", p. 257; Pertusi, "La Caduta", p. 18; see also: ASVe, Senato, Secreti, 19, 203v-r [July 1453].
23 Caselli (ed), *Ad serenissimum principem et invictissimum regem Alphonsum Nocolai Sangundini Oratio*, pp. X–XII.
24 Burke, *The Greeks of Venice, 1498-1600. Immigration, Settlement, and Integration*.
25 Raby, "Mehmed the Conqueror's Greek Scriptorium", pp. 15–34; Akasoy, "Die Adaptation byzantinischen Wissens am Osmanenhof nach der Eroberung Konstantinopels", pp. 43–56.
26 Gilbert, "Humanism in Venice", p. 15.
27 Caselli, "Ad serenissimum", p. XVI.
28 King, *Venetian Humanism in the Age of Patrician Dominance*, pp. 81–82.
29 *Ibidem*.
30 Hankins, *Virtue Politics. Soulcraft and Statecraft in Renaissance Italy*.
31 Gaeta, "Giorgio da Trebisonda, le "Leggi" di Platone e la costituzione di Venezia".
32 Trebizond in a letter to his humanist patron the Venetian Francesco Barbaro, 1451, the letter is printed in: Quirini (ed.), *Francisci Barbari et aliorum ad ipsum epistulae*, p. 290.
33 Gaeta, "Venezia da "Stato misto" ad aristocrazia "esemplare"".
34 Sariyannis, "The Princely Virtues as Presented in Ottoman Political and Moral Literature".
35 Quot. from Lambton, *Theory and Practice in the Medieval Persian Government*, pp. 91–119. For a summary, see: Schabinger von Schowingen (ed. and trans.), *Siyāsatnāma: Gedanken und Geschichten*.
36 Akdoğan (ed.), *Ahmedi. Iskender-Name*, pp. 7147–7148.
37 Wickens, *The Nasirean ethics. Naṣīr al-Dīn Ṭūsī*, 212ff.
38 İnalcık, *Devlet-i Aliyye: Osmanli Imparatorlugu Üzerine Arastirmalar*, vol. 1, p. 239.
39 Raby, "Mehmed the Conqueror's Greek Scriptorium"; Mavroudi, "Translators from Greek into Arabic at the Court of Mehmet the Conqueror".
40 Kritovoulos, *History of Mehmed the Conquero*.
41 Monfasani (ed. and trans.), *George Amiroutzes. The Philosopher, or On Faith*; Ziaka, "Rearticulating a Christian-Muslim Understanding: Gennadios Scholarios and George Amiroutzes on Islam", *Studies in Church History*, 57 (2015).
42 ASVe, Senato, Secreti, 20, 3–4.
43 Gryphii, *Plutarchi Chaeronei, Philosophi, Historici Que Clarissimi Opuscula Moralia. Interpretibus N. Sagundino*, p. 89.

44 Trans. Philippides, *Mehmed II the Conqueror and the Fall of the Franco-Byzantine Levant to the Ottoman Turks: Some Western Views and Testimonies*, pp. 9–11; Iorga, *Notes et Extraits III (Paris: N.N., 1902)*, pp. 216–323; Pertusi, "La Caduta", pp. 126–141.
45 ASVe, Senato, Secreti, 21, 58.
46 Stefec, "Die Bibliothek des Angelo Vadio da Rimini".
47 A transcription of the Latin text can be found in Raby, "Pride and Prejudice: Mehmed the Conqueror and the Italian portrait medal".
48 Malipiero, "Annali veneti", p. 112.
49 Guérin-Dalle Mese (ed.), *Giovan Maria Angiolello, Il sultano e il profeta: memorie di uno schiavo vicentina divenuto tesoriere di Maometto II il Conquistator*.
50 Mese (1985), p. 103.
51 Necipoğlu, *Architecture, Ceremonial, and Power: The Topkapi Palace in the Fifteenth and Sixteenth Centuries*, p. 210.
52 'Fu huomo ingegnoso si dilettava di virtú, et haveva persone, che gli leggeva. Era crudelissimo, come si dirá a suo luogo; si dilettava de' giardini et haveva piacere di pitture et per questo serisse all'Illustrissima Signora che gli mandasse un pittore' quot. in Lecce, "Historia Turchesca", pp. 119–120.
53 This translation is taken from: Lawrence, "Muslim Engagement with Injustice and Violence", pp. 288–289.
54 Moynihan, *Paradise as a Garden: In Persia and Mughal India*.
55 Petruccioli (ed.), *Der islamische Garten: Architektur - Natur – Landschaft*.
56 Calis-Kural, "Three circular gardens in Venice and Constantinople/Istanbul in the context of early modern Mediterranean cross-cultural exchange", p. 161. The term is used here with Marshall G. S. Hodgson in his seminal *The Venture of Islam. Conscience and History in a World Civilization, Volume 1: The Classical Age of Islam*.
57 Moraitis, Kontolaimos, and Iliopoulou, "The Ottomans and the Greek Landscape: The Perception of Landscape in Greece by the Ottomans and Its Impact on the Architectural and Landscape Design", p. 3751.
58 Birnbaum, *The Book of Advice by King Kay Ka'us ibn Iskander: The Earliest Old Ottoman Turkish Version of His Kabusname*; and Sariyannis, "Ottoman Political Thought", pp. 49–54.
59 Trans. in Ferguson, "The Proper Order", p. 255.
60 Parens, *An Islamic Philosophy of Virtuous Religions: Introducing Alfarabi*; Sweeny, "Philosophy and Jihad: Al-Farabi on Compulsion to Happiness".
61 Quot. in Sariyannis, "Ottoman Political Thought", pp. 54–55.
62 *Ivi*, p. 59.
63 Côrte-Real and Oliveira, "From Alberti's virtù to the virtuoso Michelangelo. Questions on a Concept That Moved from Ethics to Aesthetics through Drawing".
64 Hayes, "Filarete's Journey to the East".
65 Restle, "Bauplanung und Baugesinnung unter Mehmet II. Filarete in Konstantinopel".
66 Hub, "Filarete and the East. The Renaissance of a Prisca Architecture".
67 King, "Venetian Humanism", p. 3.
68 Magoulias (ed. and trans.), *Doukas, Decline and Fall of Byzantium to the Ottoman Turks: An Annotated Translation of "Historia Turco-Byzantia"*, p. 25; Szill, "Herrschaftszeiten! Zum Diskurs über die Endlichkeit von Herrschaft am Beispiel der Einnahme Konstantinopels 1453 in den Geschichtswerken des Doukas und Kritobulos von Imbros".
69 Runciman, *The Fall of Constantinople 1453*, pp. 274–275
70 Kritovoulos, "History of Mehmed", pp. 82–83 and 93–93.
71 Kemal, *Tevârih-i Âl-i Osman VII Defter*, p. 96.
72 Balivet, *Byzantins et Ottomans: relations, interaction, succession*, pp. 181–195; Lobovikova, "George of Trebizond's Views on Islam and Their Eschatological Backgrounds".

73 This information possibly came from George Amiroutzes. See: Argyriou and Lagarrigue, "Georges Amiroutzes et son dialogue sur la foi au Christ tenu avec les sultans des Turcs". For George of Trebizond, see: Hankins, "George of Trebizond: A Renaissance Liberterian?".
74 Hankins, "George of Trebizond: A Renaissance Liberterian?", p. 93.
75 Gatward Cevizli, "Bellini, Bronze and Bombards: Sultan Mehmet II's Requests Reconsidered".
76 Nagy and Nyári, *Magyar diplomacziai emlékek Mátyás király korából: 1458-1490*, p. 77.
77 Babinger, *Johannes Darius (1414-1494). Sachverwalter Venedigs im Morgenland und sein Griechischer Umkreis*, p. 70.
78 The dispatchment note is in ASVe, Senato, Secreti, 28, 42.
79 Malipiero, "Annali Veneti", p. 136; Babinger, "Johannes Darius", pp. 72–73.
80 Tiepolo, "I Greci nella Cancelleria Veneziana: Giovanni Dario".
81 Calò (ed.), *Giovanni Dario. 22 Dispacci da Constantinopoli al doge Giovanni Mocenigo*, p. 24a; Jacobs, "Mehemmed II., der Eroberer, seine Beziehungen zur Renaissance und seine Büchersammlung", p. 18.
82 Bodnar, *Cyriac of Ancona: Later Travels*; Jacobs, "Cyriacus von Ancona und Mehemmed II", p. 200.
83 Zinkeisen, *Geschichte des Osmanischen Reiches in Europa. 2: Das Reich auf der Höhe seiner Entwicklung*, pp. 423–434.
84 Born et al. (eds.), *The Sultan's World: The Ottoman Orient in Renaissance Art*, pp. 65–76; Gordon (ed.), *Robes of Honour: khil'at in Pre-Colonial and Colonial India*.
85 Tekgül, "Ottoman Politics".
86 Quot. in Ferguson, "The Proper Order", p. 256.
87 *Ivi*, p. 76.
88 Yelçe, "Royal Wrath: Curbing the Anger of the Sultan".
89 Malipiero, "Annali Veneti", p. 122.
90 Isikel, "Hierarchy and Friendship: Ottoman Practices of Diplomatic Culture and Communication (1290-1600)", p. 291.
91 The painting is in Topkapı Palace Museum, H2153, 10r; it is printed in Necipoğlu, "Visual Cosmopolitanism".
92 Atasoy, *A Garden for the Sultan: Gardens and Flowers in the Ottoman Culture*, p. 126.
93 *Ivi*, p. 170.
94 Brumett, "Ottoman Ceremonial Rhetorics of Submission in the 16th and 17th Centuries".
95 Sowerby and Markiewicz, "Introduction: Constantinople as a Centre of Diplomatic Culture"; Colwell, "Friendship and Trust between Medieval Princes: Affective Strategies for Navigating Intercultural Difference across the Mediterranean".
96 Malipiero, "Annali Veneti", p. 123.
97 ASVe, Senato, Terra, 8, 58r.
98 Pedani Fabris, "La simbologia ottomana nell'opera di Gentile Bellini".
99 Rosemann, *Die Kirche San Zaccaria in Venedig*; see also: Goy, *Building Renaissance Venice: Patrons, Architects and Builders, c. 1430-1500*.
100 For the ritual, see: Muir, *Civic Ritual in Renaissance Venice*, p. 221ff.
101 Tiroler Landesarchiv Innsbruck, Kunstsachen, I, 65. I. '[…] preterea legalitate ac virtutis amplitudine gratiam Serenitas nostre inuenit benivolam & in omnibus liberalem & merito adhibuimus eum Militum Auratum ac Comitem palatinum deputare.'
102 Fortini Brown, *Venetian Narrative Painting in the Age of Carpaccio*.
103 ASVe, Notarile, Testamenti, not. Giacomo Grasolario, 1183, 248.
104 The document is quoted in Fortini Brown, *Venetian Narrative Painting in the Age of Carpaccio*, p. 282.
105 Fortini Brown, *Venetian Narrative Painting in the Age of Carpaccio*.

106 Leis, "Von Ränkeschmieden, Amtsdienern und Gehängten. Zum Raum und Bedeutung der Piazzetta in Venedig".
107 Malipiero, "Annali Veneti", p. 122.

Bibliography

Akasoy, Anna, "Die Adaptation byzantinischen Wissens am Osmanenhof nach der Eroberung Konstantinopels", in Carsten Kretschmann et al. (eds.), *Wissen in der Krise. Institutionen des Wissens im gesellschaftlichen Wandel* (Berlin: Akademie Verlag, 2004), pp. 43–56.

Akdoğan, Yaşar (ed.), *Ahmedi. Iskender-Name* (Istanbul: Kültür Eserleri, 2010).

Andrews, Walter G., "Ottoman Love: Preface to a Theory of Emotional Ecology", in Jonas Lillequist (ed.), *A History of Emotions, 1200–1800* (London: Routledge, 2012), pp. 21–48.

Argyriou, Asterios, and Lagarrigue, Georges, "Georges Amiroutzes et son dialogue sur la foi au Christ tenu avec les sultans des Turcs", *Byzantinische Forschungen*, 11 (1987), pp. 29–221.

Asutay-Effenberger, Neslihan, and Rehm, Ulrich (eds.), *Sultan Mehmet II. Eroberer Konstantinopels – Patron der Künste* (Köln: Böhlau, 2009).

Atasoy, Nurhan, *A Garden for the Sultan: Gardens and Flowers in the Ottoman Culture* (Turkey: Aygaz, 2002).

Babinger, Franz, *Johannes Darius (1414–1494). Sachverwalter Venedigs im Morgenland und sein Griechischer Umkreis* (München: Verlag der Bayrischen Akademie der Wissenschaften, 1961).

Balivet, Michel, *Byzantins et Ottomans: relations, interaction, succession* (Piscataway: Gorgias, 2011).

Barkey, Karen, *Empire of Difference. The Ottomans in Comparative Perspective* (Cambridge: Cambridge University Press, 2008).

Birnbaum, Eleazar, *The Book of Advice by King Kay Ka'us ibn Iskander: The Earliest Old Ottoman Turkish Version of His Kabusname* (Cambridge: MIT Press, 1981).

Bodnar, Edward, *Cyriac of Ancona: Later Travels* (Cambridge: Harvard University Press, 2003).

Born, Robert et al. (eds.), *The Sultan's World: The Ottoman Orient in Renaissance Art* (Berlin: Hatje Cantz, 2015).

Bozdoğan, Sibel, and Ülker Berke Copur (eds.), *Oriental-Occidental: Geography, Identity, Space*, Proceedings (June 15–19, 2001), (Washington, DC: ACSA Press, 2001).

Brumett, Palmira, "Ottoman Ceremonial Rhetorics of Submission in the 16th and 17th Centuries", in Türk Tarih Kurumu (ed.), *XIII. Türk. Tarih Kongresi* (Ankara: N. P., 1999), pp. 1741–1752.

Burke, E. C., *The Greeks of Venice, 1498–1600. Immigration, Settlement, and Integration* (Turnhout: Brepols, 2016).

Calis-Kural, B. Deniz, "Three Circular Gardens in Venice and Constantinople/Istanbul in the Context of Early Modern Mediterranean Cross-Cultural Exchange", *Studies in the History of Gardens & Designed Landscapes*, 38 (2018), pp. 158–179.

Calò, Giuseppe (ed.), *Giovanni Dario. 22 Dispacci da Constantinopoli al doge Giovanni Mocenigo* (Venice: Corbo e Fiore, 1992).

Caselli, Cristian (ed.), *Ad serenissimum principem et invictissimum regem Alphonsum Nocolai Sangundini Oratio* (Rome: Istituto Storico Italiano per il Medioevo, 2012), pp. X–XII.

Chong, Alan, "Gentile Bellini in Istanbul: Myths and Misunderstandings", in Alan Chong and Caroline Campbell (eds.), *Bellini and the East* (London: National Gallery, 2005), pp. 106–129.

Colwell, Tania M., "Friendship and Trust between Medieval Princes: Affective Strategies for Navigating Intercultural Difference across the Mediterranean", *Emotions: History, Culture, Society*, 4/2 (2020), pp. 348–373.

Côrte-Real, Eduardo and Oliveira, Susana, "From Alberti's virtù to the virtuoso Michelangelo. Questions on a Concept That Moved From Ethics to Aesthetics Through Drawing", *disegno*, 47 (2011), pp. 83–93.

da Lecce, Donado, *Historia Turchesca*, ed. Dr. I. Ursu (Bucharest: Editiunea Academiei Romane, 1910).

D'Amora, Rosita, "Emotion, Diplomacy and Gift Exchanging Practices in the Ottoman Context", *Cromohs*, 24 (2022), pp. 66–69.

Dursteler, Eric R., "On Renaissance Bazaars and Battlefields: Recent Scholarship on Mediterranean Cultural Contacts", *Journal of Early Modern History*, 15 (2011), pp. 413–434.

Fabris, Maria Pedani, "La simbologia ottomana nell'opera di Gentile Bellini", *Atti dell'Istituto Veneto di Lettere Scienze ed Arti*, 155/1 (1997), pp. 1–29.

Ferguson, Heather, *The Proper Order of Things. Language, Power, and Law in Ottoman Administrative Discourses* (Stanford: Stanford University Press, 2018).

Fleet, Kate, "Tax-Farming in the Early Ottoman State", *The Medieval History Journal*, 61 (2003), pp. 249–258.

Fortini Brown, Patricia, *Venetian Narrative Painting in the Age of Carpaccio* (New Haven, CT: Yale University Press, 1988).

Gaeta, Franco, "Giorgio da Trebisonda, le "Leggi" di Platone e la costituzione di Venezia", *Bullettino dell'Istituto storico per il Medioevo*, 82 (1970), pp. 479–501.

Gaeta, Franco, "Venezia da "Stato misto" ad aristocrazia "esemplare"", in Girolamo Arnaldi and Manlio Pastore Stocchi (eds.), *Dalla Controriforma alla fine della Repubblica. Il Seicento* (Vicenza: Neri Pozza, 1984), pp. 437–494.

Gatward Cevizli, Antonia, "Bellini, Bronze and Bombards: Sultan Mehmet II's Requests Reconsidered", *Renaissance Studies*, 28 (2014), pp. 748–765.

Gilbert, Felix, "Humanism in Venice", in Sergio Bertelli et al. (eds.), *Florence and Venice. Comparisons and Relations* (Florence: Nuova Italia, 1979), pp. 13–26.

Gordon, Stewart (ed.), *Robes of Honour: khil'at in Pre-Colonial and Colonial India* (Oxford: Oxford University Press, 2003).

Goy, Richard John, *Building Renaissance Venice: Patrons, Architects and Builders, c. 1430–1500* (New Haven, CT: Yale University Press, 2006).

Gryphii, S., *Plutarchi Chaeronei, Philosophi, Historici Que Clarissimi Opuscula Moralia. Interpretibus N. Sagundino* (Venice: Seb. Gryphium Lugduni, 1549).

Guérin-Dalle Mese, Jeannine (ed.), *Giovan Maria Angiolello, Il sultano e il profeta: memorie di uno schiavo vicentina divenuto tesoriere di Maometto II il Conquistatore* (Milan: Serra e Riva, 1985).

Hagen, Gottfried, "Legitimacy and World Order", in Maurus Reinkowski and Hakan Karateke (eds.), *Legitimizing the Order: Ottoman Rhetoric of State Power* (Leiden: Brill, 2005), pp. 55–83.

Hankins, James, "George of Trebizond: A Renaissance Libertarian?", in Alison Frazier and Patrick Nold (eds.), *Essays in Renaissance Thought and Letters. In Honor of John Monfasani* (Leiden: Brill, 2015), pp. 87–106.

Hankins, James, *Virtue Politics. Soulcraft and Statecraft in Renaissance Italy* (Cambridge, London: Harvard University Press, 2019).

Hayes, Kenneth, "Filarete's Journey to the East", in Sibel Bozdoğan and Ülker Berke Copur (eds.), *Oriental-Occidental: Geography, Identity, Space*, Proceedings (June 15–19, 2001), (Washington, DC: ACSA Press, 2001), pp. 168–171.

Hodgson, Marshall G. S., *The Venture of Islam. Conscience and History in a World Civilization, Volume 1: The Classical Age of Islam* (Chicago: University of Chicago Press, 1974).

Howard, Deborah, "Cultural Transfer between Venice and the Ottomans in the Fifteenth and Sixteenth Centuries", in Herman Roodenburg (ed.), *Cultural Exchange in Early Modern Europe, 1400 - 1700* (Cambridge: Cambridge University Press, 2007), pp. 138–177.

Hub, Berthold, "Filarete and the East. The Renaissance of a Prisca Architecture", *Journal of the Society of Architectural Historians*, 70/1 (2011), pp. 18–37.

İnalcık, Halil, *Devlet-i Aliyye: Osmanli Imparatorlugu Üzerine Arastirmalar, vol. 1* (Istanbul: Türkiye Is Bankasi Kültür Yayinlari, 2018).

Iorga, Nicolae, *Notes et Extraits III* (Paris: N.N., 1902).

Isikel, Güneş, "Hierarchy and Friendship: Ottoman Practices of Diplomatic Culture and Communication (1290–1600)", *The Medieval History Journal*, 22/2 (2019), pp. 278–297.

Jacobs, Emil, "Cyriacus von Ancona und Mehemmed II", *Byzantinische Zeitschrift*, 30/1 (1929), pp. 197–202.

Jacobs, Emil, "Mehemmed II., der Eroberer, seine Beziehungen zur Renaissance und seine Büchersammlung", *Oriens*, 2 (1949), pp. 6–29.

Kemal, İbn, *Tevârih-i Âl-i Osman VII Defter* (Ankara: Türk Tarih Kurumu Basimevi, 1991).

King, Margaret L., *Venetian Humanism in the Age of Patrician Dominance* (Princeton: Princeton University Press, 1986).

Kritovoulos, *History of Mehmed the Conqueror*, trans. Charles T. Riggs (Princeton: Princeton University Press, 1954).

Küçükhüseyin, Şevket, "The Ottoman Historical Section of Ahmedî's İskendernâme: An Alternative Reading in the Light of the Author's Personal Circumstances", in A. C. S. Peacock and Sara Nur Yıldız (eds.), *Islamic Literature and Intellectual Life in Fourteenth- and Fifteenth-Century Anatolia* (Würzburg: Ergon, 2016), pp. 285–311.

Lambton, Ann, *Theory and Practice in the Medieval Persian Government* (London: Variorum, 1980).

Lawrence, Bruce B., "Muslim Engagement with Injustice and Violence", in Ali Altaf Mian (ed.), *The Bruce B. Lawrence Reader. Islam beyond Borders* (Durham: Duke University Press, 2020).

Leis, Daniel, "Von Ränkeschmieden, Amtsdienern und Gehängten. Zum Raum und Bedeutung der Piazzetta in Venedig", in Anna Ananieva et al. (eds.), *Räume der Macht. Metamorphosen von Stadt und Garten im Europa der Frühen Neuzeit* (Bielefeld: Transcript, 2013), pp. 141–162.

Lobovikova, Ksenia, "George of Trebizond's Views on Islam and Their Eschatological Backgrounds", *Scrinium*, 6 (2010), pp. 346–365.

Magoulias, Harry J. (ed. and trans.), *Doukas, Decline and Fall of Byzantium to the Ottoman Turks: An Annotated Translation of "Historia Turco-Byzantia"* (Detroit: Wayne State University Press, 1975).

Malipiero, Domenico, *Annali veneti dell'anno 1457 al 1500* (Florence: Pietro Vieusseux (Archivio storico italiano, 7), 1843).

Mavroudi, Maria, 'Translators from Greek into Arabic at the Court of Mehmet the Conqueror", in Ayla Ödekan et al. (eds.), *The Byzantine Court: Source of Power and Culture* (Istanbul: Koç University Press, 2013), pp. 195–207.

Monfasani, John (ed. and trans.), *George Amiroutzes. The Philosopher, or On Faith* (Cambridge-London: Harvard University Press, 2021).

Moraitis, Konstantinos, Panagiotis Kontolaimos, and Filio Iliopoulou, "The Ottomans and the Greek Landscape: The Perception of Landscape in Greece by the Ottomans and Its Impact on the Architectural and Landscape Design", *Heritage*, 4 (2021), pp. 3749–3769.

Moynihan, Elizabeth B., *Paradise as a Garden: In Persia and Mughal India* (New York: Braziller, 1980).
Muir, Edward, *Civic Ritual in Renaissance Venice* (Princeton: Princeton University Press, 1981).
Nagy, Ivan and Albert Nyári, *Magyar diplomacziai emlékek Mátyás király korából: 1458–1490* (Budapest: Magyar Tudományos Akadémia Könyvkiadó Hivatala, 1875).
Necipoğlu, Gülrü, "Visual Cosmopolitanism and Creative Translation: Artistic Conversations with Renaissance Italy in Mehmed II's Constantinople", *Muqarnas*, 29 (2012), pp. 1–81.
Necipoğlu, Gülrü, *Architecture, Ceremonial, and Power: The Topkapi Palace in the Fifteenth and Sixteenth Centuries* (Cambridge: MIT Press, 1992).
Norton, Claire, "Blurring the Boundaries", in Claire Norton and Anne Contadini (eds.), *The Renaissance and the Ottoman World* (Farnham: Ashgate, 2013), pp. 3–22.
O'Connell, Monique, "Legitimating Venetian Expansion: Patricians and Secretaries in the Fifteenth Century", in Michael Knapton et al. (eds.), *Venice and the Veneto during the Renaissance: The Legacy of Benjamin Kohl* (Florence: Firenze University Press, 2014), pp. 71–87.
Parens, Joshua, *An Islamic Philosophy of Virtuous Religions: Introducing Alfarabi* (Albany: State University of New York Press, 2006).
Pedani, Maria Pia, "Il Silenzio del Sultano", in Antonella Ghersetti (ed.), *Il Potere della Parola. La Parola del Potere tra Europa e Mondo Arabo-Ottomano tra Medioevo ed Età Moderna* (Venice: Filippi Editore, 2008), pp. 99–112.
Pertusi, Agotino, *La Caduta di Constantinopoli (Vol. 2): L'eco nel mondo* (Milan: Mondadori Editore, 1976).
Petruccioli, Attilo (ed.), *Der islamische Garten: Architektur - Natur - Landschaft* (Stuttgart: DTV, 1995).
Philippides, Marios (ed. and trans.), *Mehmed II the Conqueror and the Fall of the Franco-Byzantine Levant to the Ottoman Turks: Some Western Views and Testimonies* (Tempe: ACMRS, 2007).
Quirini, Angelo Maria (ed.), *Francisci Barbari et aliorum ad ipsum epistulae* (Brescia: Rizzardi, 1743).
Raby, Julian, "Mehmed the Conqueror's Greek Scriptorium", *Dumbarton Oaks Papers*, 37 (1983), pp. 15–34.
Raby, Julian, "Pride and Prejudice: Mehmed the Conqueror and the Italian portrait medal", *Studies in the History of Art*, 21 (1987), pp. 171–194.
Reindl-Kiel, Hedda, "Ottoman Messages in Kind: Emotions and Diplomatic Gifts", *Cromohs*, 24 (2022), pp. 70–86.
Restle, Marcel, "Bauplanung und Baugesinnung unter Mehmet II. Filarete in Konstantinopel", *Pantheon*, 39 (1981), pp. 361–367.
Rodini, Elizabeth, *Gentile Bellini's Portrait of Sultan Mehmed II* (London: I. B. Tauris, 2020).
Rosemann, Andrea, *Die Kirche San Zaccaria in Venedig* (Unpublished PhD Dissertation, Technische Universität Berlin, 2001).
Rothman, E. Natalie, *Brokering Empire. Trans-Imperial Subjects between Venice and Istanbul* (Ithaca, NY: Cornell University Press, 2012).
Runciman, Steven, *The Fall of Constantinople 1453* (Cambridge: Cambridge University Press, 1990).Sariyannis, Marinos, "The Princely Virtues as Presented in Ottoman Political and Moral Literature", *Turcica*, 43 (2011), pp. 121–144.
Sariyannis, Marinos, *A History of Ottoman Political Thought up to the Nineteenth Century* (Leiden: Brill, 2019).

Sowerby, Tracey A., and Christopher Markiewicz, "Introduction: Constantinople as a Centre of Diplomatic Culture", in Tracey A. Sowerby (ed.), *Diplomatic Cultures at the Ottoman Court, c. 1500–1630* (London: Routledge, 2021), pp. 1–26.

Stefec, Stefan, "Die Bibliothek des Angelo Vadio da Rimini", *Römische Historische Mitteilungen*, 54 (2012), pp. 95–184.

Sweeny, Michael J., "Philosophy and Jihad: Al-Farabi on Compulsion to Happiness", *The Review of Metaphysics*, 60/3 (2007), pp. 543–572.

Szill, Rike, "Herrschaftszeiten! Zum Diskurs über die Endlichkeit von Herrschaft am Beispiel der Einnahme Konstantinopels 1453 in den Geschichtswerken des Doukas und Kritobulos von Imbros", in Julia Weitbrecht et al. (eds.), *Die Zeit der letzten Dinge: Deutungsmuster und Erzählformen des Umgangs mit Vergänglichkeit in Mittelalter und Früher Neuzeit* (Göttingen: Vandenhoeck & Ruprecht, 2020), pp. 267–286.

Tekgül, Nil, "Early Modern Ottoman Politics of Emotion: What Has Love Got to Do With it?", *Turkish Historical Review*, 10 (2019), pp. 132–154.

Tekgül, Nil, *Emotions in the Ottoman Empire* (London: Bloomsbury, 2023).

Tiepolo, Maria Francesca, "I Greci nella Cancelleria Veneziana: Giovanni Dario", in Maria Francesca Tiepolo and Eugenio Tonetti (eds.), *I greci a Venezia: atti del convegno internazionale di studio; Venezia, 5–7 novembre 1998* (Venezia: Istituto Veneto di scienze, lettere ed arti, 2002), pp. 257–314.

von Schowingen, Emil Schabinger (ed. and trans.), *Siyāsatnāma: Gedanken und Geschichten* (München: Alber, 1960).

Wickens, George M., *The Nasirean ethics. Naṣīr al-Dīn Ṭūsī* (London: Allen & Unwin, 1964).

Yelçe, N. Zeynep, "Royal Wrath: Curbing the Anger of the Sultan", in Karl A. E. Enenkel and Anita Traninger (eds.), *Discourses of Anger in the Early Modern Period* (Leiden: Brill, 2015), pp. 439–457.

Ziaka, Angeliki, "Rearticulating a Christian-Muslim Understanding: Gennadios Scholarios and George Amiroutzes on Islam", *Studies in Church History*, 57 (2015), pp. 150–165.

Zinkeisen, Johann Wilhelm, *Geschichte des Osmanischen Reiches in Europa. 2: Das Reich auf der Höhe seiner Entwicklung* (Hamburg: Perthes, 1954).

3 The geopolitics of simulacra and the seventeenth-century Venetian Holy House of Loreto

Liv Deborah Walberg

For decades, architectural and cultural historians have demonstrated that the Republic of Venice was particularly adept at strategically employing architecture, as Andrew Hopkins so succinctly stated in his overview on the subject, "to inscribe into history the memory of events," and, furthermore, that movement through architectural space allowed for the "recollection and replaying of historical memory."[1] Patricia Fortini Brown's magisterial study of Venice's relationship with her past demonstrates how builders, artists and scholars carefully crafted accretions of *spolia*, re-sourced and reworked sculptures, and reconceived mosaics, paintings, architectural models, and ancient chronicles to fabricate a collective memory of the ideal Venice that could resonate through the ages, like layer upon layer of nacre contributing to the luster of a precious pearl.[2] Most often, attention has been placed on the propagandistic aspects of the display – how Venice presented herself to the rest of the world through her scenographic self-aggrandizement. This chapter will consider how such a physical history might have elicited devout nationalistic sentiments in the people of Venice in times of distress by examining how history, devotion and heroic memory melded in the architecture and commemorative monuments of San Clemente in Isola, the location of the first simulacrum of the Holy House of Loreto constructed in Venice.

It is simple to read the signs from a distance of five centuries, but Venice had set herself up for ultimate conflict from the moment the republic determined she needed a *Stato da Mar* as a trading network across the Mediterranean. After the conquest of Constantinople in 1205, she was more than a republic – she was an empire, with holdings from Corfù and the Cyclades to Crete and Negroponte. But by extending her influence into the East, Venice had placed herself in a most vulnerable situation vis-à-vis the rising power of the Ottomans.[3]

Only one hundred and eighty years after the ignominious Latin conquest of Byzantium during the Fourth Crusade, the first hints of what would become a three-century-long, brutal, bloody, and ultimately lethal conflict emerged in 1396 when Sultan Bayazid I *Yıldırım* "the Lightning Bolt" led his army to a resounding victory over an allied Christian force at the Battle of Nicopolis on the banks of the Danube River. Venice, with its outposts spread down the Dalmatian coast and across the Mediterranean, was the Western *avant-garde* and stood in the direct path of any future Turkish incursions. Over the course of the next two centuries,

DOI: 10.4324/9781003358695-3

the Most Serene Republic waged war with the Ottoman Empire in an increasingly frantic and bitter conflict, almost never gaining the upper hand, losing bit by bit everything she had gained in the centuries of her ascendance as she was slowly and inexorably bled of her life and livelihood with each successive war.[4]

The preceding description may seem overly dramatic for an academic publication, but I have set up this scenario for a specific reason. It is extremely difficult for a twenty-first-century first-world Westerner to imagine what it might have been like to live in Venice in 1645, after two and a half centuries of almost constant conflict with a hostile trading partner – its people were of a different religion and a totally different culture, with social morays that were incomprehensible to the average Venetian, speaking a language with no cognates. And they wanted to conquer you. And everyone else. And nothing seemed to be able to stop them.

Imagine the psychological state of the majority of Venetians, who were perpetually barred from the closed government debates concerning the Turkish situation. Today the average citizen is instantly informed about developments in the Middle East or the Ukraine via public and social media. In the early modern period, communications could not inform the populace of impending danger or debunk wild rumors that might spread as the result of deliberate misinformation or espionage. Ignorance bred fear, paranoia, desperation, and hatred among the populace, most of whom had no dealings with the Ottomans and could not understand the intricacies of the negotiations required to maintain a fragile peace that necessitated repeated capitulations and concessions and could break down without warning at any moment.

Uncertainty, anxiety, and fear among Christians were compounded by the many publications, in both Latin and the vernacular, as well as broadsides, woodcuts and engravings, that illustrated the Turks and the inhuman atrocities for which they were so reviled. Constantinople fell to *Fatih* Mehmet II (the Conqueror) only a decade after the invention of moveable typeface. By the sixteenth century, dozens of books relating the history of the Ottoman's rise to power, the nature of their society and government, and biographies of their Sultans were circulating through Italy and the rest of Europe. Some publications were erudite, attempting to document the true nature of the menace in order to better understand the enemy, but many were sheer fabrications operating as propaganda to bolster the war efforts.[5] This was the state of affairs in Venice in 1645 when, through no fault of her own, the republic found herself defending her last major holding in the Mediterranean, the island of Crete, from the naval forces of Sultan İbrahim I – a defense that once mounted would last twenty-eight-long and grueling years. As with every preceding war between the Ottomans and the West, it was viewed as a *jihad* by the antagonists and, from an ideological standpoint, as a crusade by the defendants.

In the Most Catholic Republic of Venice, the protection of the Virgin Mary had always been of paramount importance to her people. The city's very foundations rested on the day of the Annunciation; thus, the Mother of God was second only to St. Mark himself as guardian of the State. Miraculous images of the *Theotokos* proliferated throughout the city, but one manifestation of the Virgin became particularly important to Venetians in the third quarter of the sixteenth century – that

of the Madonna and her Holy House of Loreto. Founded in 1296, the sanctuary of the Lauretan Virgin was situated on the Adriatic coast south of Ancona.[6] In its fully developed hagiography, angels had flown the house in which the Annunciation had taken place and Jesus had lived as a child, from Palestine to Trsat (near modern-day Rijeka, Croatia) in order to protect it from the Mamluk infidels who had conquered the area. After a short stay in Croatia and other three relocations by its angelic porters, the *Santa Casa* found its permanent home on a high hill near the town of Recanati in the Italian Marche.[7]

Given the number of aerial translations the little domicile made across the Mediterranean and Adriatic and its angelic rescue from Islam, it is hardly surprising that the Madonna of Loreto would become the protector of seamen and those battling the infidel.[8] A painting of the Madonna and Child within the Holy House was replaced in the fourteenth century by a small statue carved of cypress wood that was itself deemed miraculous, placing the Holy House in a unique position as a pilgrimage destination. It was now both a relic and a reliquary. The sanctuary ascended from regional to international pilgrimage destination at the end of the fifteenth century due to a succession of popes who showered money, art and architectural patronage, and perpetual plenary indulgences upon the little building, beginning with Paul II and culminating with Sixtus V.[9] In 1507, Pope Julius II brought the sanctuary under the aegis of the papacy, which inadvertently politicized the location in a manner that would profoundly impact Venice's future relations with the sanctuary.[10]

Due to its location on the southern coast of the Adriatic and the richness of its treasury, Loreto was prone to attacks from land armies and marauding Turkish fleets. As early as 1439, the Bishop of Recanati was forced to send the nascent treasury to Venice to keep Francesco Sforza's army from pillaging it, and in 1480, the collection of liturgical furnishings and paraments had to be stored in the tower of the communal palace in Recanati to protect it from ravaging Turkish corsairs.[11] But the sanctuary was never defiled, and as a result, the Madonna of Loreto became a defender of the Christian faith against the Turks. Legends arose regarding the salvation of devotees from Turkish cruelty.[12] Freed Christian slaves brought their chains to the sanctuary as votive offerings in her honor, and captains of ships saved from Turkish destruction sent models of their galleys to hang within the Holy House.[13] The oldest Marian pilgrimage destination in Christianity had become a sanctuary of protection against Ottoman aggression. But, by the end of the fifteenth century, she was also widely esteemed as a plague saint, and after the miraculous birth of Louis XIII of France's heir in 1638, she became the guardian of dynastic succession for many of the ruling houses of Europe.[14]

The Madonna of Loreto's powerful allure never marginalized the importance of the crude little domicile in which she resided. Part of the attraction provided by pilgrimage to Loreto was the profound spiritual emotions elicited by close physical proximity to the actual spot in which the Annunciation had taken place and, more importantly, where the Incarnation of Christ had occurred. Simulacra of the Holy House began to appear in Europe as early as 1517, and in fact during the Counter Reformation, the replicas, constructed from Naples to France and Poland as well as throughout the Balkans, were closely identified with the Roman Catholic

battle against both Protestant and Islamic heresy.[15] The sanctuary's history, its hagiography and miracles, as well as instructions on the best manner in which to make pilgrimage to the holy site, had been rapidly transmitted throughout Europe by the power of print. Before long, descriptions of the *Santa Casa* emerged with enough detail to allow for the possibility of copies. These simulacra offered those who could not make the long and often dangerous journey to Loreto an opportunity to experience a spiritual journey to the Holy Land. With the rise in popularity of the *sacre monti*, the concept of visiting a reproduction of a holy site became ever more popular, and replicas of the Holy House of Loreto proliferated, particularly in regions threatened by Ottoman incursions. A simulacrum should have been the perfect focal point for national piety in the epicenter of the shrinking Venetian empire, but construction of the first simulacrum in Venice would not commence until the mid-seventeenth century.

For Venetians before the 1570s, the Madonna of Loreto was primarily the *Stella Maris*, the Star of the Sea, protecting mariners on their trading and military excursions in the Mediterranean.[16] Her role as Guardian of the West against the Turk came into clear focus for Venice on her feast day of 7 October 1571 (also that of Santa Giustina), when a coalition navy led by the papal admiral Marcantonio Colonna, the Venetian commander Sebastiano Venier, and Spain's Don Juan of Austria decisively routed the entire Ottoman fleet off the Western coast of Greece in the bay of Lepanto. Upon receiving news of the victory – the first genuine defeat of the Turks in decades – Pope Pius V declared the Madonna of Loreto the "Madonna of Victory" and the protectress of Christianity against the infidel.[17]

Hoping to capitalize on the swell of patriotic sentiment and sheer joy over the miraculous victory against a virtually invincible foe, the Venetian government attempted to inspire its citizens in as many ways as possible – from grand celebrations and the foundation of an annual ducal procession to the church of Santa Giustina on the anniversary of the victory, to printed and painted exaltations of the heroics of that day.[18] In his 1571 funeral oration for the men lost in the Battle of Lepanto, the senator Paolo Paruta suggested that monuments be erected in all the squares of the city to honor the heroes in order to offer future generations a constant stimulus to achieve similar feats.[19] The suggestion was almost certainly rhetorical – Paruta knew well that public monuments to individuals in Venice were virtually anathema to the Grand Council and its stance on *mediocritas* among the ruling class, however fictitious that ideal might have been at that point in the republic's history. But the proposal certainly had psychological and emotional values, and our case study of San Clemente was not the first instance of religious nationalism turned to war commemoration seen in the aftermath of Ottoman conflicts. A precursor may be found in the construction of a chapel closely associated with the Battle of Lepanto and the funeral monument of a martyred Venetian general in the Dominican church of Santi Giovanni e Paolo.

Three years after proclaiming the Madonna of Loreto the Guardian of Christianity against the Ottomans, Pope Pius V determined to transfer that role to a Virgin who represented a far more widely disseminated cult – the Madonna of the Rosary. This shift appears to have been only partially successful in Venice,

regardless of the widespread devotion to the Rosary present in the city. In addition to the military devotion to the Virgin of Loreto outlined later in this chapter, at least two altars dedicated to the Madonna of Loreto were founded in the city as a direct result of Venetian victories over the Turks. The first was an altar in the church of Santa Giustina, to which the doge processed every year on the anniversary of the Battle of Lepanto to give thanks for the victory. It was founded sometime before 1600.[20] Then, in June of 1656, news arrived that the Venetian fleet had successfully defeated the Ottomans in the Dardanelles and had now blocked the straits. The *Capitan General da Mar* Lorenzo Marcello had lost his life in the battle, providing yet another war hero to glorify, but this was the greatest Christian victory over the Turks since Lepanto eighty-five years earlier. A jubilant crowd removed a statuette of the Madonna of Loreto from its street shrine and carried it to the church of San Giacomo dall'Orio, where it was placed upon an altar and venerated for decades afterward. The altar was rededicated to the Madonna of Loreto, and a confraternity was founded in her honor in 1658. By the eighteenth century, the altar had been rededicated – to the Madonna of the Rosary.[21] The blending of these two cults is a phenomenon that should be examined in further detail but lies beyond the scope of this study. Nevertheless, seventeenth-century wills have even referred to the "Madonna di Loreto del Rosario" at Santi Giovanni e Paolo.[22]

This "Madonna di Loreto del Rosario" was the Madonna della Vittoria promulgated by Pius V. Shortly after the victory at Lepanto, permission was given to form a confraternity of the Rosary at the Dominican church, and in 1582, the pious organization was granted land and a chapel off the north transept. The space was completely reorganized and redecorated by the sculptor Alessandro Vittoria, assisted by a host of other talents. Work commenced that year and was functionally complete fifteen years later. In addition to the religious works that decorated its walls and soffit, paintings glorifying and commemorating the victory at Lepanto, its commanders, the fallen Christians, and the Dominican Order's role in the victory ornamented its side walls.[23]

As the work on the Chapel of the Rosary drew to a close, a decision was made that would ultimately transform the space into a far greater emotional commemoration of war, victory, and self-sacrifice. Two months before the Battle of Lepanto, the island of Cyprus was lost to the Ottomans. In the wake of a five-week summer siege, the Turks executed the Venetian commanding officers, most beheaded. But the general of the Venetian forces, Marcantonio Bragadin, was reserved for a brutal martyrdom that even by Ottoman standards was unusually cruel. He was flayed alive. News of his death, and his heroic silence as the knives peeled the flesh from his head, arms, and torso, rocked the Christian world. Bragadin had died without making a sound before the butchers reached his waist. His skin was stuffed with straw and paraded through the streets of Famagusta before being sent to Constantinople as a war trophy.[24]

In 1580, a Venetian sailor managed to smuggle back to Venice the general's preserved skin from the Arsenal in Constantinople. The family had the remains interred in a column in their home parish of San Gregorio, marking the site with an inscribed epitaph plaque. Sixteen years later, as construction and embellishment

58 Liv Deborah Walberg

of the Chapel of the Rosary drew to a close, the Bragadin gave permission for the remains to be moved to a new wall monument on the south nave wall of Santi Giovanni e Paolo, exhuming Marcantonio from his private, family tomb and placing him into a public *memento mori*.[25] The patriot's remains were reverently sealed in a large urn surmounted by his portrait bust, and a depiction of his gruesome death was painted behind the monument in verdigris monochrome, between grisaille figures of Faith and Fortitude. He had been a national martyr; now, he had become a secular saint.

Bragadin's interment in Santi Giovanni e Paolo, just as the Chapel of the "Madonna della Vittoria" was completed, gave a powerful emotional jolt to the experience of entering the church and praying the Rosary in the chapel. The Battle of Lepanto had been a partial attempt to vindicate Bragadin's death and the loss of Cyprus. Now, the great hero's relics were interred only a dozen yards away from the chapel dedicated to the victory that had avenged his martyrdom.

But why was he not buried in the chapel itself? It is an intriguing question, but in this case, perhaps overly simple to answer. Emotion, particularly grief, may be expressed in many ways. The Venetian mode tended always towards reserve. Anger was a justifiable emotion in the right circumstances, but grief must remain noble, controlled, and contained.[26] A person entering the basilica of Santi Giovanni e Paolo to pray in the Chapel of the Rosary would have first been confronted by the stark but poignant *memento mori* commemorating the war hero. A surge of internal emotion might have ensued as one considered the agony of that death and Venice's loss. Then the devotee would have had a few moments for the emotion to pass, as they moved silently into the chapel to kneel among the paintings before the enthroned Virgin and Child dressed in their sumptuous silks and covered with gems, and would have prayed the Rosary for the war dead in the hopes that no one else should ever be required to die in such a manner and that Venice would prevail in its conflict against the enemy.

The Chapel of the Rosary and Marcantonio Bragadin's funeral monument formed part of an enormous collection of ducal tombs, funerary monuments to senators and ambassadors, equestrian monuments to *condottieri*, and art works dedicated to Dominican saints. As has been pointed out, it served as a pantheon for great Venetians. The situation at San Clemente was far different. This was a small church, distant from the urban fabric of the bustling city. It offered the opportunity of a sort of pilgrimage experience, as one's gondola was rowed silently across the lagoon towards the recreation of a holy site in Palestine. San Clemente boasted the first Venetian simulacrum of the Holy House in Loreto, and the original intention was certainly to augment the cult of that Blessed Virgin in Venice.

However, Venice's first replica of the Holy House was built, not in thanks for a naval victory, but as the result of a plague vow. The Patriarchal Vicar Francesco Lazzaroni had been first priest in the parish of Sant'Angelo and served as a canon under Patriarch Giovanni Tiepolo during the devastating plague of 1630–1631. He had sworn to make pilgrimage to the sanctuary of Loreto should he survive the epidemic, but he suffered from chronic gout that kept him regularly incapacitated, and a decade later he still had not fulfilled his vow.[27] Recognizing the probability

that he would never be healthy enough to travel, Lazzaroni determined to build a simulacrum of the Holy House in Venice. The pious act would serve two purposes – it would fulfill his pledge to the Blessed Virgin of Loreto, and it could augment devotion to her cult in the Virgin city.[28]

Lazzaroni cast about for an appropriate church in which to construct his replica, thinking first to build it in his home parish of Sant'Angelo. But the building was too small to contain the simulacrum, whose dimensions were required to be identical to those of its archetype. As an expedient, in 1642, he founded an altar in the church dedicated to the Madonna of Loreto and the Archangel Michael, then commissioned a copy of the Lauretan statue carved in cypress wood to place upon it.[29]

By 1643, Lazzaroni had found his site – the church of San Clemente, situated on a small island between the Giudecca and the Lido, not far from the island of Santa Maria delle Grazie. The church formed part of a complex which by the twelfth century had become a hostel for pilgrims destined for the Holy Land. It had passed into the hands of the Lateran Canons of Santa Maria della Carità in the late fifteenth century. In an accord ratified on 11 September 1643, the canons gave Lazzaroni permission to build his replica of the Holy House in the church (at his own expense).[30] The canons had rebuilt the edifice upon taking possession of the island; thus, it possessed a proto-Renaissance façade completed in the 1480s.[31] The statue of the Madonna of Loreto at Sant'Angelo was subsequently transferred to the Carità in anticipation of the grand translation to her final home upon its completion.

At the same time, another actor mounted the stage – vested in the pure white robes of the Camaldolese Hermits of Rua. The Camaldolese had one hermitage (more properly a monastery) in Venice on the island of San Michele in Isola, and in fact this group of hermits formed its own branch of the order allied to, but jurisdictionally separate from the hermitages of Monte Corona (near Verona) and Rua, the Mother House. The fathers of Monte Corona wished to expand into the lagoon, requiring a space to build approximately fifteen hermit cells, land to farm, and a church. They were aided in their search by Andrea Mocenigo, a Venetian patrician brother in the Camaldolese hermitage in Padua, who acted as intermediary between the Camaldolese prior at Monte Corona and Prior Giacomo Antonio Corner of the Carità.[32] The cost of the island was prohibitive for such a small order, and a wealthy Venetian *cittadino* wool merchant and cloth dyer, Agostino Correggio, fronted the asking price of 6,000 ducats with the guarantee of repayment within ten years. The contract transferring the island to the Hermits of Rua was concluded on 5 October 1645.[33]

By this point, however, Francesco Lazzaroni had completed his replica of the *Santa Casa*, so, on 7 October 1646, the grand flotilla that escorted the gilded cypress statue of the Madonna of Loreto to San Clemente was accompanied by fireworks, artillery blasts, gondolas, and *peote* filled with dignitaries, the Venetian patriarch, bishops and clergy, and the Canons Regular of Santa Maria della Carità together with the Camaldolese Hermits of Rua. A Camaldolese observer commented that, were the Turks to have seen such a victorious marine procession, they would have fled in terror.[34] After the jubilant translation, the hermits took final possession of their island and their new charge – the freshly constructed simulacrum of the Holy House, symbol of that most potent guardian against the menace of Ottoman Islam.

It is ironic that in the same year the Holy House was raised in Venice, the *Kapudan Paşa* Silahar Yusuf Paşa, admiral of the Ottoman fleet, launched the campaign that would ultimately deprive the *Serenissima* of its last major Mediterranean holding. The Venetians had maintained a carefully guarded, cautious peace with the Ottoman Empire in the seventy years since they had sued for peace in the aftermath of the Battle of Lepanto, notwithstanding almost constant skirmishes, naval confrontations, and desperate attempts to prevent escalation into full-scale war. Venice preferred peace with the Ottomans since she traded with the Sublime Porte, much to the disgust of the Papacy and more conservative powers like Spain. Yet the political instability in Constantinople would not allow for a permanent settlement. When a Maltese ship attacked an Ottoman galley escorting high-ranking pilgrims to Alexandria for the *hajj* and killed the majority, the pro-war faction at the Ottoman court accused Venice of collusion, and Sultan Murad IV launched the fleet in order to wrest Crete from the republic. Within three campaign seasons, the Turks had captured all the smaller cities on the island and the hinterland, leaving only the capital city of Candia (modern-day Heraklion) in Venetian hands.

Unless one has actually studied the history of the Fifth Venetian-Ottoman War, it is difficult to understand how such a conflict could have been so protracted, when the Ottoman forces had taken control of over ninety percent of the island at its outset. This was to be a naval campaign, with opposing fleets battling to prevent supplies from reaching each other. Each side was waging war far from home – if the supply chain could be cut, the enemy could be weakened to the point of defeat. For the Venetians, the key was to blockade the Dardanelle Straits south of the Sea of Marmara. For the Turks, it meant hunting down Venetian ships whenever they could trap them in the Adriatic or along the coast of Greece. The war played out as a huge, costly, aqueous chess match spanning a quarter of a century. Despite their naval superiority, Venice never had the necessary ships to completely blockade Constantinople and protect herself as well, while the Turks were hampered by domestic turmoil. The final siege of Candia did not commence until the winter of 1666/1667, and after the twenty-eight most brutal months of the war, the keys of the city were ultimately handed to the Ottoman commander, Gazi Hüseyin Paşa, on 5 September 1669. In the end, both powers were bled of manpower, military infrastructure, and financial capital to the point that neither could ever again consider themselves European powers. Crete would be the Ottoman Empire's last permanent acquisition before its dissolution in 1923, and though Venice mounted two more campaigns against the Turk in the last quarter of the seventeenth century, she was incapable of retaining the few lands she won back before the Treaty of Passarowitz definitively concluded hostilities in 1719.

One could posit that the construction of the San Clemente Holy House was serendipitous, given the bellicose turn of events that year. In fact, a look at the records of donations to the church of San Clemente for the first five years after the hermits took control of the island shows that Venetians did demonstrate a certain devotion to the simulacrum and its Madonna. Notably, they were all non-nobles requesting masses in their wills, offering anywhere from five hundred to a thousand ducats as investments for perpetual masses.[35] But they are hardly more than a handful, certainly not an indication of a vibrant cult presence in the lagoon. This must certainly

be due to the absence of any significant indulgences granted to the Holy House and its altar of the *Annunciata*, and this absence of plenary indulgences would remain the norm throughout the balance of the Venetian republican period.[36]

Leaving aside the issue of indulgences, one can offer another compelling explanation for the inability of the hermits' simulacrum to foster a vibrant local following. If one examines the funerary monuments erected after the construction of the first Holy House in the church and surveys some of the most important bequests for penitential masses in the ensuing decades, a pattern emerges. San Clemente quickly evolved from a monastic church containing a precious relic worthy of veneration – in the tradition of the great Romanesque foundations along the Camino de Santiago – to a war memorial integrally linked to the battle for Candia and the profound emotions that lengthy conflict elicited. The Holy House within the church of San Clemente required the geopolitics of war to elicit an intense response worthy of votive offerings, donations, or pious reverence. It operated as one element in the visual and spatial consortium of funeral monuments, religious art, liturgical space, and holy replica that the Camaldolese church of San Clemente in Isola ultimately became.

This transformation commenced barely two years after the Camaldolese assumed possession of the island and its church. On 9 July 1647, the hermitage chapter met to deliberate a request from Bernardo *quondam* Francesco Morosini of the *della Sbarra* branch of the great patrician clan. Bernardo requested that the hermits receive his brother Tommaso's body, recently returned from the Aegean, and place it in a temporary tomb until the family decided on a permanent sepulchre.[37]

This was a huge honor. Tommaso, the second son of Francesco Morosini,[38] was a naval martyr. In January of that year, his galley found itself alone in the midst of a fleet of forty-five enemy ships within sight of the city of Negroponte (Euboea, Greece). He and his men single-handedly fought off the Turkish galleys, causing significant casualties and destruction – including the death of the *Kapudan Paşa* Koca Musa Paşa. But Tommaso was killed before the ship could be rescued by the arrival of the Venetian fleet under its new *Capitan General da Mar* Giovanni Battista Grimani. Despite Tommaso's demise, the battle had been an enormous blow to Ottoman morale, with corresponding jubilation resounding throughout the *Serenissima*.[39]

Several possible explanations may explain Bernardo's choice of San Clemente as the final resting place for his brother. Obviously, the Madonna of Loreto's connection to Christian victory over the Ottomans and her longstanding recognition as a premiere protectress of those who are in danger on the seas would be the most obvious. Martin Gaier points out that San Clemente's location in the lagoon, close to Venice but with a clear view of the open Adriatic, might have appealed to the dead naval commander's brother.[40] And finally, the third surviving brother, Paolo, happened to be a Camaldolese hermit.[41]

When the family returned to discuss the war hero's monument in 1651, Bernardo proposed that he be allowed to raise final tributes on the façade of the church not only to his brother but to his father as well. Francesco *quondam* Francesco Morosini had also died in the service of the State, in a naval skirmish off the coast of Corfù in February of 1618mv (1619), when Bernardo was ten years old. Francesco's feats

were nothing in comparison with those of his dead son, but he had served as *Provveditore* of Crete immediately after his older brother's tenure in the office, during the escalation of hostilities over the island long before the war broke out. At the distance of thirty years, Bernardo now wished to honor his father (whose body had never been recovered) as well as his brother. The hermits were not pleased with the idea of converting the front of their church into a secular monument to two dead war heroes. Unlike other churches who relinquished *juspatronatus* of a façade to a family in order to complete the exterior of the edifice, the church of San Clemente had a perfectly fine, white façade adorned with a statuette of the Madonna and Child and appropriate inscriptions. The monastery voted down the proposal.[42]

Morosini returned with a second proposal in July of 1652, this time suggesting that a pair of religious statues be added to the programme, and on the thirty-first of that month, the Camaldolese hermits voted to allow Bernardo Morosini the right to renovate their façade with funerary monuments to his dead kin.[43] On 11 November 1653, the contract between Morosini and the stonecutter Andrea Cominelli was drawn up for the work, which was to be completed in ten months. Cominelli was to be paid 840 ducats, half in coin and the other half in flour and wine.[44]

Nearly sixteen months passed between the time Morosini received permission to rework San Clemente's façade and the contract for its completion. Though one must find a willing artisan and workshop, have a design worked up and agree upon an initial estimate before signing a contract, sixteen months seems a long interval, especially after waiting four years beyond the return of Tommaso's remains to receive permission to proceed. Although it was not unheard of for deceased members of a family to remain *in deposito ad infinitum*, most often the reason was lack of funds. And in fact, Bernardo faced that very issue. Though it is also not uncommon to pay workmen in kind, to offer half a ten-month contract in flour and wine when Cominelli would be responsible for purchasing all the materiel for the commission is a bit parsimonious. There remains virtually no documentation for the *tagliapiera* Andrea Cominelli – either he died before attaining a level of popularity and prosperity that might have afforded him greater visibility in the records, or he was in the lower ranks of the stonecutter's guild and took the job out of necessity.[45] To wit, Bernardo Morosini could not afford a first-tier stonecutter for his commission. And yet, the funeral monuments in the façade at San Clemente display innovations hitherto unseen in commemorative memorials.

The façade of San Clemente had been constructed in the style of the Lombardo family during radical renovations to the church in the 1480s[46] (Figure 3.1). It was already clearly divided into three registers, with a lunette over the portal, the traditional large tympanum crowning the height of the façade and two half tympana on either side, much along the same lines as Mauro Codussi's façade for San Clemente's sister church of San Michele in Isola.[47] Two roundels adorned the half tympana, and a fifteenth-century half-length statue of the Virgin and Child was placed in the lunette over the door. The entire façade was plastered brick and Istrian limestone, except for the highest architrave, which had been constructed of rosso di Verona. Cominelli was commissioned to carve an epitaph plaque for each dead hero to place in the lowest register, above which he would set, within a split tympanum, a bust of Francesco on the left side of the façade[48] and that of Tommaso

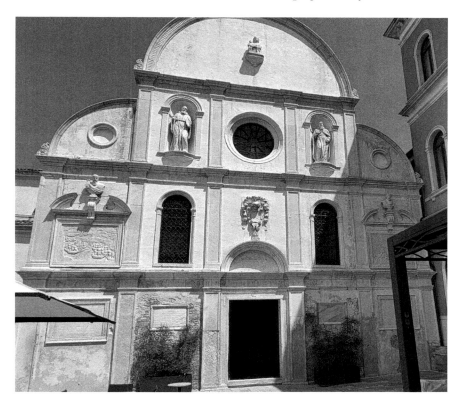

Figure 3.1 Façade of the church of San Clemente in Isola, architecture by the Lombardo family, 1483–1488; Niches, inscriptions, bas reliefs, and sculptures by Andrea Cominelli, 1651–1652. Francesco Morosini's monument at left; Tommaso Morosini's monument at right. Photograph by the author.

on the right.[49, 50] As Gaier points out, this is where the design shows its originality.[51] For the first time, rather than placing the busts above a sarcophagus or an epitaph, Cominelli situated a framed bas relief of the naval battle in which they died beneath each man's likeness. Above them, in niches in the third register, were full-length statues of Saints Benedict and Romuald carved from yellow Custoza stone. In the roundels to either side, he placed gilded stars. A high relief carving in the same yellow Custoza of two angels bearing aloft the Holy House of Loreto adorned the main tympanum. The half-length statue of the Virgin and Child was given a gilded papal tiara and moved to a position above the Holy House in the tympanum relief in order to make way for a sculpted and gilded escutcheon of the Morosini arms over the portal. Bernardo's donor inscription replaced the Madonna in the lunette over the door. A gilded iron cross was to be placed at the top of the tympanum arc. Finally, just to either side of the portal were smaller inscription plaques pertaining to the Camaldolese and their custody of the church and simulacrum.

The façade no longer reflects its original design. Sadly, what would have been the largest single element in the ensemble, the flight of the Holy House, is now lost,

along with the gilded stars. The Madonna no longer wears the papal triregnum still evident in the photo featured in the Ranucci/Tenenti study and has been moved down to a central location in the empty lunette.[52] All traces of gilding on the façade have long since vanished. But the military funeral monuments survive intact and give a clear idea of the powerful message imparted to Venetians visiting the church in the years between 1653 and 1797. By placing the epitaphs extolling the deeds of the Morosini at eye level, an educated Venetian would have been able to read and appreciate the sacrifices each man made for his country. Moving upward, the bas relief battle scenes perfectly illustrate in visual terms those same sacrifices, capped by solemn busts of the patrician father and son. Lifting one's eye higher, above the founders of the Camaldolese Order and the rule they followed, a believer could not help but feel the overarching protection of the Madonna of Loreto, seated on her *Santa Casa*, soaring above the Morosini who had given their lives to protect their country.

The irony, of course, is that they died. But when one thinks back to the painted programme of the Chapel of the Rosary at Santi Giovanni e Paolo, the concept of death and victory is called to mind. In that programme, one side of the chapel stressed the fragility of life and the inevitability of death, while the other glorified the triumph of eternal life over death.[53] Taken from the Ottoman point of view, Tommaso and his father could be likened to *gazi* – soldiers who died as martyrs for the faith and for their country. Early modern Christians considered the Madonna of Loreto to be a protection, not necessarily against the terrors of this life but against those of the next.

Less than four years later, another patrician with connections to the conflict in the Mediterranean requested burial in the church, and again, it was a member of an impoverished branch of an ancient noble family. Born in August of 1597, Gerolamo *quondam* Giovanni Giacomo Gradenigo came from a lesser branch of one of the "apostolic" noble families in the Grand Council. However, his father worked as best he could to promote his sons in the diplomatic corps, and Gerolamo and his brother Marco quickly found themselves serving abroad. After his election as Duke of Candia in 1627, Marco was named Coadjutor Patriarch of Aquileia with rights to succession in 1629 by his distant relative, the Patriarch Agostino Gradenigo – a phenomenal coup for a man of limited means. He became patriarch in 1633 and served until his death in 1656.[54]

Meanwhile Gerolamo had been earmarked from the outset for ecclesiastical posts and had been named *primicerio* – head of the church of San Marco in Candia, the parallel post to that of *primicerio* of San Marco in Venice. In 1645, his brother named him Coadjutor Patriarch (effectively removing him from the dangers of the Cretan War). At the same time, he was elected Titular Bishop of Madauros (in modern-day Algeria) and was ordained in the Cathedral of Torcello by the bishop Marcantonio Martinengo in September of 1646. In July of 1654, he was elected the Titular Bishop of Famagusta, that sorry city whose very name recalled the excruciating martyrdom of Marcantonio Bragadin. Upon his brother's death in early 1656, Gerolamo became Patriarch of Aquileia and was installed in the cathedral of Udine on 16 February. But, due to conflicts with the Holy Roman Empire, he was never able to take up his seat, or even visit his diocese before his death in Venice on 19 December 1657.[55]

Gradenigo asked to be buried in San Clemente and was specific about where his tomb and funeral monument were to be located (Figure 3.2).

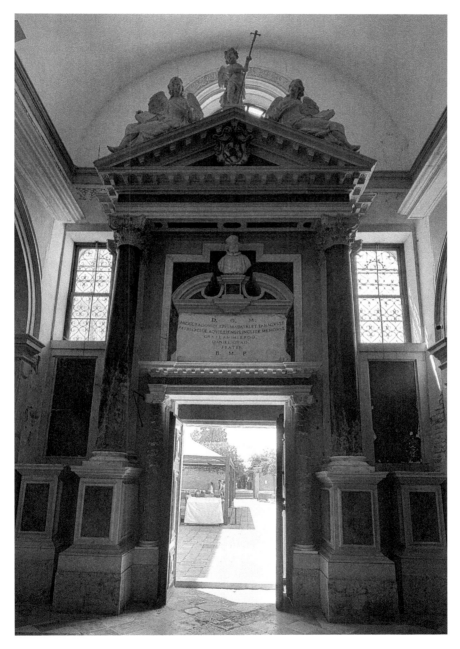

Figure 3.2 Funeral monument of Gerolamo Gradenigo, Patriarch of Aquileia, c. 1658–1660. Photograph by the author.

He wished to be buried in the center of the nave and wanted his memorial above the portal on the contrafaçade so that every person leaving the church would pass beneath his memorial. Three thousand ducats were to be spent on its construction, and a black velvet pall with the Gradenigo arms was to cover his tombstone on the anniversary of his death. His brother Daniele was responsible for the execution of the monument and the arrangements for his perpetual masses.[56]

After the heroics of the Morosini *della Sbarra* clan, Gradenigo's history seems rather pallid. But he opted not to be buried with the rest of his family, preferring a tomb and monument within the confines of the church containing the Holy House. He had spent a number of years in Crete ministering to its Roman Catholic flock as hostilities escalated and had served as the titular bishop of the city that had witnessed the greatest atrocity of the Fourth Venetian-Ottoman War. Perhaps he was a bit vain to spend three thousand ducats on a funeral monument when he served as patriarch less than two years, but his choice of final resting place points to a need to be associated with the Madonna of Loreto and her Holy House, and the cultural memories associated with them.

Only three years after Gradenigo's death, another tectonic shift took place in the arrangement of the interior of the church. In their pastoral visit to San Clemente in June of 1662, the Provincial Visitors of the Camaldolese Order announced that the Santa Casa was in an awkward position in the church and needed to be moved "eight or nine feet" further into the nave towards the choir.[57] It is difficult to imagine the logistics of such a relocation. This required nearly doubling the size of the church, and the Holy House had to be rebuilt upon completion of the expansion. However, one must recognize that at the time, the Venetian *Santa Casa* possessed no stone revetment. Marco Boschini's description of the sanctuary in 1664 indicated that the shrine had paintings appended to it and mentioned only one completed lateral altar.[58] Lazzaroni's original premise had to be totally rebuilt between 1662 and 1669.

Most importantly for this argument, the move opened up new possibilities for monumental tombs situated directly before and on either side of the altar of the *Annunciata* built into the west wall of the Holy House (Figure 3.3). Yet another branch of the patrician Morosini family, the *della Tressa*, moved to appropriate the area before the Santa Casa. When the agreement between the two parties was ratified in 1668, three of the four sons of Giovanni Morosini were still alive – and to date none had produced a male heir. Their youngest brother, Domenico, had died at the age of thirty-seven in 1653, leaving two young girls who were now married to members of the Pasqualigo and Grimani families.[59]

Pietro, the oldest of the sons, was the instigator of the donation to the church and the construction of the two family tombs. At this juncture, little of the present polychrome stone revetment had been constructed to embellish the Holy House. Pietro paid to rebuild the altar of the *Annunciata* and much of the decoration on the west wall of the revetment behind it, including three Carrara marble bas reliefs of the *Annunciation*, the *Visitation*, and the *Census in Bethlehem*, all completed between 1669 and 1670. The timing is significant – in 1669, Francesco Morosini relinquished the city of Candia and the island of Crete to the Ottomans. Pietro

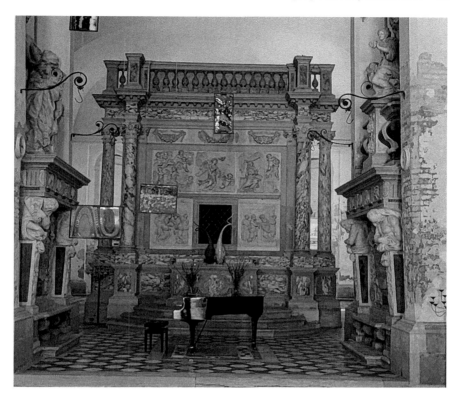

Figure 3.3 View of the Holy House and altar of the *Annunciata* from the nave of San Clemente, with Giorgio Morosini's monument at left and Pietro and Lorenzo Morosini's monument at right. Photograph by the author.

commenced his commemorative campaign just as his country lost its last major foreign holding.

As the inscription on his tomb bears out, Pietro was an avid collector of books, numismatics, military *spolia*, and works of art, and was a diligent participant in the Grand Council and in charitable activities.[60] His tomb, which is also occupied by his younger brother Lorenzo, was completed by their nieces' husbands (the family's universal heirs), Vincenzo Pasqualigo and Pietro Grimani (Figure 3.4, left). It is crowned by a seated figure of Justice, bearing a sword in her right hand and once holding aloft a set of metal scales in the left. Though neither man went to war, the lower zone of the monument is decorated with bellicose imagery, while two Oriental atlantids bear the weight of the upper zone in frozen agony upon their muscle-bound backs.[61]

The funeral monument opposite Pietro's brings the Candia/Loreto discussion back into focus. It is dedicated to Giorgio Morosini, the last, and only other married son in the family (Figure 3.4, right). Born in 1612, he negotiated a splendid match for himself in 1654, when at the age of forty-two he married the daughter of Count Carlo Antonio

Gambara, a scion of one of the great noble families of Brescia.[62] Five years later, he found himself an officer in Candia under the redoubtable Francesco Morosini, who was no close relative. The war had been in a state of stalemate since 1658, and in 1660, the supreme commander returned home in frustration after a failed attempt to retake the city of Khania, leaving the fleet and the defense of Candia in Giorgio's hands. Over the course of the next year, the "other" Morosini gallantly defended Crete as best he could, with some limited success, while Francesco Morosini dealt with a period of disfavor in the Grand Council that would not end until 1666.[63]

It is not clear exactly when Giorgio returned to Venice from his military duties, but, on 1 October 1661, he was knighted by the Grand Council for his achievements. Knighthood was followed in 1672 by election to the *Procuratie di Supra*, the highest honor in the patriciate below that of doge. He died in 1677 without producing a male heir, signifying that, like the branch of the Morosini *della Sbarra* honored on San Clemente's façade, this line of the Morosini would expire when brother Lorenzo died in 1687.[64]

Pietro and Lorenzo's tomb bears light, simple references to martial activities in the lower zone, probably employed by the sculptor, Giusto LeCourt, to align the

Figure 3.4 Left: Funeral monument of Pietro and Lorenzo Morosini. Right: Funeral monument of Giorgio Morosini. Both monuments by Giusto LeCourt, 1677–1685. Photographs by the author.

two monuments. But Giorgio's funeral monument is a late-baroque explosion of military glory. Kneeling at a prie-dieu facing the Holy House, he turns towards the viewer, half rising, lifting his head from the elbow, and hand resting on its cushion as if he is emerging from deep meditation after completing his devotions. Behind him, banners, lances, and cannon form a sunburst array to frame his figure while two *putti* pull back the heavy drapery to reveal the scene. The background is stucco incised and gilded to approximate golden mosaic – in this context always a clear reference to the Ducal Chapel of San Marco, the politico-religious epicenter of the Venetian world. Unlike its counterpart, Giorgio's monument features no sarcophagus. Pietro and Lorenzo rest in peace – Giorgio is very much alive; in fact, dressed in a cuirass and vambraces, a heavy cloak, and surrounded by the accoutrements of war, he appears as though he has been roused from prayer by the call to arms and will once more set out to scourge the enemy.

Taken as a pair, the two monuments present an ideal portrait of the perfect nobleman – the great patricians who for almost four hundred years had governed the Most Serene Republic through triumph and disaster. Well-educated, urbane, cultured, true to the old ways, unstinting in loyalty to the State, courageous at war, pious, and charitable – certainly this was a worthy addition to the propaganda of the Myth of Venice, clearly directed towards those who entered the church and stood before the Holy House. One cannot help but recall that due to the exorbitant cost of the war to preserve Crete, the Grand Council began selling patents of nobility to those merchant families who could offer 100,000 ducats to the war effort. The old families (many of them by now destitute) bitterly resented the diminution or "pollution" of the Grand Council by parvenu blood.[65] But one cannot also not help but wonder how they felt about this injection of new blood into the ruling class when news returned to Venice that approximately two-hundred and eighty noblemen had lost their lives in the final months before the fall of Candia. One quarter of the Grand Council died defending the walls of Heraklion.[66] Someone would need to replace them, and men like Giovanni Morosini *dalla Tressa*, who produced four sons but not a single grandson, could never replenish what had been irrevocably lost. In a sense, the two Morosini monuments had become a commemoration of a past that could not be retrieved, which had already slipped through the fingers of a senescent nation. Perhaps that past had never truly existed, and for this reason, it was ever more crucial to uphold its fading, misty image to Venetians, so that they might still have something to inspire them in their uncertain future.

Other patricians closely associated with the war against the Ottoman Empire offered less visible donations to the Holy House and San Clemente. As noted in previous studies, the *Procuratore* Carlo *quondam* Andrea Contarini, grandson of the eponymous doge, made an extraordinary thirty-one pilgrimages to the sanctuary of Loreto over the span of sixty years, always in periods when Venice was in active war with the Turks.[67] He also made a significant donation to the simulacrum at San Clemente, requesting masses for the soul of his second wife to be said at the altar inside the Holy House.[68] And the grandson and namesake of the Martyr of Famagusta also requested perpetual masses. Marcantonio *quondam* Antonio Bragadin's father was only three years old when Famagusta fell. In the time-honored Venetian tradition,

Antonio named his firstborn son after his murdered father twenty-two years after the loss. The younger Marcantonio went into an ecclesiastical career, rising to become Bishop of Vicenza (1639) and Cardinal in the name of San Marco (1646) after first receiving the tasseled hat in 1641. In 1655, he resigned his bishopric, returned to Rome, and was responsible for securing papal financial aid for the war effort in Candia.[69] In 1656, he gave 1,000 ducats in alms to the hermits of San Clemente, which were to be invested in the period before his death in order to finance a sung mass and a low mass to be celebrated after his death.[70]

Patrician families – the Zen, Sagredo, Badoer, and Contarini *dal Zaffo* in particular – as well as *cittadini* and the *nouveau riche* nobility, such as the Greek refugee Cottoni family, contributed to the financing of the polychrome revetment of the Holy House, the church's pavements, and the decoration of the six subsidiary altars. The financier of the island's sale to the hermits, Agostino Correggio, paid for the *jus* of one altar, and Bernardo Morosini dedicated another to St. Thomas to honor his dead brother. Abbot Andrea Mocenigo, who had helped facilitate negotiations between the Rua and the Carità, bequeathed his chalice and paten to the Holy House. All demonstrated a heartfelt devotion to the Virgin of Loreto, but none offered the powerful visual confirmation of her devotion to the Republic of Venice and her protection of its officers, army, and citizens from the looming menace in the Eastern Mediterranean provided by the funerary monuments of the Morosini and Gradenigo.

Although the Camaldolese hermits appeared firm in their insistence that blatant self-aggrandizement must not dilute the spiritual solemnity of their sacred space, the presence of monuments to two patrician war casualties facing a devotee as they approached the entrance to the church, and the two exuberant tombs framing the vista of the Holy House and its altar instantly drew the visitor into the theater of war commemoration. Five noble men – noblemen from two of the greatest Venetian families – gathered before the replica of the humble abode of the Virgin Mary encased in its polychrome marble *rivestimento*, in a perpetual display of courage, fortitude, service, and sacrifice. Every time visitors approached the church in veneration, they were confronted by the exploits and solemn visages of a father and son who had made the ultimate sacrifice for their republic, sheltered beneath the statues of the saints who had accepted one of their bodies to final rest, and the Madonna and her aerial reliquary souring above them. Every time a devotee heard mass before the Holy House, they were confronted by three more men whose tombs personified the best Venice had to offer in that stratified, class-conscious world of the seventeenth century – an honor guard for the jewel-bedecked statue nestled behind its altar. Even at a distance of four hundred years, with the church denuded of its art and the monuments in need of restoration, the dissonances the hermits sought to prevent can be clearly sensed in the silent space. Perhaps it is not surprising that almost exactly one century later, though for different motives, a second simulacrum of the Holy House of Loreto was constructed in the great parish church of San Pantalon, within the urban fabric of the city, easily accessible to all, and devoid of all secular references.[71]

Venice knew how to evoke memories and emotions in stone, brick, paint, and glass. Deborah Howard and Laura Moretti have demonstrated that in the utilization

of Venetian sacred and ceremonial space, even composers sought means by which to amplify the magnificence and emotional power of their works.[72] We tend to forget the sensory effects of what experiencing the mass, most particularly a sung anniversary mass for Gradenigo or one of the Morosini, might have been like in San Clemente, as the hermits' solemn voices emerged from the choir behind the Holy House and blended with the perfume of incense slowly swirling through the soft light of candles and lamps. In the smaller church, the experience would have been deeply moving and far more personal than that of a state commemoration at Santi Giovanni e Paolo or a mass in the sumptuously gilded and ornamented environment of the Chapel of the Rosary.

With its dozens of monuments to doges, senators, and military heroes dating back to the foundation of the Dominican monastery in the thirteenth century, Santi Giovanni e Paolo offered a palimpsest of Venetian history long before the republic ended. San Clemente offers instead a visual reference to one of the most difficult periods of Venetian history – the three decades between the onset of the War of Candia and its conclusion. After the completion of the Morosini *dalla Tressa* monuments in the 1670s – in the wake of Venice's loss of Crete and during the two ensuing Morean Wars – the church showed a marked increase in donations to its altars and especially to the simulacrum of the Holy House and requests for penitential masses from patrician and commoner alike, as well as requests for family tombs and individual burials. Now that the war was lost, the Madonna of Loreto and her *Santa Casa* became a memorial to past, though ultimately lost, glory. But for the Morosini, San Clemente was more than the resting place for four of their family and a space in which to exalt their deeds. It was a commemorative crypt for two scions of one of the greatest patrician families that died with them. The Camaldolese church and its stunningly revetted replica of the Holy House operated as an extraordinarily successful, and poignant, melding of sacred space, holy relic, and memorial to a historic past that had become mythologized before it had even concluded.

Archival sources

Archivio di Stato di Venezia (ASVe), *Ceremoniali*.
 Archivio di Stato di Venezia (ASVe), *Notarile Testamenti*.
 Archivio di Stato di Venezia (ASVe), *San Clemente*.
 Archivio di Stato di Venezia (ASVe), Miscellanea codici, Storia veneta, *Geneologie Barbaro*.
 Archivio di Stato di Venezia (ASVe), *Atti Notarile*.

Notes

1 Hopkins, "Architecture and Memory in Venice", pp. 249–250.
2 Fortini Brown, *Venice and Antiquity*.
3 See among others, Faroqhi, *The Ottoman Empire and the World Around It,* and Goffman, *The Ottoman Empire and Early Modern Europe*.
4 See among others, Setton, *Venice, Austria and the Turks in the Seventeenth Century,* and Preto, *Venezia e i turchi*.

72 Liv Deborah Walberg

5 Soykut, "Development of the Image of the Turk"; *Italian Perceptions of the Ottomans: conflict and politics through pontifical and Venetian sources*; and "Italian Documents on the Image of the Turk".
6 Although the sanctuary is several miles inland today, it overlooked the coastline in the Medieval and Early Modern period.
7 The development of the hagiography regarding the Translation of the Holy House is covered in numerous publications, including de Monterado, *Storia del culto e del pellegrinaggio a Loreto (secc. XIV–XV)*; Grimaldi, *La historia della chiesa di Santa Maria di Loreto*; Scaraffia, *Loreto*; and most recently Bercé, *Lorette aux XVIe et XVIIe siècles. Histoire du plus grand pèlerinage des temps modernes*.
8 In 1921 Pope Pius IX declared the Madonna of Loreto the patron saint of aeronauts. Her medal was taken to the moon by the astronauts of the Apollo XI mission, who are portrayed in one of the modern frescos in the basilica at Loreto. See Grimaldi, "Madonna di Loreto, patrona degli aeronauti".
9 Cracco, "Alle origini dei santuari mariani. Il caso di Loreto", pp. 119–125.
10 This argument will be developed in full in my forthcoming monograph *The Pope, the Lion and the Virgin: The cult of the Madonna of Loreto in early modern Venice*.
11 Spinelli, "Dedicazioni alla Madonna di Loreto dell'Italia nordoriente", pp. 192–193, and de Monterado, *Storia del culto e del pellegrinaggio a Loreto (secc. XIV-XV)*, pp. 197–198.
12 One of the most famous legends involved a Croatian priest who was eviscerated by Turks, and miraculously walked from Dalmatia to Loreto holding his viscera in his hands, dying only after praying in the Holy House. A collection of legends was codified in the first publication lauding the sanctuary, Tolomei, *Translatio miraculosa Ecclesie beate Marie virginis de Loreto*.
13 Walberg, "Venetian Devotion to the Sanctuary of Loreto and the 'Contarini' Ex-Voto", p. 524.
14 Bercé, *Lorette aux XVIe et XVIIe siècles. Histoire du plus grand pèlerinage des temps modernes*, pp. 155–162.
15 Vélez, *The Miraculous Holy House of Loreto: Spreading Catholicism in the early modern world*, pp. 117–128.
16 Walberg, "Venetian Devotion to the Sanctuary of Loreto and the 'Contarini' Ex-Voto", pp. 522–524.
17 Zava Boccazzi, *La Basilica dei Santi Giovanni e Paolo in Venezia*, p. 195.
18 Fenlon, "The Memorialization of Lepanto in Music, Liturgy and Art", pp. 61–78.
19 Gaier, *Facciate sacre a scopo profano. Venezia e la politica dei monumenti dal Quattrocento al Settecento*, p. 239.
20 Immediately after the victory at Lepanto the Senate approved a ducal *andata* to the church of Santa Giustina, on whose feast day the battle had taken place. At some point between the victory and 1605 the first documented altar in Venice dedicated to the Madonna of Loreto was erected in the church. Archivio di Stato di Venezia (ASVe), *Ceremoniali*, Reg. 1, cc. 40–48.
21 Vio, *Le scuole piccole nella Venezia dei Dogi: Note d'archivio per la storia delle confraternite veneziane*, p. 761.
22 ASVe, *Notarile Testamenti*, b. 228 (Giovanni Chiario), no. 372: 14 June 1633, in which Isabetta *quondam* Lodovico Rozzo of San Polo leaves 500 ducats for silver *cesendeli* to be made for the Madonna del Arsenale, the Madonna di Treviso, and the Madonna di Loreto del Rosario di San ZuanPolo.
23 All the paintings, along with precious works by Titian and Giovanni Bellini, were lost when a fire destroyed the interior of the chapel in 1863. The chapel was restored in the early twentieth century at the behest of Pope Pius IX. Zava Boccazzi, *La Basilica dei Santi Giovanni e Paolo in Venezia*, pp. 194–200.
24 DeVries, "A Tale of Venetian Skin: The flaying of Marcantonio Bragadin", pp. 51–70.
25 *Ivi*, pp. 68–70.

26 An excellent examination of the phenomenon of grief in early modern Venice is laid out in King, *The Death of the Child Valerio Marcello*.
27 Cicogna, *Delle iscrizioni veneziani*, vol. III, pp. 181–182.
28 Sansovino, *Venetia Città nobilissima et singolare*, vol. I, pp. 116–117.
29 Cicogna, *Delle iscrizioni veneziani*, vol. III, p. 123.
30 ASVe, *San Clemente*, b. 1 *Catastico*, c. 1r.
31 Ranucci and Tenenti, *Set Riproduzioni della Santa Casa di Loreto in Italia:Aversa-Parma-Venezia/San Clemente-Venezia/San Pantalon-Vescovana*, p. 136.
32 ASVe, *San Clemente*, b. 5, Fasc. 1 *Acquisto dell'Isola di San Clemente*. The fascicle contains copies of numerous correspondences between Mocenigo and Lazzeroni, and Mocenigo and Prior Spinelli.
33 ASVe, *San Clemente*, b. 3, c. 1v.
34 "*...se il turco avesse sentito e veduto un tal apparato con tante barche, che occoupavano tutte queste lagune, sicuramente si sarebbe posto in fuga e lasciato in libero il Regno di Candia.*" Ranucci and Tenenti, *Set Riproduzioni della Santa Casa di Loreto in Italia*, p. 140, note 10.
35 ASVe, *San Clemente*, b. 1, *Catastico*. The donations and requests for masses and burials between 1647 and 1660 are contained in cc. 4v – 11 r.
36 The *altare privilegiato* in a church containing a simulacrum of the Holy House is normally the Altar of the *Annunciata*, which is placed in imitation of the original altar at Loreto on the exterior of the west side of the Holy House, facing the main entrance of the church, and was generally provided with a papal indulgence – plenary or of a lesser value. San Clemente's *privilegiato* was in the Chapel of San Clemente, built by Baldassare Longhena for the Piovene family in the north transept in 1675 but the indulgence was never plenary. Carraro, *L'isola di San Clemente a Venezia. Storia, restauro a nuove funzioni*, p. 18.
37 ASVe, *San Clemente*, b. 13, Fasc. 18, fol.1
38 Not to be confused with the great *Capitan da Mar, Procuratore* and Doge Francesco Morosini "il Pelopponesiaco."
39 Setton, *Venice, Austria and the Turks in the Seventeenth Century*, pp. 147–148.
40 Gaier, *Facciate sacre a scopo profano*, p. 272.
41 ASVe, Miscellanea codici, Storia veneta, *Geneologie Barbaro*, vol. V (M-O), b. 21, c. 378.
42 ASVe, *San Clemente*, b. 13, Fasc. 18, fol. 2r.
43 *Ivi*, fol. 3r.
44 *Ivi*, fols. 4r-v., See also ASVe, *Atti Notarile*, b. 11053 (Giovanni Piccini) fol. 511v – 513r (as cited in Gaier, p. 272)
45 Gaier, *Facciate sacre a scopo profano*, p. 273.
46 Ranucci and Tenenti, *Set Riproduzioni della Santa Casa di Loreto in Italia*, p. 136.
47 Carraro, *L'isola di San Clemente a Venezia*, p. 15.
48 Francesco's epitaph is as follows: FRANCESCO MAUROCENO | SPECTATAE VIRTUTIS AC CONSILII SENATORI QUI | COMPARANDAE PRUDENTIAE MAGNA ORBIS PARTE | PERAGRATA PATRIAE REDDITUS CUM EODE(M) INTEGRITATE | ATQ(UE) ABSTINENTIA QUA URBANOS MAGISTRATUS GESSERAT | CRETAM PROVINCIAM ADMINISTRASSET CELSIOR(UM) ONERIAR(UM) | PRAEFECTUS PUBLICAE LIBERTATIS HOSTIBUS CESIS AUT FUGATIS | ADRIATICI POSSESSIONEM RETINUIT MAGNAQUE FAMILIARIS | REI IACTURA NON SEMEL AFFECTUS UTRAMQUE FORTUNAM | MODERATE TULIT. DEMUM CORCYRAE ANNO SCARALI EXTINCTUS TRISTE SUE DESIDERIUM BONIS OMNIBUS RELIQUIT. CHRISTI NATI MDCXVIII.
49 Tommaso's epitaph is as follows: THOMAE MAUROCENO | EXCELSI INVICTIQUE ANIME VIRO QUI EARUMDEM | ONERARIUM DUCTOR POST OBSESSAM AD | HELLESPONTI FAUCES TURCICAM CLASSEM DUM | ELAPSAM CRETAE FINIBUS AVERTERE STUDET CASU | IN MEDIAM SOLA PRAETORIA DELATUS CIRCUNFUSAM | BARBARIAM.

74 Liv Deborah Walberg

50 Tommaso's epitaph is as follows: THOMAE MAUROCENO | EXCELSI INVICTIQUE NON DIU MODO SUSTINUIT AC REPULIT | SED LATE EDITA MORTALIUM AC NAVIGIORUM STRAGE | IPSO PURPURATO INTERFECTO INTER PROMPTISSIMOS DIMICANS DEO AC PATRIAE SPIRITUM IMPENDIT | ANNO MDCXLVII.
51 Gaier, *Facciate sacre a scopo profano*, p. 273.
52 Ranucci and Tenenti, *Sei Riproduzioni della Santa Casa di Loreto in Italia*, p. 157, fig. F.
53 Boschini, *Le minere della pittura*, pp. 222–224.
54 "Patriarch Marco Gradenigo", https//www.catholic-heirarchy.org/bishop/bgradenma.html [accessed 6 November 2022].
55 *Ibidem*.
56 ASVe, *San Clemente*, b. 2 #34; b.1 *Catastico*, 10r, 13 December 1657.
57 ASVe, *San Clemente*, b.1, *Catastico*, c. 12r, 27 June 1662.
58 Boschini, *Le minere della pittura*, pp. 560–561.
59 ASVe, Miscellanea codici, Storia veneta, *Geneologie Barbaro*, Vol. V (M-O), b. 21, c. 295.
60 Pietro's epitaph is as follows: PETRO MAUROCENO | QUI, INGENUARUM VIRTUTU(M), ANTIQUI MORIS, INTE | MERATAE RELIGIONIS SENATOR, GRAVISSIMIS REI | PUBICAE MUNERIVUS, SUMMO STUDIO, SUMMA FIDE | PERFUNCTUS, AD EXEMPLUM GEORGII FRATRIS, CUI | US TESTAMENTO AUCTUM MILITARIBUS SPOLUS PA | LATINUM ARMAMENTARIUM, BIBLIOTHECA. CUM | VIVERET, LIERARIA VARII GENERIS, ATQ(UE) OPERIS SU | PELLECTILI, MORIENS, ANTIQUORUM NUMISMATUM | EXQUISITISSIMA COPIA, EXORNAVIT, PROLATA CHA | RITATE AD PAUPERES, IN NON EXIGAM PARTEM HAE | REDITATES VOCATOS; DIGNITATIS, ET HONORIS APICE(M) | CONSCENSURUS, NISI MORS IMATURA SENI, VOTA, URBIS | ET CIVIUM OCCUPASSET, OBIIT AN(NO) 1681 AET(ATIS) 72. | LAURENTIUS FRATER H(OC).M(OMUMENTUM).P(OSUIT). Anno MDCLXXXV QUI TRIENNIO POST | EXPLETO DIGNITATIBUS AEUO | INTEGRITATISQ(UE) FAMA PROLATA | TERTIO SUPRA SEPTUAGESIMUM ANNO | ULTIMUS VITAE DOMUSQ(UE) SUAE FATA CLAUSIT | VINCENTIUS PASCHALICO ET PETRUS GRIMANI | AMBO NEPOTES SIMULQ(UE) HAEREDES | MEMORIAM AUXERE.
61 Both monuments were designed and executed by the Flemish sculptor Josser LeCourt (Giusto Le Court) between 1677 and 1680. Ranucci and Tenenti, *Set Riproduzioni della Santa Casa di Loreto in Italia*, p. 137.
62 ASVe, Miscellanea codici, Storia veneta, *Geneologie Barbaro*, Vol. V (M-O), b. 21, c. 295.
63 Gullino, "Francesco Morosini".
64 ASVe, Miscellanea codici, Storia veneta, *Geneologie Barbaro*, Vol. V (M-O), b. 21, c. 295.
65 Davis, *The Decline of the Venetian Nobility as a Ruling Class*.
66 "War for Crete", www.msc.gr/veniva/uk/main/p2.htm [accessed 2 December 2022].
67 Walberg, "Venetian Devotion to the Sanctuary of Loreto and the 'Contarini' Ex-Voto", pp. 526–532.
68 ASVe, *San Clemente*, b. 1, *Catastico*, 28r, 26 February 1692.
69 Benzoni, "Marcantonio Bragadin".
70 ASVe, *San Clemente*, b. 2, #33; also b. 1 *Catastico*, c. 9r, (27 May 1656) in which it is made clear that the ducats are alms *(elemosine)* not an investment for perpetual masses.
71 Brunet and Marchiori, *La Chiesa di San Pantalona Venezia*.
72 Howard and Moretti, *Sound and Space in Renaissance Venice: Architecture, music, acoustics*.

Bibliography

Benzoni, Gino, "Marcantonio Bragadin", in *Dizionario biografico degli Italiani*, https://www.treccani.it/enciclopedia/marcantonio-bragadin_res-d90c59e5-87e8-11dc-8e9d-0016357eee51_%28Dizionario-Biografico%29/ [accessed 13 July 2022].

Bercé, Yves-Marie, *Lorette aux XVI^e et XVII^e siècles. Histoire du plus grand pèlerinage des temps modernes* (Paris: Sorbonne, 2011).
Boschini, Marco, *Le minere della pittura* (Venice: Francesco Nicolini, 1664).
Brunet, Ester, and Marchiori, Silvia, *La Chiesa di San Pantalona Venezia* (Venice: Marcianum Press, 2017).
Carraro, Martina, *L'isola di San Clemente a Venezia. Storia, restauro a nuove funzioni* (Pescara: CARSA Edizioni, 2003).
Cicogna, Emanuele Antonio, *Delle iscrizioni veneziani* (Venice: Giuseppi Orlandelli, Giuseppe Picotti, Giuseppe Molinari Stampatori, Tipografia Andreola 1824–1853), 6 voll.
Cracco, Giorgio, "Alle origini dei santuari mariani. Il caso di Loreto", in Ferdinando Citterio and Luciano Vaccaro (eds.), *Loreto, crocevia religioso tra Italia, Europa ed Oriente* (Brescia: Morcelliana, 1997), pp. 97–164.
Davis, James C., *The Decline of the Venetian Nobility as a Ruling Class* (Baltimore: Johns Hopkins University Press, 1962).
de Monterado, Luca, *Storia del culto e del pellegrinaggio a Loreto (secc. XIV-XV)* (Loreto: Congregazione universale della Santa Casa, 1979).
DeVries, Kelly, "A Tale of Venetian Skin: The flaying of Marcantonio Bragadin", in Larissa Tracy (ed.), *Flaying in the Pre-Modern World* (Suffolk: Boydell and Brewer, 2017).
Faroqhi, Suraiya, *The Ottoman Empire and the World Around It* (London: I. B. Tauris, 2005).
Fenlon, Iain, "The Memorialization of Lepanto in Music, Liturgy and Art", in Benjamin Paul (ed.), *Celebrazione e autocritica. La Serenissima e la ricerca dell'identità veneziana nel tardo Cinquecento* (Rome: Viella Editrice, 2014), pp. 61–78.
Fortini Brown, Patricia, *Venice and Antiquity* (New Haven, CT: Yale University Press, 1996).
Gaier, Martin, *Facciate sacre a scopo profano. Venezia e la politica dei monumenti dal Quattrocento al Settecento* (Venice: Istituto Veneto di Scienze, Lettere ed Arti, 2002).
Goffman, Daniel, *The Ottoman Empire and Early Modern Europe* (Cambridge: Cambridge University Press, 2002).
Grimaldi, Floriano, "Madonna di Loreto, patrona degli aeronauti", in Lenz Kriss-Rettenbeck and Gerda Möhler (eds.), *Wallfahrt kennt keine Grenzen* (München/Zürich: Adalbert-Stifler-Verein, 1984), pp. 300–305.
———, *La historia della chiesa di Santa Maria di Loreto* (Loreto: Cassa di Risparmio, 1993).
Gullino, Giuseppe, "Francesco Morosini", in *Dizionario biografico degli Italiani,* https://www.treccani.it/enciclopedia/francesco-morosini_%28Dizionario-Biografico%29/ [accessed 7 January 2023].
Hopkins, Andrew, "Architecture and Memory in Venice", in Jörg Oberste and Sabine Reichert (eds.), *Stadtgeschichte(n). Erinnerungskulturen der vormodernen Stadt* (Regensberg: Verlag Schnell & Steiner, 2017), pp. 249–296.
Howard, Deborah, and Moretti, Laura, *Sound and Space in Renaissance Venice: Architecture, Music, Acoustics* (New Haven, CT: Yale University Press, 2009).
King, Margaret L., *The Death of the Child Valerio Marcello* (Chicago: Chicago University Press, 1994).
"Patriarch Marco Gradenigo", https//www.catholic-heirarchy.org/bishop/bgradenma.html [accessed 6 November 2022].
Preto, Paolo, *Venezia e i turchi* (Florence: G. C. Sansoni, 1975).
Ranucci, Maria, and Tenenti, Massimo, *Sei Riproduzioni della Santa Casa di Loreto in Italia: Aversa-Parma-Venezia/San Clemente-Venezia/San Pantalon-Vescovana* (Loreto: Congregazione Universale della Santa Casa, 2003).
Sansovino, Francesco, *Venetia Città nobilissima et singolare* (Venice: Stefano Curti, 1663 [reprinted Venice: Filippi, 1968]).

Scaraffia, Lucia, *Loreto* (Bologna: Mulino, 1998).
Setton, Kenneth, *Venice, Austria and the Turks in the Seventeenth Century* (Philadelphia, PA: American Philosophical Society, 1991).
Soykut, Mustafa, "Development of the Image of the Turk", *Journal of Mediterranean Studies*, 9:2 (1999), pp. 175–203
———, *Italian Perceptions of the Ottomans: Conflict and Politics through Pontifical and Venetian Sources* (Frankfurt am Main: Peter Lang Verlag, 2011).
———, "Italian Documents on the Image of the Turk", in Agostino Borromeo, Pierantonio Piatti, and Hans Ernst Weidinger (eds.), *Europa cristiana e impero ottomano: momenti e problematiche* (Vienna: Hollitzer Wissenschaftsverlag, 2020), pp. 296–318.
Spinelli, Giovanni, "Dedicazioni alla Madonna di Loreto dell'Italia nordoriente", in Ferdinando Citterio and Luciano Vaccaro (eds.), *Loreto, crocevia religioso tra Italia, Europa ed Oriente* (Brescia: Morcelliana, 1997), pp. 191–210.
Tolomei, Pietro Giorgio, *Translatio miraculosa Ecclesie beate Marie virginis de Loreto* (Rome: Eucharius Silber, c. 1472).
Vélez, Karin, *The Miraculous Holy House of Loreto: Spreading Catholicism in the Early Modern World* (Princeton, NJ: Princeton University Press, 2019).
Vio, Gastone, *Le scuole piccole nella Venezia dei Dogi: Note d'archivio per la storia delle confraternite veneziane* (Vicenza: Angelo Colla Editore, 2004).
Walberg, Liv Deborah, "Venetian Devotion to the Sanctuary of Loreto and the 'Contarini' Ex-Voto", *Studi veneziani*, ns. LXXXII (December 2020), pp. 507–554.
———, *The Pope, the Lion and the Virgin: The Cult of the Madonna of Loreto in Early Modern Venice*, forthcoming.
"War for Crete", in *Viaggio virtuale tra le fonti storiche veneziane. Rotta: Venezia e il Levante (sec XV - sec XVIII)* (VENEVA Consortium, 1996), www.msc.gr/veniva/uk/main/p2.htm [accessed 2 December 2022].
Zava, Boccazzi, Franca, *La Basilica dei Santi Giovanni e Paolo in Venezia* (Venice: Fernando Ongania Editrice, 1965).

4 Mythmaking, fidelity, and urbanism in early modern Messina and Palermo

Tamara Morgenstern

Collective self-expression is a fundamental impulse in city making. Cross-insemination by founders and usurpers over centuries endows a city with artistic and cultural nuances that palpably manifest its ancestry. Embedded in a city's architecture and urban framework, traces of the past can be decoded to read the societal narrative that forged that singular urban entity.

Examining the Sicilian ports of Messina and Palermo between 1535 and the 1630s, when they were united aesthetically and administratively under a succession of Spanish Habsburg monarchs beginning with Emperor Charles V (1500–1558), we see the results of imperial dominance, tempered by a transactional exchange between the local populace and the preexisting architectural heritage. Architects and engineers imported from mainland Italy by the Spanish viceroys spearheaded urban improvements, bringing the latest currents in classicizing architecture—from High Renaissance to Mannerism and the early Baroque—to Sicily. Consequently, both cities were reconceptualized as paradigms of *civitas* and bastions of religious devotion. A crucial and largely unacknowledged corollary was that, through unchallenged authority and the wealth to implement holistic restructuring at a scale unprecedented in European planning, the Habsburgs provided an unparalleled opportunity for experimentation with trailblazing design modes that presaged many such developments on the Italian peninsula. Despite commonalities of culture, governance, and contemporary architectural language, each city assumed a distinctive urban image, largely in response to topography, local foundation myths, and their disparate status under the Spanish rulers.

Tracing Habsburg architectural mythmaking in Messina and Palermo, this study analyses how metaphorical narratives, devised to arouse feelings of fidelity, awe, and civic pride, were embedded in stone in each city as they reached an apotheosis of development by the early Seicento. Through calculated architectural production—used as an instrument to reinforce absolute rule—the Spanish reshaped what Barbara Rosenwein termed the 'emotional communities' of both cities by imposing fresh traditions to generate a new 'set of normative emotions' while maintaining established rituals and emotive touch points. Thus, material interventions may be decoded to ascertain the means of engaging and manipulating the overlapping 'emotional communities', composed of the absentee monarch, his viceregal court, the patrician class, and the greater population.[1]

In analyzing these early modern urban settings, I seek answers to the question posed by art historian Heinrich Wölfflin over a century ago: 'How is it possible that architectural forms are able to express an emotion or a mood?'[2] Integral to this investigation is the notion of 'atmosphere', which is grounded in the field of architectural phenomenology and is defined as 'emotional resonance and subsequent consonance between the perceiving subject and their architectonically arranged surroundings'.[3] Arguably, Habsburg architectural compositions were infused with this intangible essence knowingly and deliberately to encourage 'seduction of the observer, [and] to involve them in a clearly defined design narrative that sends them emotional and/or ideological messages predetermined by the author'.[4] Further, drawing on what James Ackerman identified in Michelangelo's late architectural designs as a 'kinetic architecture' that '…incites an emotional response through its capacity to move the observer physically as well as emotionally…'. I propose that architects associated with Michelangelo in Tuscany and Rome applied these principles—designed to engage the spectator in motion—to large-scale compositions in Messina and Palermo.[5]

Although Messina and Palermo form the basis of this examination, the nature of urban interventions, viceregal governance, and the amalgam of religious and cultural enterprises coalesced in a global strategy to create a 'Christian polis on a planetary scale' across the Habsburg's holdings on four continents.[6] Notably, contemporaneous architectural ventures in Naples and Genoa closely paralleled renovations in Messina and Palermo.

As an amateur architect and arts patron, Philip II (1527–1598) undoubtedly played a vital role in urban restructuring on Sicilian soil.[7] The *Laws of the Indies* of 1573, his codification of planning principles for development in the Americas—based on Alberti's Italian Renaissance treatise and Vitruvius's *De architectura*—was considered the 'most influential body of urban law in human history'.[8] However, the Habsburgs recognized that when building in preexisting Italian cities they could not maintain stability by imposing a drastic new societal order as was attempted in the New World. Rather, their task was to insinuate their own presence into the urban environment to inspire reverence and obeisance through the most persuasive and conciliatory means possible.

Fundamental disparities between New World urban interventions and those on European soil are the nature of settler colonialism in the former and methodologies of imperial rule in the latter. Under Viceroy don Francisco de Toledo, the Spanish created numerous *reducciones* (new towns) *ex novo*, exemplified by Lima, Peru. Additionally, they reconfigured many indigenous spaces to reflect the rupture between old and new societal structures, such as the Incan capital, Cusco, and Tenochtitlan—the Aztec center. Conversely, in Sicily, modernization and enhancement, rather than eradication of the shared heritage, were favored. Although the message across the Habsburg's 'empire of cities' was one of imperial hegemony, New World colonization involved repression and radical religious and social reform.[9] Alternatively, in the Kingdom of Sicily—inherited rather than conquered by Charles V in 1516—the challenge was to shift allegiance from the former Aragonese rulers to the new royal dynasty.

Successful rule over the 'composite states' under the aegis of the Spanish monarchy on European soil was accomplished through a system known as *aeque principaliter*, wherein diverse kingdoms were allowed to preserve their own laws, customs, and privileges. Within these disparate realms, the sense of uniformity created through shared values and culture helped ease tensions of subjugation.[10] This approach rose out of Machiavelli's proposal for three ways to govern newly conquered, formerly independent kingdoms. As an alternative to despoiling them or establishing residence in person, the third course, affirming the tenet of *aeque principaliter*, was to 'let them live by their laws, taking tribute from them and creating within them an oligarchical government which keeps them friendly to you'.[11] By bestowing titles, lands, and offices upon the local aristocracy and preserving a modicum of self-government, the Habsburgs thus struck a balance between dominance and self-determination. Moreover, affiliation with the alluring viceregal court and the 'mystic, divine quality of absolutist monarchy' fostered self-importance and increased loyalty.[12] Significantly, this system of semi-autonomous rule freed the distant Habsburg ruler from the intricacies and complications of administrating from afar.[13]

This multi-pronged political strategy formed the philosophical model for calculated urban restructuring that, as a form of social engineering, succeeded in shaping communal behavior and instilling emotional attachments to each city.[14] The Habsburg's psychological manipulation of the subjugated Sicilian population displayed not only the recognition of the 'culturally distinctive' nature of emotions but also an understanding of how arousing a strong emotional response could be 'agentic in shaping social conditions and relationships'.[15]

Imperial strategies: urban magnificence, architectural patronage, and dynastic legitimacy

Refashioning cities throughout the Spanish Empire was accomplished by bolstering defensive systems, consolidating an imperial identity, and espousing classical architectural principles, as well as by adhering to concepts set out by political theorist Giovanni Botero. In his sociological study of 1588, Botero argued that a monarch's power hinged on the consent of the subjected populace, which was most effectively acquired by winning their affection and admiration. A key component was the humanist ideal of 'magnificence' relating to a city's physical setting, its fine art and architecture, and other 'excellent and wonderful things'. Botero also emphasized emotional factors fundamental to a gratifying urban life, including a sense of security, harmony, and pleasure in all that 'feasts the eyes, delights the senses, and entertains curiosity'.[16] Accordingly, of the triad of qualities essential to successful architecture outlined by Vitruvius as *firmitas*, *utilitas*, and *venustas*—or 'firmness, commodity, and delight'—it is the emotive ingredient of *venustas* that we will examine in Habsburg architectural endeavors. *Venustas*—Latin for 'beauty'—implies aesthetic characteristics designed to arouse emotions of love.

Assuming a role as protector and benefactor, Charles V had instigated a strategy of informal imperialism during his unofficial domination over Rome, shrewdly

calculating that appeasement and seduction through architectural bequests would encourage loyalty from his remote subjects.[17] Patronage became a tool in the control of empire. In Sicily, the Emperor exercised a mode of 'soft' imperialism similar to that practiced with great effect in Rome. Philip II perpetuated the practice, pouring New World gold into widespread building campaigns.

Beneficence, however, was not enough. Affirmation of dynastic legitimacy was critical to asserting supremacy. The status of Charles V as Holy Roman Emperor was thoroughly established by his grandfather, Holy Roman Emperor Maximilian I, who commissioned humanist scholars and artists to formulate mythical historiographies and fictitious royal genealogies tracing Habsburg lineage to numerous luminaries, including a host of Roman emperors. In addition to autobiographical chronicles, panegyrics, and genealogical charts, Maximilian's publicity campaign was highlighted by a series of propagandistic woodcuts of 1512 by Albrecht Dürer depicting a ceremonial procession *all'antica*. The monarch's illustrious ancestry was also traced back to Hector of Troy, thereby laying claim to both the Eastern and Western Roman Empires. Consequently, by justifying territorial occupation, creating an undisputed line of descent, and inspiring fidelity to universal monarchy, Maximilian established a political power base upon which Charles V and his heirs forged an empire.[18]

Mediterranean strongholds

At the crossroads between the Eastern and Western Mediterranean Seas, Messina and Palermo bore the traces of occupation by diverse civilizations, starting in the eighth century BCE with the Phoenicians, who established the port of Palermo. Concurrently, the Greeks founded the colony of *Zancle*—later renamed *Messana*—in 730 BCE. Following several centuries as a Roman province, a succession of rulers left an architectural stamp on the environment, resulting, by the sixteenth century, in a rich, but incoherent mélange of component parts.

When Charles V inherited the Kingdom of Sicily, Messina and Palermo were key ports along trade routes to the East and were also vital naval sites at the front lines in the battle against Turkish aggression. Following his acclaimed conquest of Tunis in 1535, the Emperor surveyed these Sicilian towns for the first time. A lavish triumphal entry in Palermo, followed by a grand procession in Messina, greeted the monarch with the pomp and ceremony accorded to ancient Roman *triumphator*s. Ephemeral decorations in a profuse display of Renaissance classicism incorporated royal and mythological imagery. Theatrical productions, pyrotechnics, and celebratory parades through cities briefly transformed with stucco, tapestries, and papier-mâché into sumptuous theaters, were accompanied by meetings with local officials and aristocrats. Calculated to restore order and promote allegiance among the Emperor's new vassals, these mock-imperial settings provided a touchstone for subsequent urban restructuring.[19]

Recognizing both towns' strategic value and their vulnerability, the Emperor ordered the construction of new harbor facilities and the revamping of infrastructure and hydraulic systems. The completion of modern fortifications, begun in 1522 by

Paduan engineer Pietro Antonio Tomasello, was critical in safeguarding the Iberian and Italian peninsulas against Turkish invasions and marauding corsairs.[20] In 1535, Viceroy Don Ferrante Gonzaga appointed Bergamese engineer, Antonio Ferramolino, to complete Tomasello's work.[21] Gonzaga stressed the island's importance in a report to the Emperor in 1546, declaring Sicily 'the key to what the Catholic Majesty possesses in Italy' and further lauding Messina as 'the key to the Kingdom [of Sicily] and of that of Naples'.[22] Modern bastioned *enceintes* encircling each city read as military diagrams, reflecting the most up-to-date engineering strategies and imparting messages of strength and unity. Concurrently, the rupture between land and sea formed by the impregnable fortifying walls presented a face of fear along the littoral. Habsburg sovereignty over Sicily thus functioned as what Thomas Hobbes termed the 'Leviathan'—his justification for autocratic rule.[23]

The viceregal system was an Aragonese institution transplanted to Italy and the Americas to facilitate Spanish rule.[24] In a missive to the Duke of Alcalá, Viceroy of Naples, Philip II outlined the altruistic role he envisioned for his viceroys as his alter ego to assure that the community may 'live and rest in full security, peace, justice and quiet … [and] sleep without anxiety'.[25] Given great latitude to commission stylish architectural projects, the viceroys routinely left their mark on the environment, often exalting their own status through self-aggrandizement disguised as communal decorum and civic welfare.[26] The consistent vision for urban restructuring that unfolded over many decades, despite frequent changes in viceregal leadership, with a standard tenure of three years, suggests that supervision stemmed from the centralized monarchy in Madrid, where Philip II established an autocratic, detail-oriented ruling style.[27]

When Philip II assumed power as King of Naples and Sicily in 1554 and as King of Spain in 1556, Spain's military capability had substantially declined. Following the catastrophic defeat in the Battle of Djerba in 1560, frenzied preparations to rebuild naval power to defeat the Ottoman Turks encouraged cooperation and undoubtedly contributed to a secure alliance between the Habsburgs and the island population. Collectively, the Spanish and Sicilians shared the 'lasting trauma' of Muslim rule, which dated from the eighth century.[28] Their empathetic bond in the face of this mutual threat demonstrates Hobbes's theory that 'common peace' depended on 'the erection of some common power' where people may 'join their strengths together, against a common enemy'.[29]

Baroque cities

After 1561, when Philip II established Madrid as his capital, he and his successors rarely traveled outside Spain. To keep the remote sovereigns front and center in their subjects' consciousness, the viceroys established a regular schedule of ceremonial processions centered on the monarchy and the viceregal court, through which a 'common ritual grammar' was interwoven into the urban fabric.[30] Creating permanent accommodations for these spectacles was a prime impetus for citywide revitalization. Both aquatic routes and newly shaped streets and squares were 'ritually mapped' to establish 'authorized space for the exercise of power'.[31] The urban

form itself became an 'emotional arena' for the public display of sentiments that were astutely manipulated and habitually reinforced.[32] As a political tool to create an 'imperial geography of power', similar practices occurred in cities and towns throughout the Spanish global empire.[33]

Counter-Reformation religious policies following the Council of Trent in 1563 were based on propaganda designed to arouse the worship of the masses. Archbishop Carlo Borromeo proposed that art and architecture incorporate an 'emotional stimulus to piety'. This attitude marked a departure from the suppression of passions inherent in the decorum of Renaissance artistic production.[34] New Mannerist and early Baroque architectural, theatrical, and spatial concepts—deployed to stimulate faith and religious passion in ecclesiastical structures—fueled this stage of development. Architectural set pieces based on scenography and processional movement, laced with reminders of Habsburg hegemony and dynastic aspirations, awakened feelings of admiration, devotion, and exultation.

After the resounding victory in the Battle of Lepanto, the Sicilian ports' naval importance declined and military imagery gave way to fresh devices for Spanish self-promotion, launching a dramatic shift in emotional norms from a pervasive fear of war to an era of optimism celebrating civic wealth and stability. In a second phase of restructuring, the monarch, and subsequently his son, Philip III (1598–1621), transformed both cities aesthetically, symbolically, and experientially into distinctive Habsburg possessions. Traveler's accounts and chorographic literature—frequently commissioned by the Spanish Crown—generated geographical and military descriptions, and also provided artistic and cultural descriptions of the cities and their surroundings.

Urban analysis

Four meronomies, or categorizations of the component parts of the city, each of which influenced the populace experientially and emotionally, help facilitate an analysis of Habsburg architectural interventions: first, the encircling fortifications, the aquatic embrace of harbor jetties and their maritime structures, and the immense Norman-era structures defined each city holistically through monumental scale and infrastructure. These elements demarcated boundaries and dominated the landscape, fueling a pervasive consciousness of Habsburg sovereignty, and engendering feelings of unity, safety, and stability. Secondly, a modernized arterial system, with palace-lined roadways and stylish plazas, replaced static medieval market squares and irregular street patterns. Activating the urban setting through intensified movement and congregation heightened the connection of the inhabitants with their environs. A third element involved apertures and viewing stations, which affected bodily engagement through movement and ocular activity. City gates provided connectivity, channeled pan-urban movement, afforded perspectival views—both into the urban setting and out to the waters and hinterland—and offered a 'tension between interior and exterior' that instilled 'an incredible sense of place'.[35] Galleries atop the Porta Nuova in Palermo and seafront balconies on

the Palazzata created elite spaces for observing and being observed, accentuating class distinctions. Simultaneously, intimidating forts facilitated surveillance of the population. Finally, on the micro level—in human-scale architectural carvings, sculptures, and inscriptions—city dwellers constantly faced messages that engaged the intellect and promoted Habsburg supremacy. As a holistic experience, the orchestration of these elements produced an atmosphere with emotional reverberations that aroused visceral bonds, awakened a sense of history, restructured individual and communal identity, and altered the mental and sensorial experience of participants.

Messina

Since its founding by Greek colonists, Messina was renowned for its deep natural harbor and strategic location along maritime routes in the Mediterranean. During the Crusades, it was a customary stopover for European knights journeying to the Holy Land, as well as for Muslims participating in the annual Hajj. Court geographer for Roger II, Al-Idrisi, described Messina's 'delightful' coastal setting, proclaiming, 'The port is one of the great wonders, spoken about throughout the world'.[36] Obadiah of Bertinoro, visiting Messina on a 1487 voyage to the Holy Land, described the city in the century prior to Spanish rule.

Messina is a center of commerce for the people and ships from all corners of the earth land here… There is no other port in the world like this… It is not as large as Palermo, nor does it have springs that are just as good, but it is beautiful and rich.[37]

Bertinoro's comparison of Messina with Palermo reveals the rivalry between the two Sicilian cities that persisted through the Habsburg era, as they jockeyed for status and privileges.[38] The Messinese aristocracy constantly bargained for increased entitlements, with the goal of unseating Palermo as the Sicilian capital. The Spanish fueled this competition to assure that the two cities did not unite against the Crown. Given great latitude by the Spanish, Messina was a semi-independent republic governed by a rich bourgeoisie. As the preeminent Sicilian port, it was the commercial counterpart to Genoa and Venice.

To embellish Messina for the entry of Charles V, the Mannerist painter Polidoro da Caravaggio—who studied under Raphael—devised citywide *apparati*, known from surviving sketches and written accounts.[39] Included were Habsburg eagles and a triumphal arch evoking the monarch's *impresa* of the two Pillars of Hercules. Its motto, *Plus ultra*—'always further'—conveyed ambitions for universal monarchy beyond the classical boundaries of the ancient world at the Straits of Gibraltar.[40] This historic event gripped the imagination of viceregal leaders, providing a consistent model for urban reform over the following century, as Messina became a memory theater for reliving highlights of Habsburg history. Conceivably, the mental concepts of the art of memory, wherein imaginary architectural spaces were laden with images and meaning—grounded in the mnemonic rhetorical devices of Cicero and Quintilian and revived in the sixteenth century by Giordano Bruno and Giulio Camillo—took physical form in key sites in both Messina and Palermo.[41]

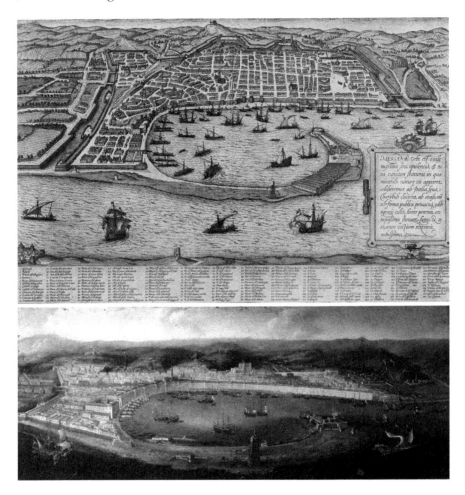

Figure 4.1 Top: Sixteenth-century view of Messina with waterfront fortifications. Braun & Hogenberg, *Civitates Orbis Terrarum*, 1588–1597, Historic Cities Center of the Department of Geography, the Hebrew University of Jerusalem and the Jewish National and University Library. Bottom: View of the port of Messina with the Palazzata, Abraham Casembrot, c. 1623–1658, Museo Regionale di Messina.

The harbor

Tracing seaborne entries and land-based processional routes through Messina, we will explore the city's architectural framework in the 1630s as contemporary viewers might have experienced it. Ships entering Messina's great aquatic basin passed between the sickle-shaped peninsula of San Raineri and the precisely demarcated town rising above the shore in the form of a natural amphitheater. Massive fortifying walls, anchored by looming bastions and immense inland forts, circumscribed an urban mass scattered with lofty cathedral spires. To the east, strewn along the

encircling arm, maritime architectural paraphernalia from the midcentury, including the Fort of San Salvatore and Montorsoli's lighthouse of 1555, proclaimed Messina's naval fame. On an island off San Raineri lay the newest Lazzaretto, built in 1622—a reminder that our twenty-first-century pandemic is nothing new.

Directly ahead, the Palazzo Reale—Messina's chief architectural complex—exemplified viceregal sovereignty. In Messinese lore, the original castle was attributed to Orion, the city's mythical founder. Tuscan architect and sculptor Andrea Calamech, who trained under Bartolomeo Ammannati, a disciple of Michelangelo, reconfigured the existing citadel, transforming it into a Renaissance palace.[42] Successive refinements focused on elevations facing the harbor and the Straits. A stately central portal, completed in 1623, drew the maritime traveler's gaze along an aquatic axis across the harbor. As *Maestro di Strada*, Calamech established an aesthetic of Mannerist classicism based on Florentine models.[43]

Restructuring the city—avenues and plazas

Leaving the harbor waters, we will traverse the grand avenues carved out in the final decades of the Cinquecento. In the fall of 1571, all eyes in Europe were on Messina as the massive Holy League fleet assembled to prepare for battle to halt Turkish aggression. Don John of Austria, the illegitimate son of Charles V and Philip II's half-brother, led the Christian armada, with Marcantonio Colonna—scion of an aristocratic Roman family—as admiral of the Papal fleet.[44] Triumph over the Turkish navy in the brutal Battle of Lepanto marked the turning point in Ottoman territorial expansion, splitting the Mediterranean into the Ottoman-controlled Eastern Sea and the Western waters—under the dominion of the Habsburgs and their associated Christian entities.

Just as Charles V's entry had stimulated urban improvements, the dazzling triumphal procession for Don John in 1571 again ignited a building fervor. During a period of relative political and economic stability from the end of the Italian War in 1559 until the start of the Thirty Years' War in 1618, the Spanish administration initiated a process of extensive urban restructuring.[45] Here, Renaissance planning theories found their way to Messina, a century after their birth on the Italian peninsula.

Three new processional thoroughfares created by Calamech revitalized the city's interior. A pan-urban road, formed by regularizing the winding via dell, Uccellatore, connected the Porta Reale with the inland Porta Imperiale, which was rebuilt to emulate the ephemera of Charles V for the arrival of Viceroy Pedro Téllez-Giron in 1620. Luminaries could thus follow in the Emperor's historic path along the stylish street. In March 1572, the Senate, not to be outdone by Palermo, proposed plans for a thoroughfare similar to Palermo's Cassaro '*per decoro di questa cita e del Regio Palacio*', called the strada Austria in honor of Don John.[46] Carved out of the Giudecca quarter in 1596, via Cardines—a second diagonal street—crossed the strada Austria, forming an intersection later called the Quattro Fontane. This spatial restructuring provided venues where inhabitants could 'tak[e] possession of the space' and become active participants, allowing the urban organism to 'come alive' as resonant space.[47]

Benefits to the viceregal administration were clear. By tying the Piazza del Duomo—Messina's traditional religious and civic core—to the Habsburg center of power at the Palazzo Reale, the Spanish exerted an incontrovertible physical and symbolic dominance within the city. Sculptural landmarks defined each pole of the rigidly straight roadway. To commemorate the stopover by the Habsburg prince, Calamech created a bronze statue of Don John, which dominated the square adjoining the royal palace.[48] The triumphant hero faced the resplendent Orion Fountain of 1553 at the other extremity of strada Austria. Designed by Florentine sculptor Giovanni Montorsoli, formerly an assistant to Michelangelo, the lofty candelabrum-style fountain memorialized spectacles from 1535, assuming a central role in the quotidian and festal life of the city. These and other key nodes in each city form what historian Pierre Nora called *lieux de mémoire*: 'ensembles constructed over time, which draw their meaning from the complex relations between their elements'.[49]

Rich iconography in the Orion Fountain, devised by humanist scholar Francesco Maurolico, melded themes of territorial domination with allusions to Messina's historical and mythical genesis.[50] Its complex decorative program—elucidated with Latin inscriptions—instigated allegorical strategies used in the ensuing decades to assert hegemony by embedding Habsburg legends in this primary urban node. English traveler Thomas Hoby, on a visit in 1550 to Messina—in his words, 'on[e] of the fairest portes in Europe'—proclaimed that the partially completed fountain 'to my eyes is on[e] of the fairest peece of worke that ever I sawe'.[51]

The viewer enjoying the splashing waters of the fountain's basin could read a narrative of hydrographic mythology, in which four reclining river gods blend Habsburg and Messinese history. The Nile figure suggests the Emperor's recent victory in North Africa. Sculptures of Scylla and Charybdis, the mythical tyrants of the Straits tie ancient lore to the Camaro River god. The god of the Ebro River in Iberia signifies the Spanish Habsburgs. An inscription beneath the Tiber River god cements ties to Rome, stating, 'In return for your ancient faith, Messina, the urn of the great Tiber pours forth perennial waters for you'.[52] Below the crowning figure of Orion, clad in Roman armor and bearing a shield with Messina's insignia, a caption proclaims, 'He is Orion, that builder of Zancle, made into a star, the witness of ancient nobility'.[53] Maurolico thus established Charles V as the 'new Orion', elevating him to the pantheon of the gods.

Development of the littoral

In 1557, Viceroy Juan de Vega initiated a new relationship between city and sea with the commission for Montorsoli's Neptune Fountain. At the center stage along the littoral, the towering figure of Neptune stood as if a conductor over the urban scene. Groundbreaking in the use of a single monumental figure, the statue brought ancient Rome to Messina's shore. Paradigms include Alberti's plans for a seaside haven, as well as celebrated port statues of antiquity, including the Colossus of Rhodes, and the massive statue of Trajan at Ostia.[54]

The potent emblem of Habsburg authority stood with his right arm extended to calm the seas and to pacify Scylla and Charybdis, in a gesture of dominance

emulating classical statues of Roman emperors.[55] The narrative formulated by Maurolico recalls the Greek tale of Poseidon—here as the Roman god Neptune—who separated Sicily from the Italian peninsula by a stroke of his trident. Within the heraldic crest, an inscription reads, 'This is the boundary of the Kingdoms. Here the land, here the waters serve the invincible Charles and Philip at the same time', alerting viewers they were entering Habsburg territory. Alluding to the 'Quos Ego' episode from Virgil's *Aeneid*, the message also kindles gratitude toward Charles V for bringing tranquility to Messina by vanquishing the Turks and the Barbary pirates, represented by carvings of ferocious chained monsters.[56] Notably, in 1550, predating these imperial monuments, viceroys had commissioned Florentine sculptor Martino Montanini to build statues of two Giants on horseback representing Mata and Grifone, Messina's legendary founders, thereby mollifying local sentiments.[57]

Following the Battle of Lepanto, waterfront ramparts became superfluous, and the relative safety of the harbor zone made civic development along the shoreline feasible. Visiting dignitaries customarily disembarked at the eagle-capped Porta Reale at the mouth of the harbor, designed by Calamech in 1571 for Don John's entry. Built on the site of the ephemeral arch for Charles V, the ensemble reverberated with historical significance. From there, one might enjoy shopping for Messina's famed silks along the elegant via dei Banchi, modernized by Viceroy Marcantonio Colonna in 1577. Or one could enjoy a seaside promenade along the strada della Marina, paved by Colonna in 1579 in a bold gesture that engaged land and water. Concurrently, Colonna instigated a similar enterprise in Palermo, thereby enfolding the aquatic and synthetic landscapes in a feat that single-handedly altered the urban experience.

By facilitating bodily movement and engaging the tactile senses in an unprecedented relationship with the formerly inaccessible shoreline, urban dwellers could enjoy refreshing sea breezes, sparkling harbor waters, and the vast expanse of water and sky. This engagement through what Pallasmaa termed 'the eyes of the skin', wherein the body is 'the very locus of reference, memory, imagination and integration', created new spatial and haptic experiences that marked the demise of constrained medieval urban life and gave rise to new, complex emotional experiences and attachments.[58]

English travel writer, George Sandys, traveling through Messina in 1610, described the charming nightly parade of pleasure-seeking residents enjoying the uplifting seaside venue:

Every evening they solace themselves along the Marine (a place left throughout between the City wall and the Haven) the men on Horse back and the Women in large Carosses being drawn with the slowest procession. There is to be seen the pride and beauties of the City.[59]

Neuroscientist Jaak Panksepp, examining the biological dynamics between human emotions and architecture, identified the instinct for play as a basic desire for interaction and social bonding that is 'coincident with the primal compulsion for ritual'. By fabricating public venues for pleasure and social interaction, and for frequent public spectacles, the Habsburgs introduced a 'playful' environment that positively impacted the 'hedonic or pleasure circuit[s]' of the urban participants.[60]

With the opening of the coastal esplanade, a cohesive composition germinated around Montorsoli's seaside fountain. Importing monumental Roman classicism, in 1589 Sicilian-born architect Giacomo del Duca—assistant to Michelangelo on the Porta Pia, the Campidoglio, and other projects in Rome—instigated this new phase of waterfront construction. Executing Calamech's proposal from 1584, he built the Porta della Loggia as a triumphal arch behind the Neptune Fountain, emulating the giant double order on Michelangelo's Palazzo dei Conservatori. Del Duca was the first to envision a maritime theater composed of an architectural curtain wall to replace the unadorned battlements. He launched the visionary enterprise by breaching a section of the fortifications to build the marble-clad Palazzo del Banco (Palazzo Senatorio), echoing the form of the Palazzo Reale.[61]

In 1622, preparations for the entry of Viceroy Emanuel Filibert of Savoy prompted a fresh look at the stalled project for a coastal building circuit. Savoy immediately approved plans to build the audacious *Teatro Marittimo*, or Palazzata, largely based on Del Duca's proposal.[62] To solicit funds from private investors, architect Simone Gullì produced a painting illustrating the proposal by Savoy's personal architect, Giovanni Antonio Ponzello.[63]

Completed by 1625, prosperous merchants and aristocrats gradually razed the severe fortifying walls along the curving harbor, replacing them with a uniform screen of 13 elegant four-story palazzos, pierced by 18 portals designed as triumphal arches. Reminiscent of High Renaissance palaces, the rhythmic composition stretched for nearly one-and-a-half kilometers. From balustraded stone balconies, occupants enjoyed spectacular, privileged views across the harbor. Unlike Palermo, where the waterfront remained in the hands of the Habsburgs, the seaside palaces formed an aristocratic residential quarter, ushering in a new, social hierarchy. Henceforth, Messina lost all semblance of a fortified city. As the shoreline became more accessible, citizens were irrepressibly drawn to the aqueous plaza, which offered constant stimulation and pleasure, with the regular 'tour à la mode' and frequent 'splendid concerts', described by Dutch landscape painter, Willem Schellinks.[64] Through the enframement of vast aquatic panoramas, planners captured the strategy of scale that became a hallmark of Baroque gardens, where magnificent perspectival vistas led the eye to infinity.

A chief tenet of Baroque architecture is its rhetorical quality or the ability to persuade. As such, the audacious new *teatro a mare* single-handedly allowed Messina to reinvent itself, thereby proclaiming the wealth and status of the thriving port. In contemporary parlance, the term 'teatro' was used primarily to refer to buildings. Its meaning, however, also included the stage, the action, and the performance of the spectacle. The use of the term 'teatro' to describe the Palazzata reveals the extent to which the idea of the theater had become interwoven with concepts of the city. Richard Krautheimer's summary of the notion of the 'teatro' in Baroque Rome is equally relevant to Messina's *teatro a mare*:

…the setting in which the action takes place…the square across which the papal cortège moves; the stage set against which the play is performed—they are constituent elements of the "teatro." … The building itself is the main actor and performs the grand show to be admired by the spectators.[65]

Sweeping slowly past the scenographic Palazzata, a sense of unreality may have overcome the newly arrived traveler who—becoming both actor and spectator—might have felt they had landed on the stage of an elegant Baroque theater designed on an urban scale. Intertwining theater, stage, and city, the Palazzata's proscenium derived from the classical *scenae frons* with multiple vanishing points opening onto perspectival street scenes, reminiscent of Vincenzo Scamozzi's stage set of 1585 for Palladio's Teatro Olimpico. Moreover, those familiar with Pirro Ligorio's reconstruction map of ancient Rome from 1561 would have felt as if they had entered a *naumachia* of antiquity. Naval prowess had evolved into civic decorum, activating a crescendo of new emotions.

Palermo

It is said, 'See Naples and die,' but I should rather say, 'see Palermo and live.'
Alexandre Dumas[66]

Palermo's origins, like Messina's, are shrouded in Greco-Roman myths, although Greek mythology played a greater role in Messinese history and Habsburg symbolism than it did in Palermo. It was, rather, the ancient personification of the city—the *Genio* or Genius of Palermo—an enigmatic pre-Christian figure of a king on a throne wearing a ducal crown with a serpent biting at its breast that spoke to the Palermitan's collective memory.[67]

Although the Habsburgs eschewed metaphorical associations with the city's profuse web of founding legends and patron deities, the viceroys honored local tradition by strategically siting new and existing images of the treasured laic figure. Their paramount objective, however, was to orchestrate a citywide allegorical program celebrating Habsburg rule. Reformulating Palermo's civic identity required a skillful balancing act, accomplished by preserving the rich historical mix of Norman and Islamic monuments - the latter an architectural heritage shared by Sicily and Spain, both of which had been under Muslim rule—while propelling the city into the modern world of classicism and urban decorum.

Called the *Conca d'Oro*, or Golden Shell, for its sheltering semicircle of mountains, Palermo fronts on a broad, natural harbor. Two rivers—the Papireto and the Maltempo—flow in a parallel course from the mountains to the sea, straddling an elevated axis that became the dominant urban artery. In describing the commodious setting in 1558, the 'father of Sicilian history', Tomaso Fazello, accentuated the buoyant, therapeutic effect of the city 'washed by the Tyrrhenian Sea':

This land is not only the most beautiful in Sicily, but in the whole of Italy. It is watered by wonderful fountains and sweet waters wherefore [...] it gladdens the most melancholy and sorrowful spirit.[68]

Drawing on centuries of rapturous acclaim for the Palermitan landscape, the Habsburgs strove to weave this exultant experiential quality into the urban setting.

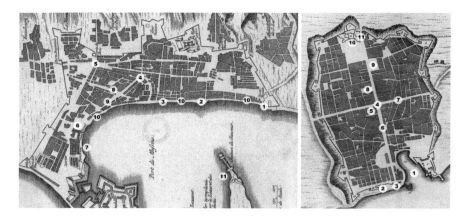

Figure 4.2 Left: Plan of Messina with Habsburg projects. 'Plan de la Ville de Messine', in *Description de l'isle de Sicile, e de ses côtes maritimes, avec les Plans de toutes ses Forteresses*, Pierre del Callejo y Angulo and Baron Agatin Apary, Amsterdam, 1734, Austrian National Library. (1) Porta Reale; (2) Strada Marina; (3) Neptune Fountain; (4) Orion Fountain; (5) Porta Imperiale; (6) Statue of Don John of Austria; (7) Palazzo Reale; (8) Via Cardines; (9) Strada Austria; (10) Palazzata; (11) Forte del Santissimo Salvatore. Right: Plan of Palermo with Habsburg projects. 'Plan de la Ville de Palermo', in *Description de l'isle de Sicile, e de ses côtes maritimes, avec les Plans de toutes ses Forteresses*, Pierre del Callejo y Angulo and Baron Agatin Apary, Amsterdam, 1734, Image from the collections of the National Library of Spain. (1) Cala; (2) Foro Italico; (3) Porta Felice; (4) Quattro Canti; (5) Fontana Pretoria; (6) Cassaro; (7) Maqueda; (8) Piazza Bologni; (9) Cathedral; (10) Palazzo dei Normanni; (11) Porta Nuova.

Urban infrastructure

In the 1530s, Ferramolino reconfigured the old Norman defensive circuit with modern ramparts conforming to the salient topographical features of the site, circumscribing a geometrical form evoking Vitruvian and Ideal City principles.[69] Set in the near-perfect rectangular fortifying walls, 12 bastions, named after saints, viceroys, and the presidents of Sicily, comingled Spanish and local politics with Counter-Reformation fidelity.[70] Responding to its vital role in housing the Spanish naval fleet, Viceroy García di Toledo instigated an ambitious program to relocate the harbor from the Cala—a diminutive horseshoe-shaped marina—to the coast northwest of the city. In courtly praise and flattery, the new Herculean monument in the sea was acclaimed 'the eighth wonder of the world' and was likened to the great ports of Alexander and Augustus. Botero declared the marvel of modern engineering a triumph of order over chaos.[71] Such hyperbole served as a rhetorical tool to heighten the political status of the city both to compete with other urban entities and to boost local pride. Alberti's schema for a seaside 'Haven', with its embellished '*Mole*', comes to mind in examining the Palermitan wharf.[72] However, unlike Alberti's porticoed jetties, Palermo's coastal façade—freed from utilitarian

use—received all the architectural flourishes. Consequently, spectacles, which had traditionally commenced at the inland gate, pivoted to the waterfront.

In a second building phase, Toledo initiated some of the most innovative and far-reaching improvements of the Cinquecento. Although most projects were not completed during his tenure, a new façade for the royal palace, revamping the city's hydraulics system, and construction of the eponymous avenue in 1567—dubbed the Cassaro—all began under Toledo's stewardship.[73] Tracing the ancient decumanus, the longitudinal artery stretched from the inland gates toward the sea, linking the chief structures of Norman Palermo and stitching together the primary religious and civic nodes.

Early modern restructuring

A decade later, Viceroy Colonna expanded on Toledo's arterial restructuring. With security still paramount, Colonna commissioned Sienese engineer, Tiburzio Spannocchi, to develop a modernized system of watchtowers encircling the island.[74] Major urban projects included paving the embankment in 1580—named strada Colonna in the viceroy's honor—and extending the Cassaro from the Piazza Marina to the sea in 1581. Botero praised the Cassaro in 1595, declaring, 'I do not know in which city in Italy there is an equal'.[75]

However, it was Colonna's vision for two monumental gates at either end of the sweeping central vector—the Porta Felice and the inland Porta Nuova—that invigorated the city. While Toledo's earlier renovations were based on Renaissance models of static purity and symmetry with a closed street/square system, Colonna's interventions transformed the Cassaro into a Baroque thoroughfare emulating Serlio's perspectival stage set based on a single vanishing point. The resultant aesthetic dynamism encouraged movement from the water through the city.

When Colonna disembarked at the Cala on 25 April 1577, as the newly appointed viceroy, ephemera included a giant shell signifying the *Conca d'Oro*. A lane formed by tall obelisks along the Molo Vecchio led to a temporary archway at the future site of the Porta Felice.[76] Iconographically, the columns referred to the Colonna family name and coat of arms, and to their purported descent from Hercules. It was perhaps at this moment—while experiencing the evanescent trappings—that Colonna envisioned the potential for dramatic alterations to the city he was to govern. Symbolic themes, including loyalty, virtue, and happiness, or *Felicità*, the overriding municipal attribute under the Habsburgs—all contained in ephemera for Colonna's reception in 1581—emerged in concrete form in the Porta Felice. In addition to evoking the sobriquet, *Palermo Felice*, Colonna named the landmark after his wife, donna Felice Orsini.

The theme of public happiness, or *felicitas publica*, dates from Aristotle's concept of *eudaimonia*, which translates as 'happiness' or 'welfare', and implies a state of joy, as well as sensations of harmony and security derived from protection under a benevolent, divinely sanctioned ruler. The Habsburgs politicized the concept to assert linkage with the Roman Empire and to bolster assertions that they scrupulously ensured their subjects' collective well-being.[77] Christened *Urbs Felix*, or

'happy city', in a panegyric of 1194, reminders of the ancient paradigm appeared in numerous viceregal projects, exemplified by the inscription on the Porta Nuova: *Undique* Felix or 'universally happy and blessed'. Hand in hand with *Felicità* were concepts of fidelity and virtue. To underscore loyalty to the Spanish, this civic attribute was inscribed on the Quattro Canti with the words '*Fidelitas Panormi Gloria*'.

Colonna focused on building the Porta Nuova, which was completed in 1583 by Tuscan architect, Giovanni Battista Collepietra. In 1602, Architect of the Senate, Mariano Smiriglio, resumed work on the Porta Felice. Various temporary arches constructed on the site during the building hiatus—including that fêting Viceroy Enrique de Guzmán, Count of Olivares, in 1592, with allegories of clemency and justice, and copious symbols of happiness, love, and honor; and the twin, pyramidal obelisks in celebrations for procurement of the reliquary of Santa Ninfa in 1593—undoubtedly influenced the final design.[78] The portal's seaside façade, completed in 1637, represents a movement away from often-dissonant Mannerist elements to the ornate, plastic monumentality of Early Roman Baroque architecture. The great rift between the wings permitted passage of processional vehicles, such as the colossal cart used in yearly festivals for Santa Rosalia; established as the patron saint of Palermo in 1624.[79]

Traversing Baroque Palermo

Arriving from the sea and following this linear pathway, nearly 2 kilometers in length, we will examine Habsburg interventions in an excursion through the seventeenth-century city. From encomiums and propagandistic rhetoric in travel accounts, expectations would have been high. Palermitan Gaspare di Reggio, in a memorandum of 1599 to the incoming Duke of Maqueda, described the 'superb streets with magnificent palaces and ornate loggias, delightful fountains and arches', encouraging the viceroy to continue such public works to placate the residents.[80] In this haptic, kinesthetic, and visual journey—informed by the lens of Maurice Merleau-Ponty's notion of bodily engagement with the built environment—we witness how architecture generated the phenomenon of emotion arising out of motion, a concept rooted in the etymology of the word 'emotion'—from the Latin *emovere* or 'to move out'.[81]

Approaching Palermo across the Tyrrhenian Sea, the sight of the Molo's cyclopean boulders would have dazzled the maritime voyager. Continuing toward Palermo's idealized form, one would have felt as if the ship were propelled along an aquatic axis leading toward the two massive wings of the Porta Felice, the sole break in the seaside walls. The extraordinary sensations aroused when contemplating this liminal space between the city and the sea were encapsulated in Goethe's words of 1787:

> No words can begin to describe the vaporous clarity which hung around the coast on the wonderful afternoon of our arrival in Palermo: the purity of forms, the softness of the whole, the range of nuances, the harmony with

which land, sea and sky were united. Whoever has seen this spectacle will treasure it in his heart for the rest of his life.[82]

Disembarking from the Cala waters at strada Colonna, we stand in a scenographic urban forecourt outside the city walls (Foro Italico), which, by the late Cinquecento, had become a theatrical space dedicated to the Spanish kings, whose statues presided in arched niches adorning the stone ramparts. In its towering scale, stateliness, and iconography, the Porta Felice greets visitors with a simple message, blatantly proclaiming that one is entering the domain of the Habsburg monarchs. Enormous eagles symbolizing the Crown and the municipality of Palermo perch atop twin blocks. Again, the Pillars of Hercules are invoked. The invigorating effect of their lofty mass is encapsulated in Wölfflin's words about the '*great vital feelings*' induced by architectural form: 'Powerful columns energetically stimulate us'.[83] In niches beneath the intertwining message of dynastic power and civic pride, statues of Santa Cristina and Santa Ninfa display the Christian virtues of the illustrious port. All the Baroque grandeur faced the open sea. By contrast, the staid Renaissance appearance of the interior elevation reveals an earlier vision for the gate.

Through the portal, one's gaze concentrates down the elegant Cassaro to the dramatic focal point of the Porta Nuova at the terminus—standing 28 meters taller than Porta Felice. Passing through the split arch, we embark on a spatial narrative that chronicles Palermitan ideals and values in a mixture of historic, new, and partially completed structures.[84] The Cala's waters shimmer to the north, while to the south, the Romanesque Gothic-style Palazzo Chiaramonte Steri—home of the Spanish Inquisition—presides over the Piazza Marina, site of the dreaded *autos-da-fé*. Despite the glamour of viceregal endeavors, the local seat of the Holy Office and the adjoining Vicaria prison, built in 1603–1605, underscored the formidable scope of Habsburg power, serving as a bitter reminder that obeisance to Church and king was critical.[85] All was thus not *felicitas* in the viceregal city. Frequent reminders of Spanish rule embedded throughout the city, with the attendant shadow of the Inquisition, undoubtedly contributed to an underlying sense of apprehension among the citizens impelling them into submissiveness and conformity.[86] Fear played a dual role in governance. Machiavelli stressed that trepidation was a crucial instrument of government, whereas Hobbes argued that freedom from fear through strong military protection was a powerful inducement for acquiescence to imperial rule.[87]

Ornate carvings on richly embellished palaces and churches in our peripheral vision 'envelop us in the flesh of the world' bringing an immediacy and sense of connection with the path itself. Pallasmaa asserts that 'Peripheral vision integrates us with space, while focused vision pushes us out of the space, making us mere spectators'.[88] Arguably, both focused and unfocused vision—with the concentrated experience of being a spectator to the awe-inspiring Spanish crown, while simultaneously being enfolded in a sensorial urban experience—was critical to the Habsburg's urbanistic goals.

Exploring the Cassaro, we see how the spatial sequences activate a range of emotions as movement is funneled along the straight avenue. In the rhythmic line

of aristocratic palazzos—embellished with robust central portals, ornate balconies, and aristocratic coats of arms—the grandness of scale contrasts with the intimacy of ornamentation and the tactile materiality of Mannerist rustication and elegant Baroque carvings, heightening our connection with the Habsburg world. Amidst the displays of secular ostentation, numerous Baroque churches and confraternities summon pious sentiments.

As we approach the heart of the city, we are oriented in space by the cross-axis of the palace-lined Maqueda, built between 1600 and 1602 by Viceroy Bernardino de Cárdenes, Duke of Maqueda. With its creation, Palermo's new quadripartite diagram reflected ideal city plans and evoked Biblical origins as the Garden of Paradise and the prophesied city of the New Jerusalem, rousing moral and divine associations. Parallels between Palermo's urban form and the design of the recently completed Escorial, reminiscent of a walled city, with its attendant Solomonic and hermetic imagery, suggest the involvement of Philip II—proclaimed 'prudent king' Solomon by the Spaniards—who had closely managed designs for the great monastery. As a facet of the meticulous program of legitimising mythmaking, the establishment of a Solomonic heritage endowed the Habsburg dynasty with the moral and religious authority to reunite the Christian world.[89]

At the intersection of the Cassaro and the Maqueda, the octagonal plaza of the Quattro Canti (Piazza Vigliena), with four concave façades encrusted with a Baroque sculptural program, arrests movement with its dazzling display. Its lavish theatricality exemplifies the type of charisma proposed by Gottfried Semper, who maintained that 'the factors determining the formation of an atmosphere should be traced to the decorative backdrop that wraps the face of a building like a garment'. Echoing these sentiments, Louis Sullivan asserted that a decorated building 'is in its nature, essence and physical being an emotional expression'.[90]

Designed in 1608 by Florentine architect, Giulio Lasso, and completed in 1621 by Mariano Smiriglio, the enclosure reads as a potent metaphor for the interlocking values of monarchy, religion, and municipal integrity. Adorning the first tier, the four seasons—signifying Fidelity, Peace, Order, and Happiness—form an ideological narrative designed to secure the loyalty of the citizenry. Figures of the Spanish rulers, with crowns, scepters, and swords—intended to preside over the plaza from the third story in Lasso's original proposal—were not ensconced on the second story until the 1660s.[91] On the third level, patron saints denoting the four city quadrants underscore Habsburg religious authority. Coats of arms and crowned eagles cap each façade. Lauded as a display of marvels derived from great Roman forums of antiquity, a city leader hoped the kingly statues 'might shine on the regal street, and animate the royal avenues, and bestow eternity on the city'.[92]

Nearby, the Fontana Pretoria, a rare example of High Renaissance art in Palermo, forms the centerpiece of the Piazza Pretoria. Not to be outdone by Messina, with its grand fountains by Montorsoli, the Senate acquired the marble fountain in 1574. Designed by Tuscan sculptor Francesco Camilliani in 1555 and considered by Vasari to be unequaled in Florence and perhaps all of Italy, it bore no Habsburg imagery but instead reflected viceregal largesse.[93] By contrast, sculptor Scipione Li Volsi's bronze statue from 1631 of Charles V as a triumphant Roman Emperor highlighted monarchal authority from the nearby Piazza Bologni.

Foreign captors left a rich architectural legacy that was considerably more exotic than that of Messina, chiefly with the eclectic Cathedral, and the Cappella Palatina with its glittering Byzantine mosaics, set within the Palazzo dei Normanni. Nearing the city's inland extremity, the great Norman structures open onto broad plazas, regularized by the Spanish to accommodate festivals and official cavalcades. Finally, the festive, pyramid-capped Porta Nuova, forming a shrine commemorating the entry of Charles V, signals the completion of the procession down the long parade avenue.[94]

The gate's two elevations differ markedly. Designed as a *scena tragica* evoking Serlio's archetypal stage scene, the façade facing the Cassaro resembles a classical triumphal arch. On festival days, the figures of the Viceroy and his retinue adorned the upper balconies, where they had glorious views from Monreale to the sea.

The *scena comica* on the exterior elevation reveals the influence of Italian Mannerism and theatrical set design. Visitors approaching from the outlying territory viewed an allegory about the remarkable conquests and unrivaled strength of Charles V. Although Colonna paid homage to the Habsburgs—perhaps to prove his loyalty to Philip II and to soften rumors of scandal in his personal life—the composition contained a self-congratulatory message, hailing his role as the hero of the Battle of Lepanto. In this idiosyncratic composition, four Moorish figures, with their arms crossed or broken in a sign of submission to the Emperor, rest on *grotesque* heads surmounting rusticated columns. The contemptuous portrayal of the subjugated Moors proclaimed Spanish hegemony in the binary relationship between the Habsburg's Western European world of the Habsburgs and their adversaries from the Orient. The gate's proximity to the Norman cathedral and the Palazzo dei Normanni—the official viceregal residence starting in the mid-Cinquecento and partially reclad in Renaissance garb in 1616—counteracted the historical dominance of Arab culture with a new dynastic chronicle asserting Occidental superiority.

Accolades

Contemporary observers exulted over the elegant city. Historian Vincenzo Di Giovanni created a metaphor for Palermo, highlighting the new balance in the physiography of the *Conca d'Oro*. Palermo, he eulogised, is composed of three golden crowns studded with precious gems. The circle of mountains and the great human constructs, highlighted by the cathedral at Monreale and the 'proud structure of the wharf', formed the first diadem. Palermo's city walls, emblazoned with projecting bastions, represented the second crown. 'Jewels' of sixteenth-century planning, including the Cassaro and the Maqueda, with their superb Octagon', and the two lofty city gates comprised the third crown.[95]

Seventeenth-century devotional publications for Santa Rosalia pictured an idealized Palermo, conferring a pious character on the city. Early modern cartographers extolled the happy circumstances of the site and urban form, labeling it '*Palermo Magnifico*' and '*Paradisus Voluptatis*'. Alexandre Dumas, enchanted in his visit of 1835, encapsulated the visual and perceptual impact of the commodious setting that had changed little since the early Seicento.

96 *Tamara Morgenstern*

Palermo still deserves the name given to her twenty centuries ago; she is today as she was then, Palermo the Happy. In fact, if there is a city in the world that unites all conditions for happiness, it is this careless daughter of the Phoenicians called Palermo Felice whom the ancients represented seated like Venus in a golden Shell.[96]

Conclusion

By the 1620s, when both cities had reached a state of equilibrium between land, sea, sky, and urban form, they contained an amalgamation of signs laden with the fictional heritage, political ambitions, and value systems of the Habsburgs.

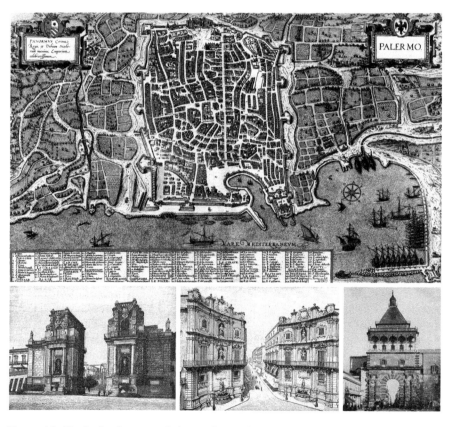

Figure 4.3 Clockwise from top: Palermo, Braun & Hogenberg, *Civitatus Orbis Terrarum*, 1588–1597; Porta Nuova, exterior elevation, Henry Pauw van Wieldrecht, c. 1893–1903, Rijksmuseum; Quattro Canti, Giuseppe Barberis, 1890, in Gustavo Strafforello, *La patria, geografia dell'Italia, Parte 5. Italia insulare*, 1893; Porta Felice, anonymous, 1890, in Gustavo Strafforello, *La patria, geografia dell'Italia, Parte 5. Italia insulare*, 1893.

The coastal façades—akin to giant billboards at each city's leading edge—bore the weight of development as frontispieces proclaiming identity and denoting authorship. Civic portraits in maps and bird's-eye views, created for the approval and pleasure of the distant Spanish ruler, facilitated this façadal approach.[97] Romanticized *vedute*, generated through the emerging field of descriptive geography, emphasized the human element in the landscape, creating narrative spaces portraying history and politics, as well as myths and legends. Accordingly, cartographers 'sought to… inspire wonder', favoring artistic fantasy over the factual in images where 'the world and everything in it was a source of delight'.[98] In a reciprocal fashion, fanciful encomiastic city views, which 'design[ed] the *emotion* of lived space', inspired planners to create environments of spellbinding allure, with rich architectural veneers that masked the disorderly realities of the urban experience.[99]

Experientially, both Messina and Palermo embodied the kinetic traits of Michelangelo's architecture, described as 'a sculptural three-dimensional art of dynamic expressive structure with axes and vistas revealed by movement through space'.[100] Drawing on Hobbes's notion of external motion stimulating internal emotion, this new dynamism ushered in an era of public spectacles that awakened sensations of piety, wonder, admiration, and devotion.[101] In Rome, Michelangelo had ignited such urban vitality in 1536 through the innovative axial sweep leading to the refurbished Campidoglio. Notably, Calamech's innovative scheme of diagonal boulevards linking civic landmarks in Messina was a presentiment of papal architect Domenico Fontana's restructuring of Sistine Rome a decade later.

The Palazzata provided a backdrop for waterborne pageants and nautical displays, enlivening Messina's port waters with new experiential energy. Unlike Messina's scenographic framing of its liquid basin, Palermo's connection to the marine environment was based on triumphal imagery and processional movement, exemplified by the powerful kinetic effect created by the phantom central bay of the Porta Felice, which drew the spectator into the ceremonial path of the Cassaro. Renaissance and Baroque theatrical devices derived from theater buildings and stage sets engaged the viewer, stimulated motion, and manipulated the spectator's gaze using the recently developed art of perspective. In each, the flat plane of the sea became fused physically and experientially with the city proper.

Calculated to capture attention through monumental scale and opulent materials, the radically reshaped environment produced emotive experiences on visceral, behavioral, and reflective levels.[102] The instinctual response to the perception of aesthetic beauty inspired wonder and excited curiosity, passion, and artistic gratification. On a quotidian basis, the formal settings established order and stability, which facilitated imperial rule. The architectural framework modified and sculpted behavioral responses. The resultant physiological sensations aroused an emotional bond, fostering a sense of place, and engaging the participant with the Spanish sovereigns.

Through metaphorical devices evoking imperial narratives, skillfully woven into key urban nodes, meaning and memory became essential components of the urban experience. This Mannerist and Baroque iconography formed a new '*lingua imperii*', articulating a universal expression of monarchical ideals that stimulated

98 *Tamara Morgenstern*

an enveloping consciousness of participation in the Habsburg's global enterprise.[103] Moreover, new foundation legends deeply woven into the spatial constructs became a crucial component of each city's collective memory, resonating over the decades as remembrances of the Emperor's visit shaped the urban environments. Thus, through the deliberate molding of feelings and behavior these viceregal colonies became 'emotional regimes', wherein, as William Reddy proposes, 'emotional control is the real site of the exercise of power'.[104]

Examining the restructuring of urban environments to further the goals of universal monarchy through psychological manipulation and human engagement—illuminated by current studies in cognition, neuroscience, and phenomenology—offers a new lens for understanding the transmission of architectural knowledge across geographic boundaries in the early modern world. Moreover, by assessing the values, motives, and emotions of the rulers themselves, a psychological profile emerges that contributes to an understanding of the interplay between royal patrons and architectural production within historical regimes.

Notes

1. Rosenwein, *Emotional Communities*.
2. Mallgrave, *Architecture and Embodiment*, p. 121.
3. Canepa, *Atmosphere*, p. 117. Theories of phenomenology and atmosphere by Gaston Bachelard, Martin Heidegger, and Maurice Merleau-Ponty, influenced numerous architects, including Aldo Rossi, Christian Norberg-Schultz, Daniel Libeskind, Steven Holl, and Peter Zumthor.
4. Ibid., p. 87.
5. Ackerman, *Architecture of Michelangelo*, p. 134. Architects born or trained on the Italian peninsula who worked in Sicily include Polidoro da Caravaggio (c. 1499–1543); Giovanni Angelo Montorsoli (1507–1563), Andrea Calamech (1524–1589), and Giacomo Del Duca (c. 1520–1604) in Messina; and Giovanni Battista Collepietra (c. 1530–1602), and Giulio Lasso (d. 1617) in Palermo. See *Dizionario Biografico degli Italiani*.
6. Malumbres, 'Política Artística', p. 8.
7. Mulcahy, *Philip II*, pp. 4–5.
8. Crouch, *Spanish City Planning*, pp. xxi, 6–19.
9. Kagan, *Urban Images*, pp. 28–39.
10. Elliott, 'Composite Monarchies', pp. 48–71.
11. Machiavelli, *The Prince*, p. 20
12. Guarino, 'Reception of Spain', pp. 97–100. Habsburg strategies to appease the Neapolitans were similarly implemented in Sicily.
13. Elliott, 'Composite Monarchies', p. 69.
14. Barclay, 'State of the Field', p. 459.
15. Ibid., p. 457.
16. Botero, *Greatness and Magnificence*, pp. 14–16.
17. Dandelet, *Spanish Rome*.
18. Aikin, 'Pseudo-ancestors', pp. 8–15.
19. Folguera, 'Viaje Triunfal', p. 12.
20. Manfrè, 'Sicilia de los Cartógrafos', pp. 79–81.
21. Vesco, 'Tomasello'.
22. Cited in Calabrese, 'honra della "Palazzata"', p. 164. On Messina as gatekeeper to the Tyrrhenian Sea, see pp. 163, 229.
23. Hobbes, *Leviathan*.

24 Malumbres, 'Política Artística', pp. 2–11.
25 Quoted in Koenigsberger, *Practice of Empire*, p. 172.
26 Piazza, 'L'architettura dei viceré' p. 22.
27 Parker, *Grand Strategy*. On the circulation of ideas between Madrid, Italy, and the Americas, see Malumbres, 'Política Artística', p. 7. See also, Kaufmann, *Geography of Art*; and Escobar, 'Spanish Habsburgs', pp. 258–259.
28 Said, *Orientalism*, pp. 59, 74.
29 Hobbes, *Elements of Law*, p. 59.
30 Osorio, 'Courtly Ceremonies', pp. 38, 59–61.
31 Ibid., p. 42. Osorio associates spaces of urban ritual to what Michel de Certeau terms a 'field of operations'. See de Certeau, *Practice of Everyday Life*, pp. 122–124.
32 Historian Mark Seymour coined the term 'emotional arenas', building on Rosenwein's notion of 'emotional communities'.
33 Osorio, 'Copy as Original'.
34 Hauser, *Social History*, p. 82.
35 On 'tension between interior and exterior', see Zumthor, *Atmospheres*, pp. 45–49.
36 Jacka, *Book of Roger*.
37 Bertinoro, *Terra Santa*, p. 18.
38 Osorio, 'Ceremonies', pp. 44–50.
39 Folguera, 'Viaje Triunfal', pp. 15–20.
40 Tanner, *Last Descendant*, pp. 154–155.
41 On the art of memory, see Bruno, *Atlas of Emotion*, pp. 219–223.
42 Sutera, 'palazzo Reale', p. 47.
43 Ffolliott, *Civic Sculpture*, p. 225.
44 Crowley, *Empires*, p. 246.
45 Guarino, 'Reception of Spain', p. 100.
46 Gigante, *Messina*, p. 62.
47 Canepa, *Atmosphere*, p. 17.
48 Ffolliott, *Civic Sculpture*, pp. 183–185.
49 Nora, 'Memory and History', p. 22.
50 Ffolliott, *Civic Sculpture*. On the Orion and Neptune fountains, see pp. 35–138. On Maurolico, see pp. 38–39.
51 Hoby, *Thomas Hoby*, pp. 44–45.
52 Ffolliott, *Civic Sculpture*, p. 78. 'Ancient faith' refers to Messina's role in aiding Rome during the first Punic War.
53 Ibid., p. 130.
54 Ibid., pp. 143–144.
55 On propaganda equating emperors with the gods, see Tuck, 'Triumphal Imagery', pp. 327–335.
56 Ffolliott, *Civic Sculpture*, p. 172, 163–166.
57 On processions with the Giants, see De Gennaro and Giannattasio, 'Schellinks', pp. 157–158.
58 Pallasmaa, *Eyes of the Skin*, pp. 10–11.
59 Sandys, *Sandys Travels*, p. 192.
60 On 'play' and architecture, see Mallgrave, *Architecture and Embodiment,* pp. 107, 179–185.
61 Aricò and Piazza, 'Palazzata', p. 481.
62 Ffolliott, *Civic Sculpture*, p. 226.
63 Aricò, 'Palazzata', p. 481. See also, Aricò, 'Del Duca'.
64 For Schellinks's description of the Palazzata from 1664, see De Gennaro and Giannattasio, 'Schellinks'.
65 Krautheimer, *Rome of Alexander VII*, p. 6.
66 Dumas, *Speronara*, p. 356.
67 di Giovanni, *Palermo restaurato*.

68 In Pirrone, 'Sicilian Gardens', p. 259.
69 Garofalo and Vesco, 'Ferramolino'.
70 Fagiolo and Madonna, *Teatro*, Fig. 93. The authors correlate Matteo Selvaggio's 1542 ideogram of Rome as the Celestial Jerusalem to symbolism in Palermo's fortifications, with 12 gates corresponding to the 12 tribes of Israel, 12 signs of the zodiac, 12 apostles, and 12 articles of Christian faith.
71 Ibid., pp. 32–33. See also Campanella, *monarchia*, p. 138.
72 Alberti, *Ten Books*, p. 172; Plate 49.
73 Malumbres, 'Política Artística', pp. 34–40, and Casamento, *Cassaro*.
74 Manfré, 'Sicilia de los Cartógrafos', pp. 79–94.
75 Botero, *Greatness and Magnificence*, p. 116. Translation by the author.
76 Pirrone, 'Sicilian Gardens'. p. 262. On pageantry for Colonna, see Fagiolo, pp. 126–133; fig. 190.
77 On *felicitas publica* in imperial iconography, see D'Onofrio, '"Felicitas Publica"', pp. 452–454.
78 On ephemera for Olivares, see Fagiolo, *Teatro*, figs. 193, 194. On Santa Ninfa, see figs. 195, 196.
79 Fagiolo, *Teatro*, p. 141.
80 Quoted in Reyes, 'Descripción de Palermo', p. 2821.
81 Bruno, *Atlas of Emotion,* pp. 6–7. See also Merleau-Ponty, *Phenomenology*.
82 Goethe, *Italian Journey*, p. 228.
83 Quoted in Canepa, *Atmosphere*, p. 154.
84 Many buildings along the Cassaro were not completed until the late Seicento.
85 The Spanish Inquisition was established in Sicily in 1478 with an office in Palermo and was formally closed in 1782.
86 Lea, *Inquisition*, p. 209.
87 Ahmed, *Cultural Politics*, p. 71.
88 Pallasmaa, *Eyes of the Skin*, p. 13. Pallasmaa evokes Merleau-Ponty's term, the 'flesh of the world'.
89 Philip II's interest in the biblical temples is evidenced in his support for Villalpando's treatise on the reconstruction of the Temple. See Taylor, 'Architecture and Magic', p. 82.
90 Canepa, *Atmosphere*, pp. 73–74.
91 Di Fede, 'festa barocca', p. 54.
92 Fagiolo, *Teatro*, p. 105.
93 Vasari, *Le Opere*, p. 628.
94 Baskins, 'Mistaken Identities', pp. 331–354.
95 In Fagiolo, *Teatro*, pp. 103–104.
96 Dumas, *Speronara,* pp. 349–350.
97 For early modern maps of Messina, see Gigante, *Messina*. For Palermo, see De Seta and Di Mauro, *Palermo*.
98 Jackson, *Necessity for Ruins*, pp. 68–69.
99 Bruno, p. 9.
100 de Zurko, review, *Architecture of Michelangelo*, pp. 43–44.
101 Rosenwein, *Generations of Feeling*, pp. 291–295.
102 Norman, *Emotional Design*, pp. 21–24.
103 Malumbres, 'Política Artística', p. 5.
104 Reddy, *Navigation of Feeling*, p. 129, and 'Against Constructionism', p. 335.

Bibliography

Ackerman, James, *The Architecture of Michelangelo* (New York: Viking Press, 1961).

Ahmed, Sara, *The Cultural Politics of Emotion* (London: Routledge, 2015).

Aikin, Judith Popovich, 'Pseudo-ancestors in the Genealogical Projects of Emperor Maximilian I', *Renaissance and Reformation*, 1, no. 1 (1977), pp. 8–15.

Alberti, Leon Battista, *The Ten Books of Architecture* (New York: Dover, 1986).
Aricò, Nicola, 'Un'opera postuma di Jacopo Del Duca. Il teatro marittimo di Messina', in Aldo Casamento and Enrico Guidoni (eds.), *L'Urbanistica del Cinquecento in Sicilia* (Rome: Edizioni Kappa, 1998), pp. 172–93.
Aricò, Nicola and Stefano Piazza, 'Per ricostruire la Palazzata seicentesca di Messina', in Alfredo Buccao and Cesare de Seta (eds.), *Città Mediterranee in Trasformazione* (Naples: Edizioni Scientifiche Italiane, 2014), pp. 481–491.
Barclay, Katie, 'State of the Field: The History of Emotions', *History*, 106 (2021), pp. 456–466.
Baskins, Cristelle, 'The Play of Mistaken Identities at the Porta Nuova of Palermo', in Borja Franco Llopis and Antonio Urquízar-Herrera (eds.), *Jews and Muslims Made Visible in Christian Iberia and Beyond, 14th to 18th Centuries* (Leiden: Brill, 2019).
Botero, Giovanni, *On the Causes of the Greatness and Magnificence of Cities* (1588), trans. Geoffrey Symcox (Toronto: University of Toronto Press, 2012).
Bruno, Gioliana, *Atlas of Emotion: Journeys in Art, Architecture, and Film* (New York: Verso, 2002).
Calabrese, Maria Concetta, 'Messina e la honra della "Palazzata" nel seicento', *Nuova Rivista Storica,* 99, no. 1 (2015), pp. 159–194.
Campanella, Tommaso, *De monarchia Hispanica dicursus,* trans. Edmund Chilmead (London: Philemon Stephens, 1660).
Canepa, Elisabetta, *Architecture is Atmosphere: Notes on Empathy, Emotions, Body, Brain, and Space* (Rome: Mimesis, 2022).
Casamento, Aldo, *La rettifica della Strada del Cassaro a Palermo* (Palermo: Flaccovio Editore, 2000).
Crouch, Dora, *Spanish City Planning in North America* (Cambridge: MIT Press, 1982).
Crowley, Roger, *Empires of the Sea: The Siege of Malta, the Battle of Lepanto, and the Contest for the Center of the World* (New York: Random House, 2009).
da Bertinoro, Ovadyah Yare, *Lettere dalla Terra Santa,* trans. Giulio Busi (Rimini: Luisè Editore, 1991).
Dandelet, Thomas James, *Spanish Rome: 1500–1700* (New Haven: Yale University Press, 2001).
de Certeau, Michel, *The Practice of Everyday Life,* trans. Steven Rendall (Berkeley: University of California Press, 1988).
De Gennaro, Rosanna and Paolo Giannattasio, 'Messina nel diario di viaggio e nei disegni di Willem Schellinks', *Prospettiva*, 157/158 (January–April, 2015), pp. 157–158.
de Seta, Cesare and Leonardo Di Mauro, *Palermo* (Bari: Laterza, 1981).
de Zurko, Edward R., *Review of* The Architecture of Michelangelo, *Landscape* 12, no. 1 (Autumn, 1962), pp. 43–44.
Di Fede, Maria Sofia, 'La festa barocca a Palermo: città, architetture, istituzioni', *Espacio, Tiempo y Forma, Serie VII, Historia del Arte*, 18–19 (2005–2006), pp. 49–75.
di Giovanni, Vincenzo, *Palermo restaurato* (1615), Mario Giorgianni and Antonio Santamaura (eds.), 4 vols (Palermo: Sellerio Editore, 1989).
Dizionario Biografico degli Italiani (Rome: Istituto della Enciclopedia Italiana).
D'Onofrio, Federico, 'On the Concept of "Felicitas Publica" in Eighteenth-Century Political Economy', *Journal of the History of Economic Thought*, 37, pp. 452–454.
Dumas, Alexandre, *Journeys with Dumas: The Speronara*, trans. Katharine Prescott Wormeley (Boston: Little, Brown, 1902).
Elliott, John H., 'A Europe of Composite Monarchies', *Past and Present: The Cultural and Political Construction of Europe*, 137 (1992), pp. 48–71.
Escobar, Jesús, 'Architecture in the Age of the Spanish Habsburgs', *JSAH*, 75, no. 3 (September, 2016), pp. 258–259.

Fagiolo, Marcello and Maria Luisa Madonna, *Il Teatro del Sole* (Rome: Efficina Edizioni, 1981).
Ffolliott, Sheila, *Civic Sculpture in the Renaissance: Montorsoli's Fountains at Messina* (Ann Arbor: UMI Research Press, 1984).
Folguera, Jose Miguel Morales, 'El Viaje Triunfal de Carlos V Por Sicilia tras la Victoria de Túnez', *IMAGO*, 7 (2015), pp. 7–21.
Garofalo, Emanuela and Maurizio Vesco, 'Antonio Ferramolino da Bergamo, un ingegnere militare nel Mediterraneo di Carlo V', in Giorgio Verdiani (ed.), *Defensive Architecture of the Mediterranean XV to XVIII Centuries* (Florence: DIDAPress, 2016), p. III.
Gigante, Amelia Ioli, *Messina* (Rome: Laterza, 1980).
Goethe, J.W., *Italian Journey*, trans. W.H. Auden and E. Mayer (London: Collins, 1962).
Guarino, Gabriel, 'The Reception of Spain and Its Values in Habsburg Naples: A Reassessment', in Melissa Calaresu, Filippo de Vivo, and Joan-Pau Rubiés (eds.), *Exploring Cultural History: Essays in Honour of Peter Burke* (Farnham: Ashgate, 2010), pp. 93–112.
Hauser, Arnold, *The Social History of Art: Renaissance, Mannerism, Baroque*, vol. 2 (London: Routledge, 1951).
Hobbes, Thomas, *The Elements of Law, Natural and Politic, (1640)* (Whithorn: Anodos, Books, 2017).
———, *Leviathan* (1651), David Johnston (ed.), (New York: W.W. Norton, 2020).
Hoby, Thomas, *The Travels and Life of Sir Thomas Hoby, 1547–1564*, Edgar Powell (ed.), (London: Offices of the Society, 1902).
Jacka, Katherine Adelaide, The *Book of Roger and the Creation of the Norman State* (unpublished doctoral thesis, University of Sydney, 2019).
Jackson, John Brinckerhoff, *The Necessity for Ruins* (Amherst: University of Massachusetts Press, 1980).
Kagan, Richard, *Urban Images of the Hispanic World: 1493–1793* (New Haven: Yale University Press, 2000).
Kaufmann, Thomas DaCosta, *Toward a Geography of Art* (Chicago: University of Chicago Press, 2004).
Koenigsberger, H.G., *The Practice of Empire* (Ithaca: Cornell University Press, 1969).
Krautheimer, Richard, *The Rome of Alexander VII: 1655–1667* (Princeton: Princeton University Press, 1985).
Lea, Henry Charles, *A History of the Inquisition in Spain*, vol. III (New York: Macmillan, 1907).
Machiavelli, Niccolò, *The Prince*, trans. Harvey Mansfield (Chicago: University of Chicago Press, 1998).
Mallgrave, Harry Francis, *Architecture and Embodiment: The Implications of the New Sciences and Humanities for Design* (London: Routledge, 2013).
Malumbres, Eloy Bermejo, 'Política Artística en el Virreinato de Sicilia Bajo el Gobierno de Don García de Toledo (1564–1567)', (unpublished master's thesis, Universidad Zaragoza, 2013).
Manfrè, Valeria, 'La Sicilia de los Cartógrafos: vistas, mapas y corografías en la Edad Moderna', *Anales de Historia del Arte*, 23, Núm. Especial (2013), pp. 79–94.
Merleau-Ponty, Maurice, *Phenomenology of Perception*, trans. Donald A. Landes (London: Routledge, 2012).
Mulcahy, Rosemarie, *Philip II of Spain: Patron of the Arts* (Dublin: Four Courts Press, 2004).
Nora, Pierre, 'Between Memory and History: Les Lieux de Mémoire', *Representations*, 26 (1989), pp. 7–24.

Norman, Don, *Emotional Design* (New York: Basic Books, 2004).
Osorio, Alejandra, 'The Copy as Original: The Presence of the Absent Spanish Habsburg King and Colonial Hybridity', *Renaissance Studies*, 34, no. 4 (2019), pp. 704–721.
———, 'Courtly Ceremonies and a Cultural Urban Geography of Power in the Habsburg Spanish Empire', in Leonard von Morzé (ed.), *Cities and the Circulation of Culture in the Atlantic World: From the Early Modern to Modernism* (New York: Palgrave Macmillan, 2017), pp. 37–72.
Pallasmaa, Juhani, *The Eyes of the Skin* (Chichester: John Wiley & Sons, 2005).
Parker, Geoffrey, *The Grand Strategy of Philip II* (New Haven, CT: Yale University Press, 1998).
Piazza, Stefano, 'L'architettura dei vicerè in Sicilia nell'età degli Asburgo: un problematico bilancio storiografico', in Stefano Piazza (ed.), *La Sicilia dei Viceré nell'età degli Asburgo (1516–1700)* (Palermo: Caracol, 2016), pp. 9–38.
Pirrone, Gianni, 'Sicilian Gardens', in John Dixon Hunt and Lucinda Byatt (eds.), *The Italian Garden: Art, Design and Culture* (Cambridge: Cambridge University Press, 1996), pp. 250–273.
Reddy, William, 'Against Constructionism: The Historical Ethnography of Emotions', *Current Anthropology*, 38 (1997), pp. 327–351.
———, *The Navigation of Feeling: A Framework for the History of Emotions* (Cambridge: Cambridge University Press, 2001).
Reyes, Carlos González, 'La Descripción de Palermo a Través de un Manuscrito del Gentilhombre Gaspare di Reggio (1599)', in Juan José Iglesias Rodríguez, Rafael M. Pérez García, and Manuel F. Fernández Chaves (eds.), *Comercio y Cultura en la Edad Moderna* (Seville: EUS, 2015), pp. 2813–2824.
Rosenwein, Barbara, *Emotional Communities in the Early Middle Ages* (Ithaca: Cornell University Press, 2007).
———, *Generations of Feeling: A History of Emotions, 600–1700* (Cambridge: Cambridge University Press, 2016).
Said, Edward, *Orientalism* (New York: Random House, 1978).
Sandys, George, *Sandys Travels* (London: John Williams Junior, 1673), 7th ed., vol. 4.
Sutera, Domenica, 'L'iconografia del palazzo Reale di Messina', *Lexicon, Storia e architettura in Sicilia*, 1 (2005), pp. 47–56.
Tanner, Marie, *The Last Descendant of Aeneas: The Habsburgs and the Mythic Image of the Emperor* (New Haven: Yale University Press, 1993).
Taylor, René, 'Architecture and Magic', in Douglas Fraser, Howard Hibbard and Milton J. Lewine (eds.), *Essays in the History of Architecture Presented to Rudolf Wittkower* (London: Phaidon, 1967), pp. 81–109.
Tuck, Steven, 'The Expansion of Triumphal Imagery Beyond Rome: Imperial Monuments at the Harbors of Ostia and Lepcis Magna', in Robert L. Hohlfelder (ed.), *Memoirs of the American Academy in Rome: The Maritime World of Ancient Rome* (Ann Arbor: University of Michigan Press, 2008) VI, pp. 325–341.
Vasari, Giorgio, *Le Opere*, Gaetano Milanese (ed.), 9 vol. (Florence: Sansoni, 1906), p. VII.
Vesco, Maurizio, 'Pietro Antonio Tomasello de Padua: Un ingeniero militar véneto en la Sicilia de Carlos V', *Espacio, tiempo y forma* 7, nos. 22–23 (2009–2010), pp. 45–73.
Zumthor, Peter, *Atmospheres* (Basel: Birkhäuser, 2005).

5 Architecture and emotions in early modern quarantine centres

Marina Inì

Many lazarettos are close and have too much the aspect of prisons, and I have often heard captains in the Levant trade say, that the spirits of their passengers sink at the prospect of being confined in them.[1]

John Howard, the famous English philanthropist and prison reformer, based this comment on the emotional impact of quarantine centres on his extensive experience and study of the topic. His treatise on quarantine stations, published in 1789, was the result of Howard's travels across the Mediterranean, when he visited several quarantine centres, collecting information, blueprints, and also experiencing quarantine in the Lazzaretto Vecchio and the Lazzaretto Nuovo in Venice at the end of his voyages. Howard's account is one of the very few written sources that allow us to get a glimpse of the emotions inside quarantine stations (or in Italian *lazzaretti*, sg. *lazzaretto*). From his words, it's evident that the quality of the quarantine space and architecture played a key role in determining the emotions of passengers and sailors about to be confined inside lazzaretti. This chapter will focus on the emotions of passengers and staff in quarantine while analysing different lazzaretti built between the sixteenth and eighteenth centuries in different states of the Western Mediterranean; it argues for the importance of examining the quarantined built environment and regulations to understand the emotional impact of lazzaretti on both passengers and staff.

Quarantine centres have a long history in the late medieval and early modern panorama of the Mediterranean as preventative institutions against the plague. Quarantine is almost as old as the Black Death: the Adriatic city of Ragusa (Dubrovnik) first adopted quarantine legislation in 1377 by admitting or denying entry to travellers based on the state of health of their regions of provenance.[2] In the beginning, quarantine sites were not permanent but usually made of makeshift barracks in isolated locations such as islands; only in 1423, Venice founded the first permanent quarantine station and the first plague hospital (preventative and public health functions coincided at the beginning and in plague years), which was quickly followed in 1456 by a second quarantine station and plague hospital, called the Lazzaretto Nuovo.[3] During the sixteenth and seventeenth centuries, Venice also established several lazzaretti in its territories in the Adriatic and Ionian Seas, and the *Terraferma*, constituting a system of several lazzaretti

DOI: 10.4324/9781003358695-5

protecting its territories from plague.[4] Between the end of the sixteenth and the beginning of the seventeenth century, other Mediterranean states (those of the Italian Peninsula, Malta, and France) started adopting lazzaretti and quarantine to protect their territories from the risk associated with commerce, the movement of people, and plague. The Venetian system was thus progressively linked to other lazzaretti, becoming a transnational network against plague. By the eighteenth century, the unified system of European lazzaretti encompassed the Venetian territories on the Adriatic, the Ionian Sea, the Italian Peninsula and the European countries on the Western Mediterranean.

Quarantine is 'preventive, permanent, rigorous, and independent of the state of local health'.[5] Integral to the concept of quarantine is its continuous application beyond epidemics to apparently healthy subjects (or suspected sick) and potentially infected goods before the disease could manifest itself. European states considered the Ottoman lands an especially sensitive area that needed to be constantly monitored for plague outbreaks. The reasons are various and multifaceted and cannot be explored in depth here, but it is important to underline that the fact plague was considered endemic in the Ottoman Empire was fundamental to the adoption of quarantine by many European states.[6] Lazzaretti and quarantine were perpetually adopted to allow trading activities and the movement of goods from the East to the West. Vast quarantine complexes were built near the most important trading posts and cities on the shores of the Mediterranean.

Lazzaretti were managed by local Health Boards which usually had legislative, judicial, and executive powers and oversaw the regulation of quarantine. Alex Chase-Levenson defines Health Boards as 'a local authority with an international remit'.[7] Indeed Health Boards protected the state of local health by monitoring and liaising with other cities and states' Health Boards to have a broader overview of the state of health of the Mediterranean and neighbouring territories. Whether quarantine was needed or not and its duration was established by the information on health passes carried by travellers and merchants for their cargo.[8] However, health passes also needed to be checked against up-to-date information on the health of different Mediterranean areas which was relentlessly shared between health offices. Health offices shared a variety of information not only on plague outbreaks: their quarantine regulations and the architectural plans of lazzaretti were regularly part of the documents sent between health offices. This is indeed particularly relevant for the analysis carried out below, which examines several different lazzaretti from different parts of the Mediterranean sharing key regulations and architectural features.

Quarantine and its institutional, political, and economic implications have been the focus of research in the past.[9] However, the social and cultural history of quarantine, especially the routine and conditions of lazzaretti, has not been analysed in depth.[10] The study of the quarantine experience is indeed complicated by the lack of first-hand accounts. Some direct accounts of quarantine exist, but they are based on atypical experiences, such as John Howard's carefully planned and informed travels to several lazzaretti in the Mediterranean, or the visits of monarchs, ambassadors, and dignitaries with their entourages. Day-to-day accounts are harder to

come by especially those of the average passengers, such as sailors or from lower social strata.[11] However, we can turn to the analysis of the quarantine space, which I argue is the key to understanding the emotional side of the quarantine experience. The buildings in which quarantine was performed have been oftentimes overlooked, while they are fundamental to understanding many aspects of this institution from medical theories (that I have analysed elsewhere) to their cultural, economic, and social history.[12] This chapter will blend the analysis of space with the available written sources to analyse the passengers and staff's emotional state once in isolation. I will refer to two types of written sources: the graffiti on the walls of the Lazzaretto of San Pancrazio in Verona dated between the seventeenth and eighteenth centuries, and the letters written by several lazzaretti's supervisors to the local Health Office during the eighteenth century. The first typology reports the passengers' experience directly through the voices of the authors, while the second one reports them indirectly by presenting their requests to the Health Board. Furthermore, supervisors' letters are employed to investigate their own emotions and those of other members of staff.

The relationship between body and space is essential to understanding the quarantine experience as the location of bodies inside the lazzaretto was the source of many concerns and influenced the architecture and the regulations of lazzaretti. The history of emotions has much to do with the body, and bodies are indeed situated in space. Space and bodies have influence over each other, and through the body, space becomes linked to emotions.[13] Sociologists, such as Henri Lefebvre, have underlined the importance of space in creating emotions (and the converse) and the role of space as a social product.[14] Space is endowed with cultural and social meanings which influence, through expectations and experience, the emotions that it generates. As evident in Howard's quote, merely the 'prospect' of the lazzaretto had already influenced the emotional response of the passengers about to enter lazzaretti.

In my analysis of quarantine space and emotions, I encountered two key problems: one, already mentioned above, is the lack of diversified, in-depth accounts of quarantine; the other is diversifying the range of emotions linked to the quarantine space from a variety of actors. The two problems are interlinked: I wanted to explore a wide range of responses to the quarantine experience while finding myself in lack of key written sources. As a solution, I have adopted the concept of atmosphere which allows us to carry out an in-depth analysis of emotions in quarantine by blending the information provided by written sources and the qualities of the space analysed. The concept has been recently successfully applied to the study of the history of emotions, space, and architecture, and I wish to do the same here.[15]

The concept of atmosphere was developed by the German phenomenologist Gernot Böhme and further developed cultural geographers and philosophers.[16] It summarises the feelings and emotions generated by the interactions between human actors and specific spaces and places. According to the philosopher Tonino Griffero, atmospheres are 'spatialised feelings', linked to space but also ambiguous in their nature.[17] Exactly this vagueness allows to include a vast range of reactions to the quarantine space, reactions that, as I will underline below, should not be taken for

granted. Through the concept of atmosphere, the aim is to understand the impact of quarantine architecture with its specific sociocultural implications on passengers and staff before and during quarantine. How much did the 'prospect of being confined' inside buildings perceived as similar to prisons impact the emotions of people in quarantine? Are emotions linked to ideas of isolation, immobility, and boredom the only ones felt inside lazzaretti? Did all passengers associate quarantine with imprisonment? What about the difference between passengers and staff or the different staffing roles inside lazzaretti? Architecture, space, and their associated emotions can surely change according to the people experiencing it.[18] The concept of atmosphere can help us understand both subjective and collective reactions to buildings as these are based on cultural and individual expectations; this will allow us to understand an array of opposite emotions in the same space.[19] Indeed, by borrowing Maja Hultman's words, 'architecture is an agent of contradicting feelings, which are used and navigated in support of or aversion' to the quarantine space.[20]

Isolation, rules, and the architecture of quarantine

The experience of quarantine was greatly influenced by the physical layout of the built environment and by the rules that shaped it and dictated how it was experienced and embodied. John Howard's words at the beginning of this chapter give us some general insight into the atmosphere of lazzaretti according to him and many ship captains he encountered: they appear to be 'close' and similar to prisons, and indeed the architecture of lazzaretti stressed isolation and compartmentalisation to avoid the accidental spread of the disease.

To fully understand the specificity of the architecture of quarantine, it is important to outline the medical principles that guided the design, the management, and the life inside lazzaretti.[21] The principles according to which plague was thought to spread in the early modern period referred to key medical theories established during Antiquity.[22] Galen explains that plague was spread by the inhalation of putrid and corrupt air (miasmas); he believed that miasmas carried the so-called 'seeds of the disease' that would enter the body causing an imbalance in the humours and then plague.[23] The galenic seeds were a recurring element throughout the centuries and appeared again in 1546, in Gerolamo Fracastoro's famous treatise *De Contagione, Contagiosis Morbis et eorum Curatione Libri III*. Fracastoro described three mechanisms for contagion: contact, through the so-called 'fomites' (objects and surfaces on which the seeds are preserved), and as caused by poisonous vapours at a distance.[24] This theory of contagion proved to be especially popular and endured for centuries. Lodovico Antonio Muratori, in his eighteenth-century treatise, still referenced Fracastoro: 'It is possible to receive the Pestilential Poison in three ways, namely touching diseased bodies, or things and animals touched by the sick, or through the air surrounding them'.[25] Thus, fear of touching the sick and their belongings, and fear of foul corrupting air characterised the preventative measures adopted to avoid the plague.

The architecture of quarantine centres clearly reflects the fear of direct and indirect contact and the anxiety produced by proximity to potentially infected passengers. First, isolation from the outside world was essential for a lazzaretto, and

this started with the choice of the location. The Health Office in Genoa stated that 'lazzaretti have to be built away from the town, windy and secret'.[26] Quarantine centres were built away from densely populated areas but not too far away from the city and always in a convenient position for the purpose of trade. Isolation was also ensured by water as many of the lazzaretti here analysed were entirely or partially surrounded by water. The Lazzaretti Nuovo and Vecchio in Venice, and those in Malta, Napoli, and Corfù were built on islands, while the lazzaretti of Ancona and Messina were artificially built in the middle of the port; the Lazzaretto of San Rocco and the Lazzaretto of San Jacopo in Livorno were surrounded by water canals, making them almost de facto islands; other lazzaretti were partially delimited by water, in the case of the Genoese Lazzaretto of Varignano built on a promontory, San Pancrazio on a river bend just outside Verona, and the Lazzaretto della Foce in Genoa built near the seashore and at the mouth of the river Bisagno.

The isolation provided by the site of lazzaretti was further enhanced by the architecture and the layout. Quarantine stations commonly had a fortified general aspect, and the comparison between lazzaretti and prisons is not surprising (Figure 5.1); in general, quarantine centres shared similarities with military fortresses. For instance, the Lazzaretto Nuovo in Venice was compared by contemporaries to a castle.[27] This is also true in general for many lazzaretti which were endowed with watch towers, high walls, and few controlled openings with the exterior world. It is quite understandable for the approaching passenger to associate the exterior fortified aspect of the lazzaretto with atmospheres of confinement as we will see below.

Isolation and control did not only involve the location and the exterior aspect of quarantine centres. Inside, the quarantine space was designed to maximise the division of potentially contagious passengers, goods, the quarantined staff, and the staff that was not in contact with contaminated people or cargo. In many instances, such as the Lazzaretto della Foce in Genoa (Figure 5.1), the lazzaretto in Ancona, and the Lazzaretti of San Rocco, San Jacopo, and San Leopoldo in Livorno, quarantine centres have a double layer of walls, creating a gradual and safe transition between the outside world free from contagion and the dangerous quarantined environment inside.

Further compartmentalisation inside separated not only goods from passengers but also goods and passengers in different categories. Passengers were usually divided into different groups according to the danger of contagion and the days of isolation prescribed. The same concepts were applied to goods; for instance, the plan of the Lazzaretto della Foce published in John Howard's treatise shows two different courtyards: one for *suspicious* goods and people (for cargoes and passengers coming from relatively but still suspicious areas potentially infected or near regions declared infected) and the other for *infected* goods and passengers who were coming from the Ottoman lands and/or areas that were declared infected. Other strategies were also used to divide and compartmentalise passengers and goods: ephemeral architecture, such as provisional wooden fences, was also used to further divide the enclosures which generally hosted more than one quarantined group; in some instances, water was again used as a separating element and canals allowed to separate the most dangerous part of the lazzaretto from the rest of the complex; guards were always employed and tasked with the surveillance of their assigned groups to avoid mingling.[28]

Architecture and emotions in early modern quarantine centres 109

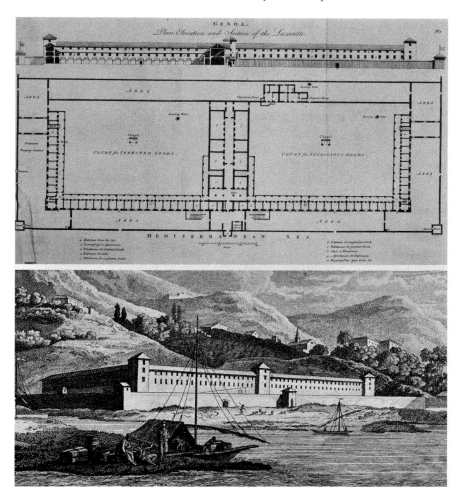

Figure 5.1 Plan, section and view of the Lazzaretto della Foce in Genoa, from John Howard, *An Account of the Principal Lazarettos in Europe* (London: 1789), Plate 3, Plate 2; Getty Research Institute, Los Angeles (85-B11700).

The strict admission procedures also marked the entrance into this peculiar institution. On arrival in the port, or in the city's territories for those arriving from land (for instance, in Verona and Split), passengers were carefully interrogated on their trip and the ports visited and questioned on any close encounter with other ships. Health passes were examined; then a physician was sent to examine the health of new arrivals (at a safe distance and without touching).[29] Belongings and luggage were checked by guardians to see if they contained anything that required disinfection (personal letters and documents were also disinfected with fumigations).[30] The length of isolation was then decided according to the state of health of the areas of provenance and the information contained in health passes.[31] These

could go from the full 40 days for the goods, and the passengers considered more at risk to a minimum of three days; however, the average was around 15 days of isolation. In general, detailed records were carefully taken, of both goods and passengers, and porters, who were tasked with the disinfection procedures of goods, and guardians, in charge of the surveillance of passengers and porters, were assigned to each quarantine.[32]

Once inside the lazzaretto, the passengers were assigned to their rooms. In the Lazzaretto della Foce (Figure 5.1), these were arranged around the two courtyards. This layout was common also in most quarantine centres as it granted passengers access to the courtyard where wells and the chapel were usually located. The size of the passenger quarters varied as some were on two storeys, but in general, they were all endowed with fireplaces, latrines, and sometimes also sinks. High-status passengers were able to afford the best sleeping quarters: for instance, in Verona, in the Lazzaretto of Pancrazio, the four corner towers provided better rooms and also a private fully equipped kitchen for passengers with a big entourage and servants. On the other hand, sailors and merchants who wanted to save money could be quarantined inside the warehouses with their goods, avoiding paying for separate guardians.[33] Ship crews also commonly spent the quarantine on their ships to reduce costs.[34]

Passengers in the lazzaretto had to abide by several rules established to restrict their behaviour, prevent cross-contamination, and promote good conduct. In general, passengers did not have much choice when it came to leisure activities. The regulations of several lazzaretti forbade any kind of distraction that might favour the mingling of different quarantine groups, such as ball games, dice and card games, dances, and eating together.[35] Wandering around the lazzaretto was forbidden. During the day, the passengers could walk but only in prescribed parts of the quarantine station and had to follow the orders of their guardians when they went to the canteen and to the parlours, and when following the celebration of Mass.[36] In the case of the lazzaretto of Marseille, the regulations mention that passengers were allowed to stroll to the hill enclosed in the quarantine complex, where a beautiful view of the harbour could be obtained.[37] The plan of the Lazzaretto of Santa Teresa in Trieste in the 1791 edition of Howard's treatise refers to 'places for exercise' near the lazzaretto docks.[38] However, quarantine stations here analysed did not normally provide spaces for leisure or at least gardens that were accessible to passengers. Some lazzaretti report the presence of gardens, such as the Lazzaretti of Santa Teresa in Trieste, San Jacopo, and San Leopoldo in Livorno; the Lazzaretti Vecchio and Nuovo in Venice; and the lazzaretto in Marseille, but they were only accessible to the supervisor and any staff not in quarantine. Others, such as Ancona, had no green space at all.

Passengers and emotions in the quarantined space

After commenting on the sinking spirits of passengers, Howards also remarked on the presence of 'several pale and *dejected* persons, and many fresh graves' inside quarantine stations.[39] Early modern medicine linked emotions to disease: emotional states such as melancholy, despair, and fear were believed to produce humoural imbalances, resulting in sickness and even death. The body was thought to be more vulnerable to the disease if emotions very common during an epidemic such as

Architecture and emotions in early modern quarantine centres 111

anxiety, grief, and especially fear were being experienced.[40] Activities that would put the spirit at ease and in a happy and relaxed state were usually recommended by treatises against the plague. The lack of gardens did not go unnoticed by Howard, and he underlined that an ideal lazzaretto needed a more 'cheerful aspect' and in his sketch of a proposed quarantine station included a salutary 'Bowling Green' with 'pleasure grounds for Passengers' in the centre of the complex (Figure 5.2).[41]

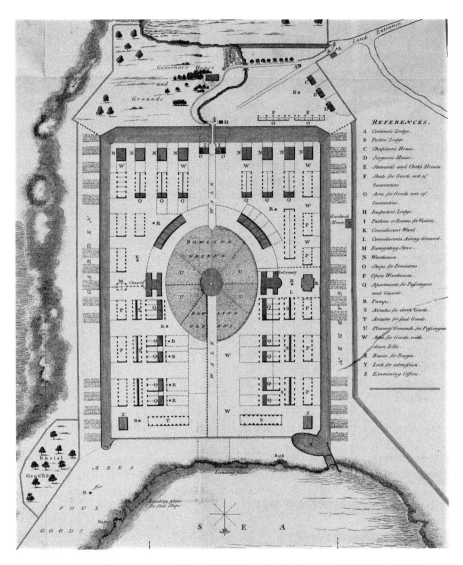

Figure 5.2 Sketch for a Lazzareto, from John Howard, *An Account of the Principal Lazarettos in Europe* (London: 1789), Plate 14; Getty Research Institute, Los Angeles (85-B11700).

This feature would have been considered an improvement to the quarantine experience and also a contribution to maintaining the good health of passengers. Gardens have a long association with physical and emotional health and were indeed a key feature of many institutions promoting both peace of mind and bodily health, such as convents and hospitals.[42] Gardens provided fresh air and a place to take exercise, while the scenery stimulated the spirit, easing harmful sensations such as anger, melancholy, and tedium.[43] However, the problem of contagion inside the lazzaretto made the presence of such spaces problematic: trees and grass were believed to retain contagious particles brought in by passengers and especially by goods.[44] Besides, the fear of contagion made the use of shared spaces such as gardens or bowling greens proposed by Howard unfeasible or too complicated to manage safely. However, Howard would have been pleased by the features of later quarantine stations adopted in North America at the end of the eighteenth century: as underlined by Quim Bonastra, they differed from European ones in that they integrated gardens to improve the well-being of passengers.[45]

Given the lazzaretto's atmosphere of seclusion, reinforced by the strict rules which forbade many leisurely activities and spaces, it is not surprising that boredom, the need for distraction, and frustration are among the most common states of mind that written sources suggest. It has been argued that boredom is a recent phenomenon and that the English word to indicate this feeling did not appear before the late eighteenth century. However, John Florio reported the Italian word 'noia' (still used today and translates the English term 'boredom') in 1611 translating it as 'annoyance, tediousness'.[46] The feeling of tediousness and boredom was surely experienced in premodern times even if expressed in other words than those that we use today.[47] These feelings are confirmed by the graffiti found in Verona where the walls themselves were used by passengers to express their emotions and thoughts:

> If time passes you cannot buy it back
> nor there is anything more precious than time.
> Why, then, gentlemen, so much time
> do you let us stay here, losing time?
> Maybe one day you won't have time
> to think too about the lost time.
> Thus, if you got here at such a good time
> Give us freedom, by now it's time.[48]

From this writing, it is evident that passengers associated the lazzaretto with a lack of freedom, confirming what Howard and the analysis of the architecture suggested. However, the passengers are also protesting for the wasted time. This was also expressed less politely:

> Curse this lazzaretto
> and the screwed cuckold who put it here
> and cursed a hundred times
> the thief that guided us inside.[49]

The term 'thief' here could still refer to the stolen time or to the fact that quarantine was very expensive.

Letters written by supervisors to Health Boards can also provide indirect glimpses of what it meant to spend time in isolation in a lazzaretto, confirming the views reported by the two passengers in Verona and the need for distraction. On 24 May 1791, the Prior of the Lazzaretto Vecchio asked the Health Board to allow the passenger Pietro Dandolo to walk on the dock of the quarantine station to also 'give some relief to his dame'.[50] Walking on the dock would have also provided a change of scenery from the closed courtyards of the lazzaretto. In 1739, Count Galeazzo Origo requested, through the supervisor, to be allowed to converse after lunch with Counts Moronelli and Cosmi who were in another quarantine group. The letter stated that this will be 'of great relief in his quarantine to be able (by talking) to distract himself'.[51] In other cases, the strict confinement with other passengers from the same quarantine group could also take its toll: in 1755, the Bailo Antonio Diedo, while in the Lazzaretto Vecchio in Venice on the return journey from Constantinople, asked to have three other passengers from his quarantine group taken to the Lazzaretto Nuovo because he could no longer tolerate them.[52] Reports of arguments and fights between passengers are not uncommon, despite several regulations stating that peace had to be preserved inside the lazzaretto and that drunkenness was not tolerated.[53] Boredom also brought passengers to often break the rules: in the lazzaretto of Verona, one of the passengers, an abbot Bologna, instead of leaving the lazzaretto at the end of his quarantine, went to visit Count Rambaldi, an acquaintance of his who was in another quarantine group. The abbot was found playing the flute in the same room as the Count playing the spinet, an action that could have put the abbot at risk of contagion all over again. And indeed, the abbot was detained for an extra day.[54] Shortly after this remarkable violation of quarantine rules, another similar incident was reported: a passenger who had just been admitted into the lazzaretto was found dining together with another passenger, who was in quarantine in a different enclosure.[55]

The architecture, the regulations of the lazzaretto, and the written sources analysed here seem to justify the views expressed and reported by Howard regarding the '*close*' atmosphere of lazzaretti. Quarantine regulations and architecture were extremely concerned in situating and controlling the body within the lazzaretto's space. Different studies have indeed compared lazzaretti to total institutions such as workhouses, schools, prisons, and hospitals. According to the sociologist Erving Goffman, total institutions are defined by a total character, which poses a barrier between the institution and the outside world, and in organising all aspects of life inside.[56] Many studies have read the lazzaretto through Goffman's ideas underlining the importance of control and surveillance in its design and regulations.[57] While it is evident that lazzaretti share some of the totalistic elements defined by Goffman, quarantine centres cannot be reduced to seclusion and control alone. Recent studies on institutions of confinement have also critiqued Goffman's totalistic principles. Moreover, a key and often misinterpreted concept in Goffman's theories is that total institutions can have different degrees of totality, openness, and closure.[58] The space of the lazzaretto was also defined by movements, flows, and porosity as they

were key institutions of the infrastructure of mobility and trade of the early modern Mediterranean allowing movement and exchange despite the disease.

Recent works have started to draw comparisons with another architectural typology, that of *hans*, *caravanserai*, and *fondaci*. This building typology was a key part of the infrastructure of mobility in the Ottoman and Mediterranean world and, like the lazzaretto, was crossed by streams of people and goods on the move.[59] Examples such as the lazzaretto of Verona and the lazzaretto of Ancona make the resemblance between quarantine centres and hans very clear: centrally planned buildings with lodgings and warehouses arranged around a courtyard with a central chapel (or prayer hall for hans) and sources of water.[60] For instance, the Ottoman traveller Evliya Çelebi, who was quarantined in Ragusa during his travels in 1663, clearly perceived the atmosphere of the lazzaretto as similar to that of the han rather than a prison:

> Nazarete (lazaretto) is the term for the han or guesthouse where merchants and diplomats are lodged. It is a square building, very like a han, with numerous and well-outfitted rooms, one after the other, and kitchens and stables and rooms for the infidel soldiery.[61]

Here the cultural association and expectations are also clear: Evliya Çelebi's perceived atmosphere of the quarantine centres is also influenced by his own culture where the han was the closest and most similar building to the lazzaretto.

The link between the lazzaretti and *fondaci* is evident also in their use: quarantine centres could sometimes be used as *fondaci*, accommodating merchants and their goods in transit, not only in quarantine. Most notably in the lazzaretto of Split, there was a separate courtyard which Ottoman merchants used as a *fondaco*.[62] Thus, we have to imagine that the atmosphere of quarantine centres was not entirely linked to their prison-like outlook and that it would also change according to the different people experiencing it. For instance, for those whose life was constantly on the move, like merchants, sailors, soldiers, and ship captains, the lazzaretto was one of the many stops that they encountered on the road or while at sea. And we can also imagine that it could have been a welcomed (or annoying) forced waypoint after days at sea or on the road. In fact, among the graffiti lamenting the lack of freedom, a passenger in Verona also expressed a different set of emotions:

> A thought surprises me, and I am sure
> that the mind of few will take it in
> the lazzaretto seems a suspected place
> if it is too hard for freedom.
> And yet it is not so, because in the darkness
> we see every pleasure in this world
> and always renew our affection for it
> running across an impure path.
> But blessed the Heaven that it is our good fate
> that lead us to love this retreat
> that boasts of cleansing the body with ease.
> Wisely the spirit thinks about death

And as the farmer tosses on the ground
the useless plants for his own advantage. [63]

While surely not popular, the idea of the lazzaretto as a place for rest, reflection, and peace was not new. The few lines above recall Francesco Sansovino's idealised description of the Lazzaretto Nuovo in Venice, where he stayed during the plague in 1575–1577, and have been carefully analysed by Jane Stevens Crawshaw. As the Lazzaretto Nuovo was used to quarantine those who were recovering from plague and isolate those who could possibly be infected, the complex offered a less daunting experience than the Lazzaretto Vecchio, where sick people were treated. Sansovino claimed that people in quarantine in the Lazzaretto Nuovo could rest instead of working and that the time given was a blessing since it could be employed for prayer and reflection.[64] While quarantine stations in non-plague years offered a very different environment from plague hospitals, it seems that a positive depiction of the lazzaretto, similar to that of Sansovino, was evoked centuries later by the anonymous passenger in Verona. In his words, the lazzaretto's atmosphere is perceived more as a '*retreat*' than a prison.

While the text above does not make direct reference to religious practices, it is also possible that this retreat atmosphere could have been influenced by the religious services held inside lazzaretti. A relatively wide degree of freedom of faith, at least privately, was allowed but, of course, only Christian, and mostly Catholic devotional practices were officiated.[65] In general, passengers and staff were able to attend Mass at least once a week. However, the frequency of such religious ceremonies varied in different years and different lazzaretti. In some cases, Mass was celebrated only on holy days, and in others every day, for instance in Trieste.[66] It is possible to assume that particularly devoted passengers would have enjoyed or found solace in the religious care provided. In Verona, where Mass was usually celebrated only on holy days, there were instances in which passengers were requested to have priests in the lazzaretto to officiate Mass every day of the week and twice a day on holy days, probably using the forced stop in their journey for pray and contemplation.[67] The experience of religious services inside quarantine centres was very different from those held outside. Chapels were designed to comply with early modern theories of contagion, reinforcing the separation typical of the architecture of quarantine centres. The most common model for chapels was an open, central building in the middle of the complex. The central design was characterised by big openings (sometimes it was just a pavilion supported by columns or pilasters) and windows that allowed passengers to follow and hear the Mass from the courtyard or even directly from their rooms, thus avoiding the dangers of mixing and contact (Figure 5.3).

The only person allowed inside the chapel was the priest.[68] It seems, thus, that the architecture and regulations of the quarantine centre also conditioned the experience of the religious service with the congregation fragmented and dispersed in different parts of the lazzaretto. However, one design feature preserved the communal character of religious services: big openings and a favourable elevated position were adopted to grant the audibility of Mass all over the quarantine complex.

116　*Marina Inì*

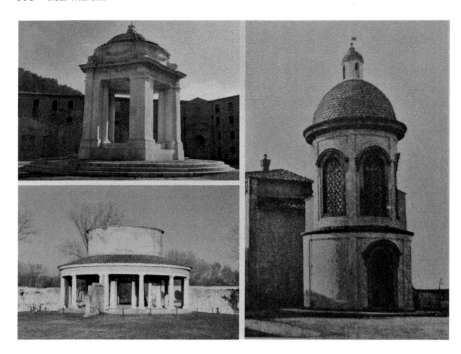

Figure 5.3 From the top left: Chapel of San Rocco in the lazzaretto of Ancona, photograph by the author; Chapel of San Leopoldo in the homonymous lazzaretto in Livorno, by kind permission of Belforte Editore Libraio; ruins of the chapel of the lazzaretto of San Pancrazio, Verona, photograph by the author.

This principle is similar to the temporary altars in street corners adopted during plague times in Italian cities which allowed the inhabitants to follow Mass and sing together from their open windows.[69] In the lazzaretto of San Leopoldo in Livorno (Figure 5.3) and the lazzaretto of Santa Teresa in Trieste, the main circular chapel was built on two levels, and Mass was officiated from the second level; passengers and staff from all around the complex could easily hear and follow the Mass through the big windows.[70] While the congregation was physically dispersed and fragmented around the quarantined complex, it was, nonetheless, brought together in the act of hearing the Mass.

Staff and emotions in quarantine

We have seen that life inside quarantine centres was dictated by specific rules and influenced by specific architectural features, and they that had an impact also on the staff who spent most of their working life inside lazzaretti, especially the higher-ranking workforce. In general, it was openly recognised and widely shared that working inside the lazzaretto was a hard and strenuous job, whatever the role. Health Boards openly acknowledged the harshness and importance of quarantine

work, and several regulations and documents refer to proper and abundant pay for the staff of lazzaretti.[71] Supervisors, who managed the entire complex and the quarantine procedures, had to spend most of their time inside the lazzaretto. As they did not normally live in contact with contaminated passengers and goods, they could leave the lazzaretto only after receiving permission from the Health Board, and the leave was limited to a few hours, or a day, and it was compulsory to return for the night.[72] On the other hand, porters and guardians were not required to reside constantly inside the lazzaretto, but, when called, they had to quarantine along with their cargo and often worked from dawn to sunset before being locked inside the warehouses for the night.[73] In some cases, such as in Venice, they also worked during holy days since they were exempted from celebrating them.[74] The opposite was applied in Livorno, where goods could not be disinfected on holy days.[75]

The emotions associated with life inside the quarantine centres sometimes emerge in the correspondence between supervisors and the Health Boards. They seem to confirm the most popular view of the lazzaretto as a prison and its atmosphere linked to isolation. In 1744, the supervisor of the lazzaretto of Varignano complained with the Health Board in Genoa that his assignment had been completed a month earlier, but having not heard from the board he asked 'to be freed from this exile'.[76] As the lazzaretto of Varignano was situated around 100 km from Genoa and around 10 km from La Spezia, the main town, the role of supervisor was probably harsher and lonelier than in other lazzaretti. The supervisor here expressed clear feelings of isolation, comparing his role to being in exile, which were probably exacerbated by the secluded position of his station. This was also confirmed by an incident that also took place in 1744 when 10 soldiers garrisoned at the lazzaretto of Varignano defected and left their posts; the supervisor reported to the Genoese Health Board that most of these defectors had been new recruits, unfit, and too inexpert to guard a place like the lazzaretto.[77]

Some letters also testify to the harshness of the job: the Prior of the Lazzaretto Vecchio in Venice, Andrea Balbi, on 19 September 1782 asked for one month's leave to try to recover from the 'distention of the veins' caused, according to him, by the effort he had poured into his tasks and especially in 'fighting indiscipline, sometimes with too much effort' inside the quarantine station.[78] In the Lazzaretto of San Leopoldo in Livorno, the overwhelmed Lieutenant Michele Taucci wrote to the Health Board to illustrate his troubles in managing the lazzaretto almost unaided. He had been moved on August 1789 from the Lazzaretto of San Rocco to act as a deputy for the sick Captain in San Leopoldo.[79] In a later letter, the Lieutenant wrote that 'my presence being always required and mandatory, I am not able to take any rest to ease myself after accomplishing my tasks, since my nerves are so fiercely assailed'.[80] He also complained about the great distance between the lazzaretto and the city, which was jeopardising the education of his sons. San Rocco, in which he was previously working, was indeed closer to the city. Conversely, the Lazzaretto of San Leopoldo, being used to quarantine cargoes and people deemed very dangerous, was built further away from the urban centre. Once again, a key characteristic of the lazzaretto, its isolated position, significantly impacted the well-being of the supervisor.

The distance of San Leopoldo from the city and its isolation also caused issues in recruiting the guards. Documents stressed that it was becoming difficult to find guards willing to work in this location underlining that in San Leopoldo, 'the service [is] more laborious and the life lonelier and more limited'.[81] Boredom probably led one of the sentinels to play tricks on his colleagues by making noises at night and convincing them that it was a 'poltergeist'.[82] But he was discovered by the same Michele Taucci and brought to trial where his stunt cost him ten days of imprisonment. As seen for passengers, boredom and seclusion also brought the staff to break the rules.

While these incidents and accounts underline the emotions associated with the isolated position of lazzaretti, we should not imagine that the entire quarantine complex was sealed off from the exterior world. Many lazzaretti had parts of their complexes which were not under quarantine (usually called *parte netta* – that is 'clean' – or *parte a pratica*). These zones usually included the supervisor's quarters which were accessible to different people, such as vendors, chaplains, and clerks. The *parte netta* of the Genoese lazzaretto of Varignano was populated by a variety of inhabitants who communicated frequently with the outside. Several health and custom officials lived there with their families, including their extended relatives and servants.[83] At San Jacopo in Livorno, the supervisor complained about the numerous people who had free and frequent access to the non-quarantined part of the lazzaretto.[84] Space in the lazzaretto was also occupied by people who were not affected by quarantining rules, thus creating different emotional responses to the architecture and to the different parts of the lazzaretto.

Different degrees of seclusion and dangers possibly provided a sense of security for staff. The common use of double walls also played a crucial role in creating contagion-free routes for the supervisor, guardians, porters, and chaplains. The zones of safety between the walls were used as a path to access different quarantined courtyards or to move around the lazzaretto complex without coming into proximity with potentially infected passengers or goods. The *parte netta* or *a pratica* must have seemed a safe haven, free from the risk of contagion in the quarantine enclosure. However, as underlined by the custom officials in Genoa, these areas were not islands within the lazzaretto. There was always communication and thus at risk of contamination between the different parts of the complex.[85]

Liminal spaces within the lazzaretto could also have had a dual atmosphere of both seclusion and mobility. For instance, the entrance of lazzaretti was not defined by a stark and abrupt division between inside and outside, control and freedom. The entrance to the quarantine area was a threshold marked gradually by progressive degrees of seclusion, leading from the outside to the interior of the complex where goods and passengers were kept.[86] The description of the entrance to the Lazzaretto Nuovo in the inventories provides clear evidence of the liminality of such spaces. Approaching from the outside, a visitor would have encountered a covered atrium with a stone bench running around the perimeter.[87] In the same entrance, there was also an oratory, a secluded space with two wooden gates 'to permit visits to the quarantined persons' a warehouse on an upper floor from which sutlers could pass food to passengers (possibly via the balconies) and a wooden gate leading to a parlour

divided into stalls and furnished with a long bench. From their description, it is easy to imagine the entrances of lazzaretti populated by seated visitors, waiting to meet their relatives and friends in quarantine and vendors with products to be sold to passengers on the other side of the wooden entrance gate.[88] Visitors were always allowed, of course, with strict rules, in all quarantine centres which often had parlours safely accessible by visitors. Again, the prison-like atmosphere of the lazzaretto and its totalistic character should not be taken for granted, especially when looking at key architectural features that embodies both the importance of control and porosity.

Conclusion

The analysis of the architecture of lazzaretti has demonstrated that space is essential to understand the emotions associated with specific institutions and their buildings, overcoming key issues for the historian wishing to shine a light on the experience of quarantine in the early modern Mediterranean. Griffero suitably explains that 'perceiving an atmosphere means grasping a feeling in the surrounding space'.[89] The key element is the body surrounded by the built environment, experiencing feelings and emotions influenced and shaped by space. However, bodies are not passive, invested by the atmosphere unleashed by architecture. The body brings with it cultural association, preconceived ideas about the space soon to be experienced: this was already clear to Howard who remarked on the prison-like aspect of the buildings, its impact on passengers, and the need for a more 'cheerful' architecture to preserve the passengers' health.

The analysis of space and the concept of atmosphere employed here have proven useful to also diversify the analysis of emotions in quarantine. While the architecture of lazzaretti was standardised in its key elements, different bodies had different perceptions and 'prospects', thus perceiving different atmospheres of the quarantine centre. There is surely a difference between passengers and staff with different roles, but also a differences between passengers themselves. The prison-like atmosphere should not indeed be considered as a default for all passengers as the lazzaretto could also be seen as a space for retreat, as a restful waypoint during journeys, and as a space for religious contemplation.

By analysing the quarantine space and its uses, it has been possible to also uncover a different idea of the space of quarantine centres which departs from the usual comparison with total institutions: the lazzaretto not as a prison but as a space of mobility and porousness. This idea of quarantine centres reveals a different type of space, an aspect of the institution, which is often neglected, made of different degrees of openness, control, and closure. The lazzaretto was not a sealed fortress but had different parts accessible to different people who would perceive it in different ways.

Archival sources

Archivio di Stato di Firenze (ASFi), Ufficiali di Sanità.
 Archivio di Stato di Genova (ASGe), Banco di S. Giorgio, Cancelleria.
 Archivio di Stato di Genova (ASGe), Manoscritti.

Archivio di Stato di Genova (ASGe), Ufficio di Sanità.
Archivio di Stato di Livorno (ASLi), Magistrato poi Dipartimento di Sanità.
Archivio di Stato di Livorno (ASLi), Ufficio di Sanità.
Archivio di Stato di Verona (ASVr), Ufficio di Sanità, Carteggi, relazioni e atti diversi.
Archivio di Stato di Trieste (ASTs), Intendenza Commerciale.

Primary sources

Capitoli, et Ordini Stabiliti dall'Illustriss. et Eccellentiss. Sig. Zorzi Pasqualigo Per la Serenissima Repubblica di Venezia &c. Proveditor Estraordinario in T. F. e Proveditor alla Sanità nel Veroneose & oltre il Mincio, A Regola e Direzione dello Sborro, e del Lazaretto di Verona, confermati dall'Eccellentiss. Magistrato alla Sanità di Venezia (Verona: Fratelli Merli, 1715).

Capitoli da osservarsi nelli lazzaretti (Venice: Pietro Pinelli, 1719).

Editto Reale per i Ristabilimento Del Lazzaretto Di Osservazione in Messina Colle Istruzioni per Buon Regolamento Del Medesimo e Colla Tariffa per l'esigenza de'Corrispondenti Diritti Pubblicato per Ordine Di Sua Maestà (Napoli: Stamperia Reale, 1786).

Howard, John, *An Account of the Principal Lazarettos in Europe; with Various Papers Relative to the Plague: Together with Further Observations on Some Foreign Prisons and Hospitals; and Additional Remarks on the Present State of Those in Great Britain and Ireland* (Warrington: printed by William Eyres, and sold by T. Cadell, 1789).

Reglemens du Bureau de Santé de Marseille (Marseille: printed by Jean Mossy, 1797).

Regolamento di Sanità, di Pulizia e d'Economia per il Lazzaretto e il Porto Sporco di Trieste (Trieste, 1769).

Sansovino, Francesco, *Venetia città nobilissima et singolare: descritta in XIII libri* (Venezia, 1633).

Notes

1 Howard, *An Account of the Principal Lazarettos in Europe; with Various Papers Relative to the Plague: Together with Further Observations on Some Foreign Prisons and Hospitals; and Additional Remarks on the Present State of Those in Great Britain and Ireland*, p. 23.
2 Blažina-Tomić and Blažina, *Expelling the Plague: The Health Office and the Implementation of Quarantine in Dubrovnik, 1377–1533*, pp. 1–5.
3 Stevens Crawshaw, *Plague Hospitals: Public Health for the City in Early Modern Venice*, p. 20.
4 On lazzaretti in the Adriatic and Ionian Seas, see Vanzan Marchini (ed.), *Rotte Mediterranee e Baluardi di Sanità: Venezia e i Lazzaretti Mediterranei*; Konstantinidou, "Santi Rifugi Di Sanità: I Lazzaretti Dell Quattro Isole Del Levante", pp. 239–259; Konstantinidou, *Lazzaretti Veneziani in Grecia*.
5 Panzac, "Plague and Seafaring in the Ottoman Mediterranean in the Eighteenth Century", pp. 45–68, 49.

Architecture and emotions in early modern quarantine centres 121

6 See Bulmuş, *Plague, Quarantines and Geopolitics in the Ottoman Empire*; Varlik, *Plague and Empire in the Early Modern Mediterranean World: The Ottoman Experience, 1347–1600*; Jones, "The Diseased Landscape: Medieval and Early Modern Plaguescapes".
7 Chase-Levenson, *The Yellow Flag: Quarantine and the British Mediterranean World, 1780–1860*, p. 85.
8 See Bamji, "Health Passes, Print and Public Health in Early Modern Europe".
9 See Panzac, *Quarantaines et Lazarets: L'Europe et La Peste d'Orient, XVIIe-XXe Siècles*; Vanzan Marchini (ed.), *Rotte Mediterranee e Baluardi di Sanità*; Booker, *Maritime Quarantine: The British Experience, c.1650–1900*; Bashford (ed.), *Quarantine: Local and Global Histories*; Robarts, *Migration and Disease in the Black Sea Region: Ottoman-Russian Relations in the Late Eighteenth and Early Nineteenth Centuries*; Chircop and Javier Martinez (eds.), *Mediterranean Quarantines, 1750–1914: Space, Identity and Power*; Chase-Levenson, *The Yellow Flag*.
10 On the quarantine experience in the nineteenth century, see Chase-Levenson, *The Yellow Flag*, pp. 108–113; on the patient experience of the two Venetian lazzaretti during plague, see Steven Crawshaw, *Plague Hospitals*.
11 See also Bilić, "Quarantine, Mobility, and Trade: Commercial Lazzarettos in the Early Modern Adriatic", pp. 157–184.
12 On medical theories, contagion, and quarantine, see Inì, "Materiality, Quarantine and Contagion in the Early Modern Mediterranean".
13 Pernau, "Space and Emotion: Building to Feel", p. 541.
14 Lefebvre, *The Production of Space*; Lefebvre, *State, Space, World: Selected Essays*, ch. 8.
15 See Hultman, "Atmospheres of the Other: Building and Feeling Stockholm's Orthodox Synagogue"; Talu, "The Effect of London": Urban Atmospheres and Alice Meynell's London Impressions".
16 Böhme, *Atmospheric Architectures: The Aesthetics of Felt Spaces*; Anderson, "Affective Atmospheres"; Griffero, *Atmospheres: Aesthetics of Emotional Spaces*.
17 Griffero, *Atmospheres*, p. 6.
18 Honarmand Ebrahimi, "Introduction: Exploring Architecture and Emotions through Space and Place", p. 71.
19 Anderson, "Affective Atmospheres", p. 80; Hultman, "Atmospheres of the Other", p. 3.
20 *Ivi*, p. 9.
21 For an analysis of the architecture of lazzaretti, see Inì, "Architecture and Plague Prevention: The Development of Lazzaretti in Eighteenth-Century Mediterranean Cities"; Inì, "Materiality, Quarantine and Contagion in the Early Modern Mediterranean".
22 Cohn, *Cultures of Plague: Medical Thinking at the End of the Renaissance*, pp. 1–4.
23 Nutton, "The Seeds of Disease: An Explanation of Contagion and Infection from the Greeks to the Renaissance", pp. 6–7.
24 *Ivi*, pp. 21–22.
25 In tre maniere si può ricevere il Veleno della Pestilenza cioè toccando i Corpi Appestati o le Robe e gli Animali da loro maneggiati e toccati ovvero l'Aria da essi o contigua.' Muratori, *Del Governo della Peste, e delle Maniere di Guardarsene*, pp. 47–48.
26 'I lazzaretti devono essere situati [lontano] dall'abitato, ventilosi, e segreti', Archivio di Stato di Genova (ASGe), Banco di S. Giorgio, Cancelleria, 479, 11 May 1762.
27 Sansovino, *Venetia città nobilissima et singolare: descritta in XIII libri*; Bonastra, "Recintos sanitarios y espacios de control: Un estudio morfológico de la arquitectura cuarentenaria", pp. 20–22.
28 Archivio di Stato di Verona (ASVr), Ufficio di Sanità, Carteggi, relazioni e atti diversi, 19, September 30, 1738.
29 *General Regolamento ed Instruzioni degli Officii di Sanità da Osservarsi in tutto il Littorale Austriaco*, pp. 9–10.
30 Archivio di Stato di Livorno (ASLi), Magistrato poi Dipartimento di Sanità, 153, *Istruzioni Generali e Particolari per i Lazzaretti di Livorno*, ch. 133–136.

31 *Editto Reale per i Ristabilimento Del Lazzaretto Di Osservazione in Messina Colle Istruzioni per Buon Regolamento Del Medesimo e Colla Tariffa per l'esigenza de' Corrispondenti Diritti Pubblicato per Ordine Di Sua Maestà*, pp. 11–12; *Reglemens du Bureau de Santé de Marseille*, p. 104; *Regolamento di Sanità, di Pulizia e d'Economia per il Lazzaretto e il Porto Sporco di Trieste*, p. 25.
32 *Regolamento di Sanità, di Pulizia e d'Economia*, pp. 8–9; ASGe, Manoscritti 988, ff. 45 v.- 46 r.; *Editto Reale*, p. 24; *Capitoli da osservarsi nelli lazzaretti*, pp. 16–17; *Commissioni in via di istruzione*, pp. 11–12; ASLi, Magistrato poi Dipartimento di Sanità, 153, *Istruzioni Generali e Particolari*, ch. 61.
33 '…ragguardevole persona', ASVr, Ufficio di Sanità, Carteggi, relazioni e atti diversi, 26, 20 August 1751.
34 *Editto Reale*, pp. 31–32; Archivio di Stato di Firenze (ASFi), Ufficiali di Sanità, 43, c. 712; *Regolamento di Sanità di Pulizia e d'Economia*, pp. 10–11.
35 *Editto Reale*, p. 33; *Capitoli da osservarsi nelli lazzaretti*, p. 17; *Regolamento di Sanità di Pulizia e d'Economia*, p. 16; ASLi, Magistrato poi Dipartimento di Sanità, p. 23, *Istruzioni per il lazzaretto di San Leopoldo*, 1779, c. 15; ASVr, Ufficio di Sanità, 2, *Capitoli, et Ordini Stabiliti dall'Illustriss. et Eccellentiss. Sig. Zorzi Pasqualigo Per la Serenissima Repubblica di Venezia &c. Provediator Estraordinario in T. F. e Provediator alla Sanità nel Veroneose & oltre il Mincio, A Regola e Direzione dello Sborro, e del Lazzaretto di Verona, confermati dall'Eccellentiss. Magistrato alla Sanità di Venezia*, p. 12.
36 ASLi, Magistrato poi Dipartimento di Sanità, 22, c. 2 r.; Magistrato poi Dipartimento di Sanità, 23, *Istruzioni per il lazzaretto di San Leopoldo*, 1779, c. 15.
37 *Reglemens du Bureau de Santé de Marseille*, p. 169; Österreichisches Staatsarchiv (ÖS), Finanz-und Hofkammerarchiv, Commerz, p. 532; *Relazione di Francesco Antonio Guadagnini*, ff. 10 v.-11 r.
38 Howard, *Account of the Principal Lazarettos*, (1791), Pl. 13.
39 *Ibidem*; emphasis in the original.
40 See Rublack and Selwyn, "Fluxes: The Early Modern Body and the Emotions", pp. 1–16; See also Alberti (ed.), *Medicine, Emotion and Disease, 1700–1950*; Cohn, *Cultures of Plague*, pp. 266–268; on plague and fear see Gentilcore, "The Fear of Disease and the Disease of Fear", in Naphy and Roberts (eds.), *Fear in Early Modern Society*, pp. 184–208.
41 *Ivi*, p. 23.
42 Stevens Crawshaw, *Plague Hospitals*, pp. 50–52; Henderson, *The Renaissance Hospital*, pp. 142–144.
43 Cavallo and Storey, *Healthy Living in Late Renaissance Italy*, pp. 174–175, 199–200.
44 *Capitoli da osservarsi nelli lazzaretti*, pp. 13–14.
45 Bonastra, "Recintos sanitarios y espacios de control: Un estudio morfológico de la arquitectura cuarentenaria", p. 34.
46 Florio, *Queen Anna's New World of Words*, s.v. "Noia".
47 Jütte, "Sleeping in Church: Preaching, Boredom, and the Struggle for Attention in Medieval and Early Modern Europe", p. 1151.
48 'Se tempo passa più non si riacquista/né vi è cosa preziosa più del tempo./ Perché dunque, signori, tanto tempo/ ne fate star qui dentro a perder tempo?/ Forse che un giorno non avrete tempo/ di pensare pur voi al perso tempo./ Dunque, se gionti siete in sì bel tempo/ Dateci libertà, che ormai n'è tempo' (1612); the lazzaretto is now in ruins but the writings are quoted in Pellegrini, "Il Lazzaretto Di Verona", p. 181.
49 'Sia maledetto questo lazzaretto/ e quel becho fotù che lo piantò,/ e sia per cento volte maledetto/ quel ladron che dentro ci portò.' *Ibidem*.
50 'un pocco di sollievo alla sua Dama'; ASVe, Provveditori e Sopraprovveditori alla Sanità, 386, 24 May 1791.
51 'sarà di gran sollievo in questa di lui contumacia di potersi (parlando) divertir'; ASVr, Ufficio di Sanità, Carteggi, atti e relazioni diversi, 19, 16 July 1739.

52 ASVe, Provveditori e Sopraprovveditori alla Sanità, 384, 10 March 1755; 12 March 1755.
53 *Editto Reale,* 33; *Capitoli da osservarsi nelli lazaretti,* p. 17; ASLi, Magistrato poi Dipartimento di Sanità, 22, c. 15; *Regolamento di Sanità di Pulizia e d'Economia,* pp. 15–16.
54 ASVr, Ufficio di Sanità, Carteggi, relazioni e atti diversi, 19, 18 January 1739.
55 *Ivi,* 3 March 1739.
56 Goffman, "The Characteristics of Total Institutions", pp. 312–338.
57 Bergdoll, "The Architecture of Isolation: M.-R. Penchaud's Quarantine Hospital in the Mediterranean"; Bonastra, "Recintos sanitarios y espacios de control"; Chase-Levenson, *The Yellow Flag,* pp. 98–99.
58 See Wallace, "On the Totality of Institutions", pp. 1–7; Davies, "Goffman's Concept of the Total Institution: Criticisms and Revisions", pp. 77–95; Moran and Gill (eds.), *Carceral Spaces: Mobility and Agency in Imprisonment and Migrant Detention*; Mountz, "Island Detention: Affective Eruption as Trauma's Disruption", p. 76.
59 See Bilić, "Plague and Trade Control. Form and Function of the Dubrovnik Lazaretto", pp. 114–116.
60 On the fondaco see Constable, *Housing the Stranger in the Mediterranean World: Lodging, Trade, and Travel in Late Antiquity and the Middle Ages*; Concina, *Fondaci: architettura, arte e mercatura tra Levante, Venezia, e Alemagna*; Howard, "Venice and Islam in the Middle Ages: Some Observations on the Question of Architectural Influence", p. 68.
61 Dankoff (ed.), *An Ottoman Traveller: Selections from the Book of Travels by Evliya Celebi,* p. 199.
62 Bilić, "Plague and Trade Control"; Bilić, "Daniel Rodriga's lazaretto in Split and Ottoman caravanserais in Bosnia: the transcultural transfer of an architectonic model".
63 'Un pensiero mi sorprende, e sono sicuro/ che nel genio di pochi avrà ricetto/ il Lazzaretto par luogo sospetto/ se per la libertade è troppo duro. E pur non è così perché all'oscuro/ veggiamo in questo mondo ogni diletto/ sempre a lui ridoniamo il nostro affetto/ imbattendo un sentier c'ha dell'impuro./ Ma viva il ciel chè nostra bella sorte/ci conduce ad amar questo ritiro/ che il corpo vanta di pulir con aggio' (1739); Pellegrini, 'Il Lazzaretto Di Verona', 181.
64 Sansovino, *Venetia città nobilissima et singolare,* V, 232; for a discussion on quarantine as a time for prayer see Stevens Crawshaw, *Plague Hospitals,* pp. 45–48.
65 ASLi, Magistrato poi Dipartimento di Sanità, p. 23, *Istruzioni per il lazzaretto di S. Leopoldo,* 21, c. 19.
66 *Regolamento di Sanità di Pulizia e d'Economia,* p. 43.
67 ASVr, Ufficio di Sanità, Carteggi, relazioni ed atti diversi, 19, 28 February 1739; 18 May 1739;
68 ACAn, Antico Regime, II, Ufficio di Sanità, 2, c. 21 r.
69 See Chiu, "Singing on the Street and in the Home in Times of Pestilence: Lessons from the 1576–1578 Plague of Milan".
70 Archivio di Stato di Trieste (ASTs), Intendenza Commerciale, 379, c. 231 v.; *Regolamento di Sanità, di Pulizia e d'Economia,* p. 43.
71 See also Chase-Levenson, *The Yellow Flag,* p. 120.
72 *Capitoli, et Ordini,* p. 12; *Commissioni in via di istruzione,* pp. 6–7; Reglemens du Bureau de Santé de Marseille, p. 136; *Editto Reale,* pp. 22–23; ASGe, Manoscritti, 988, ff. 44 v.; 61 r.
73 ASVe, Provveditori e Sopraprovveditori alla Sanità, 110, 11 September 1771.
74 *Doveri da osservarsi nelli lazzeretti dalli rispettivi priori stabiliti dal regio supremo tribunale di sanità di Venezia,* p. 20.
75 ASTs, Intendenza Commerciale, 379, c. 230 v., 1 August 1768.
76 'col liberarmi da questo esilio.', ASGe, Ufficio di Sanità, 1280, 29 November 1744.
77 ASGe, Ufficio di Sanità, 1280, 23 Dicember 1744.

78 'dilatazione di vaso'; 'opormi tal volta con troppo d'impegno alla indisciplina'; ASVe, Provveditori e Sopraprovveditori alla Sanità. 385, 19 September 1782.
79 ASLi, Magistrato poi Dipartimento di Sanità, 164, 20 August 1789.
80 'la mia presenza essendo sempre necessaria e sempre obbligata, non ho luogo dopo di avere adempito alli affari di poter prendere uno svago in sollievo de mio individuo sottoposto a dei fieri insulti di nervi': *Ivi*, 23 October 1789.
81 'il servizio [è] più faticoso, e la vita è più solitaria e ristretta', *Ivi*, Affare 79, 11 August 1779.
82 'spirito folletto', ASLi, Ufficio di Sanità, 647, Processo Camerale n. 50, 13 September 1779.
83 ASGe, Banco di San Giorgio, Cancelleria 479, 9 September 1761.
84 ASLi, Magistrato poi Dipartimento di Sanità, 172, 15 February 1793.
85 ASGe, Banco di San Giorgio, Cancelleria 479, 2 June 1762.
86 On thresholds see Jütte, *The Strait Gate*; Brundin, Howard, and Laven, *The Sacred Home in Renaissance Italy*, ch. 9.
87 ASVe, Provveditori e Sopraprovveditori alla Sanità, 1009, ff. 7 r.- 8 r;
88 The scene might have been similar to those of nunnery's parlours, see Laven, *Virgins of Venice: Enclosed Lives and Broken Vows in the Renaissance Convent*, pp. 110–111.
89 Griffero, "Atmospheres", p. 5.

Bibliography

Alberti, Fay Bound (ed.), *Medicine, Emotion and Disease, 1700–1950* (London: Palgrave Macmillan UK, 2006).

Anderson, Ben, "Affective Atmospheres", *Emotion, Space and Society*, 2.2 (2009), pp. 77–81.

Bamji, Alexandra, "Health Passes, Print and Public Health in Early Modern Europe", *Social History of Medicine*, 32.3 (2019), pp. 441–464.

Bashford, Alison (ed.), *Quarantine: Local and Global Histories* (Basingstoke, Hampshire: Macmillan International Higher Education, 2016).

Bergdoll, Barry, "The Architecture of Isolation: M.-R. Penchaud's Quarantine Hospital in the Mediterranean", *AA Files*, 14 (1987), pp. 3–13.

Bilić, Darka, "Plague and Trade Control. Form and Function of the Dubrovnik Lazaretto", in Ante Milošević (ed.), *Lazaretto in Dubrovnik: Beginning of Quarantine Regulation in Europe* (Dubrovnik: Institute for the Restoration of Dubrovnik, 2018), pp. 103–119.

———, "Quarantine, Mobility, and Trade: Commercial Lazzarettos in the Early Modern Adriatic", in Paul Nelles and Rosa Salzberg (eds.), *Connected Mobilities in the Early Modern World: The Practice and Experience of Movement* (Amsterdam: Amsterdam University Press, 2022), pp. 157–184.

Blažina-Tomić, Zlata, and Vesna Blažina, *Expelling the Plague: The Health Office and the Implementation of Quarantine in Dubrovnik, 1377–1533* (Montreal, Quebec: McGill-Queen's Press, 2015).

Böhme, Gernot, *Atmospheric Architectures: The Aesthetics of Felt Spaces* (London, England: Bloomsbury Academic, 2020).

Bonastra, Quim, "Recintos sanitarios y espacios de control: Un estudio morfológico de la arquitectura cuarentenaria", *Dynamis*, 30 (2010), pp. 17–40.

Booker, John, *Maritime Quarantine: The British Experience, c. 1650–1900* (Aldershot, England; Burlington, VT: Routledge, 2007).

Brundin, Abigail, Deborah Howard, and Mary Laven, *The Sacred Home in Renaissance Italy* (Oxford: Oxford University Press, 2018).

Bulmuş, Birsen, *Plague, Quarantines and Geopolitics in the Ottoman Empire* (Edinburgh: Edinburgh University Press, 2005).

Cavallo, Sandra, and Tessa Storey, *Healthy Living in Late Renaissance Italy* (Oxford; New York: Oxford University Press, 2013).
Chase-Levenson, Alex, *The Yellow Flag: Quarantine and the British Mediterranean World, 1780–1860* (Cambridge: Cambridge University Press, 2020).
Chircop, John, and Francisco Javier Martinez (eds.), *Mediterranean Quarantines, 1750–1914: Space, Identity and Power* (Manchester: Manchester University Press, 2018).
Chiu, Remi, "Singing on the Street and in the Home in Times of Pestilence: Lessons from the 1576–78 Plague of Milan", in Maya Corry, Marco Faini, and Alessia Meneghin (eds.), *Domestic Devotions in Early Modern Italy* (Leiden: Brill, 2018), pp. 27–44.
Cohn, Samuel K., *Cultures of Plague: Medical Thinking at the End of the Renaissance* (Oxford; New York: Oxford University Press, 2010).
Concina, Ennio, *Fondaci: architettura, arte e mercatura tra Levante, Venezia, e Alemagna* (Venezia: Marsilio, 1997).
Constable, Olivia Remie, *Housing the Stranger in the Mediterranean World: Lodging, Trade, and Travel in Late Antiquity and the Middle Ages* (Cambridge; New York: Cambridge University Press, 2004).
Dankoff, Robert (ed.), *An Ottoman Traveller: Selections from the Book of Travels by Evliya Celebi* (New York: Eland Publishing, 2011).
Davies, Christie, "Goffman's Concept of the Total Institution: Criticisms and Revisions", *Human Studies*, 12.1/2 (1989), pp. 77–95.
Ebrahimi, Sara Honarmand, "Introduction: Exploring Architecture and Emotions through Space and Place", *Emotions: History, Culture, Society*, 6.1 (2022), pp. 65–77.
Gentilcore, David, "The Fear of Disease and the Disease of Fear", in William G. Naphy and Penny Roberts (eds.), *Fear in Early Modern Society* (Manchester, England; New York: Manchester University Press, 1997), pp. 184–208.
Goffman, Erving, "The Characteristics of Total Institutions", in Amitai Etzioni (ed.), *A Sociological Reader on Complex Organizations* (New York: Holt, Rinehart and Winston, 1969), pp. 312–338.
Griffero, Tonino, *Atmospheres: Aesthetics of Emotional Spaces* (Farnham Surrey, England; Burlington, VT: Ashgate Pub, 2014).
Howard, Deborah, "Venice and Islam in the Middle Ages: Some Observations on the Question of Architectural Influence", *Architectural History*, 34 (1991), pp. 59–74.
Hultman, Maja, "Atmospheres of the Other: Building and Feeling Stockholm's Orthodox Synagogue", *Emotion, Space and Society*, 44 (2022), pp. 1–10.
Inì, Marina, "Architecture and Plague Prevention: The Development of Lazzaretti in Eighteenth-Century Mediterranean Cities", in Mohammad Gharipour and Anatole Tchikine (eds.), *Salutogenic Urbanism: Architecture and Public Health in Early Modern European Cities* (Singapore: Palgrave Macmillan, 2023).
———, "Materiality, Quarantine and Contagion in the Early Modern Mediterranean", *Social History of Medicine*, 34.4 (2021), pp. 1161–1184.
Jones, Lori, "The Diseased Landscape: Medieval and Early Modern Plaguescapes", *Landscapes*, 17.2 (2016), pp. 108–123.
Jütte, Daniel, "Sleeping in Church: Preaching, Boredom, and the Struggle for Attention in Medieval and Early Modern Europe", *The American Historical Review*, 125.4 (2020), pp. 1146–1174.
———, *The Strait Gate: Thresholds and Power in Western History* (New Haven: Yale University Press, 2015).
Konstantinidou, Katerina, *Lazzaretti Veneziani in Grecia* (Padova: Elzeviro, 2015).

———, "Santi Rifugi Di Sanità: I Lazzaretti Dell Quattro Isole Del Levante", *Studi Veneziani*, 53 (2007), pp. 239–259.

Laven, Mary, *Virgins of Venice: Enclosed Lives and Broken Vows in the Renaissance Convent* (London: Penguin, 2003).

Lefebvre, Henri, *State, Space, World: Selected Essays*, ed. by Stuart Elden and Neil Brenner (Minneapolis: University of Minnesota Press, 2009).

———, *The Production of Space* (Oxford: Blackwell, 1991).

Moran, Dominique, and Nick Gill (eds.), *Carceral Spaces: Mobility and Agency in Imprisonment and Migrant Detention* (London: Routledge, 2016).

Mountz, Alison, "Island Detention: Affective Eruption as Trauma's Disruption", *Emotion, Space and Society*, 24 (2017), pp. 74–82.

Nutton, Vivian, "The Seeds of Disease: An Explanation of Contagion and Infection from the Greeks to the Renaissance", *Medical History*, 27.1 (1983), pp. 1–34.

Panzac, Daniel, "Plague and Seafaring in the Ottoman Mediterranean in the Eighteenth Century", in Maria Fusaro, Colin Heywood, and Mohamed-Salah Omri (eds.), *Trade and Cultural Exchange in the Early Modern Mediterranean: Braudel's Maritime Legacy* (London; New York: Tauris Academic Studies, 2010), pp. 45–68.

———, *Quarantaines et Lazarets: L'Europe et La Peste d'Orient, XVIIe-XXe Siècles* (Aix-en-Provence: Edisud, 1986).

Pellegrini, F., "Il Lazzaretto Di Verona", *Studi Storici Veronesi*, II (1949), pp. 143–191.

Pernau, Margrit, "Space and Emotion: Building to Feel", *History Compass*, 12.7 (2014), pp. 541–549.

Robarts, Andrew, *Migration and Disease in the Black Sea Region: Ottoman-Russian Relations in the Late Eighteenth and Early Nineteenth Centuries* (London: Bloomsbury Academic, 2016).

Rublack, Ulinka, and Pamela Selwyn, "Fluxes: The Early Modern Body and the Emotions", *History Workshop Journal*, 53 (2002), pp. 1–16.

Stevens Crawshaw, Jane L., *Plague Hospitals: Public Health for the City in Early Modern Venice* (Farnham, Surrey, England; Burlington, VT: Ashgate, 2012).

Talu, Cigdem, "The Effect of London": Urban Atmospheres and Alice Meynell's London Impressions", *Emotions: History, Culture, Society*, 6.1 (2022), pp. 96–116.

Vanzan Marchini, Nelli-Elena (ed.), *Rotte Mediterranee e Baluardi di Sanità: Venezia e i Lazzaretti Mediterranei* (Milano: Skira, 2004).

Varlik, Nükhet, *Plague and Empire in the Early Modern Mediterranean World: The Ottoman Experience, 1347–1600* (Cambridge: University Press, 2015).

Varlık, Nükhet, "Oriental Plague" or Epidemiological Orientalism? Revisiting the Plague Episteme of Early Modern Mediterranean", in Nükhet Varlik (ed.), *Plague and Contagion in the Islamic Mediterranean* (Newark: ARC Humanities Press, 2017), pp. 57–87.

Wallace, Samuel E., "On the Totality of Institutions", in Samuel E. Wallace (ed.), *Total Institutions* (Chicago: Aldine Pub. Co, 1971), pp. 1–7.

6 The rebuilding of L'Aquila after the 1703 quake
Death and rebirth

Rossana Mancini

Lying at the centre of Apennine Italy, L'Aquila has been repeatedly destroyed by major earthquakes since its founding in the second half of the fourteenth century. These events and the consequent rebuilding efforts have had very strong emotional impacts on the city's community – effects that we can still see today, in the aftermath of the terrible quake that struck the city in 2009. The 1703 earthquake was devastating, claiming thousands of lives. A great many of the county's towns were destroyed, and L'Aquila's architectural heritage was gravely stricken.

On that occasion, the destruction was mourned and coped with at a particular moment in the city's history. The seventeenth century had been a time of great architectural renewal in spite of the difficulties the city had suffered – first and foremost the 1656 plague. L'Aquila's architecture was being renewed, and the Medieval city was *modernizing.*

Baroque was already a presence in L'Aquila in the early seventeenth century, and during the second half of the century, the main churches' interiors had been transformed in accordance with the new style.[1] Beyond the mourning, the earthquake presented an opportunity to implement those building interventions that had been dreamed of and desired and that without the destruction caused by the quake could only have been partially implemented. Disaster, then, paved the way to a new economic, artistic, and cultural opportunity. The Medieval city was partially – and enthusiastically – replaced by the new, eighteenth-century one. No space for "as it was and where it was" – a refrain that would become recurrent in subsequent centuries in the "post-seismic" thinking of communities in Italy and elsewhere. Out of the rubble, a new city was born: made of imposing constructions and rich in decorations and ornaments, L'Aquila consecrated Baroque not only inside buildings but also on their exterior, modifying the appearance of the Medieval city. Death and rebirth, tragedy and comedy: these are the elements that nurtured the Baroque style, displayed in L'Aquila in its splendour of tragedy, laughter, and tears.[2] Baroque embodies the desire to evoke states of emotion, appealing to the senses, often in dramatic ways. Some of the qualities most frequently associated with Baroque are grandeur, sensual richness, drama, vitality, movement, tension, and emotional exuberance – all moods and emotions that are present in the tragedy and rebirth connected to a drama like an earthquake. On land earlier occupied by collapsed dwellings, the palazzi of L'Aquila's new families (Romanelli, Bonanni,

Pica, Oliva) rose, and the main churches were modified or rebuilt in accordance with the new taste. In L'Aquila, mourning and grieving found their epiphany in Baroque.

Post-seismic and post-disaster rebuilding

In his article about L'Aquila's quake (1703), Alessandro Simonicca quotes Arnold Van Gennep and his rites of passage.[3] The author defines the partition into three initiation rites: separation (pre-liminal stage), transition (liminal stage; from *limen*), and reintegration (post-liminal stage). From Gennep's thinking, Susanna M. Hoffman, one of the leading anthropologists dealing with disasters and how stricken populations perceive and cope with them, reconstructs a model of cultural response to the disaster in accordance with a sequence of three phases: crisis or early recovery, passage or post-disaster, and closure.[4] The rebuilding of the city of L'Aquila followed, in Europe, a series of dramatic events that prompted the rebuilding of entire urban centres. Among these is worth remembering the Great Fire of London (1666) and the destruction of Sicily's Val di Noto, which was razed to the ground by a strong earthquake in 1693. What links these events is the desire to seize the opportunity provided by destruction and to create new urban landscapes and new architectures. This was achieved completely in Noto, where Baroque reached one of its finest expressions, whilst in London and L'Aquila, it remained only a partial project.

L'Aquila: quakes before 1703

Little is known about the modes of response to the quakes that struck the city before 1703. Only scant information may be gleaned from the documents relating to the two major Medieval earthquakes and the fifteenth-century quake of 1461. From what little is known, there appears to have been some differences, especially in relation to the population's attitudes.[5] In the fourteenth century, two destructive seismic events struck the city of L'Aquila, respectively, in 1315 and 1349. After the latter, an idea spread through the city: that L'Aquila ought to be abandoned because its founders had chosen a location unsuited for its construction and that therefore "*Aquila no se degia refare*," as Buccio di Ranallo (1290/1295–1363) reports in his L'Aquila Chronicle, written probably around 1355.[6]

Count Lalle Camponeschi, Duke of Montorio and one of the most influential figures in L'Aquila during those years, opposed the city's abandonment, as he feared this would have led to a decline in his personal power and privileges. He urged to rebuild the city and organized the first operations to reinforce the damaged buildings.[7] The discomfort of L'Aquila's inhabitants, recorded by Buccio di Ranallo after the 1349 earthquake, was aggravated by the condition of suffering they were in at the time of the quake due to the plague that had stricken the city the year before. After the 1461 earthquake, unlike what happened before, sources appear to show no evident desire to abandon the city. Institutions and the local population seem to have acted together to rebuild, although the repositioning of the residences within the city's fabric must have created conflict.

The quakes had severely stricken the city, leaving one quarter of it completely destroyed and the other three quarters severely damaged.[8] In addition to causing about 80 deaths, the fifteenth-century earthquake wiped out much of the Medieval city, built with two-storey row houses tidily inserted into plots received under concession. The rebuilding presented the opportunity for a social reorganization, which was achieved through the transfer of aristocrats and the influential leaders of the arts from the obsolete Medieval homes to new living solutions, built in the most selected and prestigious parts of town. Property merging processes were also carried out, facilitated by the decreased value of the destroyed buildings and their lots.[9]

Over the typological and formal uniformity of the Medieval city represented mainly by row houses aligned in the perimeter around urban blocks, the 1461 quake favoured the *palazzo* building type, with the buildings arranged in a sequence along some selected streets which in this way became representative of the new economic and social status. Through the sale of lots and the introduction of the new larger and more representative palazzo type, the remains of the Medieval city were incorporated into the new, Renaissance city. The house of Iacopo di Notar Nanni is considered a rare example of architecture that bears witness to the transition from the Medieval house, with its peculiar internal distribution formed by two, adjacent, functionally united, single-family homes, to the Renaissance palazzo home with courtyard and sixteenth-century loggias.[10] On the other hand, the increased urban density caused by phenomena of merged buildings, higher levels, and saturation of private open spaces inside the blocks resulted in lower urban seismic safety.[11]

London (1666)

The Great Fire of London happened in 1666, 37 years before the destruction of L'Aquila, and similarly prompted an almost complete rebuilt of the urban centre. Some of Britain's most important architects – including John Evelyn, Robert Hooke, and Valentin Knight – were summoned to develop new rebuilding plans. The plans they submitted erased the previous urban fabric, made of narrow, winding streets, to obtain one that featured regular, orderly avenues and squares.

The most well-known proposal is the one submitted by Christopher Wren, who suggested to completely rebuild the areas destroyed by the fire in accordance with a new, monumental arrangement. He aimed to build a city, in a strictly Baroque style, characterized by *pomp and regularity*. The focal points of Wren's plan, which was never approved due to issues connected with property ownership, were public and religious buildings, including Saint Paul's Cathedral, the Tower of London, and the Royal Exchange. The rebuilding instead followed the *Act for Rebuilding the City* of 1667, which enshrined the restoration of the old urban layout, limiting the planimetric transformations to small improvements connected to traffic circulation.[12] Charles II, while admiring Wren's plan (the architect was one of the six commissioners appointed to oversee the rebuilding works), made a conservative choice. The king would have not been able to give Wren *carte blanche*, since redesigning London would have required a detailed investigation to establish property rights as the basis for compensating and transferring the lots. These data did not exist,

and gathering them would have taken a great deal of time, while merchants were anxious to rebuild their shops as quickly as possible. The old road arrangement was maintained, albeit with some improvements. Houses had to be in brick or stone, with no exterior wood; roads were widened, obstacles eliminated, and the height of houses determined by their location. Even though new and important buildings were constructed, the urban fabric continued, in its general lines, to follow the pre-existing Medieval pattern.

The Great Fire was a social and economic disaster from which many thought London would never recover. It took a half-century to complete the replacement cathedral and the 51 churches chosen for rebuilding. The result was an important one, that city's image for all time. The fire, along with the creative abilities of great architects and the impetus of the fine Baroque architecture that had spread in Europe, led to the construction of great buildings that became icons of the city – first and foremost Saint Paul's Cathedral.[13]

Val di Noto (1693)

Twenty-six years after the London fire and ten before the L'Aquila earthquake, rebuilding on an urban scale was practised in Italy with positive results, at least from the artistic and architectural perspective, after the earthquake that struck the Val di Noto, in eastern Sicily, in 1693. On that occasion, the Spanish government carried out major interventions on an urban and territorial scale, rebuilding, in Late-Baroque form, numerous cities including Catania, Noto, and other smaller towns along the coastline.[14] Many of the towns in the Val di Noto had Medieval layouts, marked by narrow, winding streets whose hazards were tragically demonstrated by the earthquake. The central government's aim was to maintain the original sites in order to reduce rebuilding costs and, above all, to avoid breaking established equilibria among the various towns and to maintain the coastal defensive system unaltered. On the contrary, parishes in the valley's towns struggled to rebuild churches in a more sumptuous fashion, with no interest in maintaining the earlier positions of the buildings.[15]

In the case of Noto, the earthquake was long considered a traumatic event capable of joining together – in a sort of common reaction of life against death – the Spanish government, the feudal nobility, the clergy, and the urban communities. Recent studies are leading towards more articulated analysis.[16] While there is no doubt that the effort of the three organs of power was substantially synergistic and aimed above all at dealing with the immediate emergency, the reaction of the urban communities – which went well beyond the aims of mere reconstruction throughout the eighteenth century – was far more complicated and extensive.[17]

The study of the individual communities' social dynamics, correlated with urban planning and architectural choices, yields the image of a deeply divided and conflicted urban society, marked by the often-violent opposition of groups and factions coexisting in precarious equilibria within the urban nucleus. The destruction that the quake caused in the physical reality of Sicily's population centres was transformed into an opportunity to revise the relationship between settlements and

the surrounding territory, with substantial economic upheavals, and to redistribute the actual weight of the various social groups and their ability to control the city and its space.[18]

In Catania, the largest and most quake-stricken city, the agreement between the nobility, bishop, and government to rebuild the city in the same place made the building programmes quick and not subject to revision. The entire urbanized area was divided into two parts: in the first one, to the west, around the Benedictine monastery, lived the lower classes, and in the second, with very high property values, the higher ones. In this area, there were new roads, new piazzas, and the main new architectural elements. In the last of these settings, a wholly pre-eminent role was obviously given to the Cathedral and its urban basin.[19]

In Noto, despite the far more tortuous initial events (due to the decision to rebuild the city in a new site), the outcome was not much different. The Noto that became famed for its architectural and urban organization was, in reality, only the neighbourhood of the noble and ecclesiastical oligarchy, dominated in this case as well by the cathedral and placed at the centre of a far broader and more articulated eighteenth-century urban fabric.

As would also take place in L'Aquila several years later, in the towns of the Val di Noto social conflicts were manifested above all through the antagonism among the communities belonging to different parishes and confraternities, in an ongoing competition to hoard privileges and religious honours, behind which socioeconomic ones of course lay hidden. The 1693 earthquake, by challenging settlement strategies and questioning the self-representation of various groups within the new cities, became an explosive event capable of upsetting the old equilibrium and inflaming latent conflicts. It can be said that the quake set off a sort of war between parishes, in which the drastic division of the groups represented by different patron saints constituted the fundamental reason for the triggering of a constant architectural competition to build the respective churches.[20]

Before the quake: L'Aquila in the seventeenth century

In its political and formal traits, L'Aquila summarized a complex history that had seen the city devastated by the climate imposed by the Spanish government after 1529 and the so-called anti-Spanish revolt of the previous years. The return to order had brought financial penalties with it, such as the city's separation from the county, its historic economic lung, while the period of government under Margaret of Parma between 1572 and 1586 had conferred new prestige to the city, now home to a high-level Renaissance court.[21]

Despite the harsh Spanish reaction, over the course of the sixteenth century, a so-called "*devotio ispanica*," generated by a sense of gratitude for the *concordia ordinum* that the Spanish king had imposed on a politically restless city, was widespread among L'Aquila's population.[22] The praise of monarchy was even stronger in the early seventeenth century when, as in other cities in the Kingdom, the king bestowed noble titles upon the family aristocracies, thereby establishing a new leadership group.

Towards the middle of the seventeenth century, the population's unrest became chronic. The Thirty Years' War that tore Central Europe apart between 1618 and 1648 had indirectly consumed the Italian Mezzogiorno, triggering highly excessive taxation by the Spanish government, seeking to cover its military expenditure. In L'Aquila, the revolutionary stirrings reawakened ills that had been lacerating the community for more than a century, such as bad government, fiscal pressure, and conflicts between the commoners and the nobility, while heightening the division between the city and its county. In the second half of the century, population's welfare continued to be worsened by difficulties due to demographic decline, the devastating effects of the plague of 1656–1657, and the famines of the 1670s.

"Modernization" and the new seventeenth-century constructions

Even in this difficult social and economic situation, Baroque architecture spread in L'Aquila during those years, marking the prelude to what would be the great postquake rebuilding. In certain ways, this replicated the modes of intervention already underway, but the possibilities offered by the devastation strongly expanded the field of action of clients and architects alike.

The activity of renovating Early Christian or Medieval churches in new forms linked L'Aquila culturally to what was taking place in the rest of Italy and in Europe, in a significant way, between the post-Tridentine renewal and much of the eighteenth century. These operations occupied a central place in Europe's architectural culture, its religious thought, and its liturgy. They were not only the result of continuous additions and modifications to pre-existing constructions but had a specific nature of their own and a level of intentionality that make them an object of particular study, for which thinking in terms of process does not suffice.

This mode of intervention is premised upon a new way of assessing Christian antiquity and its character of bearing witness. This demand was to be met by the Baroque architectural language, which had a fundamental trait – *inclusiveness* – embedded in its genetic code.[23] Despite its richness and the multiplicity of its expressions, Abruzzese Baroque has been little studied and underestimated to this day, in comparison with the artistic expressions of the previous centuries. Until now, in the region, these architectures have not attracted interest similar to other southern settings like Puglia, Calabria, Basilicata, and Campania, where recent decades have seen the promotion of an intense activity of exhibitions, conferences, and monographs resulting in comprehensive reconstructions.[24]

Already in the early seventeenth century, and then in the 1670s and 1680s, thanks to the work by L'Aquila native Francesco Bedeschini and stucco workers from Lombardy and Ticino, L'Aquila's main churches were renovated, with their interiors reconfigured and transfigured. A major role was played by the renovation of Santa Giusta (around 1617–1620) and the later one of Santa Maria di Collemaggio, both under Francesco Bedeschini. These interventions, as happening elsewhere in Abruzzo, had models taken from the churches of the orders born from the Counter-Reformation, and in particular from the Jesuit Order, having a single

nave with side chapels. But this layout had to come to terms, in the operations on pre-existing churches, with basilica bodies.[25]

In the two examples under consideration, action was taken mainly through additions. The adornment of the spaces was entrusted to decorators and stonecutters originating for the most part from Lombardy, which gave the buildings plastic intensity. At Santa Giusta, the layout, originally with three naves and three apses, was transformed into a single-nave arrangement with chapels. The city already had buildings that were configured in accordance with a Jesuit pattern and that made broad use of the classic architectural orders that were widespread in the middle of the sixteenth century.

The refinement of the decoration done by Francesco Bedeschini at Collemaggio may be gleaned from the photographs taken before the "restorations" of 1970–1972 (Superintendent Mario Moretti) and from a preparatory drawing for the long strip decorated with stucco, which was intended to top the nave's arches. The mediation pursued at Santa Maria di Collemaggio between conserving the pre-existing elements (the three-nave Medieval architectural structure) and Baroque architecture in fact constitutes the Abruzzese approach to Baroque, in which Francesco Bedeschini was the leading player.[26] The Baroque transformation inside the Collemaggio basilica had begun slowly, with small additions and modifications, then blossoming into a complete transformation between 1659 and 1669. The transept began to be enriched, with the construction of two large altars at the fronts.[27] This was followed by a massive intervention aimed at fully and heavily redefining its formal and spatial character. Similarly to what took place at Santa Giusta, the operations first involved concealing the octagonal pillars within new, Baroque cruciform supports. The ogival arches were brought back to being round arches. The decorative apparatus, done in stucco, used the architectural order, outlining large pilasters that supported, formally but perhaps not statically, a cornice topped by an attic. The decoration of the latter was enriched by the presence of angels, putti, coils, and festoons. At the top of the attic, a flat wooden ceiling was placed, with octagonal coffers in blue, red, and gold, the construction of which was completed in 1669.[28]

Sandro Benedetti has observed that the space ended up becoming "activated" in reverse, which is to say intense and vibrant above, calm and rhythmic in the low articulations of the arches.[29] The lowering of the masonry of the central nave, the building of the vaults over the aisles, the flat ceiling over the nave, and the organ and Ruther's paintings might date to this time.[30] In 1673, works for the stuccowork of the gallery of the great altar were underway.[31] The most prized vestige of the seventeenth-century intervention has remained in the decorative apparatus of Cappella dell'Abate, the chapel to the right of the chorus, by the same architect.

In the case of the church of Santa Margherita, also known as the Chiesa del Gesù or Chiesa dei Gesuiti, unlike what took place at Santa Giusta and at Collemaggio, a construction was done *ex novo*, anticipating some of the post-seismic interventions in type and not only in the decorative apparatus.

In November of 1596, the *Aquilanum Collegium* (the College of Jesuits) was inaugurated, and the following year the Order came into possession of the small church of Santa Margherita della Forcella. Upon this nucleus, enriched with

targeted proprietary acquisitions, the Jesuits laid the foundations for initiating a building programme of broad scope. The design, approved on 24 May 1625, was by P. Agatio Stoia, architect of the Neapolitan Province since 1623.[32] Although the works began in 1636, in 1641 a single chapel – the Cappella della Trinità (completed in 1647) – was usable, and in 1662 only the three chapels to the south and one of those to the north were completed. In the absence of precise documentation, it can be estimated that the works were completed in the final decade of the seventeenth century. The interior had a single nave with barrel vault and six side chapels (three per side) separated by double Corinthian pilasters. The layout, classicist and Mannerist in style, was made monumental by the Baroque decoration added during the building's completion.

Use of the single nave with chapels had by now become common in L'Aquila's newly built churches; of these is worth mentioning of the church of Sant'Antonio da Padova (ca. 1646–1650), also called *chiesa dei cavalieri de Nardis*, in which the classic architectural order is accompanied by a Jesuit layout.[33]

The 1703 earthquake and the eighteenth-century rebuilding

Destruction

In the winter of 1703, part of the Papal State and the northeastern territories of the Kingdom of Naples were struck by one of the most disastrous sequences of earthquakes in Italian seismic history. Preceded by a series of tremors starting, the first, very strong, earthquake occurred during the night of the 14th of January. It struck the villages of the Valnerina and of the upper-Rieti area, causing widespread damage in L'Aquila as well, where the church of San Pietro di Sassa suffered severe damage, losing its campanile and gallery. Many chimneys in the city fell, and some buildings were damaged. The damage was worsened by a subsequent quake happening on the 16th of January, when two more campanili fell (the ones of San Pietro di Coppito and of Santa Maria di Rojo). The cathedral was severely damaged, while deep cracks opened in other churches. Those who were able to escape found shelter in the surrounding countryside.

But the strongest blow was the earthquake that stroke on the 2nd of February, during the celebrations for Candlemas, the Feast of the Purification, when L'Aquila and the surrounding towns were further devastated. The tremors were felt from Naples to Venice, causing considerable damage even in Rome. The Valnerina, the upper-Rieti area, and northern Abruzzo were severely stricken, with the destruction of dozens of towns in addition to L'Aquila, like Norcia, Cascia, and Amatrice (and its villas, Montereale, Cittareale, Antrodoco, and Leonessa, to cite the most important ones).[34] Cittareale alone lost most of its inhabitants. A document conserved at the Vatican Library, *Relatione delle Ruine fatte dal Terremoto nella Diocesi di Rieti*, reports the town's complete destruction and the deaths of 700–800 people.[35]

In the city, the earthquake caused extensive collapses. Numerous churches fell, including San Bernardino, whose façade was spared, San Filippo, the Cathedral of Saints Maximus and George, and Sant'Agostino. The collapse of the church of

San Domenico caused the deaths of hundreds of people who had gathered for the Candlemas celebrations. Even many noble palazzi suffered very severe damage. The castle, as well as the city walls and gates, was seriously ruined.[36]

The report from Alfonso Uria De Llanos, auditor of the Viceroyalty (Uditore del Viceregno), points to 2,000 deaths in L'Aquila and 7,694 in the entire province of Abruzzo Citra.[37] The death toll, then, was quite high (the number varies depending on the source), and the economic and social impact was enormous. A document held at the State Archive in L'Aquila lists 376 households for the year 1712, 847 less than those taxed during a similar census done in 1669. These numbers provide an idea of the depopulation that took place during the post-seismic period, when many people decided to leave the city for several years, or for good. This phase is the one in which the damage is discovered, and the feeling of victimhood is born. It is an emotional passage marked by an irreversible and traumatic inner change.

How the administrators reacted immediately after the quake may be partially reconstructed through the available documents, some of which are held at the Archivio di Stato dell'Aquila, including the documents of Consiglio generale della Camera Aquilana, the announcement of the head (Preside) of Provincia Abruzzo Ulteriore, the papers of the ecclesiastical authorities, and notarized deeds. The first Consiglio generale della Camera Aquilana was called on 19 February 1703, 17 days after the earthquake. It was held in front of a shack built near the Cathedral. The Council was supposed to replace the *camerlengo* (custodian and administrator of assets and finances) Alessandro Cresi and the *grassiere* (royally appointed magistrate) Nicola Romanelli, who had died in the ruins of the earthquake.[38]

The minutes of the general councils and those of the *Preside* allow us to reconstruct the first frantic moments, when it also became necessary to restore order in Piazza Duomo, where transit was made difficult by the number of temporary shelters built in the aftermath of the quake. There was the need to reactivate immediately some essential services, first and foremost the water supply, because the quakes had damaged the aqueducts.

Chronicles from that time report the loss of citizens, while some notarized deeds offer scenarios recounting daily life and the problems of those who had lost all their material assets and their employment. This was the phase of mourning over destruction, whose great emotional and social impact gave rise to the numerous religious practices aimed at doing penance and atoning for sins, and at offerings of thanks. The direct intervention of Pope Clemente XI took the form of a plenary indulgence, followed by the concession of a Jubilee on the 17th of January (Biblioteca Apostolica Vaticana, 1703a). In many towns, practices of giving thanks or collective atonement were instituted or promoted in the form of processions, masses, pilgrimages, or simply donations in money, and lasted nearly uninterrupted for several months (Figure 6.1).[39]

Francesco Maria Rampazzi, in his *Discorso fisico e morale sopra le cause del terremoto*, described the quakes as one of the 'scourges' of Divine Omnipotence, sent to awake people from the slumber of earthly things and summons sinners to repentance.[40] Rampazzi had strong criticism for those who, over the centuries, had attempted to explain earthquakes by natural causes, instead of begging for Divine

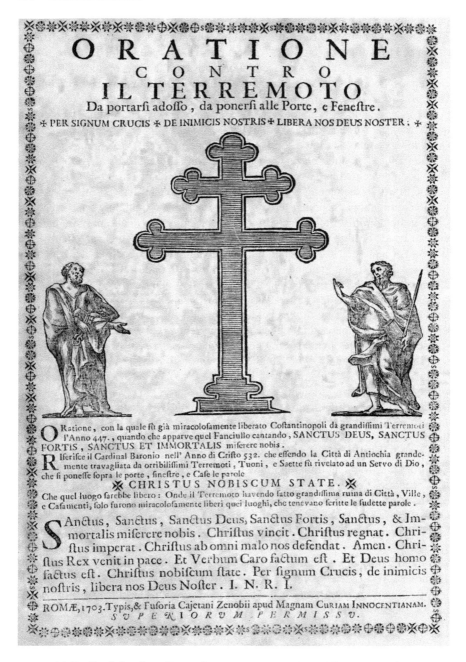

Figure 6.1 Foglio di Orazione Contro il Terremoto (1703). https://ingvterremoti.com/2022/08/11/la-sequenza-sismica-che-colpi-il-centro-italia-nel-1703.

Assistance in similar situations. The anonymous chronicler of 1703 also treated this earthquake as a means through which God manifested His indignation.[41] This view, quite common at the time, overwhelmed an already desperate population with feelings of guilt.[42]

Rebuilding

Over the centuries, it has often taken natural disasters to modify the image of cities. What had taken place a few decades earlier in London and only a decade earlier in the Val di Noto also took place in L'Aquila. Strongly shaken by the 1703 earthquake, the city was reborn with a new image, accurately captured by Vandi's 1753 map.

The *rebuilding* period is the one in which the stricken community developed the feeling of a common destiny. As happened in the aftermath of other disasters, the rebuilding phase is characterized by a strong differentiation between those who wished to abandon the destroyed area, move individually, or rebuild the city elsewhere, and those who wished to propose a new urban arrangement or maintenance of the damaged site.

The results in London, L'Aquila, and the Val di Noto (in Sicily, the reconstruction was still in progress) show shared aspects, but also many differences. What took place after a quake is the result of a dynamic between general aspects and contextual circumstances and, as such, is anything but predictable or replicable. This historic dynamic is itself part of dynamic process of local self-representation that develops in changeable, varied, and conflicting forms.[43]

In L'Aquila, as elsewhere, the rebuilding provided the opportunity to recalibrate the effective weight of the various social groups and their capacity to exert control over the city and its space. This may be noted by looking at the transformations that took place in the rebuilding of the religious centres and of the palazzi of the leading families, and particularly in how these were enlarged and repositioned within the urban fabric.

Among the first acts in L'Aquila's rebuilding was the intervention on the San Giuliano aqueduct, which was necessary for ensuring the city's water supply. During the first years, the notarized deeds held at Archivio di Stato dell'Aquila report information on the vaults to be rebuilt beneath the side naves of the Basilica of Collemaggio; there is also a record of a contract for the restoration of the Castle (notary Nicola Bucciarelli) and of the works to rebuild the gates along the city walls.

The Maiella earthquake of 1706, with its epicentre near Sulmona, slowed the initial rebuilding that had just begun.[44] Some citizens decided to abandon the city at this point. Among the first churches to be rebuilt were the Church of the Conception, starting in 1705, attributed to Carlo Fontana (starting 1707); the church of San Bernardino, with its cupola by Contini; and, starting in 1708, the church of Sant'Agostino, by the same architect.

From the second decade to the middle of the century

From 1708 to 1711, the rebuilding of Saints Maximus and George Cathedral started, under Sebastiano Cipriani's design. The whole restoration would take

almost 70 years to complete, and the Cathedral was reopened to the public only in 1780. Between the 1710s and the 1730s, works began on the churches of San Quinziano, San Domenico, and Santa Maria di Paganica, as well as on the interiors of other minor churches.

The *Relatio ad limina* written by Bishop Taglialatela in 1722 sheds an important testimony about the status of the rebuilding works 20 years after the quake. Some churches, including the Cathedral, were still in poor condition (*quoddam rude contabulatum*).[45] In the church of San Biagio, only the side walls of a nave had been restored (*usque modo lateralis tantum parietes unius navi sunt refecti*); others, like San Quinziano, had been repaired (*a ruinis reparatas*) or brought back to decorous shape and ornamentation (*ad formam ornatumque decentem redactas*). Although damaged by the earthquake, the church of San Silvestro was in good condition (*bene retenta, quamvis illius parietes ex terremotu vitium sensit*). Other religious buildings had just been rebuilt (*noviter erectas*), while others still had been restored more magnificently (*magnificentius reparatas*). The church of San Marco had been recently rebuilt (*nuper reedificata*); the Conception and Santa Maria di Paganica churches had been repaired and improved in form (*reparata et in meliorem formam redacta* for the former and *in multis ad meliorem redacta est formam* for the latter). The Basilica of Santa Maria di Collemaggio had been adorned with elegant work and exceptional magnificence (*eleganti opere et singulari magnificentia*). The church of San Domenico had been recently magnificently renovated from the foundations (*noviter a fundamentis magnificentius renovata*), while the church of Sant'Agostino had been repaired with greater magnificence (*magnificentius reparata*).

The 1740s and 1750s brought radical architectural and stylistic innovations: clients who had promptly rebuilt sacred buildings immediately after the earthquake, inspired by the magnificent constructions erected later, decided to rebuild up from the foundations with new, stylistically up-to-date designs. This is the case, for example, of Santa Caterina Martire, designed by Ferdinando Fuga, in 1753.[46]

Baroque, in L'Aquila, became an expression of that cultural drive and desire for renewal that, although already present before the quake, ended up being reinforced and promoted by the tragic event itself. Destruction released renovating energies, giving free rein to the architects' creative impetus, albeit within the constraints of collective and individual interests, as well as of economic possibilities.

The result of these interventions was that although the city essentially maintained the pre-existing urban planning arrangement, it had radically new architectural and formal *facies*. The still Medieval nature – albeit updated over the course of the sixteenth century – of urban construction disappeared, and the city took on a *modern*, more or less Baroque appearance entirely different from the previous one.[47] In L'Aquila, Baroque architecture magnificently emerged from the rubble of the 1703 earthquake.[48]

The piazzas also saw the addition of new architectures. In Piazza di Santa Giusta, the church now faced the new Palazzo Centi. Palazzo Rivera and Palazzo Persichetti were built in Piazza di Santa Maria di Roio, while Palazzo Ardinghelli was placed in Piazza Santa Maria Paganica. The works were particularly active in

Piazza di Santa Margherita and Piazza dell'Annunziata, which were given their current shape during this phase of rebuilding. These piazzas became home to some of the most important palazzi built after the quake. In Piazza di Santa Margherita, where the sixteenth-century Palazzo del Conte had previously stood, Palazzo Pica Alfieri was built, the result of a renovation and reconfiguration operation (1711–1727). Adjacent and contemporary to it, Palazzo Quinzi was built (completed in 1726); to the south, starting in 1712, Palazzetto dei Nobili was rebuilt. The new Piazza dell'Annunziata was marked by the eighteenth-century church of Santa Maria Annunciata di Preturo and by Palazzo Carli (1708–1725).[49]

The rebuilding of civic construction, which had initially lagged far behind that of religious buildings, accelerated several years later, most likely for political reasons. In 1713, in fact, the Kingdom of Naples, following diplomatic agreements, passed from the Spanish to the Habsburgs. The newly acquired stability of the Kingdom, now under a new Bourbon dynasty (Charles III in 1734), created those conditions that favoured the rebuilding of the residences of L'Aquila's leading families. This seems confirmed by the censuses of the years following the earthquake, which showed a city reduced in population, in comparison with the pre-seismic period, at least until the 1737 census. This has raised the hypothesis that the noble palazzi, closely linked to economic power, had been built only after a period of recovery resulting from the stabilized political situation.[50]

The collapse of Medieval civil buildings allowed ambitious operations to be carried out by L'Aquila's new families (Romanelli, Bonanni, Pica, and Oliva). For many of these families, the earthquake presented a unique opportunity to build palazzi that would otherwise never have existed. L'Aquila's civic architecture of the eighteenth century was defined by detailed figurative elements (windows, angle irons, portals, and cornices) whose composition, in the façades, often repeated the same patterns and architectural language of Late Roman Mannerism (Paolo Marucelli, Camillo Arcucci, and Giovanni Antonio De Rossi), marked by a more essential and austere architectural language, and of the works of Ferdinando Fuga and Luigi Vanvitelli.[51]

Religious architecture was swiftly rebuilt, and many of the main churches were heavily modified. The churches of Sant'Agostino, San Marciano, and Santa Maria Paganica as well as the Cathedral were almost entirely rebuilt, relying in some cases on changes to the pre-existing urban arrangement with the rotation of entrances and the creation of new façades.

In addition to the already cited contribution by Francesco Bedeschini, aided by stonecutters and stucco workers from Lombardy, Rome, and central Italy, along with Giovanni Battista Contini, who was active in the San Bernardino work site, the influx of Berninian languages at the city's religious work sites was accentuated. This period of Roman predominance saw the presence of Cipriani, Barigioni, and Buratti, a rather homogeneous group of architects that had come of age in the shadow of Carlo Fontana, who had been summoned to Abruzzo for the design of the Archbishop's Palace in Sulmona.[52]

Congregations, usually underrepresented, found in the quake an opportunity to claim their own space on the urban landscape, as well as exemplified by the case

of the Suffragio confraternity, which unexpectedly secured a position of prestige in Piazza del Duomo. In 1646, the confraternity obtained, through emphyteutic lease, a property in Via Roio, which belonged to the church of San Biagio. There the confraternity built an oratory with a hall, two lateral wings, and probably a small dome, designed by Francesco Bedeschini.[53] It was a small construction, then, that the confraternity had to settle for, but not for long. The oratory was reopened for worship in 1649, but works continued until the eve of the earthquake in 1701. On the 15th of January 1703, the structure collapsed and, the following 12th of February, the brothers obtained authorization to build, in Piazza del Duomo, a wooden construction for the celebrations of the dead. In the heat of rebuilding, the brothers began to purchase the lands adjacent to their *hut* until, in 1708, just five years after the earthquake, they decided to build a new church on their newly acquired properties.[54] After overcoming initial opposition from the bishops and the friars of the Chapter, who feared that the building might compete with the Cathedral that had dominated the piazza until then, in July 1713 the brothers obtained authorization for a new construction, whose design was entrusted to Carlo Buratti (Figure 6.2).

The fervour with which L'Aquila rebuilt in the decades following the quake can also be seen in the activity of the quarries located around the city, which were working at full capacity (Poggio Picenze, Cavallari di Pizzoli, Vigliano, San Gregorio, and Casamaina di Lucoli). In Abruzzo, the extraction sites were highly exploited to provide the coloured stones so characteristic of Baroque architecture.[55]

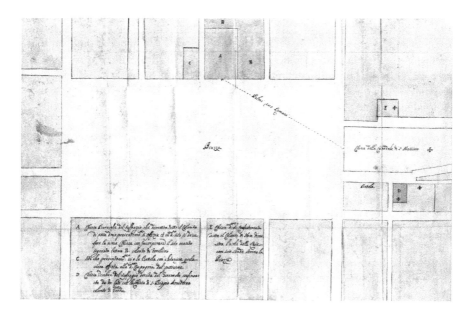

Figure 6.2 Map of Piazza del Mercato (1713), showing the Church and its distance from the Cathedral, Archivio di Stato dell'Aquila, F. Del Baccaro, Allegationes facti et iustis, 1713, E. 83.

A comparative approach to different cartographic works can clearly reveal the post-earthquake urban modifications. When comparing the map made by Giovan-battista De Rossi (1643), which depicts the city prior to the earthquake, with the ones prepared by Antonio Francesco Vandi (1753) and Vincenzo Di Carlo (1858), the changes the city went through during the rebuilding stage become evident.[56]

The role of the rubble

Rubble becomes an interesting object of analysis, when discussing post-seismic rebuilding, particularly when investigating whether it was a mere obstacle to be removed or whether it played an active role in the rebuilding process. It is known that the rebuilding of the Cathedral and of the parish churches *intra moenia* was in part self-financed through the sale of assets, by mortgaging the properties, bells, furnishings, decorations, and even the square stones originating from the collapses.

In the case of Saints Maximus and George's Cathedral, on the 22nd of April 1703, the canon procurator Ignazio Porcinari hired, for 230 ducats, the Milanese stonemasons Domenico Cometti, Pietro Longhi, and Francesco Visconti, and the L'Aquila native Narducci. Their job was to recover from the Cathedral, which had completely collapsed along with its beautiful façade, its columns, marble, and metal, and to heap everything up in the central nave. The Cathedral canon's action was no isolated initiative. In 1704, the chapter sold, for 25 ducats, the stones of the now-ruined Sant'Antonio, to procure the money for rebuilding the cathedral, whose design was entrusted to Sebastiano Cipriani in 1709.

Post-seismic inspections carried out following the 2009 earthquake revealed how some of the masonry of Santa Maria di Collemaggio had been rebuilt employing stones and fragments of bricks originating from earlier collapses. There was no desire to show the Medieval elements of the old buildings, to the complete advantage of Baroque innovation. The rubble remained within the structures, covered by plaster and never exposed. There was no thought of using it to maintain a memory, a recollection of what had been ruined, or to forge a symbolic connection with the past, as had been done with the remains of Roman buildings elsewhere and in a completely different era.

Placing the rubble inside the destroyed buildings, however, might have had a more profound meaning, linked to mourning and grief. In eighteenth-century L'Aquila, rubble became an object through which mourning the loss brought by the earthquakes, the base for a completely new future.

Conclusion

The first Medieval constructions of L'Aquila took place following the programme dictated by *Statuta Civitis Aquile*, which was based on the row house system. In subsequent building efforts, these houses were fused together to form larger building complexes, saturating the urban spaces while maintaining the building arrangement essentially unaltered. This changed in the post-1703 rebuilding when some

parts of the city were marked by the new Baroque scenography, whilst essentially confirming the previous urban arrangement.[57]

For L'Aquila and other towns in the county, this resulted in radically new architectural and formal *facies*: the strictly Medieval character of the town partially disappeared, giving way to a *modern* appearance. The urban scene, however, changed not only because of Baroque rebuilding efforts but also due to the formation of new *insulae*. These hubs of attraction, represented by piazzas, brought to the fore some important families, confraternities, and other power centres within the city landscape.[58]

The story of L'Aquila after the 1703 earthquake is the extraordinary tale of a city that swiftly elaborated its grief. It quite soon came to accept the loss, coming to terms with reality: the city loved by its inhabitants had, in part, physically disappeared and would never return. The new Baroque architecture allowed the grieving city to collect its inheritance, as it metabolized the rubble and took the stage of a new future.

Notes

1 Of essential importance are the texts by Sandro Benedetti, *L'architettura dell'epoca barocca in Abruzzo*, in *L'architettura in Abruzzo e nel Molise dall'antichità alla fine del secolo XVIII*. Proceedings of the 19th Conference of History of Architecture, L'Aquila, 15–21 sept. 1975 (L'Aquila: Ferri, 1980), II, 275–312 and Gianfranco Cimbolli Spagnesi, *L'architettura barocca ali'Aquila*, in the same volume, 495–518.

2 José Antonio Maravall, *La cultura del barroco: Análisis de una estructura histórica*, Ariel, Barcelona 1975. While Wölfflin (Wölfflin, Heinrich, *Renaissance und Barock: Eine Untersuchung über Wesen und Entstehung des Barockstils in Italien* (München: Bruckmann, 1888) discusses forms, Maravall focuses on the social history of the mentalities. For the scholar, Baroque is not simply the ideological expression of the ruling class but a concept that extends generally to all the manifestations constituting the culture of this time, and his reading is therefore well suited to interpreting every aspect involving society in the Baroque era, including the outcomes of natural disasters.

3 Alessandro Simonicca, 'Il terremoto aquilano del 6 aprile 2009, fra cultura del disastro e azione politica', in Anna Maria Reggiani, *L'Aquila. Una storia interrotta. Fragilità delle architetture e rimozione del sisma* (Roma: CISU, 2012), 13–33; Arnold Van Gennep, *Les rites de passage* (Paris: Émile Nourry, 1909).

4 Recently the literature on natural disasters has broadened, becoming an autonomous field of ethnographic research, dealt with in particular by: Anthony Oliver-Smith, Anthropological Research on Hazards and Disasters, *Annual Review of Anthropology*, 1996, 25, 303–328; Anthony. Oliver-Smith, Susanna M. Hoffman (eds.), *The Angry Hearth. Disaster in Anthropological Perspective* (New York-London: Routledge, 1999), 135–155; Anthony Oliver-Smith, ed., *Catastrophe and Culture. The Anthropology of Disaster* (Santa Fe, NM: School of American Research Press, 2002).

5 Carlo De Matteis, ed., *I terremoti in L'Aquila, magnifica citade: fonti e testimonianze dei secoli XIII-XVIII* (L'Aquila: Edizioni L'Una, 2009), 155–197.

6 «Però che era l'Aquila così male adrivata, / De ecclesie et edifitia cotanto desertata, Et anchi delle mura non era circundata, / Multi homini credevano non foxe abitata. At anchi comensaro parichi a scommorare, / Ché nne voleano gire de fore ad abitare; Credéanose che Aquila non se degia refare. / Lo conte sappe questo, abese ad conselliare. Vedendo poi lo conte la terra desolata / Per granni terramuti così male adobata; Le mura erano ad terra, non era reparata; / Pensò subitamente de fare la sticconata. Como illo comandò, foro facti li sticcati, / Et forone grandi utili, ca stevamo inserrati.» (Buccio di Ranallo, *Cronaca Aquilana*, anno 1349, quartine 837–840).

7 Anna Maria Reggiani, *L'Aquila. Una storia interrotta. Fragilità delle architetture e rimozione del sisma* (Roma: CISU, 2012), in part. 35.
8 Ludovico Antonio Muratori, *Annali d'Italia dal principio dell'era volgare sino al 1750 e continuate sino a' giorni nostri dall'abbate Coppi* (Napoli: Mariano Lombardi Editore, 1869).
9 Fabio Andreassi, *Progetti per L'Aquila: quadro conoscitivo verso una trasformazione urbana consapevole* (Milano: Franco Angeli, 2022), 67–68.
10 Alessandro Clementi, Elio Piroddi, *L'Aquila* (Roma-Bari: Laterza, 1986), n. 39.
11 Fabio Andreassi, *Progetti per L'Aquila: quadro conoscitivo verso una trasformazione urbana consapevole* (Milano: Franco Angeli, 2022), 67–68.
12 Raffaele Ruggiero, *Città d'Europa e cultura urbanistica nel mezzogiorno borbonico. Il patrimonio iconografico della raccolta Palatina nelle Biblioteca Nazionale di Napoli* (Napoli: Federico II University Press, 2018), 32–33. Much of the land in the City of London was in private ownership with complicated mix of landlords, tenants, and sub-tenants. Cutting across this complex tangle of rights with an ambitious new street plan was not a priority in 1666, when so many Londoners needed to rebuild their homes as quickly as possible. The winding streets of the Medieval city were restored in the rebuilt London. https://www.museumoflondon.org.uk/discover/housing-crisis-1666-london-rebuilt-after-great-fire.
13 Wren had met Bernini in Paris in 1665 and was highly impressed; at St. Paul's, he had combined Baroque suggestions with those gleaned from his studies on Andrea Palladio.
14 There is a vast literature on the reconstruction of the Val di Noto: Salvatore Russo Ferruggia, *Storia della città di Noto*, Noto 1838; N. Pisani, *Noto: città d'oro* (Siracusa: Ciranna, 1953); Edoardo Caracciolo, 'La ricostruzione della Val di Noto', *Quaderno F.A.U.P.*, 6 (1964); Corrado Gallo, *Noto agli albori della sua rinascita dopo il terremoto del 1693*, in A.S.S., vol. XIII, 1964, 1–125; P. Lojacono, 'La ricostruzione dei centri della Val di Noto dopo il terremoto del 1693', *Palladio* (1964), 59–74; Corrado Gallo, *Problemi ed aspetti della ricostruzione a Noto e nella Sicilia orientale dopo il terremoto del 1693*, in A.S.S., 15 (1966), 81–190; Maria Giuffré, 'Utopie urbane nella Sicilia del '700', *Quaderno I.E.A.R.M.U.P.*, 8–9 (1966), 51–129; Corrado Gallo, *Vicende della ricostruzione di Noto dopo il terremoto del 1693*, in A.S.S., 18 (1968), 133–143; Maria Giuffré, *Miti e realtà dell'urbanistica siciliana* (Palermo: Lo Monaco, 1969); Corrado Gallo, *Dell'inutile referendum del 1698 circa il sito della riedificanda città di Noto, alla definitiva decisione del Cardinale Giudice*, in A.S.S., 3 (1970); Corrado Gallo, *Il terremoto del 1693 e l'opera di governo del Vicario Generale Duca di Camastra*, in A.S.S., I, 1975, 3–21; Cleofe Giovanni Canale, *Noto, la struttura continua della città barocca* (Palermo: Flaccovio editore, 1976); Angela Marino, *Urbanistica e «Ancien Règime» nella Sicilia barocca*, in «Storia della città», 2, 1977, 3–84; Luigi Di Blasi, *Noto Barocca, tra Controriforma e illuminismo: l'utopia* (Noto: Arti Grafiche Sancorrado, 1981); Liliane Dufour, 'Dopo il terremoto del 1693, la ricostruzione della Val di Noto', *Annali della Storia d'Italia*, 8, Torino 1895, 475–498; Liliane Dufour, Henri Raymond, *Dalle Baracche al Barocco. La ricostruzione di Noto. Il caso e la necessità* (Venezia: Marsilio, 1990; *Studi sulla ricostruzione del Val di Noto dopo il terremoto del 1693*, Annali del Barocco in Sicilia, 1, 1994.
15 Stefano Piazza, *La ricostruzione difficile: conflitti sociali e imprese architettoniche nel Val di Noto dopo il terremoto del 1693*, in *Risultato della ricerca: Other*, 2012, 23–28, in part. 23. https://iris.unipa.it/retrieve/handle/10447/66083/47957/Piazza.pdf (3.01.2023).
16 See the numerous contributions contained in A. Casamento, E. Guidoni (ed.), *Le città ricostruite dopo il terremoto siciliano del 1693, tecniche e significati delle progettazioni urbane*, numero monografico di «Storia dell'Urbanistica/Sicilia II», Roma 1997.
17 Stefano Piazza, *La ricostruzione difficile: conflitti sociali e imprese architettoniche nel Val di Noto dopo il terremoto del 1693*, *Risultato della ricerca: Other*, 2012, 23–28, in part. 23. https://iris.unipa.it/retrieve/handle/10447/66083/47957/Piazza.pdf (3.01.2023).

144 *Rossana Mancini*

18 *Ibid.*
19 Liliane Dufour, Henri Raymond, *1693 Val di Noto. La rinascita dopo il disastro* (Catania: Editore Domenico Sanfilippo, 1992), 98; Stefano Piazza, *La ricostruzione difficile: conflitti sociali e imprese architettoniche nel Val di Noto dopo il terremoto del 1693, Risultato della ricerca: Other*, 2012, 23–28, in part. 23, https://iris.unipa.it/retrieve/handle/10447/66083/47957/Piazza.pdf (3.01.2023).
20 Stefano Piazza, *La ricostruzione difficile: conflitti sociali e imprese architettoniche nel Val di Noto dopo il terremoto del 1693, Risultato della ricerca: Other*, 2012, 23–28, in part. 23. https://iris.unipa.it/retrieve/handle/10447/66083/47957/Piazza.pdf (3.01.2023).
21 The county was in part destined for castles entrusted to captains in the king's army and, on the whole, for the kings demesne, to which it had always at any rate belonged. Silvia Mantini, *La scena della città: uomini, idee, rappresentazioni nell'Aquila barocca*, in Rossana Torlontano (ed.), *Abruzzo, Il Barocco negato: aspetti dell'arte del Seicento e Settecento*, De Luca, Roma 2010, 45–56, in part. 46.
22 Silvia Mantini, 'La scena della città: uomini, idee, rappresentazioni nell'Aquila barocca', in *Abruzzo, Il Barocco negato: aspetti dell'arte del Seicento e Settecento*, ed. by Rossana Torlontano (Roma: De Luca, 2010), 45–56, in part. 45.
23 About this arguments: Claudio Varagnoli, Augusto Roca De Amicis, *Introduzione*, in, *Alla moderna. Antiche chiese e rifacimenti barocchi: una prospettiva europea*, ed. by Augusto Roca De Amicis and Claudio Varagnoli (Roma: Artemide, 2015), 9–17, in part. 9. Interesting, in the same book, is the contribution by Valentina Russo, *Architecture and Memory of Ancient Times*, 69–97, on the renovation of Neapolitan churches in the seventeenth century.
24 Rossana Torlontano (ed.), *Abruzzo, Il Barocco negato: aspetti dell'arte del Seicento e Settecento* (Roma: De Luca, 2010).
25 *Ibid.*, 30.
26 *Ibid.* See also Raffaele Colapietra, 'Continuità della strutture urbane ed imbaroccimento dell'immagine nell'Aquila settecentesca', in *Per la storia dell'Abruzzo e del Molise* (Pescara: Sigraf editrice, 2000) I, 454–479.
27 The date 1650 is carved above a stone cornice on the altar of the southern front, along with the name of the creator of the work: Tomaso Van: Hi O:F:. These must have been altars done to replace the sixteenth-century one, the presence of which was noted by Alfieri.
28 The information was obtained from the date placed on the medallion painted beneath the cornice of the coffered ceiling, on the inside façade, among the stucco decorations enveloping the main entrance. Orlando Antonini, *Chiese dell'Aquila. Architettura religiosa e struttura urbana* (Pescara: Carsa Edizioni, 2004), 182, 186 n. 84.
29 Sandro Benedetti, *L'Architettura dell'epoca barocca in Abruzzo*, Proceedings of the 19th Conference of History of Architecture, L'Aquila, 15–21 sept. 1975 (L'Aquila: Ferri, 1980), II, 275–312, in part. 277.
30 Carla Bartolomucci gleans this information from Mariani. However, according to Colapietra and Antonini, the side naves were also likely to have been covered by flat ceilings, and the vaults are said to have been eighteenth-century work. Carla Bartolomucci, *Santa Maria di Collemaggio. Interpretazione critica e problemi di conservazione* (Roma: Palombi, 2004), in part. 31.
31 Ibidem, from Leosini, *Monumenti storici artistici della città di Aquila e suoi contorni: colle notizie de' pittori, scultori, architetti ed artefici che vi fiorirono* (L'Aquila: F. Perchiazzi, 1848).
32 Mario Centofanti, *La Rappresentazione dell'Architettura. Il modello e il suo doppio*, in *Dialoghi sull'Architettura I*, ed. by Simone Lucchetti, Sofia Menconero, Alessandra Ponzetta (Roma: Sapienza Università Editrice, 2022), 43–56. The Parisian holding organized by Valery-Radot conserves six drawings referring to a project of broad scope,

which saw only partial and incomplete implementation, moreover in different forms and placement, albeit at the same site. The drawings are conserved at Bibliothèque Nationale de Paris, Cabinet des estampes, Hd-4, 77, 73, 69, 70, 71, 72. JVR 90, 91, 92, 93, 94, 95.

33 The church's construction was begun in 1646 by Ottavio de Nardis, in cooperation with other members of the same L'Aquila noble family. In 1650, the church was supposed to be completed. The building was severely damaged by the 1703 earthquake, which was followed by a series of major restoration interventions, including the replacement of the vaulted ceiling (perhaps collapsed) with a wooden one designed by Ferdinando Mosca.

34 Laura Graziani, Andrea Tertulliani, Mario Locati (ed.), *La sequenza sismica che colpì il centro Italia nel 1703* (https://ingvterremoti.com/2022/08/11/la-sequenza-sismica-che-colpi-il-centro-italia-nel-1703/ - 11 Agosto 2022).

35 Biblioteca Apostolica Vaticana (1703b), Manoscritti, Chigiani, M.V.IV, cc. 209–210r, *Relatione delle Ruine fatte dal Terremoto nella Diocesi di Rieti*, 1703.

36 Laura Graziani, Andrea Tertulliani, Mario Locati (ed.), *La sequenza sismica che colpì il centro Italia nel 1703* (https://ingvterremoti.com/2022/08/11/la-sequenza-sismica-che-colpi-il-centro-italia-nel-1703/ 11.08.2022).

37 Alfonso Uria De Llanos, *Relazione, overo itinerario fatto dall'auditore Alfonso Uria De Llanos Per riconoscere li danni causati dalli passati Terremoti seguiti li 14. Gennaro, e 2. Febraro M.DCCIII. Con il numero de' Morti, e Feriti nella Provincia dell'Abruzzo Citra, e luoghi circonvicini*, Roma 1603 (but 1703).

38 After brief debate, Alessandro Quinzi and Tommaso Alfieri were appointed. The latter, however, being very old, resigned after a few days and was replaced by Camillo Ciampella.

39 Romano Camassi, Viviana Castelli, *I terremoti del 1703 nelle fonti giornalistiche coeve*, in *Settecento abruzzese. Eventi sismici, mutamenti economico sociali e ricerca storiografica*, https://www.earth-prints.org/bitstream/2122/2548/1/1169.pdf [10.02.2023].

40 Francesco Maria Randazzi, *Discorso fisico e morale sopra le cause del terremoto del dottor Francesco Maria Rampazzi*, Ronciglione 1703, 4–6.

41 ... *L'Onnipotente Iddio, che sà opprimere, & inalzare colla sua destra i Giusti, e Peccatori non manca continuamente di chiamare questi con avvisi, e prodigi salutevoli, acciò ricorrino sotto l'ali della sua infinita misericordia; e per renderli più isvegliati, e pronti a ricorrere a Sua Divina Maestà, non à mancato di far conoscere i suoi giusti sdegni contro de' Peccatori; avendo con replicate innondazioni, e poi con duplicati Terremoti, chiamati a sé le Pecorelle sperse del suo Ovile* (Anonymous, Roma: 1703).

42 The literature about the 1703 quake has been enriched with new studies and publications of sources, including Errico Centofanti, *La festa crudele: 2 febbraio 1703 il terremoto che rovesciò L'Aquila: dopo tre secoli: che accadde? Che ne resta?*, Gruppo tipografico editoriale, L'Aquila 2003. In 2004, Deputazione Abruzzese di Storia Patria organized a conference dedicated entirely to the L'Aquila earthquake; its proceedings were published in 2007: R. Colapietra, G. Marinangeli, P. Muzi (ed.), *Settecento abruzzese: Eventi sismici, mutamenti economico-sociali e ricerca storiografica*, Proceedings, L'Aquila 29–31 oct. 2004 (L'Aquila: Colacchi, 2007).

43 Alessandro Simonicca, *Il terremoto aquilano del 6 aprile 2009, fra cultura del disastro e azione politica*, in Anna Maria Reggiani, *L'Aquila. Una storia interrotta. Fragilità delle architetture e rimozione del sisma* (Roma: CISU, 2012), 13–33, in part. 18.

44 In Abruzzo, the towns in the departments of Chieti and Penne were more stricken than those in the department of L'Aquila. This major earthquake, little explored both in terms both of seismology and of historiography, was to a large degree "overshadowed" by the more famous seismic period of 1703. (INGV, *Catalogue of strong earthquakes in Italy 461 B.C. – 1997 and Mediterranean Area 760 B.C. – 1500*, https://storing.ingv.it/cfti/cfti4/quakes/01348.html#.

45 Archivio Storico Vaticano, *Visites ad Limina, Aquilana*, 1722, Domenico Taglialatela.

46 On this building, see Raffaele Giannantonio, *La chiesa di Santa Caterina Martire dell'Aquila e la sua mancata demolizione*, in «Particolari in Abruzzo», 1999, 2, 21–30.
47 On L'Aquila's architecture after the 1703 quake: Luigi Vicari, *La chiesa di S. Agostino e La chiesa di S. Maria del Suffragio a L'Aquila,* in «Bullettino della Deputazione Abruzzese di Storia Patria», LVII–LIX, 1967–1969; Proceedings of the 19th Conference of History of Architecture, L'Aquila, 15–21 sept. 1975 (L'Aquila: Ferri, 1980), in particular see Sandro Benedetti, *L'Architettura dell'epoca barocca in Abruzzo*, 275–312; Gianfranco Spagnesi, *L'architettura barocca a L'Aquila*, 495–518; Alessandro Del Bufalo, *G.B. Contini e la tradizione del tardo-manierismo nell'architettura tra '600 e '700* (Roma, Kappa, 1982); Piero di Piero, Sandro Annibali, *Architetti romani attivi a L'Aquila nella prima metà del Settecento* (L'Aquila: Terra Nostra, 1990); Raffaele Colapietra, Mario Centofanti et al., *L'Aquila: i palazzi* (L'Aquila: Ediarte, 1997). About L'Aquila see Gianfranco Spagnesi, Pierluigi Properzi, *L'Aquila. Problemi di forma e storia della città* (Roma-Bari: Laterza, 1972); Mario Centofanti, *L'Aquila 1753–1983, il restauro della città* (L'Aquila: Colacchi, 1984); Alessandro Clementi, Elio Piroddi, *L'Aquila* (Roma-Bari Laterza, 1988); Mario Centofanti, Raffaele Colapietra et al., *L'Aquila città di piazze* (Pescara: Carsa Edizioni, 1992).
48 Conference *Il Barocco negato. Aspetti dell'arte del Seicento e del Settecento in Abruzzo*, held at the University of Chieti in November 2007.
49 Mario Centofanti, Stefano Brusaporci, Architettura e città nella rappresentazione cartografica dell'Aquila tra Settecento e Ottocento, Città e storia, 6 (2011), 151–187, in part. 164.
50 Luigi Zordan, 'Il Palazzo Centi e la piazza S. Giusta a L'Aquila', in *L'architettura in Abruzzo e nel Molise dall'antichità alla fine del secolo XVIII*, Proceedings of the 19th Conference of History of Architecture, L'Aquila, 15–21 sept. 1975 (L'Aquila: Ferri, 1980), II, 519–524.
51 Gianfranco Cimbolli Spagnesi, 'L'architettura barocca all'Aquila', in *L'architettura in Abruzzo e nel Molise dall'antichità alla fine del secolo 18*. Proceedings of the 19th Conference of History of Architecture, L'Aquila, 15–21 sept. 1975 (L'Aquila: Ferri, 1980), II, 495–518, in part. 510.
52 A. Del Bufalo, 'La chiesa di San Bernardino all'Aquila e l'intervento di G. B. Contini', in *L'architettura in Abruzzo e nel Molise dall'antichità alla fine del secolo XVIII*, Proceedings of the 19th Conference of History of Architecture, L'Aquila, 15–21 sept. 1975 (L'Aquila: Ferri, 1980), II, 539–554; Id., *G.B. Contini e la tradizione del tardo manierismo nell'architettura tra '600 e '700, appendice XII*, Roma 1982, 333–340.
53 Raffaella Lancia, 'Il cantiere della chiesa del Suffragio a L'Aquila', in *Abruzzo, Il Barocco negato: aspetti dell'arte del Seicento e Settecento*, ed. by Rossana Torlontano (Roma: De Luca, 2010), 120–125. On the church, see also Maria Gabriella Pezone, *Carlo Buratti. Architettura tardobarocca tra Roma e Napoli* (Firenze: Alinea, 2008), in part. 154–155 and Federico Bulfone Gransinigh, Santa Maria del Suffragio e la sua facciata: un cantiere barocco fra L'Aquila e Roma, *Lexicon Storie e architettura in Sicilia e nel Mediterraneo*, 32 (2021), 15–30.
54 Raffaella Lancia, *Il cantiere della chiesa del Suffragio a L'Aquila*, in Rossana Torlontano (ed.), *Abruzzo, Il Barocco negato: aspetti dell'arte del Seicento e Settecento* (Roma: De Luca, 2010), 120–125.
55 On the excavation activity in L'Aquila: Rossana Mancini, *Le pietre aquilane. Processi di approvvigionamento della pietra e sue forme di lavorazione nell'architettura storica* (Roma: Ginevra Bentivoglio Editoria, 2012).
56 Mario Centofanti, Stefano Brusaporci, 'Architettura e città nella rappresentazione cartografica dell'Aquila tra Settecento e Ottocento', *Città e storia*, 6 (2011), 151–187.
57 *Ibid.*
58 Silvia Mantini, *La scena della città: uomini, idee, rappresentazioni nell'Aquila barocca*, in Rossana Torlontano (ed.), *Abruzzo, Il Barocco negato: aspetti dell'arte del Seicento e Settecento* (Roma: De Luca, 2010), 45–56.

Bibliography

Andreassi, Fabio, *Progetti per L'Aquila: quadro conoscitivo verso una trasformazione urbana consapevole* (Milano: Franco Angeli, 2022), 67–68.

Anonymous, Relazione de' danni fatti dall'Innondazioni e Terremoti nella città dell'Aquila ed in altri luoghi circonvicini dalli 14. Del mese di Gennaro sino alli 8. del mese di Febraro 1703 (Roma: Stamperia del Zenobj, 1703).

Antonini, Orlando, *Chiese dell'Aquila. Architettura religiosa e struttura urbana* (Pescara: Carsa Edizioni, 2004).

Bartolomucci, Carla, *Santa Maria di Collemaggio. Interpretazione critica e problemi di conservazione* (Roma: Palombi, 2004).

Benedetti, Sandro, L'architettura dell'epoca barocca in Abruzzo, in L'architettura in Abruzzo e nel Molise dall'antichità alla fine del secolo 18, Proceedings of the 19th Conference of History of Architecture, L'Aquila, 15–21 sept. 1975 (L'Aquila: Ferri, 1980), II, 275–312.

Bulfone Gransinigh, Federico, 'Santa Maria del Suffragio e la sua facciata: un cantiere barocco fra L'Aquila e Roma', *Lexicon, Storie e architettura in Sicilia e nel Mediterraneo*, 32 (2021), 15–30.

Camassi, Romano, and Castelli, Viviana, I terremoti del 1703 nelle fonti giornalistiche coeve, in Settecento abruzzese. Eventi sismici, mutamenti economico sociali e ricerca storiografica, https://www.earth-prints.org/bitstream/2122/2548/1/1169.pdf [10.02.2023]

Canale, Cleofe Giovanni, *Noto, la struttura continua della città barocca* (Palermo: Flaccovio Editore, 1976).

Caracciolo, Edoardo, *La ricostruzione della Val di Noto* (Palermo: Tip. La cartografica di P. Lo Monaco (Quaderno F.A.U.P., 6), 1964).

Casamento, Aldo, and Guidoni Enrico (eds.), *Le città ricostruite dopo il terremoto siciliano del 1693, tecniche e significati delle progettazioni urbane* (Roma: Edizioni Kappa (Storia dell'Urbanistica/Sicilia, II), 1997).

Centofanti, Errico, *La festa crudele: 2 febbraio 1703 il terremoto che rovesciò L'Aquila: dopo tre secoli: che accadde? che ne resta?*, Gruppo tipografico editorial (L'Aquila: Gruppo tipografico editorial, 2003).

Centofanti, Mario, 'La Rappresentazione dell'Architettura. Il modello e il suo doppio', in *Dialoghi sull'Architettura I*, ed. by Simone Lucchetti, Sofia Menconero, Alessandra Ponzetta (Roma: Sapienza Università Editrice, 2022), 43–56.

Centofanti, Mario, *L'Aquila 1753–1983, il restauro della città* (L'Aquila: Colacchi, 1984).

Centofanti, Mario, Colapietra, Raffaele et al., *L'Aquila città di piazze* (Pescara: Carsa Edizioni, 1992).

Centofanti, Mario, and Brusaporci, Stefano, 'Architettura e città nella rappresentazione cartografica dell'Aquila tra Settecento e Ottocento', *Città e storia*, 6 (2011), 151–187.

Cimbolli Spagnesi, Gianfranco, L'architettura barocca all'Aquila, in L'architettura in Abruzzo Abruzzo e nel Molise dall'antichità alla fine del secolo 18, Proceedings of the 19th Conference of History of Architecture, L'Aquila, 15–21 sept. 1975 (L'Aquila: Ferri, 1980), II, 495–518.

Clementi, Alessandro, and Piroddi, Elio, *L'Aquila* (Roma-Bari: Laterza, 1988).

Colapietra, Raffaele, Centofanti Mario et al., *L'Aquila: i palazzi* (L'aquila: Ediarte, 1997).

Colapietra, Raffaele, 'Continuità della strutture urbane ed "imbarocchimento" dell'immagine nell'Aquila settecentesca', in *Per la storia dell'Abruzzo e del Molise* (Pescara: Sigraf editrice, 2000) I, 454–479.

Colapietra, Raffaele, Marinangeli, Giacinto, and Muzi Paolo, eds., Settecento abruzzese: Eventi sismici, mutamenti economico-sociali e ricerca storiografica, Proceedings, L'Aquila 29–31 ottobre 2004 (L'Aquila: Colacchi, 2007).

De Matteis, Carlo (ed.), *I terremoti in L'Aquila, magnifica citade: fonti e testimonianze dei secoli XIII-XVIII* (L'Aquila: Edizioni L'Una, 2009), 155–197.

Del Bufalo, Alessandro, 'La chiesa di San Bernardino all'Aquila e l'intervento di G. B. Contini', in L'architettura in Abruzzo e nel Molise dall'antichità alla fine del secolo XVIII, Proceedings of the 19th Conference of History of Architecture, L'Aquila, 15–21 sept. 1975 (L'Aquila: Ferri, 1980), II, 539–554.

Del Bufalo, Alessandro, *G.B. Contini e la tradizione del tardo manierismo nell'architettura tra '600 e '700* (Roma: Kappa, 1982).Del Pesco, Daniela, 'L'immagine negata: L'Aquila nella cartografia barocca', in *Abruzzo, Il Barocco negato: aspetti dell'arte del Seicento e Settecento*, ed. by Rossana Torlontano (Roma: De Luca, 2010), 68–78.

Di Blasi, Luigi, *Noto Barocca, tra Controriforma e illuminismo: l'utopia* (Noto: Arti Grafiche Sancorrado, 1981).

Di Piero, Piero, and Annibali, Sandro, *Architetti romani attivi a L'Aquila nella prima metà del Settecento* (L'Aquila: Terra Nostra, 1990).

Dufour, Liliane, 'Dopo il terremoto del 1693, la ricostruzione della Val di Noto', *Annali della Storia d'Italia*, 8, Torino 1895, 475–498.Dufour, Liliane, and Raymond, Henri, *1693 Val di Noto. La rinascita dopo il disastro* (Catania: Editore Domenico Sanfilippo, 1992).

Dufour, Liliane, and Raymond, Henri, Dalle Baracche al Barocco. *La ricostruzione di Noto. Il caso e la necessità* (Venezia: Marsilio, 1990).

Gallo, Corrado, 'Noto agli albori della sua rinascita dopo il terremoto del 1693', in *Archivio Storico Siciliano* (A.S.S.), 13, 1964, 1–125.

Gallo, Corrado, 'Problemi ed aspetti della ricostruzione a Noto e nella Sicilia orientale dopo il terremoto del 1693', *Archivio Storico Siciliano*, 15, 1966, 81–190.

Gallo, Corrado, 'Vicende della ricostruzione di Noto dopo il terremoto del 1693', *Archivio Storico Siciliano*, 18, 1968, 133–143.

Gallo, Corrado, 'Dell'inutile referendum del 1698 circa il sito della riedificanda città di Noto, alla definitiva decisione del Cardinale Giudice', *Archivio Storico Siciliano*, 3 (1970), pp. 3–111.

Gallo, Corrado, 'Il terremoto del 1693 e l'opera di governo del Vicario Generale Duca di Camastra', *Archivio Storico Siciliano*, 1, 1975, 3–21.

Giannantonio, Raffaele, 'La chiesa di Santa Caterina Martire dell'Aquila e la sua mancata demolizione, Particolari', *Abruzzo*, 2, 1999, 21–30.

Giuffré, Maria, 'Utopie urbane nella Sicilia del '700', *Quaderno I.E.A.R.M.U.P.*, 8–9, 1966, 51–129.

Giuffré, Maria, Miti e realtà dell'urbanistica siciliana (Palermo: Lo Monaco, 1969).

Graziani, Laura, Tertulliani, Andrea, and Locati, Mario (eds.), La sequenza sismica che colpì il centro Italia nel 1703 (https://ingvterremoti.com/2022/08/11/la-sequenza-sismica-che-colpi-il-centro-italia-nel-1703/-11 Agosto 2022).

INGV, Catalogue of strong earthquakes in Italy 461 B.C. – 1997 and Mediterranean Area 760 B.C. – 1500, https://storing.ingv.it/cfti/cfti4/quakes/01348.html#.

Lancia, Raffaella, 'Il cantiere della chiesa del Suffragio a L'Aquila', in *Abruzzo, Il Barocco negato: aspetti dell'arte del Seicento e Settecento*, ed. by Rossana Torlontano (Roma: De Luca, 2010), 120–125.

Leosini, Angelo, *Monumenti storici artistici della città di Aquila e suoi contorni: colle notizie de'pittori, scultori, architetti ed artefici che vi fiorirono* (L'Aquila: F. Perchiazzi, 1848).

Lojacono, P., La ricostruzione dei centri della Val di Noto dopo il terremoto del 1693, in «Palladio», 1964, 59–74.

Mancini, Rossana, *Le pietre aquilane. Processi di approvvigionamento della pietra e sue forme di lavorazione nell'architettura storica* (Roma: Ginevra Bentivoglio Editoria, 2012).

Mantini, Silvia, 'La scena della città: uomini, idee, rappresentazioni nell'Aquila barocca', in *Abruzzo, Il Barocco negato: aspetti dell'arte del Seicento e Settecento*, ed. by Rossana Torlontano (Roma: De Luca, 2010), 45–56.

Maravall, José Antonio, *La cultura del barroco: Análisis de una estructura histórica* (Barcelona: Ariel, 1975).

Marino, Angela, 'Urbanistica e «Ancien Règime» nella Sicilia barocca', *Storia della città*, 2, 1977, 3–84.

Muratori, Ludovico Antonio, *Annali d'Italia dal principio dell'era volgare sino al 1750 e continuate sino a' giorni nostri dall'abbate Coppi* (Napoli: Mariano Lombardi Editore, 1869).

Oliver-Smith, Anthony, 'Anthropological research on hazards and disasters', *Annual Review of Anthropology*, 25, 1996, 303–328.

Oliver-Smith, Anthony, and Hoffman, Susanna M. (eds.), *The Angry Hearth. Disaster in Anthropological Perspective* (New York-London: Routledge, 1999), 135–155.

Oliver-Smith, Anthony, ed., *Catastrophe and Culture. The Anthropology of Disaster* (Santa Fe, NM: School of American Research Press, 2002).

Pezone, Maria Gabriella, *Carlo Buratti. Architettura tardobarocca tra Roma e Napoli* (Firenze: Alinea, 2008), 154–155.

Piazza, Stefano, 'La ricostruzione difficile: conflitti sociali e imprese architettoniche nel Val di Noto dopo il terremoto del 1693', in Risultato della ricerca: Other, 2012, 23–28, https://iris.unipa.it/retrieve/handle/10447/66083/47957/Piazza.pdf (3.01.2023).

Pisani, Nicolò, *Noto: città d'oro* (Siracusa: Ciranna, 1953).

Randazzi, Francesco Maria, *Discorso fisico e morale sopra le cause del terremoto del dottor Francesco Maria Rampazzi* (Ronciglione: 1703), 4–6.

Reggiani, Anna Maria, *L'Aquila. Una storia interrotta. Fragilità delle architetture e rimozione del sisma* (Roma: CISU, 2012).

Ruggiero, Raffaele, *Città d'Europa e cultura urbanistica nel mezzogiorno borbonico. Il patrimonio iconografico della raccolta Palatina nelle Biblioteca Nazionale di Napoli* (Napoli: Federico II University Press, 2018), 32–33.

Russo, Valentina, 'Architecture and Memory of Ancient Times', in *Alla moderna. Antiche chiese e rifacimenti barocchi: una prospettiva europea*, ed. by Augusto Roca De Amicis, Claudio Varagnoli (Roma: Artemide, 2015), 69–97.

Russo, Ferruggia, *Salvatore, Storia della città di Noto* (Noto: Pappalardo, 1838).Simonicca, Alessandro, 'Il terremoto aquilano del 6 aprile 2009, fra cultura del disastro e azione politica', in *L'Aquila. Una storia interrotta. Fragilità delle architetture e rimozione del sisma*, ed. by Anna Maria Reggiani (Roma: CISU, 2012), 13–33.

Spagnesi, Gianfranco, and Properzi, Pierluigi, *L'Aquila. Problemi di forma e storia della città* (Roma-Bari: Laterza, 1972).

Torlontano, Rossana, ed., *Abruzzo, Il Barocco negato: aspetti dell'arte del Seicento e Settecento* (Roma: De Luca, 2010).

Trigilia, Lucia (ed.), *Studi sulla ricostruzione del Val di Noto dopo il terremoto del 1693* (Roma: Gangemi Editore (Annali del Barocco in Sicilia, 1),1994).

Uria De Llanos, Alfonso, Relazione, overo itinerario fatto dall'auditore Alfonso Uria De Llanos Per riconoscere li danni causati dalli passati Terremoti seguiti li 14. Gennaro, e 2. Febraro MDCCIII. Con il numero de' Morti, e Feriti nella Provincia dell'Abruzzo Citra, e luoghi circonvicini, Roma: 1603 (but 1703).

Van Gennep, Arnold, *Les rites de passage* (Paris: Émile Nourry, 1909).

Varagnoli, Claudio, and Roca De Amicis, Augusto, 'Introduzione', in *Alla moderna. Antiche chiese e rifacimenti barocchi: una prospettiva europea*, ed. by Augusto Roca De Amicis, Claudio Varagnoli (Roma: Artemide, 2015), 9–17.

Vicari, Luigi, Negrini, Annamaria, 'La chiesa di S. Maria del Suffragio a L'Aquila e i suoi architetti', *Bullettino della Deputazione Abruzzese di Storia Patria*, 57–59 (1967–1969), pp. 189–198.
Zordan, Luigi, Il Palazzo Centi e la piazza S. Giusta a L'Aquila, in L'architettura in Abruzzo e nel Molise dall'antichità alla fine del secolo XVIII, Proceedings of the 19th Conference of History of Architecture, L'Aquila, 15–21 sept. 1975 (L'Aquila: Ferri, 1980), II, 519–525.
Wölfflin, Heinrich, *Renaissance und Barock: Eine Untersuchung über Wesen und Entstehung des Barockstils in Italien* (München: Bruckmann, 1888).

7 Identity perception in monuments, ruins and remains

Roman and Romano-British heritage in British travel accounts c. 1770–1820

Barbara Tetti

The concepts of *identity* and *heritage* are strictly connected, as heritage acts as the material or immaterial memory of a single or collective past, forming a decisive and significant part of the sense of self. Individual and collective understandings of heritage are influenced by cultural archetypes but also shaped by personal experience. Accounts of encounters with heritage sites or objects are, of course, framed by these modes of perception. When considering the cultural reverberation around the built heritage of seventeenth-, eighteenth-, and nineteenth-century Italy and Britain, it is worth noting that the etymology of the word in late Latin is *identĭtas-atis*, but when its meaning is derived from the Ancient Greek, it is ταὐτότης, which indicates a set of elements making the uniqueness of a person, allowing him or her to be recognised as such and not to be confused with someone else. The current definition of *identity* in English is 'the state of having unique identifying characteristics held by no other person or thing', connecting the concept with notions of individuality, character, uniqueness and singularity.[1] In Italian, the term is defined as 'the same, perfect equality; being one and the same person or thing that at first glance appeared distinct'.[2] Even if the two idioms apparently recall the opposite concepts of *uniqueness, singularity, and separateness*, on the one hand, and *sameness, uniformity, and equivalence*, on the other, *distinctiveness* clearly emerges as the pivotal concept.

Considering self-awareness and self-perception, both of which imply the concept of 'identity', the search for the individual self develops in the continuous confrontation aimed at placing various individualities side by side. In this regard, the travel experience becomes crucial, offering the opportunity to approach diverse cultures, places and societies whose idea was previously shaped by reading books, listening to recounts, observing pictures, orcatching some invented stories. Anyway, the imagined reality can be brought in real existence only using the five senses, in a personal experience giving everyone distinct feelings and so emotions. The sensations everyone feels are generated by the element constituting the surrounding space: sound and noise, light, temperature, colours, objects' dimensions and proportion, usage of the space by people and so on. Accordingly, the consideration of the recount about urban space and architecture becomes a preferential point of observation because of

DOI: 10.4324/9781003358695-7

the role played by the environment in forming or changing self-perception, up to self-identity. And referring to the 'heritage' as the material or immaterial memory representing a single or collective past, the emotional individual process underlaid can be investigated.

Within this framework, this chapter aims to investigate the theme of identity in women's writings about Roman and Romano-British artistic and architectural heritage. The period in question encompasses the decades before and after the French domination of Rome (before 1803 and after 1814) and considers individual and mutual, British and Roman *identities*. This discussion will necessarily engage with questions about the continued importance of classical antiquity in early nineteenth-century culture and society and the way this was articulated by women at the time.

Rome, in the late eighteenth and the early nineteenth century, represents a compelling field of enquiry because it was in this city that a new approach to understanding historical architecture was devised. This change in approach led to the emergence of a new conception of the *past* and consequently to shifts in the methods of care and restoration of historical monuments. During the last quarter of the eighteenth century, Rome became the catalyst for a new sensitivity towards material evidence of the past, delineating rules concerning archival research and palaeography, the study of human history, the significance of religion in the ancient world, and the origin of paganism.[3] During these years, the Papal City was also characterised by the strong presence of many foreign visitors who contributed, with their varied cultural and personal sensibilities, to the discussion about the past.[4] In this context, paradoxically, the object of the visit was identified with the visitor as Anna Miller, an English poet and travel writer, wrote in 1711, as she visited the so-called 'Orazi and Curiazi Tomb' in Albano:

> Near the entrance of Albano is a great Mausoleum [...] One of our postillion inquiring the road to this Ruin, of a gardener upon the road, received for answer, that the Antica Robba Inglese he asked for, was about a half a mile from the town. This idea of it being an English Antiquity must have been arisen from the numbers of English who inquire for and visit it.[5]

The latter part of the eighteenth century witnessed the apogee of the Grand Tour, a mode of travelling favoured by most of the elite men of the time. In this context, it is worth considering what women's writings tell us about travelling across Europe at this time. Like their male counterparts, typically it was only women of a middle- or upper-class background, with good education, who undertook these trips and recorded their experiences in the form of diaries, letters, and drawings. Among this group, a few individuals committed to paper a more formal travel report. These texts describe the unconventional scenario of independent or semi-independent female travel, but are nonetheless revealing of larger social and cultural themes.[6]

Traditionally, travel abroad was considered far beyond the abilities of women, even if this constraint was directly critiqued by some women and largely ignored by others. As Anne Katherine Elwood clearly expressed in the preface to her 1826

publication, *Narrative of a Journey Overland from England,* the journey was considered to be:

> [...] Impracticable for a Lady [...] women naturally take a lively interest in what concerns their own sex, she flatters herself, that the following account of adventures of the first and only female who has hitherto ventured overland from England to India, wholly unacceptable to the fair part of the reading community.[7]

With these words, Elwood expressed her pride in accomplishing such a brave adventure, conveying a defiant attitude towards men and society's conventions. In the first lines of Letter I, contained in the same volume, Elwood summarised the contents she was developing. Claiming her role as a pioneer traveller, she asked:

> I am the only Lady who travelled thither overland [...] and probably mine was the first Journal ever kept by Englishwoman in the Desert of Thebasis and on the stores of the Red Sea [...] You will meet with Agas and Cacheffs, and hear of Pahas and Rajahs; and for the ceremonies of the Holy week, you will have the initiatory rites of the Mahometan Hadje, the Mohurrum, and the Hindo Hoolie. You must ascend the Pyramids, and descend into Joseph's well, penetrate into the tomb of King Sesostris, and explore the caves of Elephanta [...] Have you the courage to accompany me?[8]

Different patterns of publications can be found amongst the women travelling before the French domination. For example, in 1700, Anna Miller wrote three volumes entitled *Letters from Italy,* which were published in 1778. Ellis Cornelia Knight wrote *Description of Latium* between 1778 and 1800, publishing them in 1805.[9] This book illustrated the territories in the proximity of Rome and included a map along with 22 engravings portraying views, vestiges and landscapes from the area. Between 1784 and 1786, Hester Lynch Piozzi wrote *Observations and Reflections in the Course of a Journey Through France, Italy and Germany,* which was published in 1789 in the form of a diary.[10] Finally, *Letters from Italy* by Mariana Starke was published just before the French domination of Rome started and was intended for *The Use of Invalids and Families.*[11] The structure of Starke's text does not take the form of an epistolary exchange but, instead, reports a series of brief accounts of her experiences with many practical hints for the prospective traveller. This latter example represents a vanguard among travel guides, providing a model for the subsequent *Handbook of Italy,* published by John Murray in 1842.[12] In this variegated sample of women's writing, it is possible to identify some peculiarities and significant exceptions concerning the vision and consideration of antiquity in the material heritage of eighteenth-century Rome.

When Cornelia Knight wrote *Description of Latium* in 1778, she remarked at the very beginning of the book that 'travellers, although many of our own nation, who visit Italy, with a desire of treading that earth which their early studies have thought

154 *Barbara Tetti*

them to love and respect'.[13] At this time, travelling through Italy was thought of as a means of connecting with the very core of European culture:

> The states of Tuscany and Rome present a picture of uninterrupted civilization for the space of little less than three thousand years; a period without example in the annals of any other people which have come to our knowledge. Greece and Africa are lost in ignorance and subjection. [...] The most polished states of modern Europe can date their civilization from no very ancient period, when compared with that of which we are now speaking.[14]

For well-educated women, Rome became the stage where they could imagine those literary adventures learnt as young pupils. Cornelia Knight, writing in 1778, went so far as to describe the Roman environment as a 'theatre':

> In the Roman Campagna we read, with the more peculiar satisfaction, the works of Livy, of Virgil, of Horace, and of every other writer who has either related the greatest actions performed on this interesting theatre.[15]

This understanding of the city as a stage, or theatre, for antiquity persisted throughout this period, and when Elizabeth Frances Batty reflected on this issue in a volume published in 1820, she likewise used this terminology: '...To have seen Italy is [...] by many considered the necessary complement of a classical education. The theatre of some of the most pleasing fiction of the poets'.[16][17] The fragmentary material remains of the city were often observed through the lens of their literary connections, and, accordingly, 'classical travel' was experienced as a return to collective humanistic roots.[18] Education was a distinctive character of these travellers and acted as a factor of common class identity which remained persistent in the mentality of the British, who saw their culture reflected in the mirror of extant classical remains, even after the Papal Restoration.

It was six months into 1815 when Pope Pius VII returned to Rome. To the British, his return meant the possibility of visiting Rome again, and an enthusiastic phase of travel started. Moreover, large-scale excavations across the city had begun, hoping to unearth further structures and artefacts of Ancient Roman civilisation.[19] At the beginning of 1816, when the sisters Charlotte and Jane Waldie (from now on referred as, respectively, Eaton and Watts) reached Rome, as part of a long journey through the Continent, they compiled accounts of what they saw.[20] These texts, *Rome in the Nineteenth Century* and *Sketches Descriptive of Italy in 1816–1817*, were both published in 1820. From Eaton's *Preface* to her book, we can appreciate how the idea of Rome as common cultural root persisted, even after the interruption of regular travel to the city. Here, the author intended to:

> Recall its remembrance to those who have seen it and convey to those who know it not, some faint picture of that wonderful city, which boasts at once the nobles remains of antiquity, and the most faultless masterpiece of art [...] which in every age has stood foremost in the world [...] the fountain of

Identity perception in monuments, ruins and remains 155

civilization to the whole western world - and which every nation reverences as their common nurse, preceptor, and parent.[21]

Despite the recalled cultural common ground, the direct experience of Rome's architectural heritage was viewed as pivotal in the consideration of cultural identity as the architect Joseph Woods summarised, during his visit in 1817:

> [...] In spite of all that may have been seen elsewhere of magnificent buildings, and all of the views and drawings which have been published of the eternal city, Rome is still a new world to an architect. You may know in detail the appearance of every building here, but you can't feel nothing, you can't imagine nothing of the effect produced, on seeing, on finding yourself thus among them.[22][23]

He contemplated architectures in a reciprocal relationship with the surrounding landscape and in the context of the site they occupied. His architectural study considered a wide range of values:

> Nothing has astonished me more than the numerous fine points of views which the ancient city must have offered. The hills were insignificant in themselves, but they seem made to display the buildings to the great advantage; and one grand object rising behind another and varying in combination at every point of view, must have exhibited a scene of splendour and magnificence [...] the hills and country about Rome are well disposed for architecture, and for uniting its object with those of the landscape.[24]

As this quote highlights, Woods – and others like him – felt that there was no substitute for personal experience, which – unlike a written account – provoked a personal emotional response and an element of surprise, even when viewing the most iconic Roman monuments. In 1771, when facing the Coliseum, Anne Miller wrote:

> The ruins we have seen, greatly exceed an idea formed of them from books and prints.[25] [...] I think is the most grand stupendous Ruin in Rome [...] the proportion of this glorious Ruin are so just that it does not appear near so large as it really is.[26]

Piozzi wrote that the Coliseum was 'four times as large as I am told', after seeing the building for the first time in person.[27] From the sources, it emerges a common aim to experience, in reality, those imagined places, aspiring to recreate historical episodes with the help of environment characteristics such as light, shapes, vegetation, and buildings. Concrete circumstances, and the arousing of feelings and emotions, changed this aim and allowed to discover each situation in its peculiarity and unknown features, even fortuitous. So, the contact with reality – experienced *here and now* – radically changed the way of looking at both the real place and the imagined one.

Those who were not able to travel tried to recreate a sort of virtual visit of the most iconic places of Rome. In this regard, it is worth considering that during the last years of the eighteenth century, and again during the era of French occupation, many visitors and architecture students who found their travel to Rome hampered were visiting instead the Richard Dubourg Museum in London. This museum presented the visitor with models of Roman monuments positioned side by side and interpreted by guides who pretended to replicate a city tour.[28] At the same time, the first publication referring to the survey of the most known monuments in Rome, measured and engraved with details in feet and inches, was published in London by Taylor and Cresy in 1821.[29]

Taylor and Cresy arrived in Rome in 1817, with the aim of drafting a highly accurate survey of the city's built heritage. Between October 1818 and March 1819, they requested many permissions to build scaffolding at various locations to get the close view needed for their survey. They measured many buildings in the Roman Forum, such as the Titus Arch, the Settimius Severus Arch, the Constantine Arch, the temples of Vespasianus, Saturnus, Antoninus and Faustina, Castor and Pollux, Portunus, and Hercules Victor, in addition to the Column of Marcus Aurelius, the Column of Phocas, the Basilica of Maxentius, and the Colosseum. In 1821, the results of these efforts were published under the title *The Architectural Antiquities of Rome*.[30] This text quickly became a crucial reference point for English students of architecture, due to its detailed accuracy and exact measurements, which were provided in feet and inches. Readers could access a collection of hundreds of drawings, including bird's-eye perspectives, graphic reconstructions, and detailed descriptions of architectural orders. Thanks to lithography, Taylor and Cresy could present greyscales of mouldings and ornaments (in a 1:4 scale). This substantial volume opens with a double plate, entitled *Plan and Section of the Ancient Building of Rome, from the Colosseum to the Capitol*, a plan of the area that goes from the Colosseum to the Capitol. These plans are accompanied by a cross section that describes altimetry and the relationship between monuments. Hereafter, ancient buildings are shown individually, through engravings of bird's-eye perspectives of their current condition. Alongside plans, Taylor and Cresy included prospects and sections that represented ideal reconstructions of monuments, by identifying the ruins discovered and providing their measurements. Detailed plates of architectural orders are illustrated in two different editions: a black-and-white carving with measurements and a lithography to highlight plasticity. Points of view seem to be chosen to provide a report on the current condition of excavations – such as for the Temple of Castor and Pollux, which is represented through two drawings: a south-eastern and a north-eastern one, with orthogonal projections that seem to lead to a graphical reconstruction. The text, since it was addressed to an English audience, seems not to interest the Italian one. Taylor himself complained in his autobiography about the fact that Desgodetz's *Les Edifices Antiques de Rome* – republished in 1822 by Carlo Fea – was still being used as a key reference, despite the major errors it contained in respect of its survey.[31] Nevertheless, while a few new works appeared on the book market, which included surveys, the status of current excavations, and historiographical theories that were able to build a more

complex context for architectural analysis, despite the measurement precision and the attention to the condition of excavations, the English publication seems to be limited to a series of images with very short captions, with no comments neither descriptions – useful to new projects.

In this framework of direct surveys and graphic reconstructions stands James Pennethorne, who applied to the Accademia di San Luca in 1825 with a depiction of an ideal reconstruction of the Foro – entitled *An Idea of the Restoration*.[32] To complete his application, he asked to be sent from London the 1818 Taylor and Cresy plan of this monument. At the same time, he received the latest updates on the excavation status of the site through the *Del Foro Romano*, as well as via a copy of Cockerell's reconstruction. He considered his work as an exercise: he studied only the latest archaeological data and direct observations of recent excavations, noting that:

> It is not from the remaining parts but from the study of the whole building when perfect that I ought to derive the greatest advantage -for thought the drawing [of] the remains is absolutely requisite yet it is I think secondary and mechanical compared to the exertion of the mind in the former. For the labour of the hand must be subject to understanding.[33]

In this way, Pennethorne highlighted the important role of ideal reconstructions in visualising and appreciating buildings of this kind. With this in mind, he prepared a large painting to submit with his application to the Accademia di San Luca for honorary membership – to offer the Academicians a view not only of the archaeological evidence but also of the emotional power of these buildings. Pennethorne's subject was not simply Ancient Rome but also the city's image. Commenting his new approach to reading the antiquities compared to the French one, on the 26th of April 1825, Pennethorne wrote 'they made me feel unhappy about everything I did'.[34]

It emerges how the city was not regarded as a living body as such, but more as a repository of ideas, a cabinet of curiosity, or the display of youthful reading. The desire to relive past times was on the rise, bringing the "spectator" of the "theatre" to imagine its former state, as Philippina Deane, mother of Cornelia Knight, wrote when visiting the Coliseum: 'the moon entered the broken parts […] you could almost believe that is whole and full of spectators'.[35] During the same visit, Cornelia Knight went further, "playing" inside the building, touching and exploring its recesses and, in the end, hoping for its reconstitution:

> I climbed it once, not to the top indeed, but till I was afraid to look down from the place I was in, and penetrated many of its recesses. The modern Italians have not lost their taste of a prodigious theatre; were they once more a single nation, they would rebuild this I fancy.[36]

These contemporary responses to Rome's built heritage reveal the importance of tactile experience for these tourists, in their effort to imagine a building's former state – a state that they had primarily engaged with through literature and

paintings. At the same time, for these individuals to appreciate the state of the ruins as emblematic of the current spirit of the time, direct experience of their space and materiality became the counterpoint of an iconic experience, planned and imagined for a long time, which brought the wish to relive the ancient past and simultaneously to enjoy of the present-day ruins. As Piozzi commented in 1778:

> The ruin is gloriously beautiful; possibly more beautiful than when it was quite whole; there is enough left now for Truth to repose upon, and a perch for Fancy beside, to fly out from, and fetch in more.[37]

Ruins evoked an imagined fantasy about antiquity and, at the same time, the possibility to live that fantasy through the reality that the concrete remains were offering experienced directly in their own environment by senses and then feelings. Anyway, as in theatre, fiction is believable only when based on accurate representations of true traces.

This attitude is well exemplified in *Pompeiana* by William Gell, compiled with John Peter Gandy and published in 1817.[38,39] In this book, each monument is accompanied by two illustrations placed side by side, depicting the current condition of the ruins and its ideal reconstruction, enlivened by scenes of everyday life. This way of representing the antiquities satisfied and, in the meanwhile, nourished the readers' desire for ancient world materialisation – through images, in a picturesque manner, and with fantasy features. It is crucial to point out that Gell's drawings had been created with a cutting-edge scientific technique.[40] His method was detailed in the preface to the first edition: 'The original drawings for this work were made by the camera lucida by Sir William Gell. To render the subject clearer, a slight alteration has in two or three instances been made, but always mentioned in the text.[41]

Figure 7.1 (Left) W. Gell with J. P. Gandy, *Pompeiana. The Topography, Edifices, and Ornaments of Pompeii*, 1817. (Right) W. Gell, A. Nibby, *La Carta de' Dintorni di Roma*, 1837.

Camera lucida had been patented in 1806 as an optical science groundbreaking in its novelty and constituted photography's immediate predecessor. Using a prism, the artist was able to see simultaneously both the object to represent and the paper to draw on. Through this method, it was possible to achieve a high level of accuracy in reproduction.[42] Comparing the drawings published in *Pompeiana* with the ones conserved in the British Museum Archives, it is possible to deduct the methodology Gell applied. A good example is the *Tempio della Fortuna* illustrations: in one picture, the ruin's profile is traced out with a pen, using the camera lucida; whilst in another one, on the same outline, using perspective geometrical rules, he pencil-sketched a few lines to draft an initial idea of the ruined architecture's ideal reconstruction.[43] This second sketch is the engraving base: the part of the image that has been drawn *in situ* is cut out, whilst the few elements that restrict the view of the monument are removed. The ruin's representation is then enriched with vegetation, animals, and – sometimes- humans. At the same time, the idealised vision of the ancient monument is defined, and it is enriched with vivid scenes that are meant to represent the everyday activities of those places – which are now isolated and crumbling. This process enlightens the way in which Gell combined the most up-to-date scientific techniques of his day with creative processes to recall fantasy scenes in a romantic approach – tailored to a British sensibility.

During his Italian stay, Gell started a collaboration with Italian archaeologist Antonio Nibby,[44] culminated with the publication of *Tentamen Geographicum*, in which images are used as tools for travellers in need of a precise guide for Rome's surroundings.[45] The volume was meant to be an illustrative text with comments, including a map, of the wide area stretching from the Latium coast to the Appennino Abbruzzese slopes, with clear recalls of *Description of Latium*, compiled by Cornelia Knight before the French domination. Gell created a topographic map through the triangulation method.[46] The map included objective representation parameters, such as orography, hydrography, routes, and ancient and contemporary place names. Filippo Trojani engraved the carving but, as the preface stated, Gell's contribution and his following of English guidelines remained extremely recognisable. The map featured vivid colours, especially for the highest mountains, whilst place-naming is given with tiny characters, to highlight soil morphology:

> Considering the shade, maintaining a gradation of colour proportionated to the height of the mountains was necessary, so that the highest ones appear very black, and subsequently the less elevated ones are less dark.[47][48]

Gell's main aim was to achieve an orthographic correct restitution, as he clearly stated: '[…] Serious would be finding errors about the triangulation of places, defects in the accuracy of the scale adopted, or an alteration in the accuracy of the topography'.[49] Evidently, Gell intended to illustrate places with their real characteristics, using the most appropriate methods – both for the images to derived from ideal reconstructions and for excursion maps. This map was therefore well known amongst visitors, and it was re-published in London in 1834, engraved by James Gardner senior with the title: *Rome & Its Environs, from a Trigonometrical Survey,*

By Sir William Gell, attached to *Topography of Rome and Its Vicinity*, with funds provided by the *Society of Dilettanti*.

In this spirit, the architect Charles Robert Cockerell, during his stay in Rome in 1816, prepared *An Idea of a Reconstruction of the Capital and Forum of Rome*, an imaginative picture of ancient Rome, exhibited at the Royal Academy in 1819.[50][51] In the picture, he eliminated all the buildings that obstruct the view of the most imposing monuments and added some imaginary elements. The success was huge: in a few years, many copies were printed and sold. In 1820, Pietro Parboni and Giuseppe Acquaroni engraved it in Rome, whilst in 1824, John Coney produced a version that was again displayed at the Royal Academy in London. In 1842, Alexandre-Charles Dormier made a replica of the image in Paris, and, in the same year, the original artwork by Cockerell was diffused through the reproduction made by George Scharf, under the title *Rome in the Augustan Age, a Restoration by C. R. Cockerell R. A.*[52][53] It was also featured on the title page of the successful volume *Lays of Ancient Rome* by Thomas Babington Macaulay.[54]

Macaulay's book was amongst the most popular publications of the first half of the nineteenth century, along with *The Last Days of Pompeii* by Edward Bulwer-Lytton.[55] Lytton's novel, dedicated to the city suddenly disappeared in AD 79, clearly expressed the evocative and imaginative intention that underlined ideal reconstructions – both literary and artistic. Taking advantage of the suggestive value of the ruins of a such dramatic event, he stimulated the emotions by the dialectic *pathos* between life and death, arousing feelings starting from the remains, in the spirit of these years:

> I feel a keen desire to people once more those deserted streets to repair those graceful ruins to reanimate the bones which were yet spared to his survey to traverse the gulph of eighteen centuries and to wake to a second existence the City of the Dead.[56]

Figure 7.2 (Left) Giacomo Rocrué, *Antico Foro Romano / Tempio dei Castori già Giove Statore / Tempio e recinto di Vesta l'antico Foro Romano*, Robert Cockerell, 1818. (Right) Thomas Babington Macaulay, *Lays of Ancient Rome*, 1847.

The poverty and corruption encountered by British visitors in Italy formed a sharp contrast with the image of classical splendour attributed to the Italian past. British attitudes to Ancient Rome were complex: Rome represented the classical, antique virtue of the past and a present of decadence; it symbolised both the evanescence of all human achievements and, at the same time, the durability of their remains. Rome was a sign of both the triumph of Christianity and the continuing authority of pagan culture.[57] Charlotte Eaton brilliantly revealed her vision ascending the Tower of the Capitol, looking at the Forum:

> What a prospect burst upon our view! To the north, to the east, and even to the west the Modern City extends; but to the south, Ancient Rome reigns alone. The time-stricken Mistress of the world, sadly seated on her desert hills, amidst the ruined trophies of her fame, and the mouldering monuments of her power, seem silently to mourn the fall of the city of her greatness. On her solitude the habitations of man have not dared to intrude, no monuments of his existence appear, except such as connect him with eternity.[39]

The counterpoint to the narration of the Coliseum is undoubtedly Charlotte's account of her visit to the Pantheon:

> It is sunk in the dirtiest part of modern Rome; and the unfortunate spectator, who comes with a mind filled with enthusiasm to gaze upon this monument of the taste and magnificence of antiquity, finds himself surrounded by all that is most revolting to the senses, distracted by incessant uproar, pestered with a crowd of clamorous beggars, and stuck fast in the congregated filth of every description that covers the slippery pavement; so that the time he forces himself to spend in admiring its noble portico, generally proves a penance from which he is glad to be liberated, instead of an enjoyment he wishes to protract. [...] You may perhaps form some idea of the situation of the Pantheon at Rome, by imagining what Westminster Abbey would be in Convent Garden Market [...] Nothing resembling such a hole as this could exist in England [...] Still, while I gazed upon the beauty of the Pantheon itself, I could not but remember that this noble monument of taste and magnificence was already built in these time when our savage ancestors still roamed through their native forests scarcely raised above the level of the beasts they chased; their very name unknown to all the world besides, excepting to the Romans, by whom they were considered in much the same light as the South-Sea inlanders are by us. [...] Beautiful as the Pantheon is, it is not what it was. [...] Its beauty is that sort, which, while the fabric stands, time has no power to destroy.[58]

In Eaton's description, classical vestiges become the chain linking Rome's cultural supremacy in the past to Britain's economic and political prosperity in the present. A kind of 'anti-hereditary' stance is made explicit when Britain, instead of Italy, is designated as the worthy successor of the glories (and power) of Rome.[59] The idea

that the British were the heirs to this Classical role of the vanguard of the world was shared by Italians. As Craufurd Tait Ramage reported, talking with the

> Respectable inhabitants of the village [...] one of the group said that he was afraid that Italians had changed places with the Ultimi Britanni, and that high civilization had passed from Italy to Great Britain, which now occupied the noble position in the world with their ancestors had maintained in former times.[60][61]

A circuit breaker of identity was rising: the British were finding a way to escape the pitiful contrast with the former greatness of Rome (a greatness they felt themselves to have in the present) offered by contemporary Italian life. They recoiled from the present as a possible omen of their own nation's future decline.[62] Decadence was to be traced in the material remains of Ancient Rome as much as in the surviving accounts of Roman moral failing, architecture provided concrete evidence and expression of the classical past.[63] Buildings encapsulated ideas about antiquity, transmitted the past to the present, and were intensively engaged with by British visitors in those last moments before such ideals were subsumed by the growing nationalism of the nineteenth century.[64]

At this time, a Roman pagan empire could still serve as a model for British imperial ambitions, but the ancient vestiges represented both republican virtue and imperial decadence, and their ruins symbolised both the transience of all human achievements and their durability.[65] Visiting the ancient Ostia, in *Description of Latium*, Cornelia Knight wrote:

> All is now changed, and from this truly distressing scene the British traveller will naturally turn his thoughts with exultation to his native country, which at the time when Ostia flourished in wealth and activity, could boast of as little naval glory as that of modern Rome. Yet let him remember that triumphant fleets, and victorious army [...]: let him reflect on the revolution of empires, and the vicissitudes of human affairs, forbear to despise a people once our masters, but unite his prayers and efforts for the continuation of that energy, and those advantages which distinguish the Island of Great Britain, and secure her independence, while they render her the mistress of the seas.[66]

The book mentioned by Cornelia Knight shows how the female sphere was participating in the spirit of the time: Cornelia was involved in observing, reflecting upon, and describing the Italian landscape, cities, and villages and, above all, admiring the vestiges of ancient monuments by literature. During her stay in Rome, Knight completed about 800 drawings, both *capricci* and life drawings. After the Restoration, in fact, significant works dedicated to graphic representation started to be produced and circulated.

In 1816 and 1817, Elizabeth Batty and James Hackewill worked on *Italian Scenery* and *A Picturesque Tour of Italy*, a series of illustrations of Italian heritage sites, which were published in 1820.[67] Elizabeth Batty's work included 60

 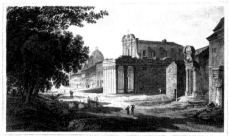

Figure 7.3 (Left) James Hakewill, *A Picturesque Tour of Italy,* 1820. (Right) Elizabeth Batty, *The Temple of Antonino e Faustina in the Campo Vaccino,* in Italian Scenery, 1820.

plates: 10 related to Rome, among which two views of the Coliseum, Temple of Venus and Rome, the Forum, Giano's Arch, Nerva's Forum, City walls at Laterano, and Minerva's Temple. The vestige subject was also included by Hackewill in his sketchbook,[68] which contained nine handouts of the city, even though his publication was more focused on public exhibitions of ancient art. Hackewill intended to provide the British public with a summary of the ancient artistic masterpieces conserved in the principal museums in Rome and Florence.[69]

Focusing on Roman vestiges and ancient monuments, these books offered evidence of European culture, which at the time was incarnated by the British, and they reconstructed a history that began with the Romans. During the eighteenth century, in fact, British scholars were reconsidering the question of the Roman conquest of Britain. In 1712, Robert Atkins wrote that, before, Romans only had '*a multitude of barbarous kings*', and he started investigating systematically the territory to identify where legions of the Roman army were stationed in Britain.[70] Twenty years later, in 1732, John Horsley edited *Britannia Romana or the Roman Antiquities of Britain*.[71] From these early studies emerged an awareness that Roman structures remained recognisable in the British landscape through paths, encampments, aqueducts, and baths. It was in this period that antiquaries were gradually becoming aware of the extent to which Roman structures had been routinely incorporated into the physical fabric of towns (such as Gloucester or Leicester).[72] This knowledge created, inevitably, a tension between the admiration for the achievement and the reality that the Romans had slain and conquered the native Britons, leading to extreme definitions of Anglo-Roman antiquities as 'vestigial of a horde of plunderers'.[73] These kinds of statements show the intent to claim a distinctive British identity during the period of Roman subjugation. The research for national origins, at the same time, developed a deeper interest in ancient Britons and Celtic Antiquities: admiration for the Anglo-Saxons grew, as they were perceived as embodiment of moral virtues such as liberty, value, and simplicity, in contrast to the formal classicism of Roman civility. By the end of the eighteenth century, the Saxons were being awarded greater credit for having purged the nation from

164 *Barbara Tetti*

the corruption and decadence of the late Roman presence in Britain.[74] A female testimony to this dual approach can be seen in the work of the architect Sara Losh, who built a replica of Bewcastle Cross as a memorial to her parents in 1835 and a schoolteacher's house based on a villa in Pompeii.[75]

During the pontificate of Leon XII (1823–1829), the number of British people living in Rome increased. Indeed, the 1813 *Pontificia Accademia Romana di Archeologia* regulations expected 40 contributors, including those of Edward Dowell and James Millingen, who were honorary members.[76][77] They were amongst the few British intellectuals who had remained in Rome during the French occupation. In the following years, William Hamilton, William Gell, and Charles Robert Cockerell, along with Richard Burgess, John Talbot, and John Egofoster became members as well.[78] British intellectuals were even more involved with the *Istituto di Corrispondenza Archeologica*, established in 1829: a delegate of the British group was the archaeologist, James Millingen. Publications from the *Istituto*, the *Bollettino*, and the *Annali* were promptly reprinted in London: at the time of its establishment, the Istituto could claim 27 British members, two years later this number had risen to 55, and to 71 by 1836, double the number of Germans and French.[79] In 1824, Enrico Keller, a member of the *Accademia Romana di Archeologia*, compiled a list of British artists in Rome.[80] The list included the names of distinguished people not directly connected to official organisations, such as the painter James Atkins and the sculptor John Gibson.[81][82] At the beginning of the 1820s, Richard Burgess arrived in Rome as newly appointed Chaplain of the All-Saints Anglican Church. Burgess was a Professor of Divinity at Cambridge and became a leading figure in the *Istituto di Corrispondenza Archeologica*. In Rome, Burgess focused on archaeology, regularly meeting with Nibby, whose thoughts he often welcomed.[83] In 1831, he published (in London) a text called *The Topography of Antiquities of Rome, Including the Recent Discoveries Made About the Forum and the Via Sacra*. The intention of his work was explained in the preface, as he criticised Roman scholars and their stance regarding the 'authenticity' of the monuments and their elements:

> The ruins and the topography of Rome, ever since the revivals of letters, have been considered by all learned man as a subject worthy of much attention, and tending greatly to illustrate the Latin classics: indeed, the Roman antiquaries, during the last three centuries, may be said, in more senses than one, to not 'left a stone unturned' [...] on the other hand, as they reasoned but little upon the authenticity of the monuments [...] and hence many strange errors [...] laid up for posterity. [...] The design of the following work, therefore, is to supply this deficiency in this branch of our classical literature, to investigate, with the aid of that has gone before it, the site of Ancient Rome.[84]

The volume was written in collaboration with Architect Giuseppe Pardini, who edited the images accompanying the text.[85] In particular, Pardini worked on a plate

dedicated to Temple of Venus and Rome, as he was asked by Burgess to produce two parallel drawings in orthogonal projection: one named *Section of the Temple of Venus and Rome (restored)* and the other known as *Section in Its Present State*. In the latter, Pardini gently drew the frontal prospect of its ideal reconstruction as a background to the remains' survey. Unlike previous publications, no external elements are featured in any of the drawings, and the monument is depicted as completely isolated from its context. At the end of the chapter, Burgess adds a timeline of the edifices to provide the audience with a tool to identify the urban structure across the centuries. This outline of the characters and the events that occurred between the Restoration of Pius VII's Pontificate and the end of Leo XII's reign clearly shows how various approaches to Roman antiquities enabled cultural interchange concerning intervention, interpretation, and restitution of ancient buildings. These thoughts were circulating between European capitals, continuously referring to each other, creating a fervent intellectual exchange

Final remarks

This analysis has explored the reciprocal interchange between different cultures that foregrounded pivotal concepts such as authenticity and recognisability. It was explained in the chapter how different factors, such as nature and the built-in environment, impacted how people approached ancient remains and the emotional responses that aroused from these encounters. At the same time, scholars and travellers that approached ancient remains interacted with them in different manners, by either depicting them, providing detailed measurements, or producing idealised reconstructions of the monuments. Through the direct experience transmitted by senses and emotion, the travel experience became a pivotal step in considering those environmental elements constituting the space. Architecture, with its memorial value, encouraged significant observations about single and collective past, present, and future. Visiting Rome, crossing its stratified palimpsest of history, became an experience dictated by the senses, an emotional experience that stimulated a reflection over identity and memory, contributing to point out individual characteristic and skills, up to unpredictable ones, revealing and breaking stereotypes involving both the subject looking and the object being observed. In this framework, the voices of women narrating their experiences through perception and emotions emerge as less constrained by professional roles, returning us unprecedented visions of the city and capturing the spirit of an era and society. All these elements, including different approaches and patterns, nourished a continuous reciprocal flux of ideas, which led the study of antiquities to a new phase of knowledge production, which then flourished during the middle of the century.

Archival sources

British Museum, Department of Greek and Roman Antiquities, Cockerell misc.
 Fondazione Marco Besso, Collezione fotografie e stampe.

Notes

1 Collins Dictionary, London: Collins, 2018, *ad vocem*.
2 Vocabolario della Crusca, IV ed., p. 702, vol. 2 (1729–1738), *ad vocem* Identità, Identitade Definiz: *Medesimezza; ed è termine de' filosofi, e de' legisti. Lat. identitas. Gr.* Ταυτότης; Quinta edizione, pagina 10, volume 8 (1863–1923) *ad vocem* Identità, Identitade *Astratto di identico, essere identico, ciò che fa che una cosa sia identica ad un'altra, medesimezza, uguaglianza, dal basso latino identitas*.
3 Raspi Serra, "Winckelmann archeologo e cronista degli scavi e ritrovamenti nella Roma metà del XVIII secolo", pp. 271–280. Exemplar figure is Francesco Bianchini (1662–1729). He studied theology, anatomy, botany, mathematics, physics, and astronomy; in 1689, he moved to Rome where he studied languages, among which Hebrew, Greek, and French together with archaeology and history. Under his presidency at Roman Antiquity (1703), the excavations on the Palatine and the Appia were started – among his writings, especially *Storia universale provata con monumenti e figurata con simboli degli antichi*, Rome 1697. These issues were taken on, in particular, in the activity of the *Riformata Accademia de' Concilj*, directly controlled by the Curia through the cardinal Annibale Albani.
4 Tozzi and D'Amelio, *Luoghi comuni*; especially Valenti Prosperi Rondinò, "O Roma, mia patria, città dell'anima. Il mito di Roma e della campagna romana nei pittori e incisori francesi, inglesi e tedeschi del XVIII e XIX secolo", pp. 9–12; Tozzi, "Tra ragione e sentimento, Roma nelle immagini dei vedutisti stranieri", pp. 13–32. Pearce, *Visions of antiquity. The Society of Antiquaries of London, 1707–2007*; Sweet, *Antiquaries: The discovery of the past in XVIII Britain*; Peltz and Myrone (eds.), *Producing the past, aspect of antiquarian culture and practice, 1700–1850*, especially Lolla, "Ceci n'est pas un monument: Vetusta Monumenta and antiquarianism aesthetics", pp. 15–34, and Buchanan, "Sense and sensibility: architecture and antiquarianism in the early XIX century"; Bann, *The invention of the History: essays on the representation of the past*; Momigliano, "Ancient history and the antiquarianism"; Lolla, "Monuments and texts: antiquarianism and the beauty of antiquity".
5 Miller, *Letters from Italy*, Letter XLV, Rome, 1771 May 14. In 1776, the letters were published anonymously in three volumes, and the second edition, in two volumes, appeared in 1777.
6 Sweet, *Cities and the Grand Tour, The British in Italy 1690–1817*, p. 27.
7 Anne Katherine Elwood (1796–1873) was a British traveller, writer, and biographer. Elwood, *Narrative of a Journey Overland from England, by the continent of Europe, Egypt, and the Red sea, to India*, p. 2.
8 *Ibidem*.
9 Ellis Cornelia Knight (1757–1837) was an English gentlewoman, traveller, landscape artist, and writer of novels, verse, journals, and history; *A Description of Latium, or La Campagna di Roma* includes her own etchings.
10 Hester Lynch Thrale (27 January 1741–2 May 1821) was a Welsh-born diarist, author, and patron of the arts; in 1789, she published *Observations and Reflections Made in the Course of a Journey Through France, Italy and Germany*.
11 Mariana Starke (1761/1762–1838) was an English author. Among her writings are *Letters from Italy, between the years 1792 and 1798 containing a view of the Revolutions in that country*; *Travels on the Continent: written for the use and particular information of travellers*; and *Travels in Europe Between the Years 1824 and 1828*.
12 The first Murray's Handbook for Italy, *Hand-Book for Travelers in Northern Italy: States of Sardinia, Lombardy and Venice, Parma and Piacernza, Modena Lucca, Massa-Carrara, and Tuscany, as far as the Val D'Arno*, was published in 1842; McNees, "Reluctant source: Murray's handbooks and 'pictures from Italy'"; Sweet, *Cities and the Grand Tour, The British in Italy 1690–1817*, 2007, p. 11 and p. 64.
13 Knight, *Description of Latium or La Campagna di Roma*, pp. IX, X.
14 *Ivi, Conclusions*, p. 262.

Identity perception in monuments, ruins and remains 167

15 *Ivi*, Introduction, pp. IX, X.
16 Elizabeth Frances Batty, later Martineau (1791–1875), daughter of a physician and amateur artist Robert Batty, to whom this book is dedicated.
17 Batty, *Italian Scenery*, pp. 1, 2. «*The descriptions were written by a friend of the Publisher's*», anonymous, as clarified in the colophon.
18 Liversidge and Edwards, "Foreword", p. 10.
19 Jonsson, *La cura dei monumenti alle origini: restauro e scavo di monumenti antichi a Roma 1800–1830*; Sette, *Restauro architettonico a Roma nell'Ottocento*; De Seta (ed.), *Imago Urbis Romae, l'immagine di Roma in età moderna*; Debenedetti (ed.), *Architetti e ingegneri a confronto, l'immagine di Roma fra Clemente XIII e Pio VII*.
20 Charlotte Anne Eaton (1788–1859) was a Scottish travel writer, memoirist, and novelist. She wrote *Narrative of a Residence in Belgium, during the Campaign of 1815, and of a Visit to the Field of Waterloo by an Englishwoman*, published in London in 1817; in 1820, she published anonymously, in three volumes, *Rome in the Nineteenth Century* (Edinburgh); second and third editions appeared, respectively, in 1822 and 1823 (a fifth edition was published in 1852 and a sixth in 1860). Jane Watts (1793–1826), Charlotte's young sister, was an artist and author, who wrote a four-volume account of her travels titled *Sketches descriptive of Italy in 1816–17; with a brief Account of Travels in various parts of France and Switzerland*.
21 Eaton, *Rome in the Nineteenth Century*, pp. XI–XII.
22 Joseph Woods (1776–1864) botanist and geologist, was a member of the Society of Antiquaries and an Honorary Member of the Society of British Architects. In 1806, he founded the London Architectural Society and became its first President. In 1816, immediately after the end of the Napoleonic Wars, he travelled throughout the Continent, visiting France, Switzerland, and Italy. From this experience, he published *Letters of an Architect from France Italy and Greece*, London 1828.
23 Woods, *Letters of an Architect from France Italy and Greece*, letter XXIII, p. 327.
24 *Ivi*, Letter XXIII p. 329; January 1817.
25 Miller, *Letters from Italy*, Letter XL, *Roma*, 1771 March 26th.
26 *Ivi*, Letter XLII, *Roma*, 1771 April 12th.
27 Piozzi, *Observations and Reflections Made in the Course of a Journey Through France, Italy and Germany*, p. 389.
28 Salmon, *Building on ruins: the rediscovery of Rome and English architecture*, pp. 47–49. Some reproductions, in scale and made of cork, are still preserved today at the Victoria Museum in London; see Gillespie, "Richard Du Bourg's 'Classical Exhibition', 1775–1819".
29 Edward Cresy (1792–1858), architect and civil engineer; George Ledwell Taylor (1788–1873), architect. In his autobiography, *The Autobiografy of an Octuagenarian architect*, London 1870, Taylor wrote: *At Rome was so enchanted with the ancient buildings, and convinced that they required to be better described, that we resolved at once to measure accurately and draw the different temples, with the view of publishing them when we returned to England*, vol. I, p. 87.
30 Taylor and Cresy, *The Architectural Antiquities of Rome*.
31 Taylor, *The Autobiografy of an Octuagenarian architect*, vol. II, p. 251.
32 James Pennethorne (1801–1871), architect; in October 1824, he left England for France, Italy, and Sicily. He trained in Rome, where he was a member of the Accademia di San Luca; Dictionary of National Bibliography, from here DNB, *ad vocem*.
33 Salmon, *Building on ruins: the rediscovery of Rome and English architecture*, note 45.
34 '[…] Mi hanno fatto sentire non contento di tutto quello che ho fatto […]', in Salmon, *Building on ruins: the rediscovery of Rome and English architecture*, note 46.
35 Lady Knights' letters, March 1778, letter X, in Wilton and Bergamini, *Grand Tour: Il fascino dell'Italia nel XVIII secolo*.
36 Piozzi, *Observations and Reflections Made in the Course of a Journey Through France, Italy and Germany*, p. 389.

168 Barbara Tetti

37 *Ivi*, p. 388.
38 John Peter Gandy (1787–1850), later John Peter Deering, was a British architect. In 1805, he was admitted to the *Royal Academy Schools*; he exhibited at the *Royal Academy* between 1805 and 1833 and his early exhibits included "*A Design for the Royal Academy*" (1807) and two drawings "*An Ancient City*" and "*The Environs of an Ancient City*" (1810). From 1811 to 1813, as an architectural draughtsman to accompany Sir William Gell, he joined an expedition to Greece on behalf of the *Society of Dilettanti*. Gell and Gandy also published Pompeiana (1817–1819).
39 Gell and Gandy, *Pompeiana. The Topography, Edifices, and Ornaments of Pompeii, London 1817–1819*. William Gell, intellectual, was sent in 1801 for his first diplomatic mission to Greece; among the members of the *Society of Dilettanti*, *Society of Antiquaries of London*, *Institute of France*, *Royal Academy in Berlin* e *Fellow*, and *Royal Society*. See Riccio, *William Gell, archeologo, viaggiatore e cortigiano*; Sweet, "William Gell and Pompeiana"; Clay, *Sir William Gell in Italy: letters to the society of Dilettanti 1831–1835*.
40 He aimed at achieving ruins' reproductions as faithfully as possible and to always alert his audience when representations have been altered. His method has been detailed in the first edition's preface: 'it may be proper to state, that the original drawings for this work were made by the camera lucida, by Sir William Gell. To render the subject clearer, a slight alteration has in two or three instances been made, but always mentioned in the text', in Gell and Gandy, *Pompeiana*, Preface.
41 'The views and pictures have been uniformly made by the author, as before, with the prism of Dr. Wollaston', in Gell and Gandy, *Pompeiana*, pp. XXIII, XXIV.
42 On the topic Hockney, *Secret knowledge: rediscovering the lost techniques of the Old masters*; Hammond and Austin, *The camera lucida in art and sciences*; Wallace-Hadrill, 'Roman Topography and the Prism of William Gell'.
43 British Museum, Department of Greek and Roman Antiquities, Cockerell misc., drawings, in Salmon, *Building on ruins: the rediscovery of Rome and English architecture*, dis. 86, nota 58; the drawing is attributed to Gell by F. Salmon; it is recorded among those attributable to Cockerell, but the temple had not yet been excavated at the time of his visit to Pompeii; moreover it presents a point of view similar to that of the sight of the temple of fortune inserted in Pompeiana.
44 Antonio Nibby (1792–1839) was an Italian archaeologist; he excavated around the Forum Romanum from 1827 and cleared the Cloaca Maxima in 1829. He was a professor of archaeology at the University of Rome and at the French Academy in Rome. Working together with William Gell, he published a study on the walls of Rome in 1820 and a study on the topography of the Roman Campagna.
45 Published in 1827, the book's extended title was *Munificentia Exc. viri Caroli Iohannis Comitis Blessington hoc tentamen geographicum exhibens Latium Vetus et regiones contermine Etruriae Sabinae Aequorum Volscorumque iuxta faciem hodiernam post plurimas trigonometricas observationes et loco rum perscrutationes a Wilhelmo Gellequite Britanno delineatum ab Antonio Nibby professore Archeologiae crebis adnotationibus illis tratum nunc primum prodit*. Map published in Frutaz (ed.), *Le piante di Roma*, I, LV, 3 (ill., III, Tav. 239. On the topic, Masetti and Gallia, *La Carta de' dintorni di Roma di William Gell e Antonio Nibby (1827), Diffusione cartografica, trasformazione, conservazione e valorizzazione dei beni territoriali e culturali*.
46 Nibby and Gell, as explained in the preface of the volume, use the method set by Maire and Boscovich for *Nuova Carta Geografica dello Stato Ecclesiastico*.
47 Stefania Quilici Gigli, *Da Nibby al programma Latium vetus: centocinquanta anni di ricerche topografiche nella campagna romana*, Roma 1994; Asor Rosa et al., *Strumenti cartografici per la tutela e pianificazione del suburbio di Roma: dalla carta dell'Agro romano alla carta per la qualità nel nuovo Piano regolatore*; Bevilacqua, *Nolli, Vasi, Pieranesi, Percorsi e incontri nella città del '700*; Sponberg Pedley, *Scienza*

e Cartografia. Roma nell'Europa dei lumi; Imago et mensura mundi; Lo Sardo, *La cartografia dello Stato pontificio in età napoleonica*, in *Villes et territoire pendant la période napoléonienne (France et Italie)*, Actes du colloque de Rome (3–5 mai 1984) Rome, École Française de Rome, 1987, pp. 121–131; Antonietta Brancati, *La cartografia dell'agro romano*, Roma 1990.

48 'Era necessario mantenere nella tinta quella gradazione di colore che fosse proporzionata all'altezza rispettiva de' monti, in modo che nerissimi apparissero i più alti, e successivamente men tetri i meno elevate [...]', in Nibby, *Analisi storico-topografico-antiquaria della carta de' dintorni di Roma, Roma 1837*, I, p. X.

49 'Male sarebbe, se si trovassero errori nella triangolazione de' luoghi, o difetti nella esattezza della scala adottata, o infine alterazione nella verità della topografia', *ivi*, I, pp. X–XI.

50 Charles Robert Cockerell at the end of 1814 reached Italy and visited Naples and Pompeii; in 1815–1816, he was in Rome for the second time; he made important friendships, including that with the French painter Ingres for the second time, from the end of 1816 to the spring of 1817.

51 Complete title *An Idea of a Reconstruction of the Capital and Forum of Rome, from an elevated point between the Palatine hill and the Temple of Antoine & Faustina from the existing remains, the authorities of ancient writers, and the description of Piranesi, Nardini, Venuti and others*. In the correspondence between the Duchess Elizabeth of Devonshire and the architect is preserved a letter of 1818 in which the noblewoman, praising the drawings, defines them as '*valuable explanation*' of ancient Rome. Cockerell had already performed similar works for some ancient architectures of Athens, defined by him as restoration, to be intended as restitutions: Salmon, *Building on ruins: the rediscovery of Rome and English architecture*; Bordeleau, *Charles Robert Cockerell, Architect in Time: Reflections around Anachronistic Drawings*. Six drawings are conserved in the British Museum: there are four views towards the west and two sketches of ideal reconstructions British Museum, Department of Greek and Roman Antiquities, Cockerell misc. drawings 3, 11, 12, 15 and drawings 13 and 14. Based on that one made in Rome by Giacomo Rocrué, copies are in Rome at Biblioteca Marco Besso, *Antico Foro Romano/Tempio dei Castori già Giove Statore/Tempio e recinto di Vesta l'antico Foro Romano di C. R. Cockerell*, and at Gabinetto Nazionale delle Stampe, FC 36777.

52 A copy is in Rome, at Fondazione Marco Besso, Collezione fotografie e stampe, *Restaurazione del Foro Romano*, 72.H.I, 61.

53 About this issue Edwards, "Translating Empire? Macaulay's Rome".

54 Thomas Babington Macaulay (1800–1859), British historian, visited Italy in the autumn of 1835. *Lays of Ancient Rome*, published in 1842, is a collection of narrative poems, or lays, by Thomas Babington Macaulay, regarding recount heroic episodes from early Roman history with strong dramatic and tragic themes; in the first ten years, over 18,000 copies were sold.

55 *The last days of Pompeii* was published in London in 1834 by Edward Bulwer-Lytton (1803–1873), English writer and politician; the book was promptly translated and published in Italian in 1836.

56 Bulwer-Lytton, *The last days of Pompeii*, Preface.

57 Edwards, "The road to Rome", p. 13.

58 Eaton, *Rome in the Nineteenth Century*, Letter XXII, vol. I, pp. 328, 333, 334.

59 Agorni, "L'Italia come geografia estetica e culturale - Hester Piozzi's observation and reflections: Italy in the feminine", pp. 73–74.

60 Craufurd Tait Ramage (1803–1878) was a Scottish travel writer and anthologist; among his publications is *The Nooks and Byways of Italy. Wanderings in Search of Its Ancient Remains and Modern Superstitions* (Liverpool, 1868), based on a journey in southern Italy.

61 Hornsby, *The impact of Italy: the grand tour and beyond*, p. 5.

170 *Barbara Tetti*

62 'Recoiling from contact with the contemporary Italian life […] as pityful contrast with the former greatness of Rome, a greatness they felt themselves', in Churchill, *Italy and English literature: 1764–1930*.
63 Edwards, "The road to Rome", pp. 8–19.
64 On the topic, Watkin, *The architectural context of the Grand Tour: the British as honorary Italians*.
65 Edwards, "The road to Rome", p. 7.
66 Knight, *A Description of Latium, or La Campagna di Roma*, p. 104.
67 James Hakewill (1778–1843) was an English architect, best known for his illustrated publications; in 1816–1817, he travelled in Italy and, on his return published in parts *A Picturesque Tour of Italy* (London, 1820).
68 Some drawings are kept at the British School at Rome Library and published in Cuberbly and Hermann (eds.), *Twilight of the Grand Tour. A Catalogue of the drawings by Jame Hackewill in the British School at Rome Library*. Among these, not included in the publication: Piazza Traiana, the Baths of Caracalla, the Temple of Minerva Medica, the Grotto of Egeria, Porta Furba, four drawings regarding the Tomb of Cecilia Metella, and the sculptures of Moses in S. Pietro in Vincoli, and in Santa Cecilia in Trastevere.
69 '[…] the views of several public galleries of sculpture and painting (though they form the chiefboast of the country) have not, as far as the author is aware, before given in any similar publications […]', in Hakewill, *A picturesque tour of Italy*, London 1820, *Preface*.
70 Sweet, *Antiquaries: The discovery of the past in XVIII Britain*, p. 120. Sir Robert Atkyns (1647–1711) was a topographer, antiquary, and Member of Parliament.
71 John Horsley (c. 1685 – 12 January 1732) was a British antiquarian; in 1732, he published the book *Britannia Romana or the Roman Antiquities of Britain*.
72 Sweet, *Antiquaries: The discovery of the past in XVIII Britain*, p. 173.
73 From *The autobiography of John Britton*, in Sweet, *Antiquaries: The discovery of the past in XVIII Britain*, p. 187.
74 The work by Elizabeth Elstob (1683–1756) on Anglo-Saxon history and culture sought to show a direct line of connection between their ancient Christianity and eighteenth-century Anglicanism, becoming a pioneering scholar of Anglo-Saxon studies.
75 Sara Losh (1785–1853) was an English architect and designer; Jenny Uglow, *The Pinecone: the story of Sarah Losh, forgotten Romantic heroine – antiquarian, architect, and visionary*.
76 Edward Dowell was a traveller and archaeologist. From 1806, he settled in Italy, between Naples and Rome; DNB, *ad vocem*.
77 James Millingen (1774–1845) was an archaeologist; he lived in Rome and Naples, was an honorary member of the Royal Society of Literature and of the Societies of Antiquaries of London, and was a correspondent of the Institute of France; DNB, *ad vocem*.
78 Pietrangeli (ed.), *La Pontificia Accademia Romana di Archeologia: note storiche*.
79 The periodicals were printed by a London publisher, Roswell-Newbond Street, connected to William Gell, until 1835, and subsequently to Bohn-Henrietta Street, Covent Garden.
80 Keller, *Elenco degli artisti esistenti in Roma l'anno 1824, compilato ad uso de' stranieri*; the volume is dedicated to Lord Compton, Marquis of Northampton, residing in Italy between 1820 and 1830.
81 James Atkins was a painter; he studied in Italy from 1819, staying in Venice, Florence, and Rome; he exhibited at the Royal Academy of London in 1831 and 1833; Dictionary of Irish Artists, *ad vocem*.
82 John Gibson (1790–1866), sculptor, arrived in Rome in 1817; he received his first education in the art of sculpture by Canova, being then admitted to the Academy of San Luca. During his stay in Rome, he also attended Thorvaldsen's; DNB, *ad vocem*.
83 Salmon, *Building on ruins: the rediscovery of Rome and English architecture*, pp. 169 e 60 e 61.

84 Burgess, *The topography and antiquities of Rome*, pp. V, VI.
85 Giovanni Pardini (1799–1884) was an architect. In 1817, he moved to Rome to attend the courses of the Accademia di San Luca; in 1826, he achieved a certificate of praise for the Architectural Essay. Cresti and Zangheri, *Architetti e ingegneri nella Toscana dell'Ottocento*, pp. 89, 176–177.

Bibliography

Agorni, M., "L'Italia come geografia estetica e culturale - Hester Piozzi's observation and reflections: Italy in the feminine", in Lilla Maria Crisafulli (ed.), *Immaginando l'Italia: itinerari letterari del romanticismo inglese* (Bologna: CLUEB, 2002), pp. 71–80.

Ancient and present state of Gloucestershire (London: W. Bowyer for Robert Gosling, 1711).

Asor Rosa, Laura, Marina Marcelli, Paola Rossi and Luca Sasso D'Elia, "Strumenti cartografici per la tutela e pianificazione del suburbio di Roma: dalla carta dell'Agro romano alla carta per la qualità nel nuovo Piano regolatore", *Semestrale di studi e ricerche di Geografia*, 1 (2007), pp. 61–84.

Bann, Stephen, *The invention of the history: essays on the representation of the past* (Manchester: Manchester University Press, 1990).

Batty, Elizabeth Frances, *Italian scenery* (London: published by Rodwell & Martin, New Bond street, 1820).

Bevilacqua, Mario, *Nolli, Vasi, Pieranesi, Percorsi e incontri nella città del '700*, in *Immagine di Roma antica e moderna* (Roma: Artemide, 2005).

Bianchini, Francesco, *Storia universale provata con monumenti e figurata con simboli degli antichi* (Roma: Stampata à spese dell'autore nella stamperia di Antonio de Rossi, 1697).

Bordeleau, Anne, *Charles Robert Cockerell, Architect in time: reflections around anachronistic drawings* (Farnham: Ashgate, 2014).

Brancati, Antonietta, *La cartografia dell'agro romano* (Roma: F.lli Palombi, 1990).

Buchanan, Alexandrina, "Science and sensibility: architecture and antiquarianism in the Early XIX century", in Lucy Peltz and Martin Myrone (eds.), *Producing the past, aspect of antiquarian culture and practice, 1700–1850* (Aldershot: Ashgate, 1999), pp. 169–186.

Bulwer-Lytton, Edward, *The last days of Pompeii* (London: Bentley, 1834).

Burgess, Richard, *The topography and antiquities of Rome* (London: Longman, 1831).

Churchill, Kenneth, *Italy and English Literature: 1764–1930* (London; Basingstoke: Macmillan, 1980).

Clay, Edith, *Sir William Gell in Italy: Letters to the Society of Dilettanti 1831–1835* (London: Hamish Hamilton, 1976).

Cresti, Carlo, and Luigi Zangheri, *Architetti e ingegneri nella Toscana dell'Ottocento* (Uniedit: Firenze, 1978).

Cresy, Edward, and George Ledwell Taylor, *Architecture of the middle ages in Italy: illustrated by views, plans, elevations, sections, and details of the cathedral, baptistery, leaning tower or campanile, and Campo Santo of Pisa: from drawings and measurements in the year 1817* (London: The authors, 1829).

Cubebrly, Tony, and Luke Hermann (eds.), *Twilight of the grand tour. A catalogue of the drawings by Jame Hackewill in the British School at Rome Library* (Roma: Istituto poligrafico e Zecca dello Stato, Libreria dello Stato, 1992).

Debenedetti, Elisa (ed.), *Architetti e ingegneri a confronto, l'immagine di Roma fra Clemente XIII e Pio VII* (Roma: Bonsignori, 2008).

De Seta, Cesare (ed.), *Imago Urbis Romae, l'immagine di Roma in età moderna* (Milano: Electa, 2005).

Eaton, Charlotte Anne, *Narrative of a residence in Belgium, during the Campaign of 1815, and of a visit to the field of Waterloo by an Englishwoman* (London: John Murray, 1817).
Eaton, Charlotte Anne, *Rome in the Nineteenth Century* (Edinburgh: James Ballantyne, 1820).
Edwards, C., "The road to Rome", in Michael Liversidge and Catharine Edwards (eds.), *Imagining Rome: British artists and Rome in the nineteenth century* (London: Merrell Holberton, 1996), pp. 8–19.
Edwards, Catharine, "Translating empire? Macaulay's Rome", in Catharine Edwards (ed.), *Roman presences: receptions of Rome in European Culture, 1789–1794* (Cambridge: Cambridge University Press, 1999), pp. 70–87.
Elwood, Katherine, *Narrative of a journey overland from England, by the continent of Europe, Egypt, and the Red Sea, to India* (London: Colburn and Bentley, 1830).
Frutaz, Pietro Amato (ed.), *Le piante di Roma* (Roma: [s.n.], 1962).
Gell, William and John Peter Gandy, *Pompeiana. The topography, edifices, and ornaments of Pompeii, London 1817–1819* (London: Jennings and Chaplin, 1819).
Gillespie, Richard, "Richard Du Bourg's 'classical exhibition', 1775–1819", *Journal of the History of Collections*, 29, 2 (2017), pp. 251–269.
Grazia Lolla, Maria, "Monuments and texts: antiquarianism and the beauty of antiquity", *Art History*, 25 (2002), pp. 431–449.
Hakewill, James, *A picturesque tour of Italy* (London: John Murray, 1820).
Hammond, John H., and Jill Austin, *The camera lucida in art and sciences* (Bristol: Adam Hilger, 1987).
Hand-Book for Travelers in Northern Italy: States of Sardinia, Lombardy and Venice, Parma and Piacernza, Modena Lucca, Massa-Carrara, and Tuscany, as far as the Val D'Arno (London: John Murray, 1842).
Hockney, David, *Secret knowledge: rediscovering the lost techniques of the old masters* (London: Thames and Hudson, 2001).
Hornsby, Clare, *The impact of Italy: the grand tour and beyond* (London: The British School at Rome, 2000).
Jonsson, Marita, *La cura dei monumenti alle origini: restauro e scavo di monumenti antichi a Roma 1800–1830* (Stockholm: Svenska Institutet i Rom, 1986).
Keller, Enrico, *Elenco degli artisti esistenti in Roma l'anno 1824, compilato ad uso de' stranieri* (Roma: s.l., 1824).
Knight, Cornelia, *Description of Latium or La Campagna di Roma* (London: printed for Longman, Hurst, Rees and Orme, 1778).
Liversidge, Michael and Catharine Edwards, "Foreword", in Michael Liversidge and Catharine Edwards (eds.), *Imagining Rome: British artists and Rome in the nineteenth century* (London: Merrell Holberton, 1996).
Lolla, Maria Grazia, "Ceci n'est pas un monument: Vetusta Monumenta and antiquarianism aesthetics", in Lucy Peltz and Martin Myrone (eds.), *Producing the past, aspect of antiquarian culture and practice, 1700–1850* (Aldershot: Ashgate, 1999), pp. 15–34.
Lo Sardo, E., "La cartografia dello Stato pontificio in età napoleonica, in Villes et territoire pendant la période napoléonienne (France et Italie)", in *Actes du colloque de Rome* (3-5 mai 1984) (Rome: École Française de Rome, 1987), pp. 121–131.
Masetti, Carla and Arturo Gallia, "La Carta de' dintorni di Roma di William Gell e Antonio Nibby (1827), Diffusione cartografica, trasformazione, conservazione e valorizzazione dei beni territoriali e culturali", *Bollettino della Associazione Italiana di Cartografia*, 2016 (156), pp. 46–58.
McNees, Eleanor, "Reluctant source: Murray's handbooks and "pictures from Italy"", *Dickens Quarterly*, 24, 4 (2007), pp. 211–229.

Miller, Anne, *Letters from Italy* (London: printed for Edward and Charles Dilly, 1777).
Momigliano, Arnaldo, "Ancient history and the antiquarianism", *Journal of the Warburg and Courtalud Institute*, 13 (1950), pp. 285–315.
Nibby, Antonio, *Analisi storico-topografico-antiquaria della carta de' dintorni di Roma* (Roma: Tipografia delle Belle Arti, 1837).
Pearce, Susan, *Visions of antiquity. The Society of Antiquaries of London, 1707–2007* (London: Society of Antiquaries of London, 2007).
Peltz, Lucy and Martin Myrone (eds.), *Producing the past, aspect of antiquarian culture and practice, 1700–1850* (Aldershot: Ashgate, 1999).
Pietrangeli, Carlo (ed.), *La Pontificia Accademia Romana di Archeologia: note storiche* (Roma: L'Erma di Bretschneider, 1983).
Piozzi, Hester Lynch, *Observations and reflections made in the course of a journey through France, Italy and Germany* (London: Strahan and Cadell, 1789).
Quilici Gigli, Stefania, *Da Nibby al programma Latium vetus: centocinquanta anni di ricerche topografiche nella campagna romana* (Roma: Quasar, 1994).
Raspi Serra, Joselita, "Winckelmann archeologo e cronista degli scavi e ritrova- menti nella Roma metà del XVIII secolo", in Rosanna Cioffi and Ornella Scognamiglio (eds.), *Mosaico. Temi e metodi d'arte e critica per Gianni Carlo Sciolla* 1 (Napoli: Luciano Editore, 2012), pp. 271–280.
Riccio, Bianca, *William Gell, archeologo, viaggiatore e cortigiano* (Roma: Gangemi, 2013).
Salmon, Frank, *Building on ruins: the rediscovery of Rome and English architecture* (Aldershot: Ashgate, 2000).
Sette, Maria Piera, *Restauro architettonico a Roma nell'Ottocento* (Roma: Bonsignori, 2007).
Sponberg Pedley, Mary, "Scienza e Cartografia. Roma nell'Europa dei lumi", in Carla Clivio Marzoli (ed.), *Imago et mensura mundi*, Atti del IX congresso storiografia (Roma: Istituto della Enciclopedia italiana, 1985), pp. 37–47.
Starke, Mariana, *Letters from Italy, between the years 1792 and 1798 containing a view of the revolutions in that country* (London: printed by T. Gillet … for R. Phillips, 1800).
Starke, Mariana, *Travels on the continent: written for the use and particular information of travellers* (London: John Murray, Albemarle street, 1820).
Starke, Mariana, *Travels in Europe between the years 1824 and 1828* (Leghorn: printed and sold by Glaucus Masi, 1828).
Sweet, Rosemary, *Antiquaries: The discovery of the past in XVIII Britain* (London; New York: Hambledon and London, 2004).
Sweet, Rosemary, *Cities and the grand tour, the British in Italy 1690–1817* (Cambridge: Cambridge University Press, 2007).
Sweet, Rosemary, *Cities and the grand tour, the British in Italy 1690–1817* (Cambridge: Cambridge University Press, 2012).
Sweet, Rosemary, "William Gell and Pompeiana", *Papers of the British School at Rome,* 83 (2015), pp. 245–281.
Taylor, George Ledwell, *The Autobiografy of an Octuagenarian architect* (London: Longmans, 1870).
Taylor, George Ledwell and Edward Cresy, *The Architectural Antiquities of Rome, measured and delineated by L. Taylor and E. Cresy* (London: Lockwood, 1874).
Tozzi, Simonetta, "Tra ragione e sentimento, Roma nelle immagini dei vedutisti stranieri", in Simonetta Tozzi and Angela Maria D'Amelio (eds.), *Luoghi comuni. Vedutisti stranieri a Roma tra il XVII e il XIX secolo* (Roma: Campisano, 2014), pp. 13–32.
Tozzi, Simonetta and Angela Maria D'Amelio (eds.), *Luoghi comuni. Vedutisti stranieri a Roma tra il XVII e il XIX secolo* (Roma: Campisano, 2014).

Uglow, Jenny, *The Pinecone: the story of Sarah Losh, forgotten Romantic heroine - antiquarian, architect, and visionary* (London: Faber and Faber, 2012).
Valenti Prosperi Rondinò, Simonetta, "'O Roma, mia patria, città dell'anima', il mito di Roma e della campagna romana nei pittori e incisori francesi, inglesi e tedeschi del XVIII e XIX secolo", in Simonetta Tozzi and Angela Maria D'Amelio (eds.), *Luoghi comuni. Vedutisti stranieri a Roma tra il XVII e il XIX secolo* (Roma: Campisano, 2014), pp. 9–12.
Wallace-Hadrill, Andrew, "Roman topography and the Prism of William Gell", in Lothar Haselberger (ed.), *Imaging ancient Rome: documentation, visualization, imagination* (Portsmouth, RI: Journal of Roman Archaeology, 2006), pp. 285–96.
Watkin, D., "The architectural context of the Grand Tour: the British as honorary Italians", in Clare Hornsby (ed.), *The impact of Italy. The grand tour and beyond* (London: The British School at Rome, 2000), pp. 49–62.
Watts, Jane, *Sketches descriptive of Italy in 1816–17; with a brief Account of Travels in various parts of France and Switzerland* (London: John Murray, 1820).
Wilton, Andrew, and Ilaria Bergamini, *Grand Tour: Il fascino dell'Italia nel XVIII secolo* (Milano: Skira 1997).
Woods, Joseph, *Letters of an Architect from France Italy and Greece* (London: printed for John and Arthur Arch, 1828).

Index

Note: Page numbers followed by "n" refer to end notes.

Amatrice 134
Ancona 55, 108, 110, 114, 116
Aurelian Walls 5, 12

Balkans 55
Basilica of Maxentius 156

Camino de Santiago 61
Campanile: of San Pietro di Coppito 134; of Santa Maria di Rojo 134
Candia 60, 61, 64, 66–71
Cascia 134
Castor and Pollux: equestrian group 5; temple 156
Chapel: of the "Madonna della Vittoria" 58; of the Rosary 57–58, 64, 71
Church: Cappella Palatina 95; Conception and Santa Maria di Paganica churches 138; Holy House of Loreto 53, 55–56, 58–61, 63, 66–67, 69–71, 72n7, 72n12, 73n36; of St. Andrew and Gregory *ad Clivum Scauri* 11, 14–15; St. Mark's Basilica 43; St. Maximus and George's Cathedral 139, 141; of San Bernardino 139; of San Biagio 138, 140; of San Clemente in Isola 53, 56, 58–64, 66–71; of San Domenico 138; of San Gregorio (L'Aquila) 140; of San Gregorio (Venice) 57; San Marciano 139; of San Marco (Candia) 64; of San Michele in Isola 59, 62; of San Pietro di Sassa 134; of San Quinziano 138; of San Silvestro 138; of Sant'Angelo 58–59; of Sant'Agostino 138–139; of Sant'Antonio da Padova (also called *chiesa dei cavalieri de Nardis*) 134, 141; of Santa Caterina Martire 138; of Santa Giusta 132–133, 138; of Santa Maria Annunciata di Preturo 139; of Santa Maria di Collemaggio 132–133, 138, 141; of Santa Maria delle Grazie (Venice) 59; Santa Maria Paganica 139; Santa Margherita (also known as the Chiesa del Gesù or Chiesa dei Gesuiti) 133; of Santi Giovanni e Paolo (Venice) 56–58, 64, 71
Circus Maximus 5, 13–14
Coliseum 155, 157, 161, 163
columns: *Colonne di San Marco e San Todaro* 43; Column of Marcus Aurelius 156; Column of Phocas 156
confraternity: Scuola Grande di San Giovanni 25, 42–43; Scuola Grande di San Marco 29, 42; Suffragio confraternity 140
Constantinople 26–28, 32–33, 35–38, 40, 53–54, 57, 60, 113; as Byzantine Empire 27, 35

Florence 15, 29, 94, 163
Fondaco (fondaci) 114, 123n60
Fort of San Salvatore 85
fountains: Fontana Pretoria 94; Neptune Fountain 86, 88, 90; Orion Fountain 86, 90
France 55, 105, 153, 167n22, 167n32

176 *Index*

gates: Porta Appia 5, 18n26; Porta Capena 14; Porta della Loggia 88; Porta Felice (Palermo) 91–93, 96–97; Porta Imperiale 85, 90; Porta Nuova (Palermo) 82, 91–93, 95–96; Porta Reale 85, 87, 90
Genoa 78, 83, 108–109, 117–118
Greece 46n57, 56, 60–61, 154, 168n38, 168n39; Corfù 53, 61, 108; Crete 53; Cyclades 53–54, 60, 62, 66, 68–69, 71

Italy 36, 54, 77, 81, 89, 91, 94, 127, 130, 132, 139, 151, 153–154, 161–163, 167n22, 167n32, 169n50, 169n54, 170n67, 170n76, 80–81

L'Aquila 127–150
La Spezia 117
Lazzaretto: della Foce 108–110; Lazzaretto Nuovo 104, 108, 113, 115, 118; Lazzaretto Vecchio 104, 113, 115, 117; of San Jacopo 108, 110, 118; of San Leopoldo 108, 110, 116–118; of San Pancrazio 106, 108, 110, 116; of San Rocco 108, 116–117; of Santa Teresa 110, 116; of Varignano 108, 117–118
Lepanto 56–58, 60, 72n20, 82, 85, 87, 95
Livorno 108, 110, 116–118
London 128–130, 137, 156–157, 159–160, 164; Royal Exchange 129; Saint Paul's Cathedral 129–130; Tower of London 129

Madrid 81, 99n27
Malta 105, 108
Messina 77–78, 80–81, 83–90, 94–95, 97–98, 100n97, 108; Palazzata 83–84, 88–90, 97
Moletta tower 15
Monastery of Saint Praxedes 12
Monte Corona 59

Naples 55, 78, 81, 89, 134; Kingdom of Naples 134, 139, 169n50, 170n76, 170n77
Negroponte 29, 53, 61
Norcia 134
Noto 128, 130–131; Val di Noto 128, 130–131, 137

Orazi and Curiazi Tomb in Albano 152
Ostia 86, 162

Padua 59
Palaces: Archbishop's Palace (Sulmona) 139; Ducal Palace (Venice) 42–43; Palazzo Ardinghelli 138; Palazzo del Banco (Palazzo Senatorio) 88; Palazzo Carli 139; Palazzo Centi 138; Palazzo del Conte 139; Palazzetto dei Nobili 139; Palazzo dei Normanni 95; Palazzo Persichetti 138; Palazzo Pica Alfieri 139; Palazzo Quinzi 139; Palazzo Reale 85–86, 88, 90; Palazzo Rivera 138
Palermo 77–78, 80, 82–83, 85, 87–97, 100n70, 100n85; Cassaro 85, 91, 93–95, 97, 100n84; *Conca d'Oro* 89, 91, 95; Foro Italico 93; Molo Vecchio 91
Palestine 55, 58
Palestrina 9
Pantheon 7–8, 161
peninsula of San Raineri 84–85
Poland 55
Province: of Abruzzo Citra 135; Neapolitan 134

Ragusa (Dubrovnik) 104, 114
Recanati 55
Roads: via dei Banchi (Messina) 87; strada Colonna 91, 93; strada della Marina (Messina) 87; via Roio 140; via dell'Uccellatore 85
Roman Arches: Constantine Arch 156; Giano's Arch 163; Settimius Severus Arch 156; Titus Arch 156
Roman Forum 94, 156; Nerva's Forum 163
Roman Temples: of Antoninus and Faustina 156, 163; of Castor and Pollux 156; of Hercules Victor 156; Minerva's Temple 163; of Portunus 156; of Saturnus 156; *Tempio della Fortuna* 159; Venus and Rome 163, 165; of Vespasianus 156
Rome 1, 4, 6–7, 9, 11–16, 70, 78–80, 86, 88–89, 97, 99n52, 100n70, 134, 139, 152–157, 159–165, 166n3, 167n32, 168n44, 169n50, 169n51, 170n82, 171n85; Palatine Hill 13–14, 166n3; Quirinal Hill 5; *rione Pigna* 12

Septizodium 7, 13–16; as *Septem Solia* 14–16, 20n88, 20n89, 20n91; as *Septem Solia maior* 14; as *Septem Solia minor* 14
Sicily 77–78, 80–81, 87, 89–90, 98n5, 98n12, 100n85, 128, 130, 137, 167n32
Spain 60, 81, 89
Split 109, 114
squares: Piazza dell'Annunziata 138; Piazza Bologni 94; Piazza del Duomo (L'Aquila) 135, 140; Piazza del Duomo (Messina) 86; Piazza Marina 91, 93; Piazza Pretoria 94; Piazza San Marco (St Mark's Square) 25–26, 37, 41–43, 44; Piazza di Santa Giusta 138; Piazza di Santa Margherita 138; Piazza Santa Maria Paganica 138; Piazza di Santa Maria di Roio 138; *Piazzetta* 42–43; Quattro Canti (Piazza Vigliena) 92, 94

Teatro Olimpico 89
Tivoli 9
Topkapı: *Sarayı* garden 25; as garden 26, 28, 33–34, 44; as Palace 33–34, 41
Trieste 110, 115–116
Trsat 55
Tuscany 78, 154

Venice 27–30, 36, 38, 40, 43–44, 53–61, 64, 68–71, 72n20, 83, 104, 108, 110, 113, 115, 117, 134, 170n81; Giudecca 59, 85; *Serenissima* 26–32, 37, 40, 43, 60–61; *Stato da Mar* 29, 53
Verona 59, 106, 108–110, 112–116

9781032415635